Madame Cézanne

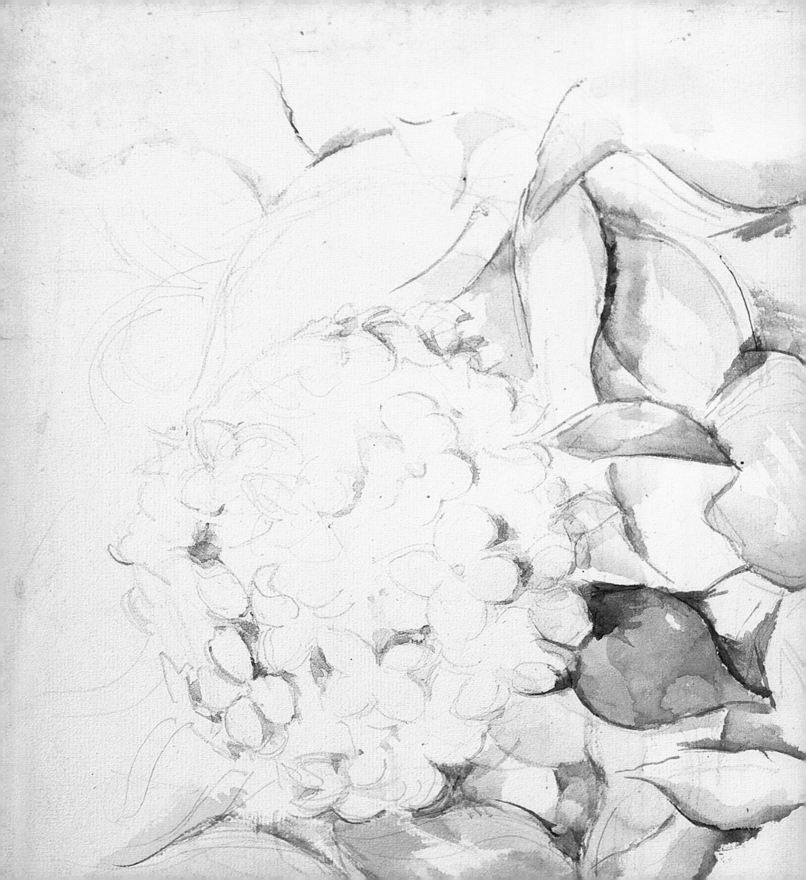

Madame Cézanne

Dita Amory

With contributions by Philippe Cézanne, Ann Dumas, Charlotte Hale, Kathryn Kremnitzer, Marjorie Shelley, and Hilary Spurling

THE METROPOLITAN MUSEUM OF ART, NEW YORK
Distributed by Yale University Press, New Haven and London

This catalogue is published in conjunction with "Madame Cézanne," on view at The Metropolitan Museum of Art, New York, from November 19, 2014, through March 15, 2015.

The exhibition and catalogue are made possible by The Florence Gould Foundation.

The exhibition is supported by an indemnity from the Federal Council on the Arts and the Humanities.

Published by The Metropolitan Museum of Art, New York

Mark Polizzotti, Publisher and Editor in Chief
Gwen Roginsky, Associate Publisher and General Manager of Publications
Peter Antony, Chief Production Manager
Michael Sittenfeld, Managing Editor
Robert Weisberg, Senior Project Manager

Edited by Anna Jardine
"The Portraits of Hortense Fiquet, Madame Cézanne" edited by Amelia Kutschbach
Designed by Laura Lindgren
Production by Paul Booth
Image acquisitions and permissions by Jane S. Tai and Ling Hu
Translation of Philippe Cézanne's essay from the French by Jane Marie Todd

Photographs of works in the Museum's collection are by The Photograph Studio, The Metropolitan Museum of Art; new photography is by Katherine Dahab and Mark Morosse.

Additional photograph credits appear on p. 224.

Typeset in Nexus, Conqueror Sans, and Fell French Canon
Printed on 150 gsm Perigord
Separations by Professional Graphics, Inc., Rockford, Illinois
Printed and bound by Ediciones El Viso, S.A., Madrid, Spain

Jacket illustrations: front: Paul Cézanne, *Madame Cézanne in a Red Armchair*, ca. 1877 (pl. 4, detail); back: Paul Cézanne, *Portrait of Madame Cézanne*, ca. 1885–87 (pl. 27, detail)

Frontispiece: Paul Cézanne, *Madame Cézanne with Hortensias*, 1885 (pl. 42, detail)

Additional illustrations: p. vi: Paul Cézanne, *Madame Cézanne in the Conservatory*, 1891 (pl. 28, detail); p. viii: Paul Cézanne, *Portrait of Madame Cézanne*, ca. 1885–87 (pl. 27, detail); p. xvi: Paul Cézanne, *Madame Cézanne in Blue*, ca. 1888–90 (pl. 18, detail); p. 34: Paul Cézanne, *Portrait of the Artist's Wife*, ca. 1879–82 (pl. 6, detail); p. 44: Paul Cézanne, *Portrait of Madame Cézanne*, ca. 1885 (pl. 14, detail); p. 86: Paul Cézanne, *Madame Cézanne in a Red Dress*, ca. 1888–90 (pl. 22, detail); p. 106: Paul Cézanne, *Portrait of Madame Cézanne*, 1876–79 (pl. 31, detail); p. 146: Paul Cézanne, *Portrait of Madame Cézanne*, ca. 1885–88 (pl. 16, detail); p. 160: Paul Cézanne, *Portrait of Madame Cézanne*, ca. 1888–90 (pl. 25, detail)

The Metropolitan Museum of Art
1000 Fifth Avenue
New York, New York 10028
metmuseum.org

Distributed by Yale University Press, New Haven and London
yalebooks.com/art | yalebooks.co.uk

Cataloging-in-Publication Data is available from the Library of Congress.
ISBN 978-1-58839-546-7 (The Metropolitan Museum of Art)
ISBN 978-0-300-20810-8 (Yale University Press)

CONTENTS

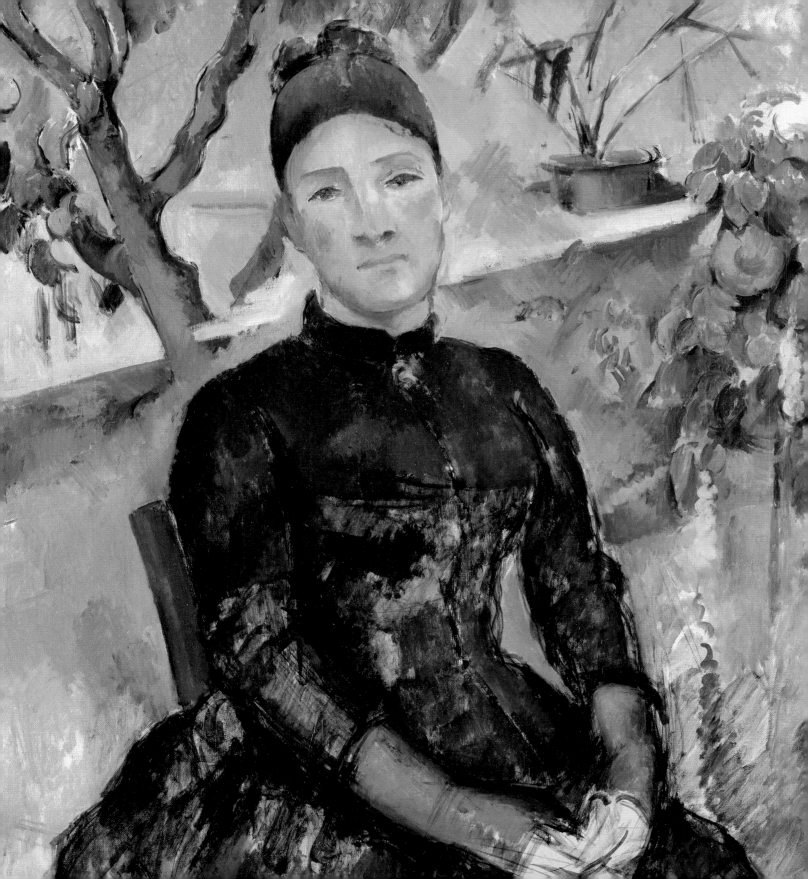

DIRECTOR'S FOREWORD

Hortense Fiquet played a pivotal role in the life of Paul Cézanne. She sat for twenty-nine portraits, more than any other model in his long career. She was the central focus of his figure paintings, the constant in his ever-searching investigations of form, space, and light. And yet as preferred model, mother of his only son, and life companion, Hortense was rarely noticed as having any measurable impact on her husband's life as an artist. She was credited only with posing for hours without moving or talking, and with lending herself "to the endless sittings he inflicted on her." Over time, she was all but forgotten in the literature. Even the mesmerizing portraits, legacies of her presence, were often titled, dismissively, "Portrait of a Woman." So it is with great pleasure, and deserved consideration, that The Metropolitan Museum of Art has organized the first exhibition ever of the portraits of Hortense Fiquet, Madame Cézanne.

We thank the private collections and public museums for their generous loans. Many individuals at the Metropolitan Museum have contributed to the exhibition and its accompanying catalogue, most of all its curator, Dita Amory, Acting Associate Curator in Charge and Administrator of the Robert Lehman Collection, who has succeeded in uniting twenty-four portraits among the twenty-seven traceable to public and private collections in the United States, Europe, Brazil, and Japan.

We would like to express our appreciation to The Florence Gould Foundation for its generous support of this exhibition and catalogue. The Foundation's long-standing commitment to the Metropolitan's exhibitions program has been integral to the realization of numerous scholarly projects highlighting the rich cultural traditions of France, and we are deeply grateful. Our sincere thanks also go to the Federal Council on the Arts and the Humanities for its important contribution to this project.

Thomas P. Campbell
Director
The Metropolitan Museum of Art

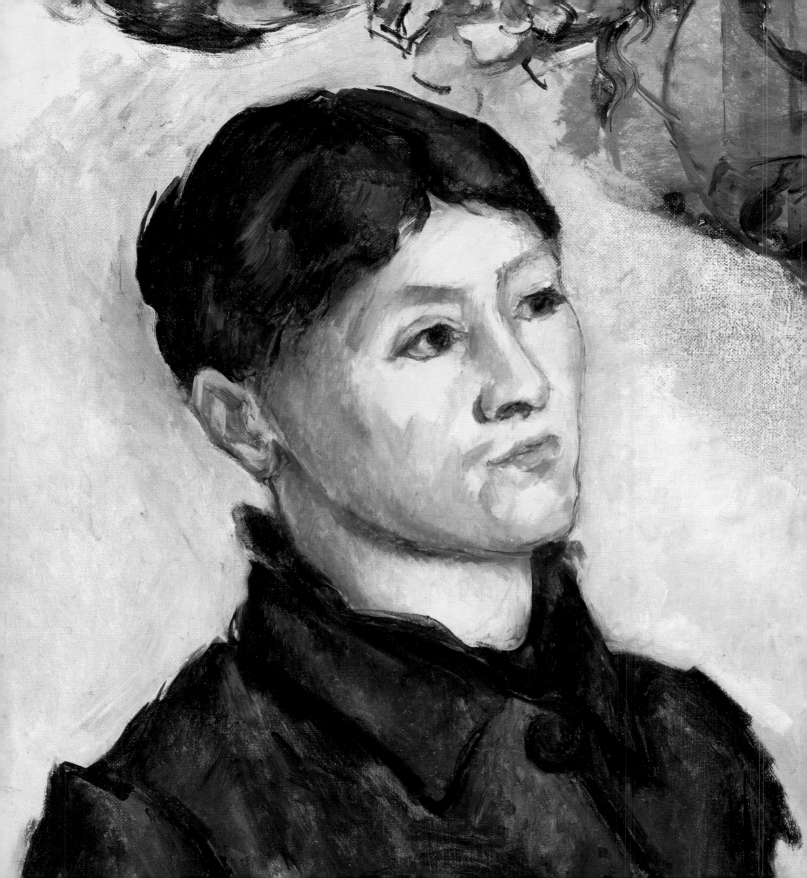

PREFACE

Paul Cézanne's portraits of his wife and most frequent model, Hortense Fiquet, profoundly shaped his practice as a figure painter and stood as a paradigm for later artists. Pablo Picasso called Cézanne "my one and only master . . . the father of us all, and indeed, he is often named a painter's painter." If these quietly powerful paintings of Hortense Fiquet came to be acknowledged as a testing ground for Cézanne's innovation and experimentation with paint on canvas, their subject and her vital partnership as model, mistress, wife, and mother have been willfully overlooked. This study considers that partnership in all its facets and complexities, bearing in mind that the portraits in oil, watercolor, and pencil provide the only material clues to a largely inscrutable relationship. For all the documentation laid out in these pages, we still wonder how often and for how long Hortense sat in silence as her husband advanced his canvases. Living largely at a distance, even after marriage, how did she come to model for him so frequently, and where did she pose for an artist who moved restlessly from studio to studio, from Paris to Aix and back again? Their story is a deeply compelling one, perhaps even more so for the very absence of all its particulars.

Paul Cézanne met Hortense Fiquet in Paris in 1869. She was working not as a model at the Académie Suisse, where Cézanne drew informally in the mornings, but rather as a bookbinder. Although the circumstances of their first encounter are unknown, an early portrait (now lost) of the sensual twenty-two-year-old tells us that she was modeling for the artist by 1872. She would spend the rest of her life serving the extraordinary Paul Cézanne. Their only child, Paul, was fourteen when his father finally married his mother—a marriage born not of abiding love but of the artist's wish to formalize his son's inheritance. Until that moment, Cézanne took great pains to conceal his mistress and their love child, fearing his father's disapproval. The complicated subterfuge led to separate residences, frequent and often desperate appeals for funds, and long periods of living apart. And yet, despite this familial abandonment and seeming neglect, the portraits in this exhibition witness the constancy of a relationship, and an aesthetic dependency singularly critical to the artist's practice. Cézanne made twenty-nine portrait paintings of Hortense Fiquet over the course of some

twenty years. And in the evenings, especially in Paris, he could be found casually sketching his subject sleeping or sewing, and often in the company of their young son. While few of these sketches relate directly to the painted portraits as preparatory, they glimpse a tender interchange—informal, unguarded moments—exposing an intimacy rarely seen in the oils.

Cézanne's studio practice was another matter. There the artist painted from nature with a rigorous intensity, sometimes pausing for twenty minutes between brushstrokes. Referring to his own concentration as he worked, Cézanne once said, "My eyes, you know, my wife tells me that they jump out of my head, they get all bloodshot." We know from his many letters and from the subjects that reappear in his paintings that Cézanne could work only from familiar motifs—whether the landscape surrounding Mont Sainte-Victoire, a plaster cast of Cupid, a jug, or an apple. Familiarity with the geometry and palette of his imagery freed him to deepen his perceptions with every investigation, responding anew to sensory experience. And so it was with the many portraits of Hortense Fiquet. He readily knew the lines of her jaw, the asymmetry of her eyes, and the distinctive pallor of her coloring. Hortense was his catalyst, enabling the enterprise. This process is nowhere more apparent than in a series of portraits in which his protagonist sits in a yellow brocade chair, wearing a red dress. Visual touch points link the paintings, but the sitter's expression varies, as do the structural appointments of the composition. Together they map the artist's advancing practice, and yet we have no knowledge of the circumstances in which they were painted, in what order they were finished, what studio was used, whether in Provence or Paris. It is the allure of these mysteries that draws us to the artist after so many years, and after volumes of critical analysis.

Hortense Fiquet has not fared well in the writings on Cézanne, neither as his model nor as his wife. With little understanding of her as a human being, critics have taken the portraits as a platform for character analysis, citing her sour expression and remote, impenetrable demeanor. Over time, these unflattering observations have crafted a wholly undeserved reputation, in and out of Cézanne's studio. One need only read the few extant letters in the hand of Hortense Fiquet to recognize her strengths and the qualities of character that redeem her memory. In one letter, she conveys her joy in the reconciliation of Cézanne's mother and sister, a seemingly small aside yet suggestive of her forgiving generosity toward his family. Cézanne's family

never welcomed Hortense into their hearts, even after the couple married. In another letter, with sophistication and resolve she discusses future publications and exhibitions of her husband's work. The tenor and content of these documents would seem to contradict her undeserved legacy—emphatically articulated in her day by Cézanne's family and friends, and burnished by critics and art historians throughout the past century.

Cézanne's portraits of Hortense Fiquet have attracted far less attention than his landscapes and still lifes. With a few exceptions—notably the rhapsodizing commentary of the poet Rainer Maria Rilke upon seeing *Madame Cézanne in a Red Armchair* (pl. 4) in the 1907 Salon exhibition—critical opinion has refused to consider their weight in the trajectory of Cézanne's artistic practice. Some have found Hortense's detached expression no more animated than his still-life apples. This is perilous territory, for Madame Cézanne was no inanimate equivalent. Her portraits carry far more nuanced layering than evidenced in a formal investigation of the interrelationship of still-life objects on a table. Indeed, she plays a seminal role in the process of developing a structural language on canvas, much as an apple does elsewhere, but the commonality stops there. It is precisely these nuanced layers that have puzzled critics for decades. Hortense Fiquet was both model and wife; the implicit emotional ties are often elusive. To understand the full power of these portraits takes time and patience. No two portraits share the same facial expression. They elicit differing responses. Their technical development covers a broad spectrum of methodologies: the thickness of the paint film, the apparent lack of finish, the vigor of underdrawing and its aesthetic role—all shift and vary without pattern or expectation. We know that Cézanne perceived form in terms of color relationships, patches of color that coalesced in warm-cool contrasts, and yet his approach was not systematic. It is the endlessly varying development of these canvases that has so intrigued and challenged this study. Just as Hortense Fiquet's likeness refuses to come forth with clues to her character, so, too, does the manner in which she was painted, often painstakingly, confound us at first glance. It is thanks to the opportunity to closely examine these pictures as objects, as works of art, as clues to a long relationship, that we come a little closer to Cézanne, and to the still-ephemeral qualities of his remarkable life.

Dita Amory
Acting Associate Curator in Charge and Administrator,
Robert Lehman Collection, The Metropolitan Museum of Art

ACKNOWLEDGMENTS

An exhibition that traces a particular passage in the career of a painter relies on the generosity of its lenders, and the support of many individuals. Presenting Paul Cézanne's portraits of his wife, Hortense Fiquet, is one such enterprise. As two of the early portraits are now lost, and others do not travel, it was with some hubris that we embarked on this project, confident that even a few extraordinary portraits would constitute an arresting exhibition. It is thanks to many lenders and colleagues, and the encouragement of the painter's great-grandson Philippe Cézanne, that we have collected nearly all the portraits. Every one carries its own weight and mystery and stands as the precious legacy of an elusive partnership so fundamental to Cézanne's portrait practice.

We owe our deepest gratitude to the private collectors and public museums that graciously agreed to part temporarily with their portraits and share important research materials. Of the private collectors, we thank Ralph Fassey, Richard and Mary L. Gray and the Gray Collection Trust, Jasper Johns, Stephen Mazoh, William C. Paley and the Paley Foundation, Mrs. Georges Pébereau, Véronique and Louis-Antoine Prat, Judy and Michael Steinhardt, Isabel Stainow Wilcox, and several who wish to remain anonymous. In this regard, we are grateful to Gerard Faggionato and Salomé Prada for their assistance with an anonymous loan. I greatly appreciate the support of Olivier Berggruen, whose encouragement and diplomacy secured important paintings and drawings from his family collection.

Of the institutional lenders, we thank Douglas W. Druick, Suzanne Folds McCullagh, Gloria Groom, Stephanie D'Alessandro, Frank Zuccari, Harriet Stratis, and Kelly Keegan at the Art Institute of Chicago; Christopher Brown at the Ashmolean Museum; Ernst Vegelin van Claerbergen and Stephanie Buck at the Courtauld Gallery; Graham W. J. Beal, Salvador Salort-Pons, and Alfred Ackerman at the Detroit Institute of Arts; Samuel Keller, Raphael Bouvier, Oliver Wick, Markus Gross, and Friederike Steckling at the Fondation Beyeler; William M. Griswold, Jennifer Tonkovich, Emily Leonardo, Maria L. Fredericks, Lindsey Tyne, and John Alexander at the Morgan Library & Museum; Stéphanie Lardez at the Musée Granet; Isabelle Testu at the Musée des Lettres et Manuscrits, Paris; Marie-Paule Vial at the Musée de l'Orangerie; Guy Cogeval, Isabelle Cahn, Caroline Mathieu,

Xavier Rey, Bénédicte Trémolières, and Isabelle Gaëtan at the Musée d'Orsay; Eugênia Gorini and Lucas Pessoa at the Museu de Arte de São Paulo Assis Chateaubriand; Sjarel Ex at the Museum Boijmans Van Beuningen; Malcolm Rogers, Ronni Baer, Emily Beeny, Rhona MacBeth, and Irene Konefal at the Museum of Fine Arts, Boston; László Baán and Zsuzsanna Gila at the Museum of Fine Arts, Budapest; Gary Tinterow, Helga Aurisch, David Bomford, and Zahira Véliz at the Museum of Fine Arts, Houston; Glenn D. Lowry, Christophe Cherix, Kathy Curry, and Milan Hughston at the Museum of Modern Art, New York; Earl A. Powell III, Mary Morton, Margaret Morgan Grasselli, Jean Henry, Kimberly Schenck, and Lisa MacDougall at the National Gallery of Art, Washington, D.C.; Magnus Olausson at the Nationalmuseum, Stockholm; Timothy Rub, Mark Tucker, Catherine Herbert, and Jennifer L. Vanim at the Philadelphia Museum of Art, and with deepest thanks to Joseph J. Rishel, whose loan of every Hortense Fiquet portrait in that museum's collection enriched the exhibition immeasurably; Richard Armstrong and Gillian McMillan at the Solomon R. Guggenheim Museum and Foundation; Kyllikki Zacharias and Felicia Rappe at the Staatliche Museen zu Berlin, Nationalgalerie, Museum Berggruen; and Eriko Osaka at the Yokohama Museum of Art.

At the Metropolitan Museum, we are grateful to our Director, Thomas P. Campbell, and Associate Director for Exhibitions, Jennifer Russell, for their early endorsement of the project. To Emily Kernan Rafferty, President, and Nina McN. Diefenbach, Vice President for Development and Membership, we give heartfelt appreciation for securing funding for the exhibition and its publication. The support of The Florence Gould Foundation, as well as an indemnity granted by the Federal Council on the Arts and the Humanities, has made this project possible, and we are most grateful.

The exhibition owes its success to colleagues throughout the Museum: in the Department of European Paintings, Keith Christiansen, John Pope-Hennessy Chairman, and Susan Alyson Stein, Engelhard Curator of Nineteenth-Century European Painting; Charlotte Hale, Conservator, Department of Paintings Conservation, and Marjorie Shelley, Sherman Fairchild Conservator in Charge, Sherman Fairchild Center for Works on Paper and Photograph Conservation; George R. Goldner, Drue Heinz Chairman, and Cora Michael, Curator, from the Department of Drawings and Prints; Elyse Topalian, Mary Flanagan, and Mary Arendt in

Communications; Susan Sellers, Michael Langley, Sue Koch, JiEun Rim, and Melanie Malkin in Design; Mary McNamara, Meryl Cohen, and Allison B. Barone in the Registrar's Office; Kenneth Soehner, Arthur K. Watson Chief Librarian, The Thomas J. Watson Library, and his colleagues Nancy B. Mandel and Mindell Dubansky; Joseph Loh, Jennifer Mock, and Alice W. Schwarz in Education; and Robin Schwalb and Paul Caro in Digital Media.

Many other colleagues at the Museum lent support, from the exhibition's inception to its realization, among them Michael Gallagher, Sherman Fairchild Conservator in Charge, Sherman Fairchild Center for Paintings Conservation, Rebecca Rabinow, Leonard A. Lauder Curator of Modern Art and Curator in Charge of the Leonard A. Lauder Research Center for Modern Art, and Sabine Rewald, Jacques and Natasha Gelman Curator for Modern Art, as well as Julie Arslanoglu, Jessica Bell, Mary Jo Carson, Silvia A. Centeno, Sharon H. Cott, Martha Deese, Maria E. Fillas, Robyn Fleming, Kathryn Calley Galitz, Lisa M. Harms, Amy Lamberti, Patrice Mattia, Jessica Ranne, Evan Read, Yer Vang, Mark Wypyski, and Mary Zuber. And so did colleagues outside the Museum: Lilah Aubrey, Karen Barbosa, Thomas Becker, Laura Bramble, Emily Braun, Marina Ferretti Bocquillon, Barbara Buckley, Denis Coutagne, Judith Dolkart, Chantal Duverget, Peter Ertl, Lukas Gloor, Pierre Gobert, Caroline Heider, Amanda Hon, Raymond Hurtu, Grant Johnson, Anna Jozefacka, Emma Kronman, Pedro Corrêa do Lago, Mary Tompkins Lewis, Patricia Loiko, Isabella Lores, Ruth Nagel, Elizabeth Reissner, Andreas Ritter, Christa Savino, Dominique Sennelier, Jean José Sepulveda, Anya Shutov, Maggie Spicer, Linda Sylling, Renata Vieira da Motta, Heinz Widauer, and William Wyer.

To the trustees of the Robert Lehman Foundation, especially its President, Philip H. Isles, I appreciate the opportunity to present this exhibition in the galleries of the Lehman Wing. And I thank my friends in the Lehman Collection, Alison Manges Nogueira, Debra Jackson, Manus Gallagher, Meg Black, and Lawrence D. Weimer, for their many contributions to the exhibition and for their patience as Paul Cézanne diverted my attention for many months.

It is to Mark Polizzotti and his team in the Museum's Editorial Department that we owe the success of this publication. Mark embraced the project from the start, and his interest was shared by many colleagues with whom it was a pleasure to collaborate: Michael Sittenfeld, Gwen Roginsky, Peter Antony, Robert Weisberg, Elizabeth Zechella, Marcie M. Muscat, Jane S. Tai, Ling Hu, and Briana Parker. We owe special thanks to Anna Jardine,

guest editor, for copyediting the essays, to Amelia Kutschbach for her fine documentary research, to Paul Booth for effortlessly setting a high standard of production, and to Laura Lindgren for designing this handsome book.

Several art historians deserve praise for their scholarly support. First, I would like to thank my dear friend Jack Flam, whose casual comment in the galleries of the Philadelphia Museum of Art led to this exhibition. To David Nash of Mitchell-Innes & Nash and Jill Newhouse of Jill Newhouse Gallery, we are ever grateful for providing third-party values preparatory to the United States Government Indemnity application. We thank Robert Parker for chasing down the elusive letter in manuscript from Hortense Fiquet to Marie Chocquet. On the eve of launching the much-anticipated digital catalogue raisonné of Paul Cézanne's paintings, a revised edition of John Rewald's seminal study, we thank its authors, Jayne Warman, Walter Feilchenfeldt, and David Nash, for sharing the documentation that populates the apparatus of this book. Their generosity from the start, especially that of Jayne Warman, is deeply appreciated. While this publication accompanies the first exhibition to assemble the portraits of Madame Cézanne, it is not the first to undertake a solid study of Cézanne's favorite model. Susan Sidlauskas was the first to write on Hortense Fiquet and Paul Cézanne, and we are grateful for her carefully considered, groundbreaking analysis. An exhibition devoted to Madame Cézanne is by definition a highly selective culling of portraits marking an extraordinary career. Our presentation is a preamble to the much more expansive exhibition of Paul Cézanne's portraiture to be organized by John Elderfield, Xavier Rey, and Mary Morton in the years to come.

This book has been a scholarly collaboration in the best of circumstances. I am grateful to my fellow authors—Philippe Cézanne, Ann Dumas, Charlotte Hale, Kathryn Kremnitzer, Marjorie Shelley, and Hilary Spurling—for extending the scope of our study well beyond the studios of Paul Cézanne. Last but not least, I want to express my gratitude to Kathryn Kremnitzer, Research Assistant, who has shared this journey with me every step of the way. Her impressive research, fine editorial skills, patience, and intelligence have inflected this entire project, and I know I speak for the authors of this publication, as well as the Editorial Department, in thanking her profoundly.

Dita Amory

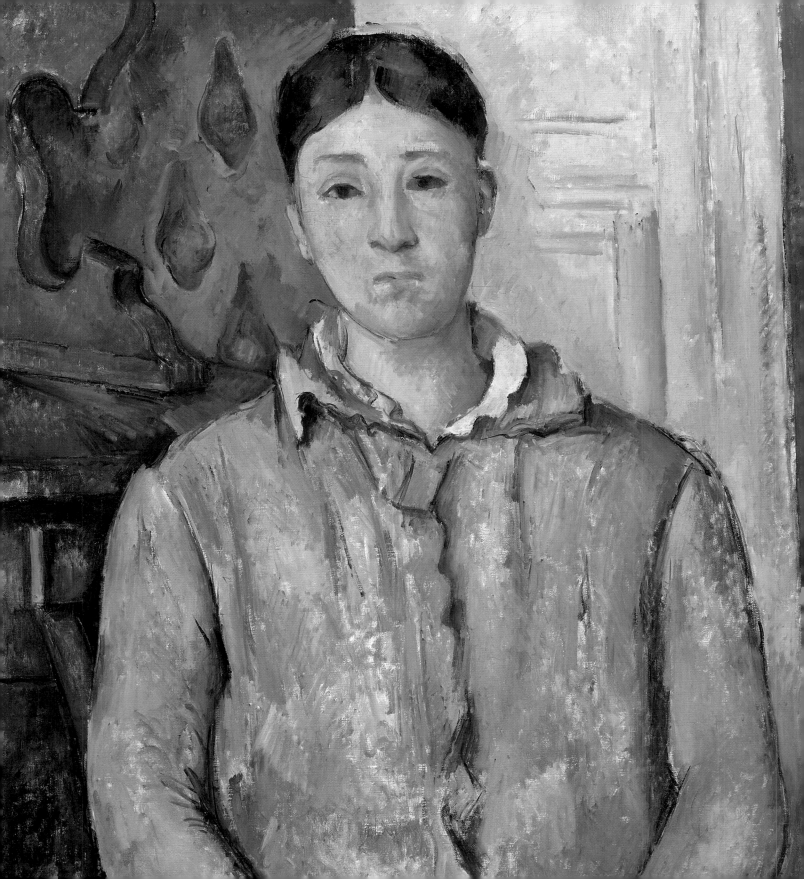

Dita Amory

Newly Seeing the Familiar
Paul Cézanne, Hortense Fiquet, and the Portraits

> For months posing was torture to her. Life no longer seemed to
> consist of the two of them living happily together; it was as if a
> third party had been introduced, a mistress, the woman he was
> painting with her body for the model. Between them stood the
> enormous canvas, like a great insurmountable wall and he lived
> on one side of it with the other woman. . . . What was she, after all,
> this other woman? Nothing, really; dust, color on canvas, an image.
>
> —Emile Zola, *The Masterpiece*[1]

Thinly veiled fiction, Zola's novel traces the Parisian career of an unfulfilled
painter and his adoring mistress in the later decades of the nineteenth
century, when, mirroring reality, the French Salon repeatedly rejected the
new aesthetics of a rising avant-garde. Paul Cézanne was no exception, his
own misery and frustration laid out in the unvarnished narratives of Zola's
The Masterpiece. Many would recognize the protagonist, Claude Lantier, as
Paul Cézanne, and it took little imagination to link provincial Christine
Hallegrain to Hortense Fiquet. The exposure of that relationship in the
pages of Zola's fiction must have been devastating. For seventeen years,
through subterfuge and blind luck Cézanne kept his quiet liaison a secret
from an authoritarian father, fearing the loss of a modest monthly allowance
on which he fully depended.

Zola's novel led to the rupture of a long and deeply felt friendship. For the author and the artist had grown up together in Aix-en-Provence. Best friends in grade school, they roamed the countryside as children. It was Zola who urged Cézanne's move to Paris, to train among established artists and to sketch from the great masters of the Louvre. Later, when Cézanne's stipend was insufficient to support his clandestine family (his son, Paul, was born in 1872), he turned to Zola for funds. "If therefore, my father does not give me enough, I shall appeal to you in the first week of next month, and I shall give you Hortense's address to whom you will be kind enough to send it."[2] And two months later: "Here is my monthly prayer to you recommencing. I do hope it does not weary you too much. . . . But your offer saves me so much embarrassment that I am having recourse to it again. My good family, otherwise excellent, is, for an unhappy painter who has never been able to achieve anything, perhaps a little bit mean, a slight failing and easily excusable without doubt in the provinces. . . . I am asking you to be kind enough to send sixty francs to Hortense, who, by the way, is feeling no worse."[3] Despite their long-held ties, Paul Cézanne abandoned his old friend, unwilling to forgive the unsavory characterization of Claude Lantier, so close to his own temperament. It was a literary exploitation of unforgivable proportions.

The precise circumstances under which Paul Cézanne met the nineteen-year-old Marie-Hortense Fiquet are unclear. We know it was early in 1869, and in Paris. Art historians conjecture that she was earning a meager living as an artist's model. She may have met Cézanne, eleven years her elder, in an art studio on the Left Bank. A well-documented chronology tells us that the artist arrived in Paris in 1861, accompanied by his father.[4] Intending to enroll at the Ecole des Beaux-Arts, he spent his mornings sketching at the Académie Suisse, a drawing studio at 4, quai des Orfèvres, where, for a nominal fee, artists could gather informally to draw and paint from a live model.[5] The Académie Suisse attracted a cast of illustrious characters earlier in the century—Daumier, Courbet, Manet, Fantin-Latour, Carolus-Duran—and no fewer in Cézanne's day. It was there that he met fellow artist Armand Guillaumin, who would introduce him to the charismatic Camille Pissarro. And it was Pissarro who would encourage the young painter in Auvers and Pontoise in the years to come.

Studies of Fiquet family history suggest that Hortense was not in fact a studio model when she made the acquaintance of Paul Cézanne, but a

bookbinder.[6] Her great-grandson Philippe Cézanne relates that Marie-Hortense Fiquet was born on April 22, 1850, in Saligney, a village in Jura, near Besançon.[7] She was the oldest of three children; her siblings, François-Jules and Marie-Eugénie-Ernestine, died very young. Her father, Claude-Antoine Fiquet, moved the family to Paris sometime in 1854, after a cholera epidemic. Working first as a bailiff's clerk, he was later recorded as a bookbinder after the untimely death of his wife, Catherine Déprez.[8] Hortense herself appears to have been working in a bookbindery in 1869, the year of her first encounter with Cézanne.

For the next thirty-seven years, Hortense would play a role, indeed many roles, in the life of Paul Cézanne. She sat for twenty-nine mesmerizing portraits and, at times unwittingly, for dozens of pencil drawings laid out in small sketchbooks filled with jottings and notations.[9] She bore the artist's only child, a son, Paul, and raised him on her own with little help from his father, or anyone else for that matter.[10] She endured hardship and neglect on many levels, not least Cézanne's refusal to honor her presence in the greater Cézanne family. It was not until 1886 that he legitimized their union, not in a reaffirmation of love but more likely to sanctify paternity and matters of inheritance. Young Paul was deeply loved by his father, though largely at a distance. The artist's letters, on which we rely for direct glimpses of character, demonstrate that affection. Those letters speak caringly, too, of Hortense Fiquet, though more often as the mother and caretaker of their son than as a loving life partner.[11]

Piecing together a life portrait of Cézanne's most frequent portrait model is no simple task. We catch fleeting cameos of her by way of the artist, whose every destination is thoroughly recorded. Cézanne's peripatetic lifestyle—from Aix to Paris, from Paris to Pontoise, L'Estaque, or Marseille—scarcely found his family in parallel motion. But in the early years of their partnership, the couple lived quite blissfully, and that passion is often overlooked in considerations of their life together. We have no record of when Hortense began posing for Cézanne, but we do know that in 1870 they were living together in the village of L'Estaque, on the Mediterranean—a move from Paris prompted by the upheavals of the Franco-Prussian War and conscription. It appears that Cézanne's mother, Anne-Elisabeth, by then knew of the young woman and the clandestine nature of the liaison.[12] It would take another sixteen years before his father, Louis-Auguste Cézanne, would acknowledge Hortense Fiquet and his first grandchild.

Although it is often difficult to date the portraits of Hortense, an early example captures her tenderly breastfeeding her son (pl. 3). The picture, painted in broad strokes evocative of Cézanne's early paintings, is now lost, but it could date only to the months following January 4, 1872, when little Paul was born.[13] That same year, at the urging of Camille Pissarro, Cézanne relocated his family to Auvers-sur-Oise, a rural village northwest of Paris. For the next year and a half, he walked the four-mile journey every day from Auvers to Pontoise and painted landscapes *en plein air* alongside Pissarro. "Pissarro was like a father to me. He was a wise counselor and something like God Almighty," Cézanne said.[14] Pissarro remained his champion for many years, encouraging his craft and buying his paintings.[15]

Soon after returning to Paris with his young family in 1874, Cézanne was summoned back to Aix, his parents eager for news and for his company. He agreed to go on condition that they raise his monthly allowance from 100 to 200 francs, an appeal sparked by the need to provide for Hortense and little Paul. Though Paris was always in his sights, Cézanne was fundamentally an Aixois.[16] His attachment to his native Provençal culture, and indeed his native landscape, was as powerful as his dependence on his mother and father, and this he never abandoned. Critics have often mentioned Cézanne's chronic anxiety, a malaise that brought self-doubt, irascible behavior, and a restlessness that followed him to the grave. But given his family circumstances, along with the repeated rejection of his paintings in the public arena, it is no wonder that life's trials shook his emotional well-being.[17] Cézanne could only try to reconcile the irreconcilable: a father, a mother, and two sisters who, even after his marriage, refused to welcome Hortense into the family; chronic financial straits as an unfulfilled artist; the need to draw and paint without domestic distraction; and a will to continue working in a climate of critical humiliation. He was further challenged by a fractured lifestyle, running back and forth between Aix and Paris, between the comforts and peace of familiar ground in the south and a call to Paris, that inexorable struggle for elusive recognition among contemporaries.

It was in small, crowded Paris apartments that Paul Cézanne painted many of his affecting portraits of Hortense Fiquet (fig. 1).[18] She was his most frequent female model, posing for the artist more often than anyone but himself. One might say she was an obsession, not one of passion, but rather of circumstance and familiarity. Hortense may not have understood the nuanced

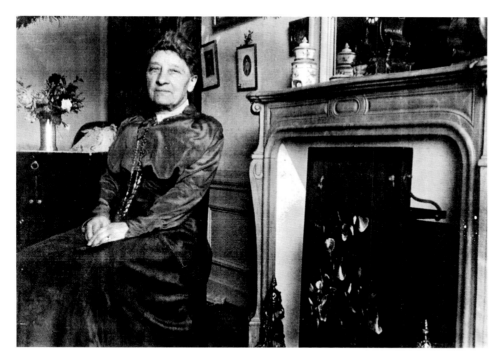

Fig. 1. Hortense Fiquet in her Paris apartment. Photograph courtesy of Philippe Cézanne

creative process that was Cézanne's genius, but she would sit patiently for hours as he advanced his canvases, realizing what he called his *sensations* (sensations) through *taches* (touches) of colored hues.[19] In search of the right metaphors for his *sensations*, Cézanne worked on his canvases holistically all at once. "I take these colors, tones, shades from the right, the left, here, there, everywhere; I fix them, I bring them together. . . . They take on volume. They have a value."[20] It was the process of capturing sensory perception that led him to translate objects into patches of color, transforming nature—his subjects— into motifs. This was as true for still lifes and landscapes as for portraits.

Cézanne painted slowly, and in some instances sequentially; this suggests that multiple portraits were in process at once. And while one may be inclined to draw conclusions from sequential portraits having common ground, it is more likely that the artist took what information he needed from one portrait as visual data for the next. He was not serializing Hortense Fiquet, nor was he preoccupied with relating one portrait to another as a counterpoint. It was, understandably, convenient to use the same setup more than once, an earlier image serving as a laboratory for an ongoing formal investigation. One need only remember the multiple landscapes of Mont

Sainte-Victoire, all alike and yet each unique, to recognize the process by which Cézanne evolves and moves his imagery. "Here on the bank of the river the motifs multiply, the same subject seen from a different angle offers subject for study of the most powerful interest and so varied that I think I could occupy myself for months without changing place, by turning now more to the right, now more to the left."[21] These words could just as easily have applied to Cézanne's studio practice where Hortense is the focus, "a subject for study of the most powerful interest and so varied."

Given their common pictorial touch points, the portraits might seem to arrange themselves in a chronology spanning the twenty years of production. We recognize dresses and jackets that appear, disappear, and reappear.[22] Fashion was fickle in nineteenth-century France. Taste shifted often and in radical ways. Bustles came and went. Skirts were gathered and ruffled one minute, and then covered in lace another. While Hortense lived on a modest allowance in an expensive city in the early years of her liaison with Cézanne, she could not have been blind to fashion. It is said that her spending became quite extravagant in the years after her husband's handsome inheritance, and this caused consternation and criticism in the Cézanne household in Aix. The many portraits of Hortense in silks and velvets, bustles and bows, attest to a refined taste in contemporary fashion.

By 1870, French portraiture had come a long way since Jean Auguste Dominique Ingres memorialized refined ladies of noble birth in sumptuous portraits of virtuosic paint finish. The introduction of the camera, and the consequent proliferation of inexpensive portrait photographs, led to a surfeit of painted portraits. Emboldened by the promise of ready sales, artists of the period flooded the Salon with examples of the genre. Zola found the Salon exhibition of 1868 covered with "silly grimacing faces."[23] It was, of course, the Impressionists who set the stage for this quiet reformulation of portraiture, placing their sitters in seemingly random settings of contemporary life. In many such examples, sitters share the stage in a narrative more "genre" than portraiture, their presence often surrounded by eclectic attributes of personal metaphor. Edouard Manet's famed portrait of Zola is a case in point (fig. 2). Linda Nochlin rightly calls the illustrious sitter "an object among objects, a surface among elegantly deployed surfaces."[24]

The de-emphasis of identity in Impressionist portraits calls into question common nomenclature. Do we consider their subjects models or

sitters—defining models as anonymous, paid professionals and sitters as individuals with predetermined expectations, and a purse to support the enterprise? In many instances, this differentiation is clear-cut. Traditional portraits were commissioned, after all. How we characterize Hortense Fiquet as subject has less to do with identity than with how Paul Cézanne observed her in the studio, how she conformed to his long and complex investigations of surface relationships on canvas. We recognize her as the sitter, most of the time, but still call her the model.[25] The artist told Joachim Gasquet that to paint effectively one must bring the model into harmony with oneself and one's colors.[26] A portrait works only with the right model, he said.

What was she, after all, this other woman?[27] In her groundbreaking study of Hortense Fiquet as model and "counter-muse" to Paul Cézanne, Susan Sidlauskas examines the dualities—the compelling, emotional interplay of the artist and his model.[28] Historical opinion has often cited Cézanne's phobic resistance to physical contact. It is said that he could not paint without a "palpable" distance between himself and his model. Sidlauskas argues, by contrast, that reciprocity—a felt engagement—was fundamental to the realization of these portraits. To Cézanne's "self" was implacably linked Hortense Fiquet's "other."

Ill humored, discontented, remarkably plain, sullen, remote, disconsolate—so critics, art historians, and the public have mythologized Hortense Fiquet in viewing her portraits. There is a resistance to acknowledging any expression of love, either in the painted image or by implication in its maker. And yet, one need only look at any number of frontal portraits to see in the gaze a tender interchange, and a figure fully engaged as object of the creative enterprise. In the early portraits, there is an air of self-consciousness in the sitter. She rarely looks directly at the artist. She is more object than ally. But by the mid-1880s, the portraits demonstrate an increasing complexity of feeling—given and reciprocated love. We even detect empathy for the artist in the sitter's tender expression. She now stares directly at Cézanne with newfound strength, endorsing the endeavor. In the Berlin picture, from about 1885 (pl. 14), Cézanne paints with a restraint of touch and palette. Her

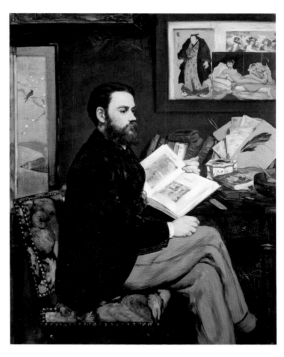

Fig. 2. Edouard Manet (1832–1883), *Emile Zola*, 1868. Oil on canvas, 57⅝ × 44⅞ in. (146.5 × 114 cm). Musée d'Orsay, Paris (RF 2205)

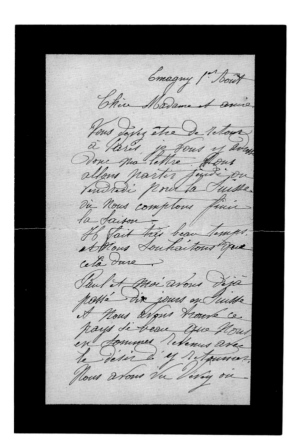

Fig. 3. Page of letter from Hortense Fiquet to Marie Chocquet, Emagny, August 1 [1890], on mourning stationery. Musée des Lettres et Manuscrits, Paris (37119)

gaze is unequivocal. Her differentiated eyes convey the dialogue. Hortense is almost beautiful in this delicate treatment. The Musée d'Orsay portrait, from about 1885–88 (pl. 16), though less giving physiognomically, evokes a feeling for the sitter that could come only from considered affection. The discretion of color relationships suggests a special presence between artist and model. Among the many bust-length portraits of this period is an example of extraordinary sensuality in the Philadelphia Museum of Art (pl. 27). One need only look at how Cézanne sees the transition from the right cheek across the bridge of the nose to the left cheek or the transition of pink flesh to the greenish space of the wall. The sensitivity of the brush as it caresses the canvas is a revelation of intimacy in these portraits—affection transferred, if you will, through the touch of the brush.

Set in a defined interior, a similarly sympathetic example in Houston (pl. 18) delivers a sitter at one with herself, and again at one with the enterprise. A few years earlier, Cézanne made a graphite drawing of Hortense resting on a soft pillow, alongside a watercolor of hortensias (pl. 42). This private moment, drawn with economy, presents Madame Cézanne as truly beautiful. One would hardly recognize the watercolor as a work from 1885, for the youthful woman belies any such assumption. It is extraordinary to think that she sat for every portrait to completion, especially given periods of absence and the slow nature of Cézanne's working methods. He was fundamentally dependent on observation, on direct contact with his model. That ineffable artist-model dynamic is often missed in an evaluation of these portraits. Dozens of informal graphite sketches of Hortense, accumulated over time in any number of the artist's sketchbooks, convey a deeply felt dynamic that endured, for better or worse.

For the hundreds of self-revealing extant letters exchanged between Paul Cézanne and his contemporaries, few survive in the hand of Hortense Fiquet.[29] She wrote to Marie Chocquet on the eve of departing for Switzerland in 1890 (fig. 3). Her tone is filled with spirit, warmth, and affection, and even some generosity toward her in-laws.

Dear Madame and friend,

You must be back from Paris, so I am sending you my letter. We are going to leave on Thursday or Friday for Switzerland where we expect to end the season.

It is very good weather and we are hoping that continues.

[Young] Paul and I have already spent ten days in Switzerland and we found the country so beautiful that we came back eager to return. We saw Vevey where Courbet did the lovely painting you own.

I hope, dear Madame, that you and Monsieur Chocquet and little Marie are well.

You must be very busy with your *hôtel* for it is no small matter to restore and furnish four floors. I hope that it will be finished promptly and that you will be able to settle in soon. I think that you will like it there and that you will not much regret any trouble caused.

We are fine. I feel better than when I left, and I am hoping that my trip to Switzerland will put me right completely. We plan to look for somewhere to stay and to spend the summer there. My husband has been working pretty well; unfortunately he was disturbed by the bad weather that we had until 10 July. Still he continues to apply himself to the landscape with a tenacity deserving of a better fate.

Monsieur Chocquet must be very busy with all his paintings, furniture and lovely bibelots. We hope that next year we shall have the pleasure of seeing you in Switzerland. You will not have the disruption of this year and I can assure that you will find the country superb; I've never seen anything so beautiful and it is so refreshing in the woods and on the lakes, and it would give us so much pleasure to have you.

My husband and Paul join me in sending you our best wishes and beg you to recall our great friendship for Monsieur Chocquet. . . .

For you, dear Madame and friend, I embrace you with all my heart and am your affectionate

<div align="right">Hortense Cézanne</div>

P.S. My mother-in-law and sister-in-law Marie are reconciled, I am in heaven. Once we are established in Switzerland I will send you our address.[30]

Cézanne's descendants have published very little in memoriam over the past century. Philippe Cézanne, the painter's great-grandson, is one exception. Marthe Conil is another. She wrote anecdotally yet insightfully about her great-uncle and his wife in the *Gazette des beaux-arts* in 1960. We have access to few such family memories of intimate relations:

> One doesn't speak much of the wife of the painter. She wasn't without qualities, without humor, and a tested patience. When Cézanne could not sleep, she would read to him at night, and that lasted sometimes for hours. Her mother-in-law, who had no special feeling for her, noted her patience; then, of course, she gave him a son. In the family, we called her "La Reine Hortense."[31]

To critics and friends of Paul Cézanne, Hortense went by the unflattering nickname "La Boule," a reference, no doubt, to her silhouette.[32] The picture that emerges in the literature is even more unflattering. John Rewald, who spent a lifetime studying and writing on the life and work of the artist, dismissed her as having no influence whatsoever on him, neither on his art nor his friendships. Rewald was not without sympathy, however, for her predicament:

> Hortense's only contribution to her husband's life as an artist was in posing for him repeatedly without moving or talking. Cézanne rarely painted any other woman, and it must have entailed considerable sacrifice on the part of his lively and talkative wife to lend herself to the endless sittings he inflicted on her. When she occasionally attempted to participate in the discussion on art that Cézanne had with his friends, her husband would say to her in a quiet, reproachful voice: Hortense, be still, my dear, you are only talking nonsense.[33]

Such stories, real or apocryphal, have inflected the perception of Hortense Fiquet for more than a century. Cézanne's affection for her has been written off as patronizing, and his immediate family considered it an impediment to the artistic practice. Roger Fry, the English art critic and champion of Cézanne, blamed Hortense for Cézanne's unsuccessful

landscape paintings: "To get really into such a nature is difficult. It's complicated to begin with, and life changed him enormously. Perhaps that sour-looking bitch of a Madame counts for something in the tremendous repression that took place."[34] Similar expressions of misogyny run through the literature. Henri Matisse, who owned a portrait of Hortense, was somewhat more forgiving.[35] Writing to a friend in 1947, he called himself "an old fool; I'm like what Madame Paul Cézanne said about her husband. I've been told that Madame Pissarro said the same thing about her husband. These women of simple background served their husbands with their modest means and then judged their heroes as one might judge a simple carpenter who has taken it into his head to construct tables with legs in the air."[36]

If Hortense is not to be credited with understanding or appreciating Cézanne's aesthetics, she deserves praise for her constancy and patience in the studio.[37] The first of the more ambitious paintings, *Madame Cézanne in a Red Armchair* (pl. 4), was painted in lodgings near Montparnasse in about 1877. The cramped fourth-floor apartment at 67, rue de l'Ouest appears to be where Cézanne made twenty-two pictures of varying subjects, and where he shared quarters with his wife and young child. The apartment's pale green and blue-lozenge-patterned wallpaper is the obvious giveaway to dating these works.

Madame Cézanne in a Red Armchair is an exercise in color relationships—modulated tones of blue, green, gray, violet, and brown interrelate throughout the canvas. The soft blues and greens of the elegant silk striped skirt echo in the modeling of the face. Green brushstrokes color the flesh tones, integrating the physiognomy with that recurrent palette throughout the canvas—from the jacket bodice to the patterned wallpaper to the saturated blue-green wainscoting. As with so many images of Hortense Fiquet, the facial expression appears unmoved by the model-painter dialogue. Though cast in a halo of illumination, her face seems to recede from focus as the red chair and voluminous costume command the portrait and establish its scale. When this painting was shown at the 1907 Salon d'Automne in a commemorative exhibition to honor the recently deceased artist, it caused quite a stir. The poet Rainer Maria Rilke was overcome. In a widely cited letter to his wife, he wrote:

> Already, even after standing with such unremitting attention in
> front of the great color scheme of the woman in the red armchair,
> it is becoming as irretrievable in my memory as a figure with

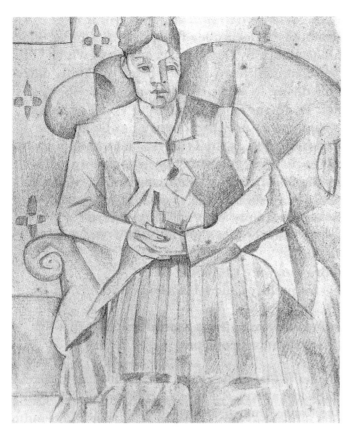

Fig. 4. Juan Gris (1887–1927), *Seated Woman (after Cézanne)*, 1916. Graphite on paper, dimensions unknown. Whereabouts unknown

many digits. And yet I memorized it, digit by digit. In my feeling, the consciousness of their presence has become a heightening which I can feel even in my sleep; my blood describes it within me, but the naming of it passes by somewhere outside and is not called in.[38]

The painting has resonated as strongly ever since, with citations in literature and a rich exhibition history unrivaled in Hortense Fiquet portraiture. Juan Gris took up the image in a drawing, *Seated Woman (after Cézanne)* (fig. 4), a preamble to his own portraits of 1916.[39] He was one of a number of artists in the twentieth century to reprise the imagery of Hortense Fiquet.[40]

In a rather eccentric discourse on Cézanne and his female models, D. H. Lawrence inveighed against what he calls clichéd portraiture. Quoting Cézanne's celebrated exhortation to his models—"Be an apple! Be an apple!"—Lawrence coined the term "appleyness," meaning that to avoid banality and cliché the artist must sublimate the sitter's likeness and character in the service of his own intuitive awareness.[41] In many of Cézanne's portraits, his sitter is stilled like an apple while the material world, like the actual world, remains in flux. This analysis has particular resonance in the portraits of Hortense Fiquet, where her expression is often remote, even inscrutable, while the surrounding environment shifts and skews. In *Madame Cézanne in a Red Armchair*, the affect lies not in characterizing likeness but in situating volume in space. The armchair has been called the painting's protagonist.[42]

The year 1878 was fraught with personal misfortune, or rather misadventure, for Paul Cézanne. In March, he settled Hortense and six-year-old Paul in Marseille, intending to divide his time among the Jas de Bouffan, the family estate outside Aix, where his father and sister Marie lived; L'Estaque, where his mother resided; and Marseille. He told Zola: "I

go to Marseille in the evening to sleep and come back [to L'Estaque] the next morning."[43] And if this itinerant life was not unsettling enough, Cézanne's subterfuge was nearly laid bare. For Louis-Auguste Cézanne was in the habit of opening his son's mail. In the spring, Victor Chocquet sent a letter addressed to Paul Cézanne at the Jas de Bouffan. In it Chocquet referred to "Madame Cézanne and little Paul." Again fearing the loss of his allowance, Cézanne wrote to Zola: "I am on the verge of having to provide entirely for myself if, indeed, I am capable of it."[44] Then, on March 28, responding to Zola's comforting reply, he wrote:

> I think as you do that I should not renounce my father's allowance too hastily. But judging by the traps that have been set for me and which I have thus far managed to escape, I foresee a great debate about money. . . . It is more than probable that I will only receive 100 francs even though my father promised 200 when I was in Paris. I shall, therefore, have recourse to your kindness since "le petit" has been sick for the past two weeks with an attack of typhoid fever. I am taking every precaution to prevent my father from gaining absolute proof.[45]

The odds were against Paul Cézanne, despite his "every precaution." It would be only a matter of time. That same year, Paris hosted the Exposition Universelle at the Champ de Mars. Paul and Hortense gave the apartment key to a next-door neighbor. The neighbor, in turn, lent the apartment to out-of-town guests visiting the fair. When the landlord learned of this, he sent a letter of complaint to Cézanne in Aix. Once again Louis-Auguste opened the mail, and now accused his son of keeping mistresses. A third incident further challenged the charade. In September, Hortense's father sent a letter to "Madame Cézanne, rue de l'Ouest, Paris."[46] It was forwarded to the Jas de Bouffan, where Louis-Auguste promptly opened it. Cézanne wrote to Zola with his alibi: since Hortense's name did not appear in the body of the letter, he assured his father disingenuously that it must have been addressed to "some other woman."[47] Cézanne continued to ask Zola for financial aid, increasingly so during this period. In one letter, he mentioned Hortense's "petite aventure" in Paris, yet he seems to have been unmoved by it: "In the end, [it was] nothing much."[48]

Cézanne spent much of the next few years painting in Provence. While keeping a studio in the spacious ground-floor salon at the Jas de Bouffan, he generally worked out-of-doors in the villages of L'Estaque, Bellevue, and Gardanne. The landscapes and seaside motifs of L'Estaque sustained his production in the early 1880s. He was notably joined there by Auguste Renoir on two occasions.[49]

In 1882, Cézanne drafted a will leaving his annuity income and property to his two sisters and his son, "for if I were to die in the near future, my sisters would be my heirs, and I think my mother would be cut out, and my little boy (having been acknowledged when I registered him at the *mairie*) would, I think, still be entitled to half my estate, but perhaps not without contest."[50] Hortense Fiquet is a telling omission. Much later, toward the end of 1901, Cézanne acquired property on a hill north of Aix near Les Lauves, where he would build his studio. The deed of purchase lists ownership under his name and that of his wife. The following year, however, he issued a new will, stating in his own hand that "my wife, should she survive me, will have no legal claim on the property that will constitute my estate on the day of my death."[51] Hortense Fiquet would survive her husband by sixteen years, living partly in Switzerland with a paid companion.

Cézanne entered a period of emotional upheaval in 1885; that year, he urged Zola to forward letters to a young woman with whom he was infatuated.[52] Although we have no proof of her identity, the literature suggests that her name was Fanny Toule and that she was a maid at the Jas de Bouffan. On the reverse of one of his drawings, now at the Albertina in Vienna, Cézanne professed his love for her in longing, rapturous prose (fig. 5).[53] Unsettled by this development, he left Aix in the spring seeking solace in the company of Zola in Paris, and later of Renoir in La Roche-Guyon.[54] It has been said that Renoir was none too pleased with Cézanne's indiscretion.[55] Back in Aix,

Fig. 5. Verso of letter from Paul Cézanne to an unknown woman, 1885. Pen on paper, 9¼ × 6⅞ in. (23.5 × 17.5 cm). Albertina, Vienna (24080v)

Cézanne resumed his daily seven-mile journey to the village of Gardanne, where Hortense and young Paul were living at the time.

Against this background of intensive landscape painting and passionate distraction, Cézanne made numerous portraits of Hortense and his son. Clearly these paintings point to a studio production, and yet we cannot place them in time or space with any real certainty. Many telltale features—pale porcelain skin, perfectly oval head, and central hair part—imply the same model, but no two are alike. Even the portraits in Philadelphia and Berlin (pls. 13, 14) that at first appear quite similar are fundamentally different in technique and brushwork, pose and expression.[56] But if we look into the sitter's gazing eyes, eyes focusing directly on the artist and his easel, the universal affect is one of tenderness, even vulnerability. Cézanne has streamlined the canvas rectangle to frontal, bust-length expressions, material traces of a liaison often understood only by inference.

After reading the newly released novel *The Masterpiece* in the spring of 1886, Cézanne severed communication with Emile Zola, abruptly and irreversibly. In his last letter to his old friend, the artist said, "I thank the author of the 'Rougon-Macquart' [novels] for this kind token of remembrance, and I ask that he permit me to clasp his hand while dreaming of bygone years."[57] Zola's fictive ridicule of struggling artists struck a nerve in others as well, among them Claude Monet, who wrote to Pissarro, "Have you read Zola's book? I'm afraid he is doing us a great wrong."[58]

Soon after this devastating separation from Zola, Paul Cézanne married Hortense Fiquet. The civil ceremony took place in the Hôtel de Ville at Aix on April 28, with Louis-Auguste and Anne-Elisabeth Cézanne both present (fig. 6). After the civil service, Hortense and her son returned with the elder Cézannes to the Jas de Bouffan, while the groom, his brother-in-law Maxime Conil, and a friend went out to lunch. The next morning, in the presence of witnesses Maxime Conil and Jean-Baptiste Galby, the religious ceremony was held at Saint Jean-Baptiste, the parish church of the Jas de Bouffan. It is said that Cézanne's pious sister Marie urged the marriage. The wish to formally recognize young Paul, now sixteen, was another motivating factor for the artist. Together with these considerations, it is likely that the artist was weary of the machinations necessary to separate his immediate family from an aging mother and father. Six months later, on October 23, 1886, Louis-Auguste died. Paul Cézanne would

A. 34

L'AN mil huit cent quatre-vingt- *six* et le *vingt-huit Avril* à *onze* heures du *matin*, par-devant Nous *Charles Richaud, chevalier de la Légion d'honneur, officier public de l'État civil délégué*

ont comparu à l'Hôtel-de-Ville et publiquement, Sieur *Paul Cézanne, artiste peintre, né à Aix, le dix-neuf janvier mil huit cent trente-neuf, y domicilié et demeurant avec ses père et mère au quartier du Jas de Bouffan, fils majeur de Louis Auguste Cézanne, propriétaire, et de Anne Elisabeth Honorine Aubert, sans profession, ici présents et consentants. Et Marie Hortense Fiquet, sans profession, né à Saligney (Jura), le vingt-deux avril mil huit cent cinquante, domiciliée et demeurant à Gardanne (Bouches-du-Rhône), fille majeure de Claude Antoine Fiquet, propriétaire, domicilié à Lantenne (Doubs) absent mais consentant ainsi qu'il résulte de l'acte public reçu en brevet le vingt-un mars dernier par Me Isabite notaire à Lantenne, et de feue Marie Catherine Deprey, sans profession, décédée à Paris le vingt-trois juillet mil huit cent soixante-sept. Et aussitôt les dit époux nous ont déclaré qu'il est né d'eux à Paris le quatre janvier mil huit cent soixante-douze un enfant du sexe masculin qui a été enregistré à la mairie du cinquième arrondissement sous les prénom et nom de Paul Cézanne, lequel enfant au moyen de cette déclaration est reconnu et légitimé par les susdits époux*

N° 67
Paul
Cézanne
et
Marie Hortense
Fiquet

lesquels, après nous avoir déclaré qu'il *n'* a *pas* été fait *de* contrat de mariage nous ont requis de procéder à la célébration du mariage entre eux et dont les publications ont été faites devant la principale porte d *— Hôtel-de-Ville d'Aix, et à Gardanne les onze et dix-huit Avril courant.*

jours de dimanche, à l'heure de midi. Aucune opposition audit mariage ne nous ayant été signifiée, faisant droit à la réquisition des parties, après avoir donné lecture de toutes les pièces ci-dessus mentionnées et annexées au présent acte, ainsi que du Chapitre VI, Titre V, du Code civil, concernant les droits et devoirs respectifs des époux. Nous, dit officier public de l'état-civil, avons demandé au futur époux et à la future épouse s'ils veulent se prendre pour mari et pour femme. Chacun d'eux ayant répondu séparément et affirmativement, déclarons au nom de la loi, que Sieur *Paul Cézanne et Marie Hortense Fiquet.*

sont unis par le mariage. De quoi nous avons dressé acte en présence des Sieurs *Maxime Conil, sans profession, âgé Trente deux ans, beau-frère de l'épouse; Jules Richaud, commis, âgé de trente neuf ans, domicilié à Aix; Louis Barret, cordier, âgé de quarante trois ans et Jules Peyron, commis principal des contributions indirectes, âgé de trente deux ans, domicilié à Gardanne, ces trois derniers non parents des époux. Tous témoins requis par les parties, lesquels après lecture faite du présent acte ont signé avec nous ainsi que les époux et les père et mère de l'époux.*

Fig. 6. Hortense Fiquet and Paul Cézanne's marriage certificate, April 28, 1886. Archives Municipales, Aix-en-Provence (A.M. AIX E1_ART86)

never again find need to beg for money, his father's estate providing for him ever afterward.

The marriage of Paul Cézanne and Hortense Fiquet might have led to more contact and a life of greater intimacy. It did not. Just as the impetus for marriage was not fueled by a solidifying love, so, too, the aftermath brought no real change to the artist's peripatetic lifestyle. Furthermore, his ties to his mother and sisters held strong. After Claude-Antoine Fiquet's death in December 1889, Cézanne did accompany Hortense to her native Lantenne-Vertière in Franche-Comté to settle her father's will. In a concessionary gesture, he then spent several months in 1890 traveling with her and Paul in Switzerland. Hortense was in her element there.[59] "My wife likes only Switzerland and lemonade," said her husband.[60] For Cézanne, the trip to Neuchâtel, Bern, Fribourg, Vevey, Lausanne, and Geneva was an unnecessary interruption to his practice. In a letter to Zola describing Cézanne's ill-fated travels, the writer Paul Alexis blamed Hortense in mocking prose: "He is furious with La Boule, who, after a year in Paris, last summer inflicted on him five months of Switzerland and hotels, where the only sympathetic presence he encountered was a Prussian."[61] Although Cézanne would travel to Lake Annecy with Hortense and his son on a later occasion, the excursion of 1890 was their last extended visit together.[62] Cézanne returned to the Midi, while his family relocated to Paris, yet again.

It was probably in the late 1880s in a Paris apartment at 15, quai d'Anjou that Cézanne painted a suite of portraits of Madame Cézanne in a red dress (pls. 19–22).[63] While they are now dispersed (in public collections in Basel, Chicago, and São Paulo, and at The Metropolitan Museum of Art), it is very likely that Cézanne had them in his studio at the same time. Madame Cézanne sits in a yellow brocade chair, her hands in her lap. In the Chicago and Basel portraits, her verticality is counterbalanced by the wainscoting of the wall behind her. In the São Paulo variant, there is no chair, no wainscoting, no environment. The exercise is solely that of figure-ground. Madame Cézanne appears fatigued by the rigors of modeling. The portrait in the Metropolitan has greater formal complexity, a sharp geometry, spatial incongruity, and the attributes, if only in detail, of a domestic setting. Given Cézanne's approach to painting, this elaborate canvas may well be the last of the four. As we know, Cézanne's paintings grew through a slow accumulation of brush marks, marks connecting to other marks of color and tone as he

filled the rectangle.[64] His paintings developed in response to his *sensations*—his sensory experience of a subject. He once said that whenever he stood before a canvas he was another man and always Cézanne.[65] This remark is a telling reference to a very personal process of newly seeing the familiar. These variant sittings of Hortense in a red dress materialize the journey from the spare articulation of a figure to one embedded in complex geometry.

Cézanne was democratic when it came to distributing his inheritance. He shared his resources three ways, in equal parts. But in 1891, in an effort to convince Hortense and Paul to leave Paris for Aix, this time to set up residence, he cut his wife's allowance in half. She and Paul returned to the Midi once again, settling into an apartment at 9, rue de la Monnaie in Aix. Like the metaphoric wall that divided Christine Hallegrain, the model, from Claude Lantier, the artist, in Zola's *The Masterpiece*, Cézanne maintained the separation of his wife and son from his mother and sisters, even after marriage.[66] He would continue to live and paint at the Jas de Bouffan until its sale in 1899.

It was there that Cézanne made his last full-scale portrait of Madame Cézanne (pl. 28). Paul *fils* told the dealer Ambroise Vollard that he remembered his mother posing for the picture in the conservatory.[67] She sits in a simple wood chair, wearing a dress we recognize from past portraits. Surrounded by delicately sketched-in foliage emblematic of a greenhouse or garden, Madame Cézanne is a powerful presence, despite her apparent state of unfinish. Cézanne has given her face a flattering, serene expression, while her body's soft forms begin to define the contours of her dress. He has laid in fingerless gloves with no real articulation of the digits. Contrary to usual practice, he appears to have worked his way down the canvas from top to bottom. Having resolved the ethereal greenery (with no spatial anchor) and the graceful face and bodice, he abandoned the canvas. The portrait actually gains for its curious lack of finish, and its clues to the artist's painting process.[68] It was shown in Cézanne's first solo exhibition, hosted by Vollard in 1895. Numbering some 150 works, the exhibition was a revelation to all. No one had seen Cézanne's paintings for two decades, and he was an instantaneous success. *Madame Cézanne in the Conservatory* was sold to the Russian collector Ivan Morozov, who ultimately would own seventeen Cézannes.[69]

Anne-Elisabeth Cézanne, the artist's beloved mother, died in 1897 at the age of eighty-three. After the sale of the Jas de Bouffan, Cézanne moved

into the second floor of a house at 23, rue Boulegon in Aix. He hired a housekeeper, a Madame Brémond, who sat for several portraits.[70] Some years later, the writer André Gide told the painter Maurice Denis that Cézanne had consecrated a room in his apartment to the memory of his mother. It was filled with mementos and bibelots. One day, in a fit of rage, Hortense burned them all. Afterward she confided to a friend, "Do you know what? I burned everything." When asked how her husband reacted, she replied, "He just wandered in the country—he's an eccentric."[71]

Cézanne spent his last years in the south. With few travel interruptions, he lived a quiet life in his new studio at Les Lauves, an environment more sympathetic to his practice than anywhere else in Aix. Complications from diabetes have often been blamed for his increasingly agitated behavior, and indeed his increasingly fragile health. Hortense and Paul traveled back and forth to Paris during this period, favoring the city in the summer months. In a letter written in the summer of 1906, Cézanne asked his son to take good care of his mother, who was ill herself. He urged "the well-being, coolness, and diversions appropriate to the circumstances."[72]

Paul Cézanne's health continued to decline. He suffered bronchitis in August and chronic headaches through the summer. Yet he kept painting in the landscape. On October 15, he collapsed outdoors and remained in the rain for several hours before being rescued and carried home in a laundry cart. The next day he tried to work on his portrait of Vallier, the gardener, in his studio, but soon returned home feeling ill. He then set up a studio in his wife's dressing room. When his sister Marie wrote to her nephew to come urgently to Aix to help care for his father, she alerted him that Hortense might as well remain in Paris, because her dressing room was in use.[73] Two days later, Madame Brémond telegraphed Paul that his father was gravely ill: "Venez desuite tous deux père mal."[74] Hours later, on the morning of October 23, Cézanne died from pneumonia. His wife and son arrived too late for his last rites.[75] The funeral was held the next day in the Cathedral of Saint-Sauveur. The artist was buried in the Cemetery of Saint-Pierre.

As executor of his father's estate, Paul Cézanne *fils* lost no time. Within weeks of the funeral, he and his mother removed all the paintings, watercolors, and drawings from the studio at Les Lauves. Sales to Vollard, who shared the estate with the Bernheim-Jeunes, are said to have exceeded 275,000 francs, a shrewd exchange from which the illustrious *marchands*

would later profit handsomely.[76] Although Hortense Fiquet had no legal authority over the disposition of her husband's estate, she did inherit a generous sum of money. And we know she participated in art sales well before he died. In a 1905 letter to Emile Bernard, she discussed copyright issues for a forthcoming Dutch publication on Cézanne, and mentioned that fending off requests for more exhibitions of his work was tiring her:

> Dear Monsieur Bernard,
>
> I enclose the requested authorization. I hope that it is in the desired form? But my husband says that you have absolutely no need for it in Holland. One can reproduce whatever one wants, there is no law for the protection of artworks—nor books—no one can make any complaint on that subject. And since my husband is a doctor of law (he did his studies before becoming a painter) he should know!
>
> Nevertheless I am writing this evening to the "Wereldbiblio-theek" [an Amsterdam publishing house] which has the folios to send us an authorization. However, if they do not do it, do not worry—it is an indication that you do not need one. . . .
>
> You saw from my previous letter that the drawings are at [illegible]. I hope those twenty-five drawings are enough for you? With the others that makes a reasonable total and as I said, I can *categorically* promise the others. The choice is yours—that is all I can do. You have no idea how much trouble this causes me all the time. Now they are asking me for more exhibitions for November. I had only two months' rest this summer and I really needed them because I am worn out! In any event good luck with your book. I shall be very glad to have a copy of your South of France!
>
> All the best to you.
>
> M.C. [?]
>
> Good wishes from my husband and son . . .[77]

Much has been made of Hortense Fiquet's profligate spending. John Rewald called her "an inveterate gambler, seen more frequently in casinos than in art galleries," and commented that "her son . . . showed more gifts for losing money in all kinds of schemes than in earning any."[78] It is said

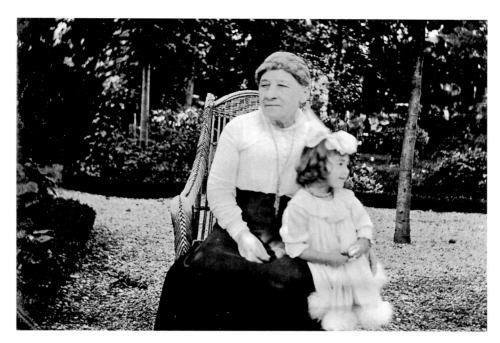

Fig. 7. Madame Cézanne and Aline Cézanne, Chevillé, 1917. Photograph courtesy of Pierre Gobert

that together they went right through the fortune amassed by Louis-Auguste Cézanne in his lifetime and later inherited by his son.

Paul *fils* may not have had the gift of prudence in personal finance, but he never lost sight of his aging mother, who spent her final days with him and his wife, Renée, in their Paris apartment. Renée Rivière, the adopted daughter of Auguste Renoir and his wife, Aline, had lost her mother at the age of fourteen; Aline brought her into the fold and later introduced her to Paul *fils*.[79] Renée would eventually bear Paul Cézanne's five grandchildren, none of whom he would know. Hortense continued to spend time in her beloved Switzerland in the years after her husband's death, though she remained a Parisian in the loving care of her son. Gregarious and good-natured to the end, our elegant but frail protagonist appears in several family photographs (fig. 7) and in a wedding photograph (see fig. 8 on p. 36), surrounded by family and friends gathered for the marriage of Renoir's son Claude and Paulette Dupré. Several months later, in May 1922, Hortense Fiquet Cézanne would be laid to rest in Père-Lachaise Cemetery, a grave site her son would share twenty-five years later. Remembered as the mother of Paul Cézanne's only child, she sat for twenty-nine portraits, a gift of immeasurable worth to a man whose overriding passion was his painting.

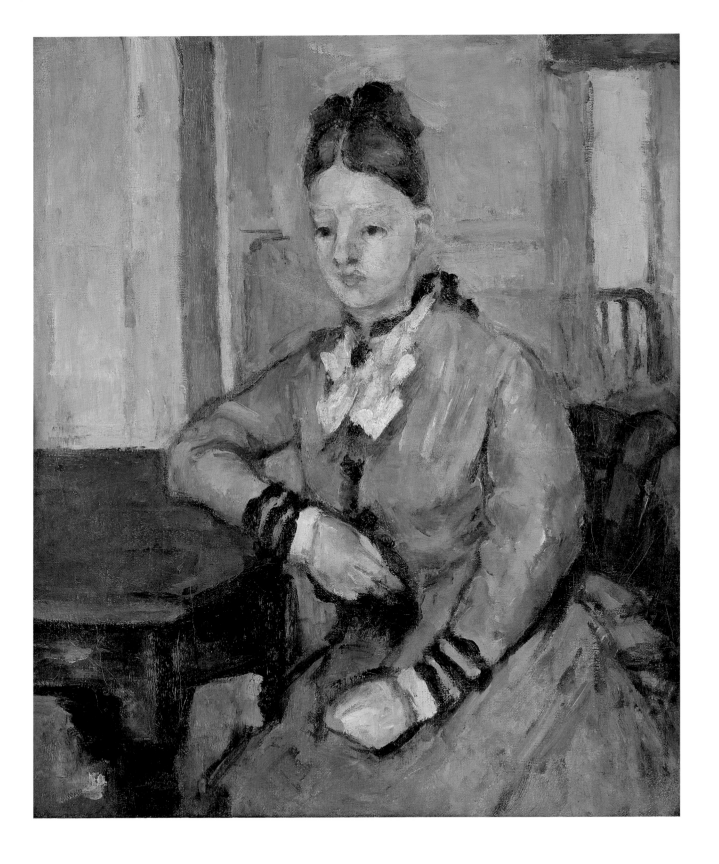

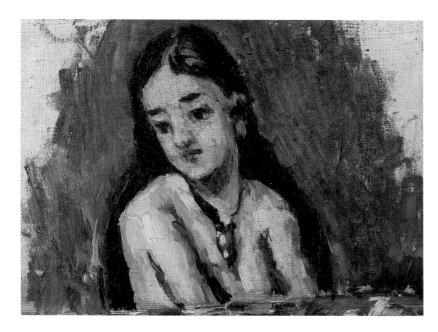

PLATE 2. *Young Woman with Loosened Hair*,
ca. 1873–74
Oil on canvas, 4³/₈ × 6 in. (11 × 15.2 cm)
Private collection, on loan to Staatliche
Museen zu Berlin, Nationalgalerie,
Museum Berggruen

right
PLATE 3. *Woman Nursing Her Child*,
ca. 1872
Oil on canvas, 8⁵/₈ × 8⁵/₈ in. (22 × 22 cm)
Whereabouts unknown

opposite
PLATE 1. *Madame Cézanne Leaning on a
Table*, ca. 1873–74
Oil on canvas, 18¹/₈ × 15 in. (46 × 38 cm)
Private collection, care of Faggionato,
London

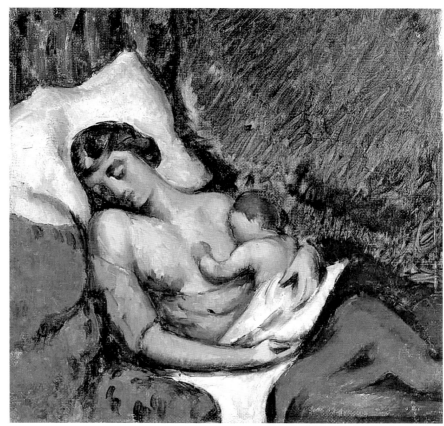

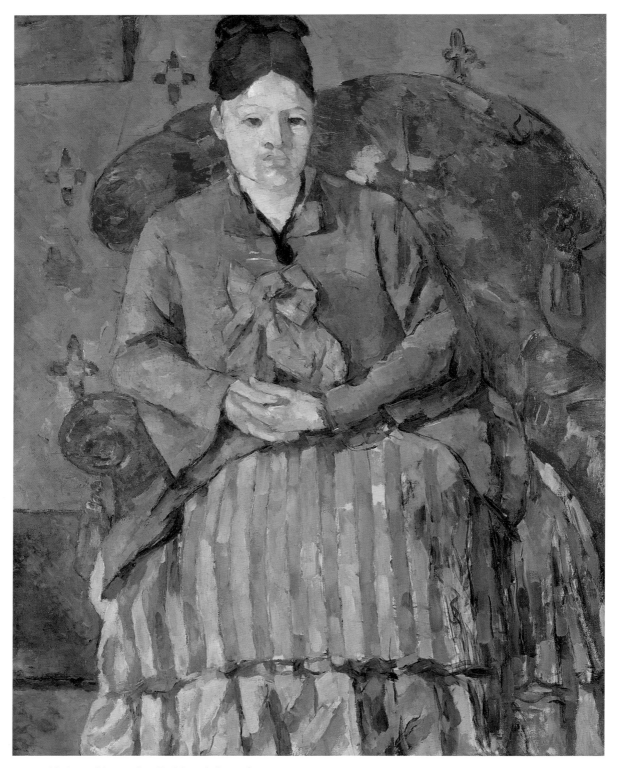

PLATE 4. *Madame Cézanne in a Red Armchair*, ca. 1877
Oil on canvas, 28½ × 22 in. (72.5 × 56 cm)
Museum of Fine Arts, Boston, Bequest of Robert Treat Paine, 2nd (44.776)

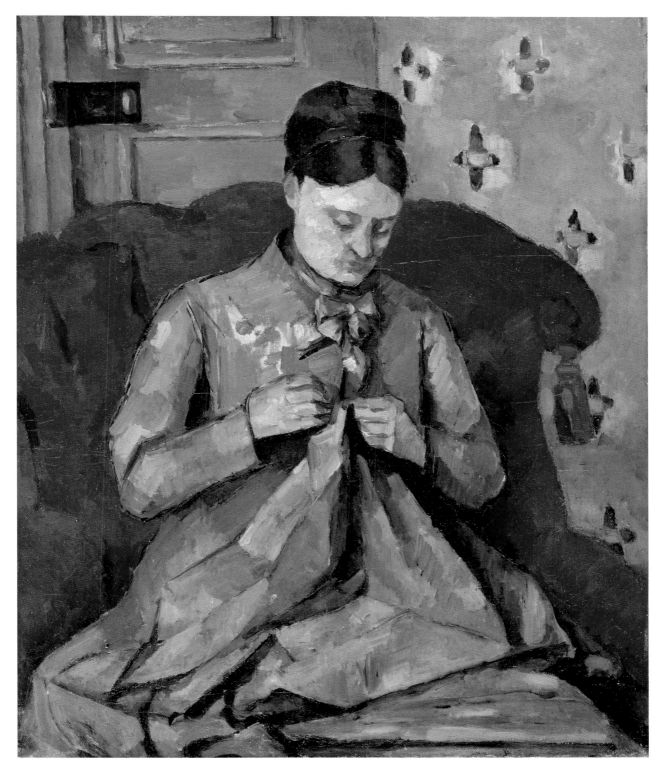

PLATE 5. *Madame Cézanne Sewing*, ca. 1877
Oil on canvas, 23⅝ × 19⅝ in. (60 × 49.7 cm)
Nationalmuseum, Stockholm, Bequest of Grace and Philip Sandblom, 1970 (NM 6348)

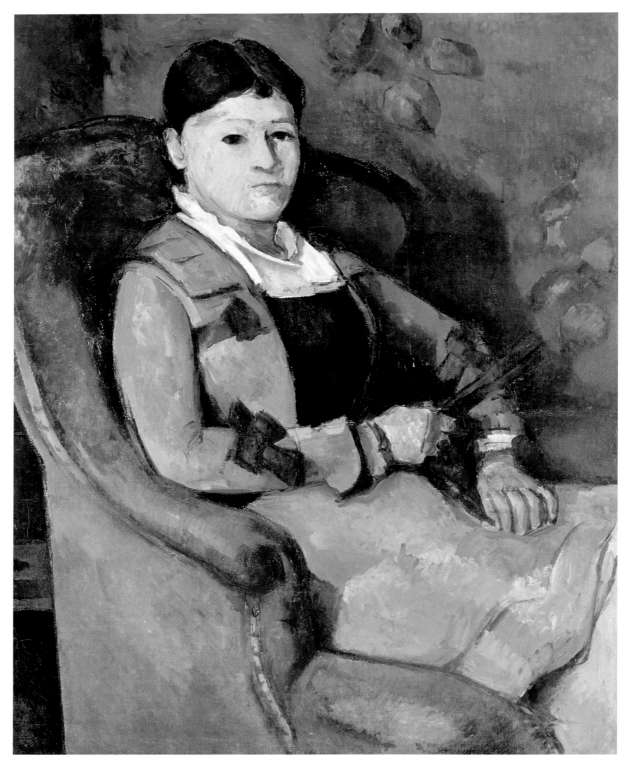

PLATE 6. *Portrait of the Artist's Wife*, ca. 1879–82, possibly reworked ca. 1886–88
Oil on canvas, 36³/₈ × 28³/₄ in. (92.5 × 73 cm)
Foundation E. G. Bührle Collection, Zurich (16)

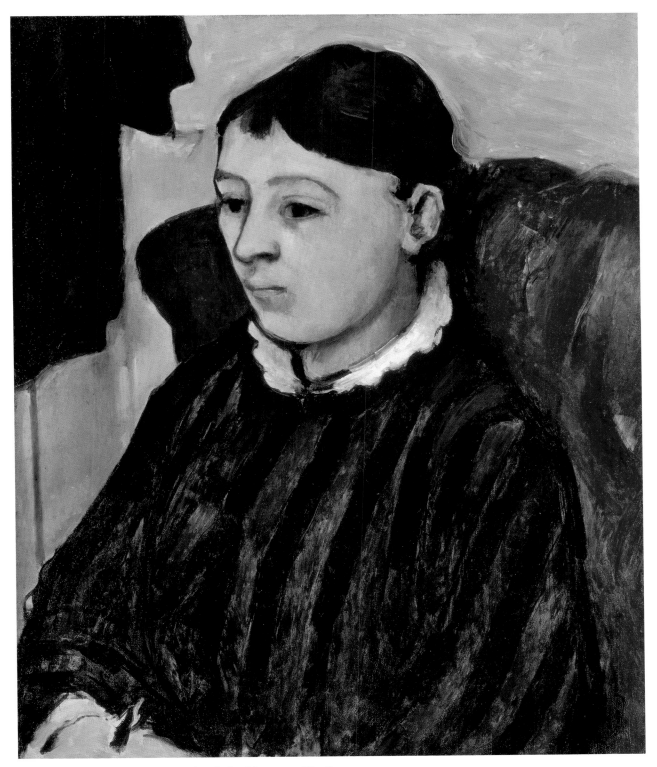

PLATE 7. *Portrait of Madame Cézanne in a Striped Dress*, ca. 1883–85
Oil on canvas, 22³/₈ × 18¹/₂ in. (56.8 × 47 cm)
Yokohama Museum of Art (87-OF-001)

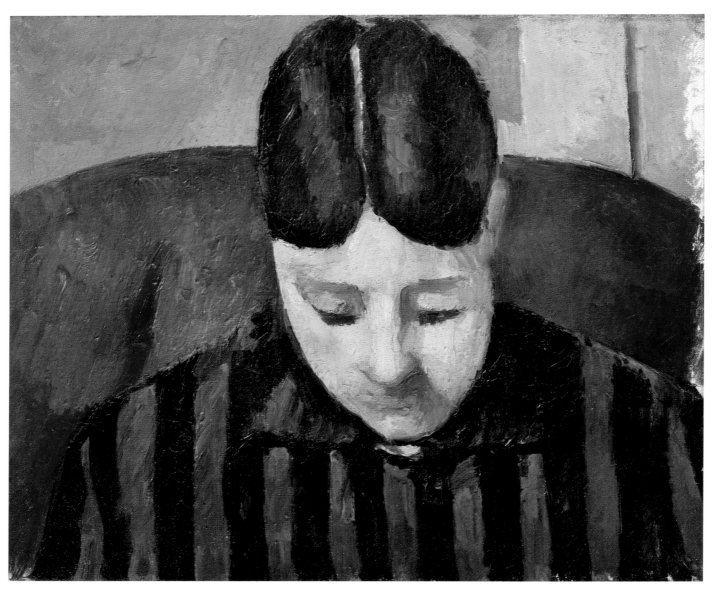

PLATE 8. *Portrait of Madame Cézanne*, ca. 1877
Oil on canvas, 10¼ × 12¼ in. (26 × 31 cm)
Private collection

PLATE 9. *Portrait of Madame Cézanne*, 1890–92
Oil on canvas, 24⅜ × 20⅛ in. (61.9 × 51.1 cm)
Philadelphia Museum of Art, The Henry P. McIlhenny
Collection in memory of Frances P. McIlhenny, 1986
(1986-26-1)

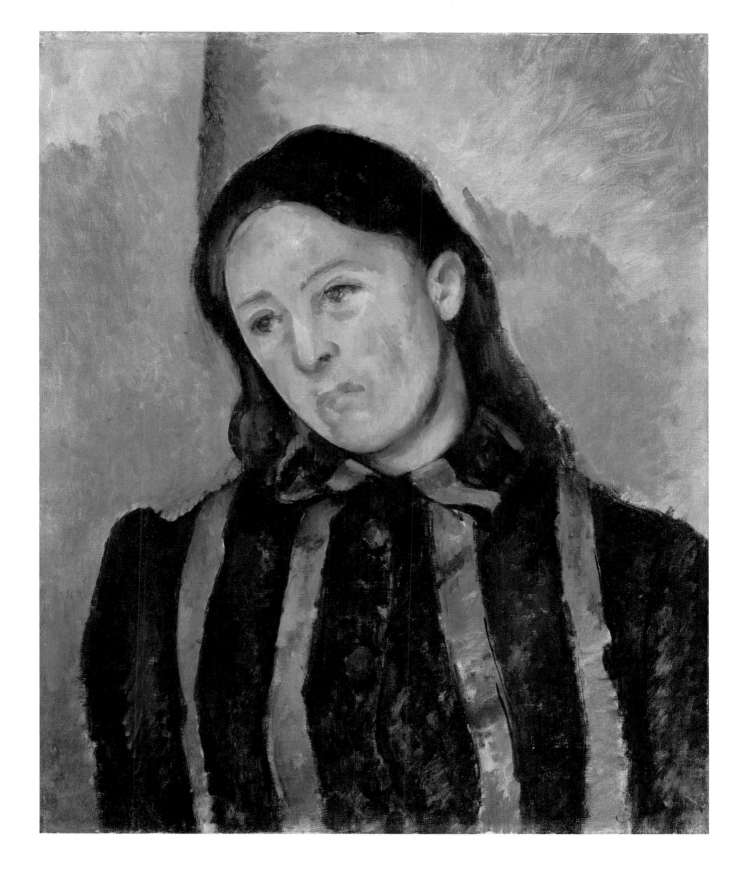

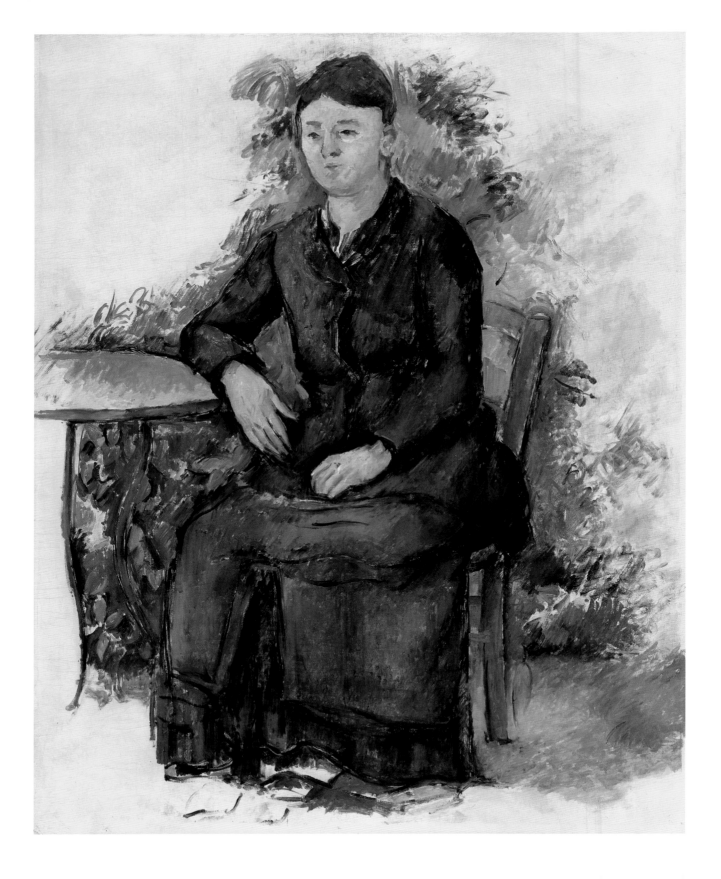

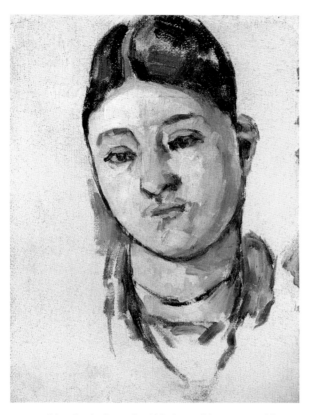

PLATE 11. *Sketch of a Portrait of Madame Cézanne*, ca. 1883
Oil on canvas, 8 × 5½ in. (20.3 × 14 cm)
Richard and Mary L. Gray and the Gray Collection Trust

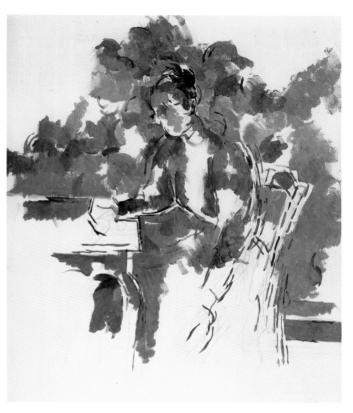

PLATE 12. *Portrait of a Woman (Madame Cézanne)*, ca. 1895–1900
Oil sketch on canvas, 25½ × 21⅞ in. (64 × 53 cm)
Collection of Stephen Mazoh

PLATE 10. *Madame Cézanne in the Garden*, ca. 1880
Oil on canvas, 34⅝ × 26 in. (88 × 66 cm)
Musée de l'Orangerie, Paris, Collection Walter Guillaume, 1959 (RF 1960-8)

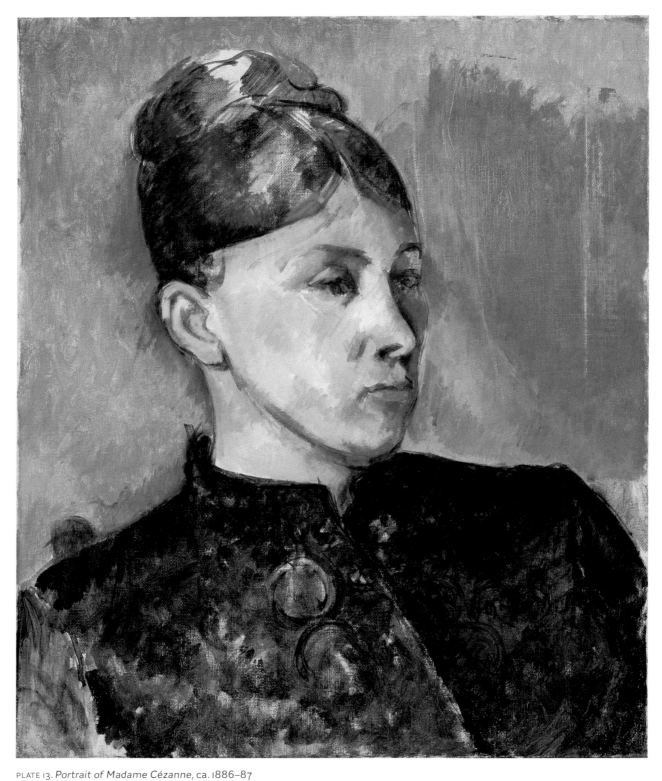

PLATE 13. *Portrait of Madame Cézanne*, ca. 1886–87
Oil on canvas, 18³/₈ × 15³/₈ in. (46.8 × 38.9 cm)
Philadelphia Museum of Art, The Samuel S. White 3rd and Vera White Collection, 1967 (1967-30-17)

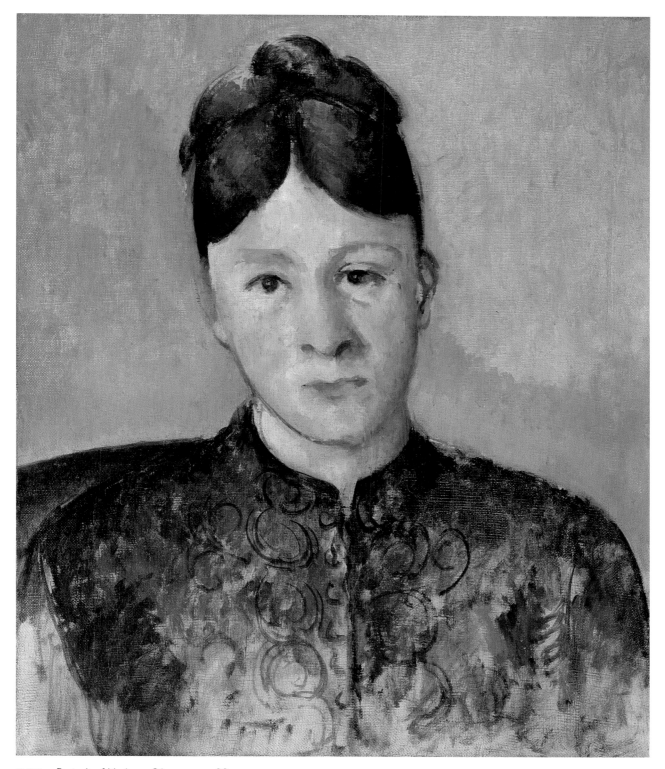

PLATE 14. *Portrait of Madame Cézanne*, ca. 1885
Oil on canvas, 18⅛ × 15 in. (46 × 38 cm)
Private collection, on loan to Staatliche Museen zu Berlin, Nationalgalerie, Museum Berggruen

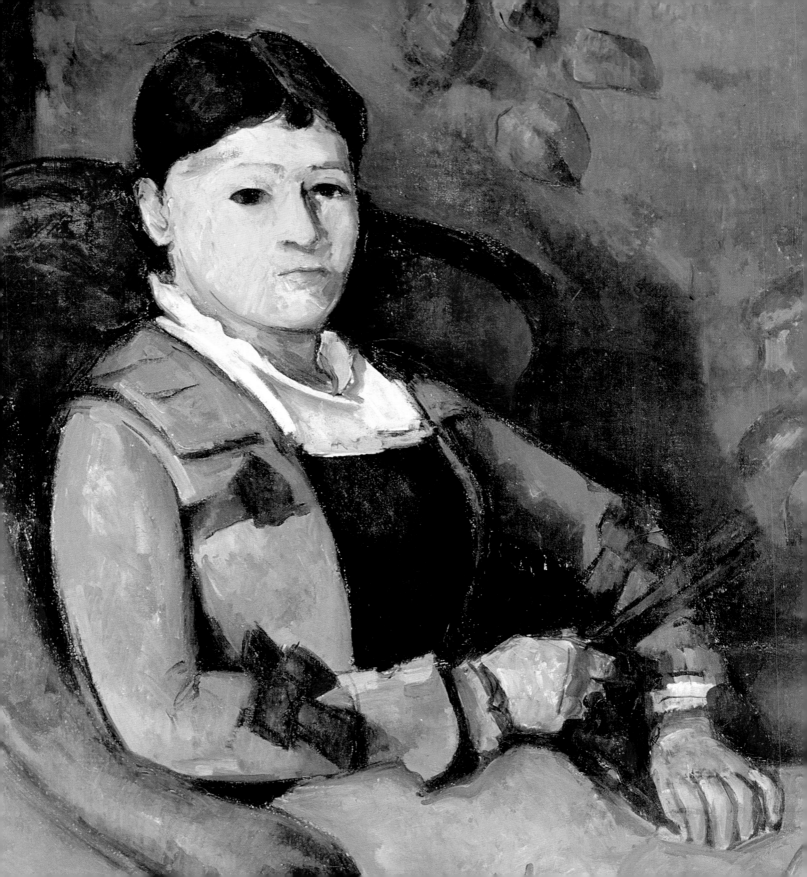

Philippe Cézanne

My Great-Grandmother Marie-Hortense Fiquet

We have little information about my great-grandmother Hortense. Her grandchildren—my aunt Aline, born in 1914, and my father, Jean-Pierre, born in 1918—had few recollections of that somewhat distant person. She lived with her son and his family, but after her husband's death, she spent most of her time in Monaco or Switzerland; she wrote to Georges Rivière in 1921 that she preferred Lausanne to Geneva because of its drier climate. She was, however, with the Cézanne family at the wedding of Claude Renoir, known as "Coco" (Auguste Renoir's youngest son), and Paulette Dupré, in Cagnes-sur-Mer in 1922.[1] She appears in a photograph, front and center next to the newlyweds, very dignified in a black dress with a wide lace collar (fig. 8).

Paul Cézanne first met Marie-Hortense Fiquet in early 1869. She was nineteen years old, a rather pretty girl with strawberry-blond hair, according to Jean de Beucken's book on Cézanne.[2] Did de Beucken get that information from the painter's son, his friend? For in the portraits of Hortense, her hair is actually dark. She was born on April 22, 1850, in Saligney, a village in the department of Jura, near Besançon. Her father, Claude-Antoine Fiquet, a farmer's son, was short, slight, fairly strong, tending toward the Spanish type, and he wore a beard. Her mother, Catherine Déprez, was the daughter of the blacksmith of Lantenne-Vertière. After the cholera epidemic of August 1854, the family moved to Paris; they lived on rue Childebert, near the Church of Saint-Germain-des-Près.[3] In 1859, Claude-Antoine was a bailiff's

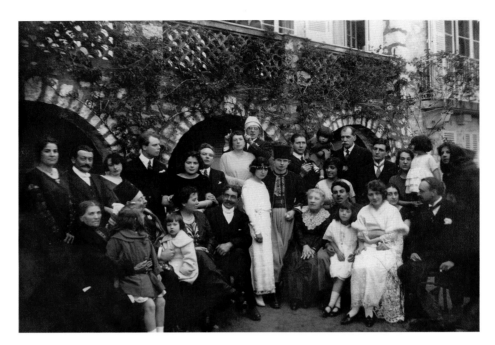

clerk, but by July 1867, when his wife died, he had become a bookbinder. When Paul Cézanne made her acquaintance, Hortense was working as a bookbinder at a shop with her friend Thérèse, Antoine Guillaume's future wife. Did Hortense work with her father? The circumstances under which she and Cézanne met are unknown; at the time, he was living on rue Notre-Dame-des-Champs, near Montparnasse.

At some point in 1870, the painter went off to hide in L'Estaque, to escape the military draft. He rented a small house on the church square and sent for Hortense. He painted from life (*sur le motif*), while his companion was only his mistress-servant. She had no friends there and spent her free time reading sentimental novels. During that yearlong stay, the couple received few visitors: the painter's mother, Anne-Elisabeth, who was in on the secret of their relationship, and Emile Zola and his wife, Alexandrine, en route to Marseille.

The couple lived together in Paris, but in the Midi, Paul had to rent an apartment for his companion; he lived with his father at the Jas de Bouffan, the family estate outside Aix-en-Provence. Life was not easy for Hortense. In both the Midi and Paris, she had to change residences at the painter's whim. Even after the two married, she was never accepted by her in-laws, particularly

the painter's sister Marie. Hortense's only wish was to live in Paris, where she saw a few close friends, such as the family of the cobbler Guillaume, whose son Louis was close to Paul *fils*.[4] She also saw the Goupils and the Chocquets, who were always very kind to her, receiving her often in their homes.[5] This was not the case with the Zolas. Madame Zola seems to have had a particular aversion to Hortense, who was not very popular with the painter's friends.

For nearly seventeen years, Cézanne would conceal his affair with Hortense from his father, and for fourteen the birth of his son, Paul, on January 4, 1872, in Paris. That did not make their life together easy. Cézanne used his old friend Achille Emperaire as a messenger to announce the birth to his mother.[6] Then, in the spring, he moved from Paris to Auvers with his wife and child, joining Camille Pissarro in Pontoise to paint. At that time, he produced a small portrait of Hortense nursing her baby (pl. 3), along with a few subsequent portraits (pl. 1; fig. 9) and a small nude study (pl. 2). When he returned to Paris, he wrote to his parents to explain why he had not been back to Aix for three years. He wanted more personal freedom and fewer reproaches, and a larger allowance, which—though he did not say so—would permit him to support Hortense and little Paul during his stays in the Midi.

While living with his parents in Aix in June 1874, Cézanne informed Pissarro that the critic Anthony Valabrègue had brought him a letter from Hortense with news of his son. In the next few years he moved between Paris and the south, sometimes living with Hortense and little Paul. In March 1878, Cézanne was painting in L'Estaque and Hortense was in Marseille. In a letter he told Zola of the tense situation with his father, who was threatening to cut off his allowance. Louis-Auguste had opened a letter from Victor Chocquet, addressed to his son, "Mons. Paul Cézanne, painter": the paterfamilias considered it normal to open mail addressed to the children living under his roof. His suspicions were therefore confirmed by Chocquet's line about "Madame Cézanne and little Paul." The artist decided to return to his father at the Jas de Bouffan, in an attempt to calm the situation and keep his allowance. In another letter to Zola, Cézanne agreed with his friend's advice concerning the allowance; he felt he could secure only 100 francs a month rather than a hoped-for 200 francs. That would undermine his ability to support Hortense and his son, who, moreover, had been suffering from typhoid fever for two weeks. Zola—keeping it a secret from his wife—immediately offered to send a little money to see to Cézanne's needs in

Fig. 9. Paul Cézanne (1839–1906), *Portrait of Madame Cézanne*, ca. 1872. Oil on canvas, 18⅛ × 14⅝ in. (46 × 37.4 cm). Whereabouts unknown

anticipation of better days. In April 1878, at Cézanne's request, Zola sent the sum of 60 francs to Hortense, then living at 183, rue de Rome in Marseille. The painter went back and forth between Aix and Marseille to see his son, who was very dear to him. On one occasion, he missed the last train out of Marseille and had to walk the eighteen miles to the Jas de Bouffan, arriving late for dinner.

In June of the same year, Cézanne again asked his friend for money for his companion, the same amount as before; he wrote that she was "feeling no worse."[7] The couple's money problems were therefore already in evidence. Zola's payments continued for months. In July, Hortense was living at 12, vieux chemin de Rome in Marseille. Another sign of trouble arose that month. Paul Guillaume had lent Cézanne's Paris apartment to friends, and the landlord informed Cézanne in writing of the unexpected guests. Louis-Auguste, of course, learned of the letter and inquired into the nature of that presence: Was his son harboring women? Throughout the summer, Paul worked at L'Estaque but usually slept in Marseille or Aix. He was looking for new, inexpensive lodgings. The year 1878 was cursed for him. In September, yet another sign of trouble: Hortense's father wrote to his daughter under the name "Madame Cézanne" at their Paris address on rue de l'Ouest. The letter was forwarded to the Jas de Bouffan and, naturally, Louis-Auguste opened it. Fortunately for the couple, he was having a fling with a young maid while his wife was in L'Estaque. He generously gave his son 300 francs. In November, Hortense was back in Paris, having left her son with his father. Cézanne found six-year-old Paul very unruly. Cézanne learned that Hortense had had a "petite aventure"—inconsequential as far as he was concerned. She returned to Marseille, living at 32, rue Ferrari.

In February 1879, Cézanne confided to his friend Victor Chocquet: "My wife, on whom rests the burden of attending to our daily food . . . well knows the trouble and bother it causes."[8] He was thus quite aware of the weariness brought about by petty everyday concerns. This simple remark shows that he was compassionate and respectful of his companion's responsibilities. From June 1879 to March 1880, Cézanne lived in Melun, southeast of Paris. How

long was Hortense with him, if at all? Between June 9 and 20, he was in Paris and went northwest to Médan. She sent him a letter in care of Zola, which Cézanne discovered when he returned to Melun, where Zola had sent it. Cézanne was in Paris again on October 6 to see a production of Zola's *L'Assommoir*, his friend having procured him three seats. Hortense found the incessant rushing from place to place increasingly unbearable.

Impelled by his sister Marie, who now knew about his relationship and his paternity—and about a possible

Fig. 10. List of marriages in Aix-en-Provence, France, 1883–92. Archives Municipales, Aix-en-Provence (A.M.AIX E2_ART10)

affair of his in 1885—Cézanne married his son's mother, in the presence of his whole family, on April 28, 1886, in Aix (fig. 10).[9] Hortense took up residence in nearby Gardanne, where the teenaged Paul attended school. In late October, Louis-Auguste died. Yet nothing changed for Hortense: no one accepted her into the family, and her husband was interested in nothing but his painting, which she did not understand. In March 1887, she was living on cours Sextius in Aix, where she received a letter from her friend Thérèse Guillaume: "I'd like you to tell us as soon as possible when you've returned to Paris, since we could talk more easily there than by letter. If only the earthquake had been stronger and had made Paul decide to leave the Midi. But let's hope there will be no need for an earthquake to make up your mind for you and that you will come sooner than expected. Let's be of good cheer. Above all, worry less."[10] Here, once again, is confirmation of the distance between Paul and Hortense. The romance was gone, and now that his father's estate was settled, her husband had no further financial problems. She wished only for greater comfort and freedom.

When her own father died in 1890, Hortense needed her husband's signature to settle the estate: at that time, a wife passed from her father's guardianship to that of her husband. The couple went to Jura, where her father had owned some property. He had lived in a modest dwelling in Lantenne-Vertière, among the outbuildings on the farm of a gendarme named Claude-François Guignaud, who employed him as a servant. Guignaud's son

would later recount seeing Cézanne, in a rage, rip up a just-completed canvas. He would also remember the elegant and beautiful woman, still young-looking, who formed such an odd contrast to the irascible and slovenly painter. Then, for several months, Hortense dragged her husband and son around Franche-Comté and Switzerland. During that trip, on August 1, she wrote to Marie Chocquet from Emagny, in Doubs.[11] She declared that Cézanne loved Switzerland, where they had already spent ten days. "We found the country so beautiful that we came back eager to return. We saw Vevey where Courbet did the lovely painting you own." They would look for housing, so that they could spend their summers there. The painter worked a great deal, but rainy weather often prevented him from going out to paint from life. Hortense issued an invitation to the Chocquets for the following year: "I can assure that you will find the country superb; I've never seen anything so beautiful and it is so refreshing in the woods and on the lakes, and it would give us so much pleasure to have you. . . . Once we are established in Switzerland I will send you our address." Hortense's declaration may be merely a fanciful notion: although Cézanne sought out cool weather in the summertime because of his illness, the Alps were too high and distressed him, as he would write several years later during a stay in Talloires.

For three months of the trip, the couple visited Neuchâtel and the surrounding region. As Raymond Hurtu later commented, "Madame Cézanne, very stylish, loves beautiful clothes. So she haunts the fashion shops, which are not numerous enough for her taste. The benches favor small talk, and Hortense is making friends there. She reads a great deal, especially novels, but also probably serials in the local newspapers. Tearooms and pastry shops are for the late afternoon. In the evening, in the common area of the hotel, she likes to play cards with the guests of the establishment. On rainy days, she embroiders."[12] As for Cézanne, he painted the Château de Colombier, beloved of Jean-Jacques Rousseau, the lakeside in Cortaillod, and the Areuse Gorge. Then on to Bern and Fribourg, where, on October 26, violent anti-Catholic demonstrations in the streets so frightened Cézanne that he fled to Geneva without telling anyone. After informing his wife and son by mail, he was reunited with them, and they visited Lausanne and again Vevey. In November, Cézanne returned to Aix, Hortense and young Paul to Paris.

In February 1891, Paul Alexis sent Zola news of Cézanne and his family:

He is furious at La Boule [Hortense], who, after spending a year in Paris, last summer inflicted five months of Switzerland and table d'hôtes on him. . . . The only one he had any rapport with was a Prussian. After Switzerland, La Boule, escorted by her bourgeois son, was foisted on Paris. But when her food supply was cut off, she turned up in Aix.

Last night, Thursday, at seven, Paul left us to fetch them at the train station, her and that toad of a son. The Paris furniture, transported for four hundred francs, will also arrive. Paul intends to put all of it in a place rented on rue de la Monnaie, where he will pay them an allowance (he even told his offspring: No matter what stupid things you do, I won't forget that I'm your father). Notwithstanding, he does not intend to leave his mother and . . . sister, at whose home he is living in the suburbs, where he feels quite content, clearly preferring it to his wife there. Now if, as I hope, La Boule and the brat set down roots here, nothing will prevent him any longer from going to live in Paris for six months, from time to time. Long live the beautiful sun and freedom, he shouts. . . . Besides, no money worries. Thanks to his old man, whom he now venerates, he has the wherewithal to live. First, he divided up his income into twelve monthly chunks. Then each of them was subdivided in three: for La Boule! for Le Boulet! and for him! Except that La Boule—crafty, it appears—has tended continually to encroach on his personal share. Today, propped up by his mother and sister, who despise the person in question, he feels up to the task of resisting.

In 1896, the art critic Numa Coste reported to Zola:

Cézanne, however, has a certain feeling of gratification, and at sales his works are having a success to which he was not accustomed. But his wife must have made him do a lot of stupid things. He is obliged to go back and forth from Paris on her orders. To have some peace, he was compelled to get rid of his assets and, according to confidences he lets slip, he was supposedly left with an income of only about a hundred francs a month. He rented a cottage in the dam quarries and spends most of his time there.

These comments may seem rather biting and one-sided with respect to Hortense and Paul *fils*. With Cézanne, nothing is black-and-white, nothing is simple. He had a quick temper, was ill at ease with women, and had money problems. Painting was the driving force of his life, and he loved solitude. The many separations certainly suited him, but throughout his life he worried about the health of his wife and son, so far away and yet so close. He always displayed affection toward them, even though he sometimes lost his temper, and even though, as with all couples, there were many altercations. It is likely that he would have found a less independent woman unbearable.

On June 4, 1896, Cézanne and his family attended the First Communion of his niece and goddaughter, Paule Conil. Afterward Hortense and young Paul took him to Vichy for a monthlong course of treatment for his diabetes. They also made him spend the summer in Talloires, at the Hôtel de l'Abbaye, along Lake Annecy. They passed through Chambéry and visited the great charterhouse at Saint-Laurent-du-Pont. "After quite a lot of toing-and-froing, my family, in whose hands I find myself at the moment, has made up my mind for me to settle down for the time being where I am," Cézanne wrote

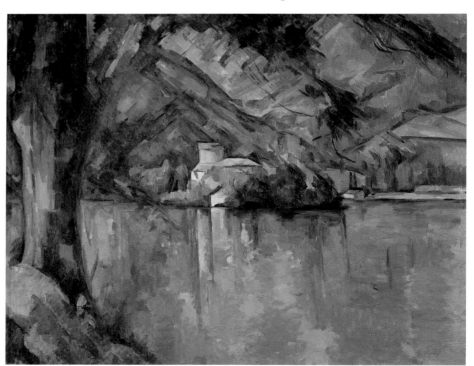

Fig. 11. Paul Cézanne, *Lake Annecy*, 1896. Oil on canvas, 25⅝ × 31⅞ in. (65 × 81 cm). Courtauld Institute of Art, London (P.1932.SC.60)

to Joachim Gasquet. "I am staying at the Hotel de l'Abbaye. What a superb remnant of ancient times:— an open staircase five metres wide, a magnificent door, an interior courtyard with columns forming a gallery all round; a wide staircase leading up, the rooms look out on to an immense corridor, and the whole thing is monastic. . . . To relieve my boredom, I paint."[13] Cézanne painted a view of Lake Annecy (fig. 11) and a few watercolors of the lake during boat rides with his son near the Roc de Chère. He also did a portrait of a child in a straw hat, the son of Monsieur Vallet, a gardener at the hotel (fig. 12), and several studies for the portrait. When the family returned to Paris, Cézanne looked for a studio and an apartment. He did not go back to Aix until late May 1897. In October, his mother died. Cézanne, Hortense, and Paul were together again in January 1898 in Paris; Cézanne moved into the Villa des Arts, near place de Clichy. He was in Paris and Ile-de-France until June 1899.

In September, the Jas de Bouffan, which was jointly owned by Cézanne and his two sisters, had to be sold. The sale affected him deeply. He moved his belongings into an apartment at 23, rue Boulegon in Aix. In 1902, he was with Hortense and Paul in Aix until May. From then until his death, his wife and son spent several months each year with him in Provence.

For more than thirty years, Hortense put herself in the service of her husband's art, considering it her duty to pose at his request. For days on end she sat, motionless and silent, displaying extraordinary patience, accepting her husband's difficult temperament, even though she did not understand his work as an artist. He did twenty-nine paintings of Hortense, as well as four watercolors and some fifty drawings. The last painting dates to about 1892, the last of the drawings to about 1904. Although the portraits of Hortense generally show the same grave, resigned, and calm expression, love sometimes comes through in these representations: in the painting *Woman Nursing Her Child* (pl. 3), of course, and especially in the watercolor *Madame Cézanne with Hortensias* (pl. 42).

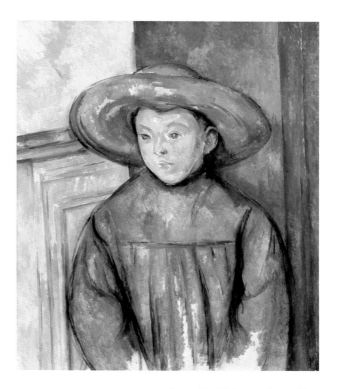

Fig. 12. Paul Cézanne, *Boy with a Straw Hat*, 1896. Oil on canvas, 27⅛ × 22⅞ in. (68.9 × 58.1 cm). Los Angeles County Museum of Art, Mr. and Mrs. George Gard de Sylva Collection (M.48.4)

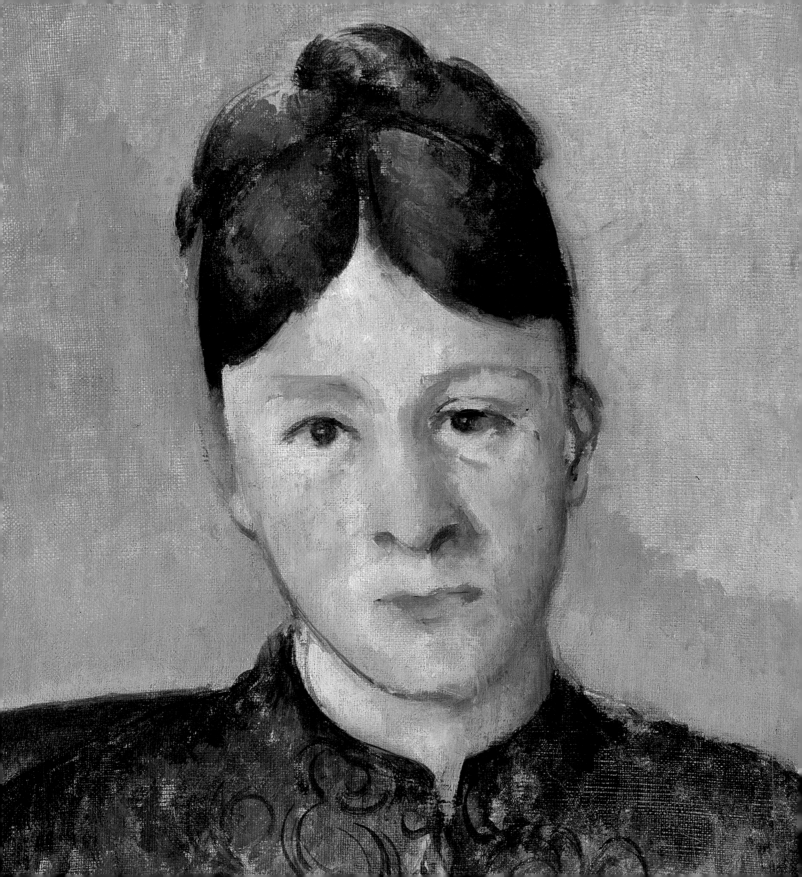

Charlotte Hale

A Template for Experimentation
Cézanne's Process and the Paintings of Hortense Fiquet

In the museums where they reside, Paul Cézanne's paintings of his wife elicit more comments than do his iconic still lifes, landscapes, and cardplayers. Why, visitors ask, does she look so sad, so bored—frankly, so odd? More pointedly, they wonder, why do her eyes look blank, why are her hands unfinished, why does she appear to be tipping over, and what exactly was going on between the artist and his model? The combination of alluring and confounding qualities in Cézanne's paintings described by contemporaries and experienced by present-day visitors is distilled in the artist's portraits of his wife. This essay explores what lies behind the quiet hold of these works from the standpoint of technique. It examines ways in which this most innovative of artists constructed these paintings, his concerns as a picture-maker, and the complex working relationship between Cézanne and Hortense Fiquet.

MODEL AND TEMPLATE

Cézanne's influence on the arts has been so profound and pervasive that it is hard to appreciate the degree to which his innovations have become part of the vocabulary of our visual experience. He sought no less a goal than the recalibration of the relationship between the contemplation of the subject—his *motif*, as he called it—and its expression on canvas. "Painting does not mean slavishly copying an object," he said. "The artist must perceive and

capture harmony from among many relationships. He must transpose them in a scale of his own invention while he develops them according to a new and original logic."[1]

Cézanne's "new and original logic" was built on stable foundations in terms of subject matter. Painting from nature was essential to him, and his favored *motifs* were places, objects, and people he knew well.[2] For most of his life he lived in and around Aix-en-Provence, in the south of France. He painted the grounds of the Jas de Bouffan—the family estate near Aix—and the neighboring countryside, notably some seventy images of Mont Sainte-Victoire, which provides a striking backdrop for his grave in the Cemetery of Saint-Pierre. Cézanne worked in other conventional genres: still lifes of fruit and talismanic objects (many of which can still be seen in his studio); self-portraits and portraits of people close to him—family, friends, and workers in the family employ. He returned to these touchstone subjects repeatedly over many years, familiarity allowing him to focus his attention on the process of painting: "I think I could occupy myself for months without changing place, by turning now more to the right, now more to the left."[3]

Cézanne's first paintings of Hortense were made about the time of the birth of their son, Paul, in 1872, and the last in the early 1890s; none of them is securely dated, and as with much of his oeuvre, their chronology has long been debated.[4] In this approximately twenty-year time span, Hortense was the artist's most frequent model other than himself. He knew the perfect oval of her head and the line of her jaw as well as he knew the profile of Mont Sainte-Victoire. Without expectations on either side, Cézanne seems to have felt the freedom to explore his process when painting his wife, using her as a template for experimentation. The twenty-nine pictures vary greatly in scale, ambition, and finish, and she looks different in each.[5] The paintings of Hortense are in a category of their own relative to Cézanne's other portraits, better characterized as compositions based on her head and figure, each charged by complex interactions between artist and model, husband and wife. These are quietly explosive paintings about painting, with Hortense Fiquet as catalyst.

The unconventional nature of Cézanne's portraits of his wife has prompted discussion about the degree to which he regarded her as an object.[6] There is no question that Cézanne responded to the formal aspects of Hortense's head and body, and certain features—her jawline and the part in her hair—were zones of particular fascination for him, reworked repeatedly in many of the paintings.

Intense concentration on his *motif* was the bedrock of Cézanne's working practice, but emotion—albeit hard to parse—is an essential component of the pictures of Madame Cézanne. The overt sensuality of his early work, reined in as he found ways to paint with greater rigor, remained an integral aspect of what he called his *sensations*—his sensory experience of his subject, whether apple or spouse.[7] As he told his friend Joachim Gasquet while at work on a portrait of his father: "I feel, with each brush stroke . . . there's a little of my blood mixed with your father's blood . . . and there is a mysterious exchange, which he isn't aware of, which goes from his soul into my eye."[8] Cézanne required of his models lengthy, multiple sittings and absolute stillness. He castigated his dealer, Ambroise Vollard, for nodding off in the first of what would be more than a hundred sittings: "You wretch! You've spoiled the pose. Do I have to tell you again you must sit like an apple?"[9] (Thereafter, Vollard resolved to drink a cup of strong coffee before arriving at the studio.) Close examination of the paintings of Hortense suggests that Cézanne required much less time of his wife, a known quantity, and with less riding on the outcome; but as the subject of twenty-nine paintings over two decades, Hortense was clearly a willing and patient sitter.[10]

SENSATION AND *RÉALISATION*: MAKING THE PAINTINGS OF HORTENSE
"I have never been able to tolerate anyone watching me paint."[11] There are few firsthand accounts of Cézanne at work, and the descriptions we have of the artist at the easel come from late in his life.[12] From Vollard, we learn that Cézanne yearned for "clear gray" weather, required absolute silence, and could not endure the barking of dogs.[13] We scan for information the handful of photographs of the artist in his studio and painting outdoors.[14] Of *Madame Cézanne in the Conservatory* (pl. 28) we have a rare snippet from Paul *fils*, who annotated a photograph of the painting with the date, 1891, recalling his mother posing for this picture in the conservatory at the Jas de Bouffan.[15] Fortunately, because of Cézanne's unconventional technique, the paintings themselves reveal a great deal of evidence about how they were made. Infrared imaging and X-radiography can further reveal the artist's initial drawing and early applications of paint, along with subsequent changes and adjustments.

For Cézanne, the making of a painting was a gradual process during which his *motif* was subsumed into the composition—the fleeting made eternal. "I wanted to make of Impressionism something solid and enduring

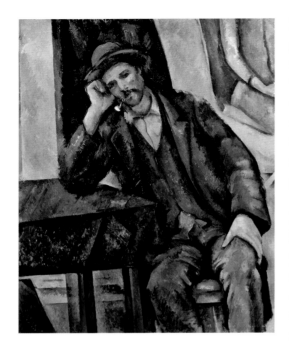

Fig. 13. Paul Cézanne (1839–1906), *Man Smoking a Pipe*, ca. 1902. Oil on canvas, 35⁷/₈ × 28³/₈ in. (91 × 72 cm). Pushkin State Museum of Fine Arts, Moscow (3336). *Madame Cézanne* (pl. 17) appears in the upper right, pinned to the wall.

like the art in the museums," he said.[16] This approach guided his choice of materials and the execution of all stages of creation. His incremental, open-ended process is well demonstrated in *Madame Cézanne in the Conservatory*, one of the later paintings of Hortense, and arguably the most ambitious composition. The varying degrees of finish in this work—from areas left unpainted to areas that were reworked—track the evolution of the painting toward his goal of *réalisation*: the realization of his *sensations* in paint.

As a prerequisite for experimentation, Cézanne kept his materials simple, with little variation throughout his life.[17] Like the majority of his work, all but the four smallest paintings of his wife are on standard-size supports, readily available from color merchants.[18] The format he used most often for paintings of Hortense is the modestly scaled size 8 *figure*; he used larger formats for later paintings, including *Madame Cézanne in the Conservatory*.[19] One advantage of employing standard-size formats was that the stretchers could be reused. Photographs show the artist working on stretched canvases, but loose canvases pinned to walls appear in the backgrounds of some of his paintings.[20] The unstretched *Madame Cézanne*, of about 1886–88 (pl. 17)—its bottom left corner curling away from the wall—can be seen in the background of *Man Smoking a Pipe*, of about 1902 (fig. 13). Careful examination of *Madame Cézanne* shows diagonal cracks in the lower left that may have resulted from this casual display.

Some of the artist's early paintings were on colored primings.[21] Cézanne began painting consistently on light grounds—white, or white tinted with a little yellow ocher, and occasionally gray—as he adopted a brighter, more spectral palette in 1872–74, working outdoors alongside Camille Pissarro in Pontoise and Auvers-sur-Oise. All the paintings of Madame Cézanne have white or very slightly yellowish-white grounds. White or off-white grounds provided a brilliant reflective base that allowed colors to look their most prismatic; they feature to a greater or lesser extent in the portraits of Hortense, where he left areas unpainted or painted only very thinly, especially in the later works. The lead white ground with which he prepared the canvas of *Madame Cézanne in the Conservatory* can be seen in the fingers,

much of the thinly painted dress, and unpainted patches at the edges of the background.[22]

The conservatory portrait is one of the few paintings of Hortense that has a related sketch (pl. 40).[23] In addition to carefully composed drawings like this one, there are scores of casual sketches of Hortense: head down, sewing, sleeping. Many look unposed, captured with a few lines in unguarded moments (see, for example, pl. 41). These studies appear direct and faithful to the model, as far as one can tell, and many have a tenderness that is not usually seen in the paintings, at least not in their final form.

In *Madame Cézanne in the Conservatory*, the artist's initial laying in of the composition—his underdrawing—is more extensive and more prominent than in any other of the portraits. Bold strokes of a carbon-based black drawing material—probably soft graphite pencil—in the unpainted fingers and through thinly applied passages of paint can be imaged more fully using an infrared camera (fig. 14).[24] Ranging from controlled to expansive, the underdrawing provides a vivid snapshot of what Cézanne thought necessary to indicate at this first step in establishing the composition. He was concerned primarily with the placement of the figure, but rather than definitive contours, he drew, very freely, multiple lines—zones of possibility—that allowed him to keep his options open and gradually home in on contours as he applied color.

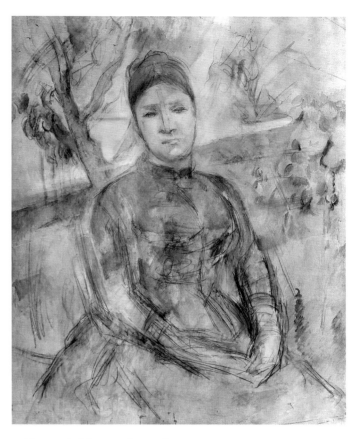

Fig. 14. Infrared reflectogram, *Madame Cézanne in the Conservatory* (pl. 28)

In Hortense's face, the infrared reflectogram reveals parallel lines running down the center on either side of the nose; at right angles to these "tramlines" are multiple sketchy lines, indicating the general placement of the eyes, and more precise diagonal "ticks" at her right nostril and the corner of her right eye (see figs. 29, 31). Vestiges of his early academic training, such registration lines may be familiar to those who have taken life drawing classes, as a technique for setting the angle of the head in space and positioning facial features. In many of the paintings of Hortense, the

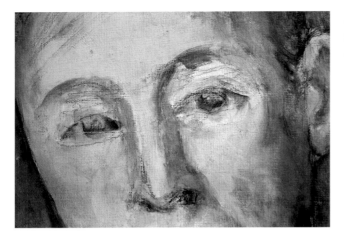

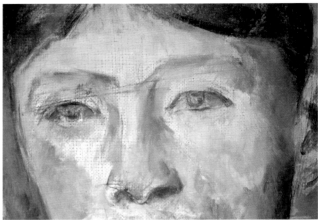

Fig. 15. Infrared photograph detail, *Portrait of Madame Cézanne* (pl. 15)

Fig. 16. Infrared photograph detail, *Portrait of Madame Cézanne* (pl. 16)

head is tilted, more or less, imparting character to the sitter and a subtle dynamism to the composition; it was clearly important for Cézanne to establish this angle from the outset. Similar sketchy lines marking the angle and location of the eyes are seen, with the aid of an infrared camera, in the underdrawings of paintings from the Musée Granet, the Musée d'Orsay, and the Philadelphia Museum of Art (pls. 15, 16, 27; figs. 15, 16, 26).[25] Infrared photography reveals abbreviated placement marks in the face in *Madame Cézanne with Green Hat* (pl. 26) and in *Portrait of Madame Cézanne* (pl. 9), where there are also "tramlines" on the chin. The artist used registration lines in only a small number of the independent figure drawings of Hortense (pl. 49).[26] A striking unfinished watercolor (pl. 48) has registration lines for the eyes and sketchy, provisional drawing in and around the figure; as with the oil paintings, these functional lines were presumably intended to be covered, at least to some degree, by subsequent layers of color.

The unusually extensive underdrawing seen in *Madame Cézanne in the Conservatory* may relate to the complex indoor-outdoor setting and the particular lighting conditions—this is the only painting of Hortense done in the semi-outdoors, with ambient daylight, rather than the directional light of a studio setup. ("You know," Cézanne wrote, "all pictures painted inside, in the studio, will never be as good as those done outside."[27]) The underdrawing in the background comprises sketchy forms alongside others drawn with more specificity: the tree to the left of the figure, the plant to the right, and the wall (or shelf) behind the figure. In the imposing *Madame Cézanne* (pl. 17), the figure is set against a curtain, with a section of patterned wallpaper on

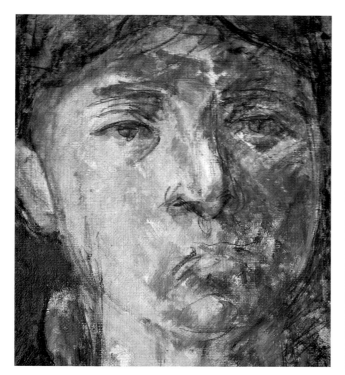 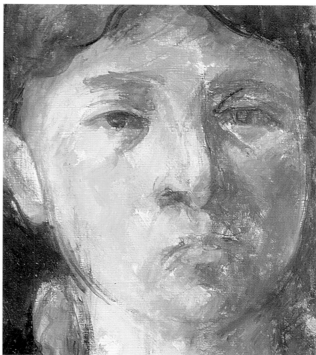

the right, but examination of the underdrawing suggests that this work was originally planned with a more elaborate background. Loosely sketched rectilinear forms to the left of the figure and plantlike forms to the right are reminiscent of the underdrawing in the background of *Madame Cézanne in the Conservatory*.[28] Here the underdrawing in the face is more precise, with strong, looping strokes for contours and features, and hatching in zones of shadow (figs. 17, 18). The most emphatic, diagonally hatched lines appear at the proper right side of the mouth, denoting the placement of Hortense's mouth or the halftone below; left partially visible, through the overlying paint, they contribute to an expression of contained anger or unhappiness.

In *Madame Cézanne in the Conservatory*, ultramarine blue painted lines take up where the carbon-based black underdrawing leaves off. In a number of the portraits it appears that all the underdrawing was carried out in fluid paint, usually blue or blue-black (pls. 13, 14, 19, 25).[29] Such lines were often reinstated or revised as the painting progressed and remain visible as elements of the composition. In *Portrait of Madame Cézanne* (pl. 13; fig. 19), the fluid dark blue line indicating the part in the hair is from the initial

Fig. 17. Infrared photograph detail, *Madame Cézanne* (pl. 17)

Fig. 18. Detail, *Madame Cézanne* (pl. 17)

Fig. 19. Detail, *Portrait of Madame Cézanne* (pl. 13), with Cézanne's painted underdrawing showing through the more open passages

underdrawing; subsequently, blackish painted lines of "overdrawing" were applied around the back of the head and the piled-up hair. Multiple painted lines are also seen around the jawline, charting the artist's reworking of this key contour.

"When I begin I paint freely, and afterwards I make corrections."[30] Any painting constitutes a multitude of decisions on the part of the artist. For the academic painters whom Cézanne so despised, the steps were preordained, and the execution of the painting in some respects required less creativity than did the sketches and studies that preceded it. Cézanne had a concept for his work when he selected his *motif* and a canvas of a particular size and orientation. But for him, once the subject (conventional), format (standard), and palette (predictable) were established, the business of creation was largely still ahead of him. Initially guided by study of the *motif* and the provisional scaffold of his underdrawing, as the painting progressed he responded increasingly to what he had already painted, making adjustments and corrections, "one stroke after the other, one after the other."[31] Without a fully preconceived notion of what would constitute the result, he remained open to the next possibility, and was willing for the multitude of decisions to play their part, so that his process became an integral part of the painting.

In *Madame Cézanne in the Conservatory*, the paint was first applied in colored washes, heavily diluted with turpentine. Dark ultramarine blue washes are seen in much of the dress below the bustline, especially at the bottom of the painting, where the paint was thinned so much that it pooled and ran down the canvas (fig. 20); brown washes were applied in the hair, green in areas of foliage around the figure. This was Cézanne's standard practice, and it is seen to a greater or lesser degree in all the paintings of his wife. With these colored washes he began to activate the whole canvas— an essential first step in the network of colored strokes to come—while allowing the underdrawing to remain visible through the translucent underpaint.

Fig. 20. Detail, *Madame Cézanne in the Conservatory* (pl. 28). Diluted underpaint has run down the canvas and pooled at the bottom.

It is hard to overstate the degree of rigor and intense concentration with which the artist studied his model: "My eyes, you know, my wife tells me that they jump out of my head, they get all bloodshot."[32] Perceiving form in terms of color relationships, he sought to transpose these to his canvas in "planes and patches" of paint that represented his sensations of color while becoming part of a new and more permanent reality.[33] Cézanne allowed his underpaint to dry and then continued to work with further patches of color—groups of strokes—where the paint was generally mixed with white, creating opaque or semitranslucent "body color," depending on how thickly it was applied. Looking closely at Hortense's dress in *Madame Cézanne in the Conservatory*, we can track his thin, cumulative applications of body color, mixtures of ultramarine blue and white; the upper parts of the bodice and shoulders are the most heavily worked, with color patches subtly modulated with a little vermilion and emerald green. Warm-cool contrasts, warm advancing, cool receding, were a traditional technique for modeling form that would have been familiar to Cézanne from his study of old master paintings in the Louvre—"the book in which we learn to read"[34]—in particular the work of

Fig. 21. Detail in raking light, *Madame Cézanne in a Red Armchair* (pl. 4)

Peter Paul Rubens, which he copied throughout his life.[35] Like Rubens, Cézanne used warm-cool contrasts extensively, for painting flesh. Here, the advancing plane of the nose is pink and the receding sides of the nose are green (see fig. 30).

Adjustments, minor and major, tend to occur along contours. In the artist's earlier, more thickly painted pictures, such as *Madame Cézanne in a Red Armchair* (pl. 4), the surface can take on the quality of bas-relief, where layer upon layer of paint has been applied on either side of what becomes a grooved contour line (fig. 21). At some points Cézanne seems to have reinstated—retooled— the contour by scraping into the buildup with a sharp implement, perhaps the end of a brush. He also made changes to the wallpaper pattern, apparently painting out a blue lozenge in the upper right corner, adding another, closer to the head, which he proceeded to repaint, just above and to the left, but leaving the lower lozenge visible. No other artist had shown with such honesty the difficulties of making a painting. What we do not see are the paintings that he lost patience with and destroyed.[36]

Painting for Cézanne was a slow and painstaking process. His technique was not systematic (he disliked theorizing—"Talking about art is almost useless"[37]), but it was rigorous. Every stroke was carefully considered— Joachim Gasquet noted that twenty minutes could go by between brushstrokes.[38] If Cézanne could not find a pictorial solution for a certain color, he would leave the area blank. Close study of the paintings of Hortense suggests that Cézanne was able to work faster—or, at least, in bursts of activity—on paintings of the model he knew so well; in all the portraits there are extensive areas of wet-in-wet, where strokes of fresh paint pick up adjacent or underlying paint that is not yet set. But in the more fully worked paintings, enough time passed between sessions for the paint to be set when he recommenced work.

Cézanne's palette changed little from the early 1870s onward; pigments described by Emile Bernard on his visit to the studio the year before the artist's death correspond closely with those identified in paintings from

about 1865 to 1905.[39] Approximately half of these pigments were modern: chrome yellow, emerald green, viridian, cobalt blue, ultramarine (synthetic), Prussian blue, and zinc white; these he used alongside traditional pigments such as iron ochers, vermilion, red lakes, lead white, and carbon black.

Cézanne generally painted with mixtures of pigments, sometimes as many as six or seven: the yellow upholstered chair on which Hortense sits in *Madame Cézanne in a Red Dress* (pl. 22), for instance, was painted with chrome yellow and lead white, with some iron ocher and zinc white; and a yellow area in the curtain contains the same pigments plus vermilion and ultramarine.[40] The overall soft brilliance of his paintings is due to the complexity of his mixtures and particularly to the large amount of lead white (and sometimes zinc white) that he added to his colored paints. An extant palette, dominated by an enormous mound of white, reflects this practice.[41]

When Cézanne painted his portrait, Vollard noted that "as he did not paint with thick impasto, but put one layer of paint as thin as water-color over another, the paint dried instantly; he never had to fear the internal conflict of the colors which produces cracks when the upper and lower layers dry at different times."[42] Medium analysis of Cézanne's paintings has identified both linseed and poppy-seed oils, sometimes heat-bodied, a refinement that would have accelerated drying.[43] It is likely that he also used a commercial siccative, which likewise would have been helpful for his incremental process.[44] His technique seems to have been very sound, and though some paintings of Hortense do have cracks caused by uneven drying—probably from working over paint that was not fully set—for example, the black bands above the wainscoting in the Basel and Chicago versions of Madame Cézanne in a red dress (pls. 19, 20), these are localized.[45]

It is unlikely that Cézanne would have applied a varnish or approved its application, as varnishing would have affected the carefully calibrated hues and tones of his paintings. Leaving paintings unvarnished, an innovative practice associated with Impressionist painters in the 1870s and after, emphasized the luminosity and materiality of the paint layers and signaled an aesthetic that consciously broke with academic practice.[46] Two of the paintings of Madame Cézanne do not have saturating varnishes (pls. 9, 17); their delicate, nuanced surfaces bring us closer to how they looked in the studio.

Cézanne needed to work directly from his *motif*, but he was not aiming for a straightforward record of what he saw; rather, his goal was a more resonant "harmony parallel to nature."[47] He tried to convey his process to Gasquet by spreading his hands apart and slowly bringing them together, clenching them, and intertwining his fingers: "That's what you have to attain!" He went on: "I guide my entire painting together all the time. I bring together all the scattered elements with the same energy and the same faith."[48] How did he achieve this "joining of hands" in his paintings of Madame Cézanne?

Cézanne's brushstrokes are the units of his compositions, simultaneously building form and pictorial unity. In the earlier paintings of Hortense, paint is, for the most part, applied thickly and with overlapping blunt, square-ended brushstrokes, a technique the artist adopted when working directly from nature with Pissarro in the early 1870s, and one especially effective for landscape painting. Though their length and orientation vary, these unblended, distinct strokes—abstractions in themselves—create a rhythm and consistency of touch across the canvas. The paintings of the 1880s onward are much more thinly painted, with minimal impasto. The brushwork is variegated, but there are sustained passages, particularly in the broader areas of flesh, hair, clothing, and background, where groups of "organized" strokes run parallel to one another, applied in overlapping chromatic sequence, "like folding screens [that] modeled and at the same time colored the object."[49] Final, individual strokes are used to define features and add punctuations of color. In addition to structural strokes are others that are free and calligraphic in character. These are often seen in the underpaint where Cézanne was painting more broadly—as in the Guggenheim portrait (pl. 23) and the upper right corner of the Detroit painting (pl. 17)—sometimes taking the form of "joined-up hatching," rhythmic zigzags or extended spirals, and sometimes as final flourishes. In the dress of the Berlin portrait (pl. 14), an early "spiral" stroke in the lower right corner indicates the shadow to the right of Hortense's breast. Later calligraphic strokes are seen in the springy, circular marks that describe the embroidered patterns on the dress, applied over little more than underpaint (fig. 22). It is instructive to compare these apparently effortless, pitch-perfect strokes to the equivalent strokes describing the same pattern on the same dress in the Philadelphia portrait, painted around the same time, which are more labored (pl. 13).

Fig. 22. Detail, *Portrait of Madame Cézanne* (pl. 14), showing a range of brushstrokes: fluid underpaint; spiral brushstroke in underpaint at right; overlapping "constructive" strokes; calligraphic strokes used for design on dress; floating contour on neck at left; and a final, autonomous stroke of flesh paint at collar opening

Final, autonomous brushstrokes often redirect the eye and undermine the form the artist worked so hard to achieve, emphasizing instead the two-dimensionality of the picture plane. In *Madame Cézanne in the Conservatory*, for instance, late strokes of light ocher paint obscure the line of the wall to the left of Hortense's head and the branches of the tree behind it; in *Portrait of Madame Cézanne in a Striped Dress* (pl. 7), white brushstrokes break the inner contour of the white frilled collar; and in *Portrait of Madame Cézanne* (pl. 8), light strokes interrupt the line of the wall where it meets the chair-back. Another category of late-stage marks are "floating" contours: outlines (often dark blue in color) that float just inside or outside an already established contour, seen along Hortense's wrists in *Madame Cézanne in a Red Dress* (see fig. 36), and in the fat lines of sienna that alone adjust the shape of the piled-up hair in *Portrait of Madame Cézanne* (pl. 15).

Each painting of Madame Cézanne has its own distinct color scheme, deriving from the costume and the background. Cézanne established the palette with the underpaint and went on to articulate colors across the canvas in the later stages of painting, sometimes with touches that are perceptible only through close scrutiny. In *Madame Cézanne in a Red Armchair* (pl. 4), the

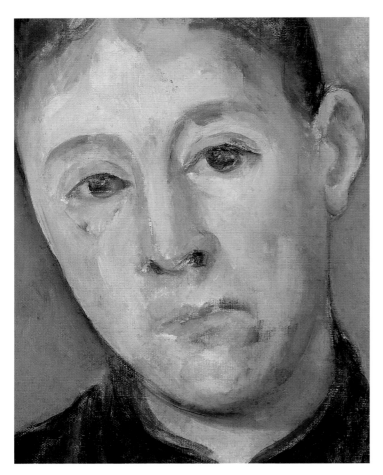

Fig. 23. Detail, *Portrait of Madame Cézanne* (pl. 15)

palette is broad; in other paintings, such as the related works in the Musée d'Orsay, the Detroit Institute of Arts, and the Museum of Fine Arts, Houston (pls. 16–18), it is narrow; but in each case color correspondences throughout the composition tie it together. In the Houston painting, the dress and paneled door are essentially gray-blue and the sideboard and wallpaper are ocher, but these colors are also syncopated across the canvas: there is a stripe of ocher within the blue door and another sliver to the right of it; in the bottom right corner is a late addition of ocher, worked into the blue, and little ocher strokes inflect the blue dress. The application of paint in *Portrait of Madame Cézanne* (pl. 15; fig. 23) is more akin to watercolor; in contrast to the majority of the paintings, where, beyond the underpaint, most colors are mixed with white (in itself a unifying technique), this work is built up very thinly with glazes and semiglazes. Two translucent colors unify the painting: The sienna that outlines the hair is echoed in touches added at a late stage to the background above Hortense's head and to her face (as in her right eyelid and the shadow below her chin). Meanwhile, the red lake of her shirt is picked up in the flesh, in the background adjacent to the proper right cheek, at the top of her right shoulder, in a line of underdrawing left visible in the blue stripe dividing the walls, and in two tiny flecks of opaque red paint on the chest below. Touches of red—a color that advances strongly even in tiny amounts—enliven and unify the surfaces of many of the portraits of Hortense, not to mention other paintings by Cézanne.[50] Rainer Maria Rilke wrote of *Madame Cézanne in a Red Armchair*: "Everything . . . has become an affair that's settled among the colors themselves: a color will come into its own in response to another, or assert itself, or recollect itself. . . . Intensifications and dilutions take place in the

core of every color, helping it to survive contact with others. . . . In this hither and back of mutual and manifold influence, the interior of the picture vibrates, rises and falls back into itself, and does not have a single unmoving part."[51]

Another important way in which Cézanne created internal cohesion in the paintings of his wife was by relating her figure to the background in compositional terms. This was a complex process that generally evolved in the course of painting, often visibly so. Hortense is always anchored to her surroundings in some way—even if this entails no more than the top of a chair behind her shoulder—and to at least one edge of the canvas. In *Madame Cézanne in the Conservatory*, the figure is directly connected to the chair, wall, and surrounding greenery inside and outside the conservatory; however, in the later stages of painting Cézanne subverted the connections through the progressive abstraction of these features. The infrared image and the X-radiograph show that the wall was originally slightly lower and at a less acute angle, the potted plant to the right of the head was larger, and there was a flowerpot—added during painting—directly to the left of the head, of which only the rim remains visible (see figs. 14, 31). Late-stage swaths of ocher-colored paint around the figure and broad strokes of pale cream-colored paint to the right and left of the head conflate indoors and outdoors, altering the space in a way that is both ambiguous and beautiful.

A more straightforward example of pictorial subterfuge is seen in *Portrait of Madame Cézanne* (pl. 9). The background of this painting has a single feature: a shaded line describing the meeting of two walls behind the head. Hortense's contemplative presence is so strong that we only gradually realize that the line that starts at the top of the painting does not continue below the wave of hair at her forehead.[52] Infrared photographs of the painting indicate that the artist never planned to continue it, knowing that it would have detracted from the rocking, rolling contour of the hair and shoulder. He employed a similar interrupted line behind Hortense's head in the Musée d'Orsay *Portrait of Madame Cézanne* (pl. 16). In the related *Madame Cézanne in Blue* (pl. 18), this line divides the blue door from the ocher-colored wallpaper; in the Musée d'Orsay painting, the "line" above the head is actually a strip of unpainted white ground between the two colored areas. In this highly reductive composition we do not question the fact that the line does not continue below the chin; rather, we accept Cézanne's pictorial logic as easily as we might the multiple spacing of justified type on a printed page.

The backgrounds of the paintings echo and amplify the figure of Hortense. The spareness of the background of the Musée d'Orsay portrait matches the extreme simplicity of the oval head, austere hair, and abbreviated, doll-like features. Cézanne painted from life, but he was extremely selective about what he included in his pictures. This work has the faintest suggestion of the patterned wallpaper shown in greater detail in the Detroit portrait (pl. 17) and in *Madame Cézanne in Blue*. The latter is as elaborate a composition as the Musée d'Orsay painting is plain. The curves of the sideboard's fretwork molding are mirrored in the curves of Hortense's ears, and in the ripples along the collar and down the opening of her dress; the tilt of her body echoes the tilt of the door behind her. Cézanne's intentions regarding his tilted lines (seen in paintings of all genres) have been extensively debated; the artist himself was noncommittal on the subject.[53] That tilted lines are not seen in his drawings suggests that they were a deliberate pictorial device. Certainly, they add a charge to the composition. The richly animated background, in which the tilted lines (emphasized by the narrow wedge of ocher on the right) play a key role, contrasts poignantly with the closed stillness of Hortense's face. Cézanne counters the asymmetry of the eyes and ears against the perfect oval of her head and mirrored parabolas of hair. In the sublime bust-length *Portrait of Madame Cézanne* (pl. 14), the artist also plays with asymmetry. Here the figure is placed frontally in what appears at first glance a frank portrayal. On the left side of Hortense's face this holds true, but the asymmetry announced by the chair-back on the left and the very slight tilt of her head is picked up in the darker, introspective side of her face, the result of multiple late-stage brushstrokes that disrupt the clean lines of the wing of hair, the eye, chin, collar, and shoulder.

The "call and response" aspect of Cézanne's picture-making plays out in intriguing and unexpected ways, as the artist gained fresh insights from what he had already set down on his canvas. Sometimes the leap was a large one. An abandoned painting of Madame Cézanne was repurposed for a landscape of the bay of L'Estaque, the coastal town about sixteen miles southwest of Aix, where he lived in 1882 and 1883 (figs. 24, 25). The figure of Hortense, partially visible below the picture surface, can be imaged more fully with infrared reflectography. The half-length pose with the hands out of the frame resembles the Houston portrait (ca. 1888–90), but as the landscape of L'Estaque is dated 1879–83, the portrait below must predate it;

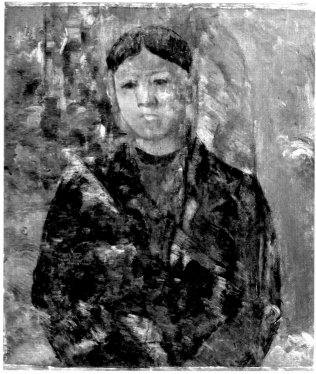

the round-faced Hortense of the infrared image recalls *Madame Cézanne in the Garden*, dated about 1880 (pl. 10). Rather than cancel the portrait entirely with a second ground or priming layer, the artist exploited elements of the underlying figure to shape the landscape.[54] The bust-length *Portrait of Madame Cézanne* (pl. 27) is a more overt case of self-appropriation. The odd, curtainlike form in the background has been the subject of much speculation. Did this derive from an abandoned landscape, or was it planned as drapery from the outset?[55] Cézanne used curtained fabric as backdrops in numerous paintings, including *Madame Cézanne in a Red Dress* (pl. 22), but in the Philadelphia painting (pl. 27) the design on the fabric does not resemble any other used by the artist; along with flowers and leaves, it incorporates ocher-colored vertical features that have been read as the walls of a house. Recent technical examination has made it clear that the design on the "curtain" began as part of a still life with flowers painted on a larger canvas turned 90 degrees clockwise.[56] But the artist's self-appropriation goes deeper: the infrared image shows that the flowers and leaves of the

Fig. 24. Paul Cézanne, *The Bay of L'Estaque* (rotated 90 degrees clockwise), 1879–83. Oil on canvas, 23³/₄ × 29¹/₄ in. (60.3 × 74.3 cm). Philadelphia Museum of Art, The Mr. and Mrs. Carroll S. Tyson Jr. Collection, 1963 (1963-116-21)

Fig. 25. Infrared reflectogram, *The Bay of L'Estaque* (rotated 90 degrees clockwise)

With the images rotated, the figure of Madame Cézanne, just discernible beneath the landscape, can be seen in the infrared reflectogram.

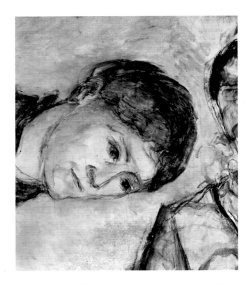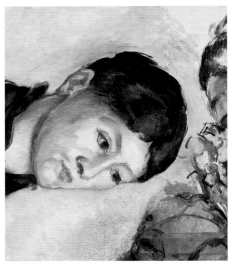

Fig. 26. Infrared reflectogram detail, *Portrait of Madame Cézanne* (pl. 27, rotated 90 degrees clockwise)

Fig. 27. Detail, *Portrait of Madame Cézanne* (pl. 27, rotated 90 degrees clockwise)

With the images rotated, a fragment of a figure, transposed into a floral still life, is seen to form the basis of the "curtain" above Hortense's head.

bouquet follow the contours of a figure that was drawn on the canvas and then abandoned (figs. 26, 27).[57] Only a section of the head and proper right shoulder are visible, the rest having been cut away by the artist when he resized and reoriented his canvas for the portrait we see now. In repurposing the earlier images for the "curtain," Cézanne scraped away the paint of the still life up to the contour of the shoulder of the original figure. The identity of this figure cannot be determined, but it is entirely possible that it was Hortense who was metamorphosed first into a bouquet of flowers, and then into the ambiguous background prop that frames the head of the present Madame Cézanne. The fluid conception of boundaries across genres as evidenced by the appropriation and reuse of motifs in these two paintings suggests that Cézanne was more attuned to the formal possibilities of his abandoned paintings than he was to their subject matter.[58]

"The more he works, the more his work removes itself from the external view [and] the more he abstracts the picture." So wrote Emile Bernard, younger painter and admirer, whom Cézanne befriended in the last years of his life.[59] Though Cézanne saw his art as firmly rooted in nature, the tendency toward pictorial abstraction that derived from his constructive process is a particularly compelling aspect of the portraits of Hortense, one not seen to the same degree in others, including the self-portraits. While it unfolds in many ways across these canvases, the most striking examples concern transformations to the figure of Hortense. *Madame Cézanne in a*

Red Armchair (pl. 4) is a small painting that combines monumentality with an intensely decorative quality, but its powerful presence evolved from more naturalistic beginnings. In Hortense's face, final strokes of pale green paint cancel earlier, dark purplish-brown shadows of the chin and nose, while a deep pink stroke darkens the tip (fig. 28). These adjustments flatten the face, heightening the patterned, playing-card aspect of the composition. The work is densely painted, except for the lower right corner. Glimpsed through the brushstrokes in this area are diagonal lines of underdrawing describing folds in the skirt, probably recorded from life in the first sitting. As he began to apply paint, these lines acted as rough guides for the shadows, but rather than follow the diagonals, Cézanne took his cue from the distinctive striped fabric, creating the patterned, abstracted motif of the skirt for which the painting is famous. The shower of brushstrokes in the lower right would be unintelligible but for their context.

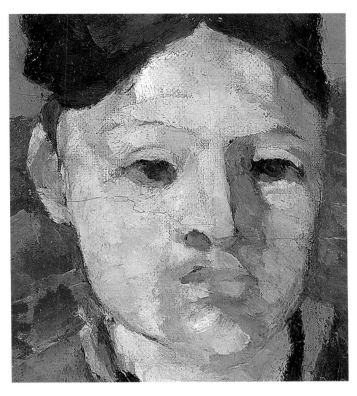

Fig. 28. Detail, *Madame Cézanne in a Red Armchair* (pl. 4)

Cézanne must have had the Boston work in mind when he made the most abstract of the paintings of Hortense, *Portrait of Madame Cézanne* (pl. 8), the diminutive scale of which is in inverse proportion to its impact. Here, the stripes of Hortense's dress were emphatically anti-illusionistic from the start, and are echoed across the canvas in the vertical part of her hair (which the artist accentuated during painting) and in the wall and door behind. Running counter to these very slightly tilted vertical lines are the horizontal line of the collar and the broad arcs of the chair-back, the parted hair, and the shoulders. In this painting Cézanne also played with the possibilities for abstraction presented by the almost frontal downward tilt of the head. It is telling that we do not see the eyes. As viewers we are drawn subliminally to the eyes of a portrait, so that we may "read" the character and emotions of the sitter; in posing Hortense looking downward, Cézanne frees us from this automatic response, allowing us to

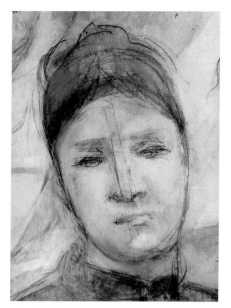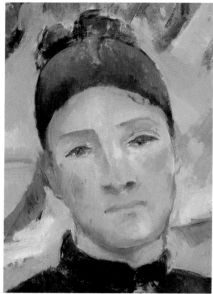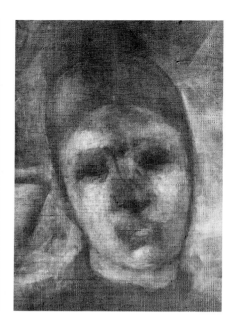

Fig. 29. Infrared reflectogram detail, *Madame Cézanne in the Conservatory* (pl. 28)

Fig. 30. Detail, *Madame Cézanne in the Conservatory* (pl. 28)

Fig. 31. X-radiograph detail, *Madame Cézanne in the Conservatory* (pl. 28)

engage more fully with the composition, which emanates from the quiet interiority of the model.

Infrared images and X-radiographs reveal that Cézanne progressively veiled and abstracted earlier, more naturalistic and expressive iterations of his wife's face in a number of the paintings (pls. 6, 20, 28). That these are among the larger and more complex compositions suggests that in narrowing or "deadening" the eyes (by darkening the whites) and rendering what have been described as masklike—certainly inscrutable—countenances, he wanted to downplay the emotional cues in favor of our seeing the painting as a whole. In *Madame Cézanne in the Conservatory*, the underdrawn image records Hortense's face at less of a tilt and turned very slightly to the left relative to her later placement in paint (see figs. 29, 30). At this initial drawing stage we are able to see Cézanne considering the shape of the hair on the forehead. He first drew it divided at the center and swept to the sides, as it appears in most of the paintings of Hortense. He then drew a single continuous arc for the hair, essentially creating a smaller oval, the face, nesting in a larger one, the head. It was this highly abstracted form (unbroken by the ears, which were added later) that he followed in paint. At one point he broke the line with a loose strand of hair on the proper left side; he then reverted to the more austere contour, but allowed the strand

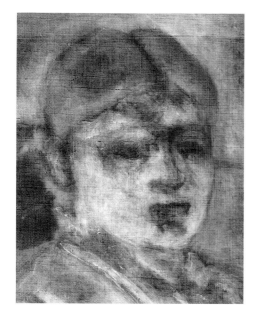 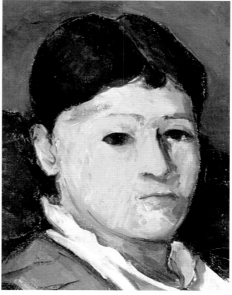

Fig. 32. X-radiograph detail, *Portrait of the Artist's Wife* (pl. 6), showing a more naturalistic representation of Hortense in an earlier stage of painting

Fig. 33. Detail, *Portrait of the Artist's Wife* (pl. 6)

to show through the overlying paint. The X-radiograph also reveals that the face was initially laid in with softer and more naturalistic modeling than is seen in the final painting (fig. 31). The last brushstrokes on the face shape the emphatically straight nose that, along with the caplike hair, contributes to the severely abstracted form of Hortense's head. In its beauty and simplicity it is both classical and utterly modern.

The magisterial *Portrait of the Artist's Wife* (pl. 6) was likely begun about 1879–80, in part on the basis of the wallpaper, which appears in a number of still lifes from about this time, when Cézanne had lodgings in Melun, southeast of Paris, and on the style of the dress.[60] The painting appears to have been substantially reworked as much as a decade later. A more naturalistic, sympathetic face of Hortense, with deeply modeled eye sockets and gently curving nose—seen in the X-radiograph—was overpainted with dense pink and mauve paint (figs. 32, 33); the proper right arm was moved a little to the right, and a number of adjustments were made in the dress, including lowering the bottom of the white shirt slightly. The striking modernity of this image was recognized by Leo and Gertrude Stein, who bought the painting from Ambroise Vollard in 1904—their largest and most important acquisition to that date—and by Picasso, who saw it on his many visits to their rue de Fleurus apartment, and who paid homage to it in his portrait of Gertrude.

"I proceed very slowly. Nature presents itself to me with great complexity, and improvements to make are endless."[61] Cézanne's rigorous, incremental approach led to considerable variation in the degree to which different areas were built up in his paintings. In *Madame Cézanne in the Conservatory*, the head and the surrounding background—his principal areas of interest— were extensively reworked, while the lower part of the dress is represented by the underpaint, and the fingers by sketchy lines on the white ground. Hortense's sheer *mitaines* were not part of the initial underdrawing, and it is possible that Cézanne posed her wearing them at a later sitting, with the aim of articulating her bare forearms; he sometimes had difficulty drawing and painting hands, which he might leave unresolved or else simply avoid (see fig. 14). This painting has been described as unfinished, but the traditional notion of finish is unhelpful for Cézanne, for whom each canvas constituted a new arena for analyzing the process of creating a painting: "Every time I stand in front of my easel, I am another man, and always Cézanne."[62] Bernard, observing him in his studio, said: "Although he was not aware of the fact, his logic complicated his ability to work to such an extent that it became extremely painful for him at times, even paralyzing."[63] Hortense Fiquet herself later told Henri Matisse that her husband "didn't know how to finish his pictures," unlike Auguste Renoir and Claude Monet, who "knew their craft as painters."[64] Cézanne was relentlessly self-critical and was fully aware that finish, or rather, *réalisation*, his own, more nuanced term, was an issue both for himself and for public recognition.[65] He did not show at all in Paris from 1878 to 1894. In 1895, *Madame Cézanne in the Conservatory* was included in his first one-man show, at Vollard's gallery in Paris. However, neither public display nor signatures (which are few, and which were applied for a variety of reasons) confer full "realization" on a painting.[66]

Indeed, it is very hard to assess Cézanne's ultimate intentions about finish, painting to painting, and for the viewer, such readings are extremely subjective. That said, the enormous variation in the degrees of finish of the portraits of Madame Cézanne bears investigation and probably involves the comparative freedom afforded by using his wife as his model. Only the bust-length *Madame Cézanne* (pl. 23) appears to have been abandoned at an early stage. This work relates closely to the highly finished *Portrait of Madame Cézanne* (pl. 15) but was likely begun as a painting rather than a sketch: on the white ground are a few lines of painted underdrawing and

patches of underpaint, characteristic of how he typically began a painting. The Guggenheim painting is the only bust-length portrait of Hortense on a standard-size *paysage* canvas (designed for landscapes), narrower than Cézanne's habitual *figure* canvas size; it is possible that he stopped painting because he felt that these proportions did not suit the bust-length format. By contrast, the diminutive *Sketch of a Portrait of Madame Cézanne* (pl. 11) is a direct study. The artist has focused on Hortense's tilting head and penetrating gaze; he has not activated the background at all. Even in what appear to be resoundingly "realized" paintings, Cézanne normally left areas—especially foregrounds—either blank or simply underpainted as, for instance, the lower right corner of *Madame Cézanne in a Red Armchair,* and across the bottom of *Portrait of Madame Cézanne* and *Madame Cézanne in the Conservatory* (pls. 4, 14, 28). Always responsive to what he observed on his canvas, Cézanne managed to harness his uncertainty for its formal possibilities. These unfinished passages also call attention to the artifice of painting and repudiate the slick academic paradigm that he abhorred.[67] As viewers, when we cross over this boundary into the reality of the painting, we confront its complexity on the artist's own terms.

MADAME CÉZANNE IN A RED DRESS

The four paintings of Madame Cézanne wearing a red dress (Fondation Beyeler, Basel, pl. 19; Art Institute of Chicago, pl. 20; Museu de Arte de São Paulo, pl. 21; The Metropolitan Museum of Art, New York, pl. 22) give special insight into the artist's process, as a sequence of closely related works made in a limited time period.[68] These paintings seem to have held significance for him—"Only I understand how to paint a Red"[69]—and prefigured later, elaborately staged portraits of other sitters.[70] The Red Dress paintings fall into two pairs: in the Basel and Chicago canvases, Hortense is turned to the right, and in the São Paulo and Metropolitan Museum canvases her pose is more frontal. There is no consensus on the order in which these works were painted, although most scholars agree that the Metropolitan painting, the largest Cézanne ever made of his wife, came last.[71] Technical examination and an understanding of Cézanne's working method suggest that one work led to another, as his ambitions for his subject grew, starting with the Basel portrait, followed by those in Chicago, São Paulo, and New York.

The Basel painting appears to have been painted relatively quickly and directly; its immediacy adds to the unguarded quality of this image of Hortense. There is extensive painting wet-in-wet in the face; much of the brush underdrawing and underpaint is visible, as are areas of unpainted white ground in the face, hands, dress, chair, and background. Closer examination reveals that details were in fact added after the paint had time to dry, such as the highlight that obscures the pattern on the chair; the gray-brown line to the right of Hortense's left arm—a floating contour that also serves to disrupt the junction of figure and background—and the black band above the wainscot, which is wider and higher on the left side of the chair than it is on the right and which contains drying cracks indicating that the artist adjusted it during painting. However, these refinements do not substantially affect the fresh, open depiction of Hortense.

In the Chicago painting—the same size as the Basel version—Cézanne transformed essentially the same pose and composition into something very different.[72] He made some changes from the outset: Hortense's position on the chair is less certain, the pockets of her dress are given more prominence, and crucially, her gaze is directed not at the viewer but out of the frame of the painting. Infrared imaging and X-radiography of the canvas reveal that the underdrawing and initial painting shared elements of the Basel portrait: the brush underdrawing of the right contour of the face was more vertically oriented, and in the initial paint layers the eyes and mouth were larger, the proper left shoulder more angular, and the side of the chair—which is visible in the Basel image—more in evidence. Here, Cézanne also made adjustments in the black band above the wainscot, which started narrower on the right and was widened during painting. As Cézanne worked on the Chicago canvas, the more naturalistic image of Hortense seen in the underlayers was subtly altered: the eyes were narrowed by painting over the eyelids; strokes of pale paint were pulled over the top lip and right side of her mouth; and much of the side of the chair was obscured. The flatter and more geometric forms of the finished head, body, and chair result in a painting that is as stylized and contained as the Basel version is natural and outward-looking, and one both more ambiguous and more universal.

The São Paulo *Madame Cézanne in a Red Dress* is a straightforward, even casual, portrait—a touching and candid depiction of Hortense—executed in a sketchier manner than was usual for the artist, with fewer adjustments and

finishing strokes. Hortense is shown against a bare wall, and in this more frontal pose, the open pockets of her dress are given more weight, anchoring the figure in place of a chair. The open pockets were possibly a characteristic aspect of Hortense's appearance; a gaping pocket also features in the Detroit portrait (pl. 17). A close associate of the Cézannes recounted that Hortense would hoist up her skirts when she sat down, which would perhaps have caused the pockets to fall to the sides.[73] In any case, Cézanne was clearly engaged by the sculptural aspects of her clothing. The manner of painting, combined with the closeness of the pose and the scale of the figure (though in a smaller format), suggests that the São Paulo version was a study of sorts for the figure of Hortense in the Metropolitan painting.

The artist's ambitions for the Metropolitan's *Madame Cézanne in a Red Dress* are implicit in its unprecedented size and elaborate composition. It is a painting of enormous spatial complexity, and the fact that it was painted boldly and with minimal adjustments indicates that the three other Red Dress paintings preceded and informed this profound expression of his theme. Here, the unsettling presentation of Hortense seen in many of

Fig. 34. Infrared reflectogram detail, *Madame Cézanne in a Red Dress* (pl. 22), showing that the right side of the mirror, originally a vertical line, was changed to a tilting line in the late stages of painting

Fig. 35. Detail, *Madame Cézanne in a Red Dress* (pl. 22)

Fig. 36. Detail, *Madame Cézanne in a Red Dress* (pl. 22)

Cézanne's portraits of his wife is intensified, pervading the composition. The pronounced tilt of her figure and its unstable pose are amplified by the dislocated slant of the wainscot and the black band on either side of the chair. The composition is further destabilized by the tilt of the right side of the mirror over the fireplace, a calculated adjustment from its initial perpendicular placement, imaged plainly in the infrared reflectogram (figs. 34, 35). The only other significant change made during painting was the adjustment of the top of the open pocket of the dress, on the right, which began a couple of centimeters above its current placement, was subsequently raised higher, and then, after the paint had set, was brought to its final, lowest—least symmetrical—position (fig. 36). Despite all the attention given to the top of the pocket, the bottom is unfinished. The juxtaposition of passages with different states of "realization" is handled with great assurance in this work, from areas left unpainted to final punctuations with opaque red paint, some so small they are barely visible to the naked eye. The hands and lap, in particular, show to brilliant effect the series of captured moments that

is Cézanne's technique. Hortense's expression is as hard to read as the space around her. The light side of her face, with its sweet and calm aspect, has little in common with its quizzical, dramatically shaded counterpart, but both were worked with the same directness, involving extensive painting wet-into-wet. Hortense absorbs and reflects the shifting yet monumental world of this extraordinary painting: model and process in perfect, discordant harmony.

On Hortense's left thumb is a curved stroke of impasto from an underlayer that was dry by the time Cézanne resumed painting. This small detail suggests that in an earlier sitting she was holding a flower—one of the paper flowers Cézanne is known to have used for his still lifes, or perhaps a fresh bloom—at a different angle, a touching artifact of the practicalities of multiple sittings and the passing of time.[74] Whatever the complexities of their relationship (examined by other authors in this volume), Cézanne's paintings of Hortense are the result of an extended collaboration between the artist and his wife that produced some of his most innovative, powerful portraits. Their direct influence is seen in the responses of artists ranging from Juan Gris, Pablo Picasso (fig. 37), Henri Matisse, and Alberto Giacometti to Roy Lichtenstein and Elizabeth Murray.[75] The broader reach of Cézanne's work was heralded by the twenty-two-year-old Bernard, who in 1891, shortly after the Red Dress paintings were made, and in the same year that *Madame Cézanne in the Conservatory* was painted, wrote that Cézanne "opens to art this unexpected door: painting for itself."[76]

Fig. 37. *Picasso between Douglas D. Duncan and Jean Planque looking at Madame Cézanne (Yokohama Museum)* (pl. 7). Photograph taken by Jacqueline Picasso, California, July 5, 1960. Collection Fondation Jean et Suzanne Planque

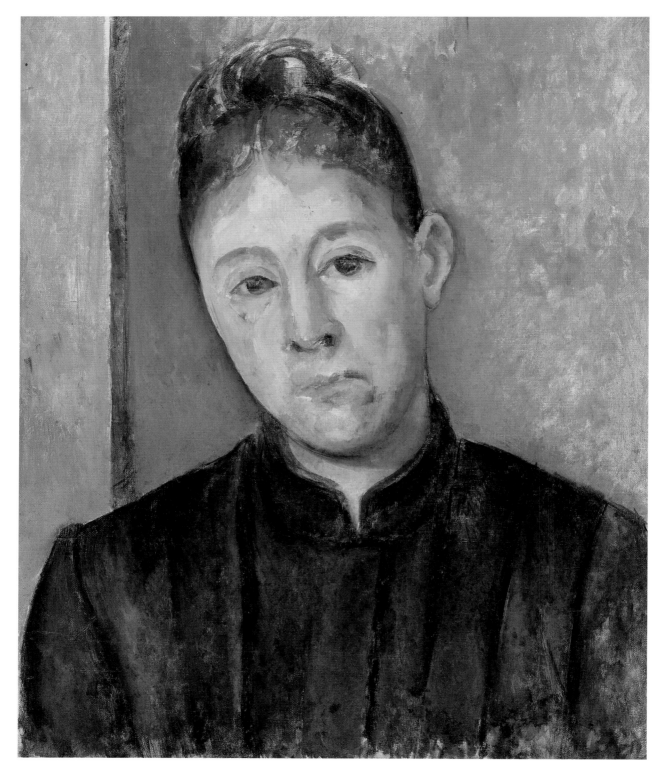

PLATE 15. *Portrait of Madame Cézanne*, ca. 1885–87
Oil on canvas, 18⅛ × 15 in. (46 × 38 cm)
Musée d'Orsay, Paris, on deposit at Musée Granet, Aix-en-Provence,
Gift of Philippe Meyer, 2000 (RF 1982-47)

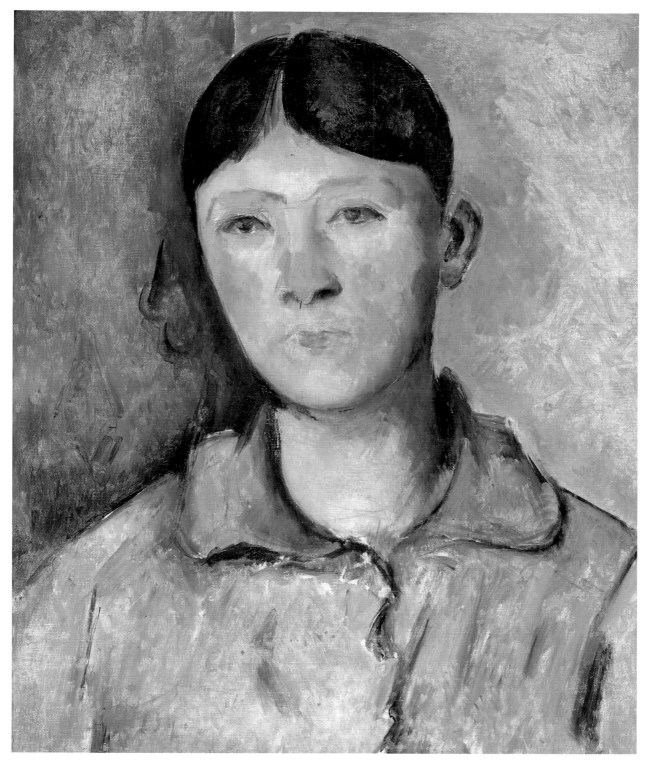

PLATE 16. *Portrait of Madame Cézanne*, ca. 1885–88
Oil on canvas, 18¼ × 15⅛ in. (46.5 × 38.5 cm)
Musée d'Orsay, Paris, Gift of Pierre Matisse, 1991 (RF 1991-22)

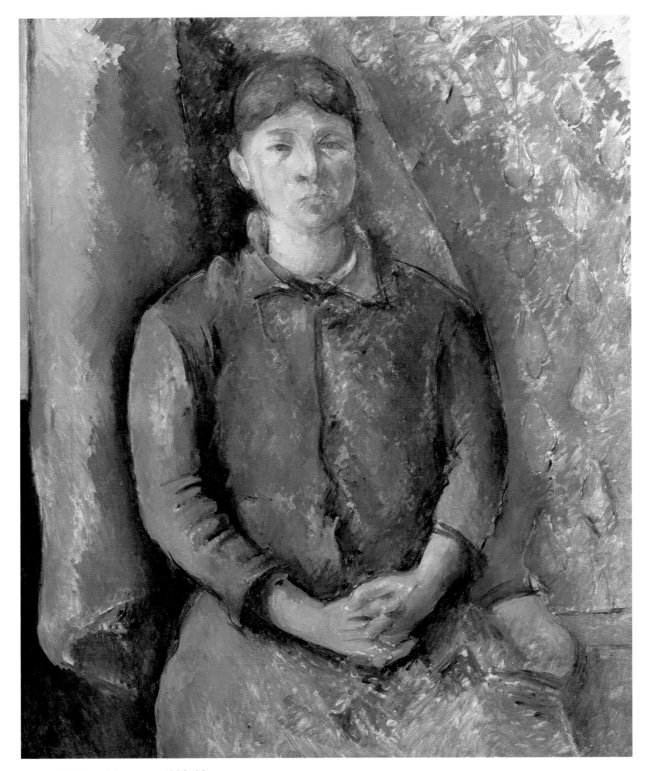

PLATE 17. *Madame Cézanne*, ca. 1886–88
Oil on canvas, 39⅝ × 32 in. (100.6 × 81.3 cm)
Detroit Institute of Arts, Bequest of Robert H. Tannahill, 1970 (70.160)

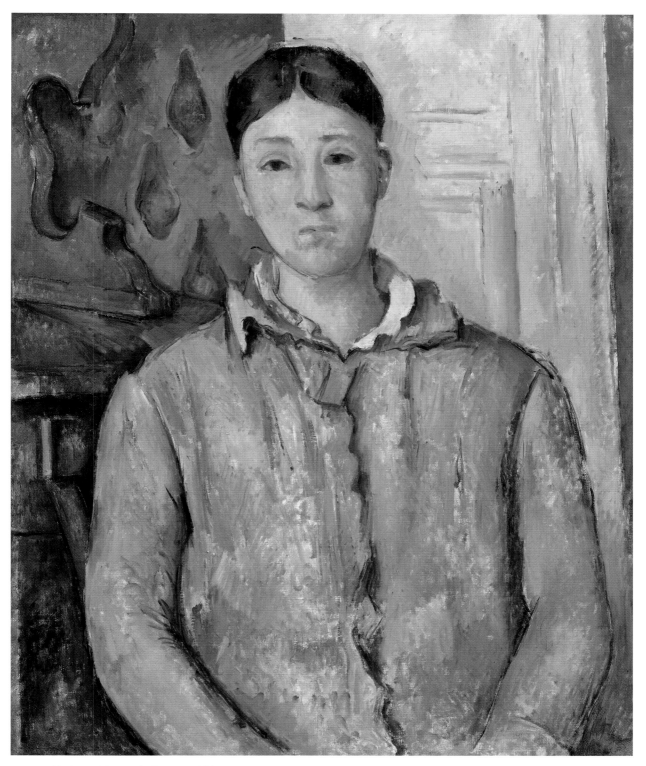

PLATE 18. *Madame Cézanne in Blue*, ca. 1888–90
Oil on canvas, 29¼ × 24 in. (74.2 × 61 cm)
Museum of Fine Arts, Houston, The Robert Lee Blaffer Memorial Collection,
Gift of Sarah Campbell Blaffer (1947.29)

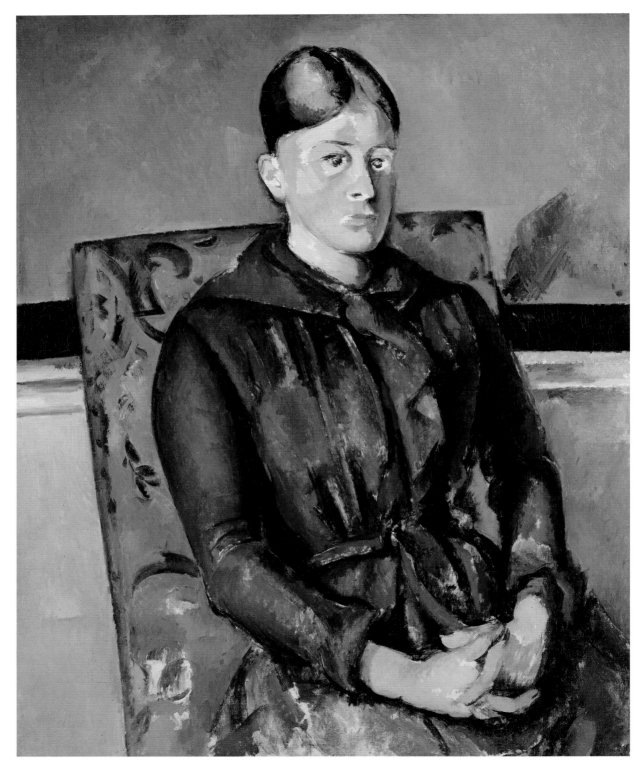

PLATE 19. *Madame Cézanne in a Yellow Chair*, ca. 1888–90
Oil on canvas, 31⁷⁄₈ × 25⁵⁄₈ in. (81 × 65 cm)
Fondation Beyeler, Basel

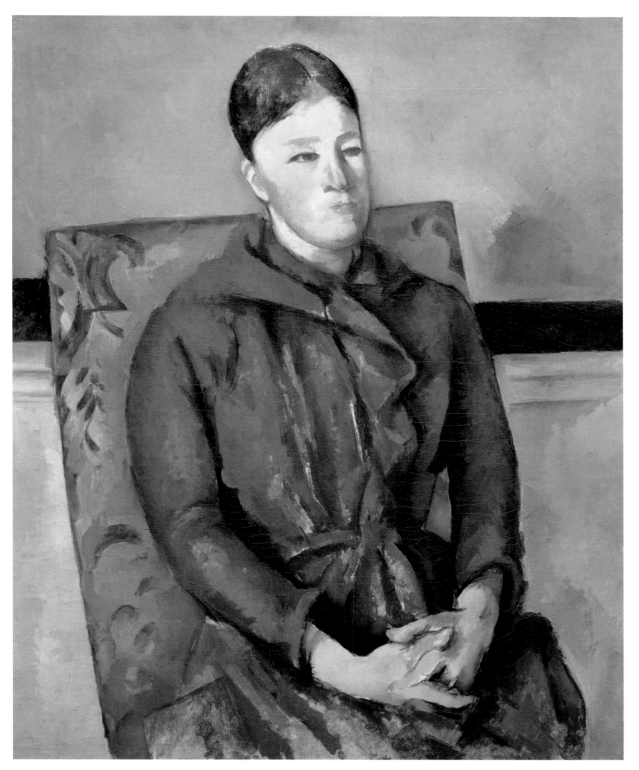

PLATE 20. *Madame Cézanne in a Yellow Chair*, ca. 1888–90
Oil on canvas, 31⁷/₈ × 25⁵/₈ in. (81 × 65 cm)
Art Institute of Chicago, Wilson L. Mead Fund (1948.54)

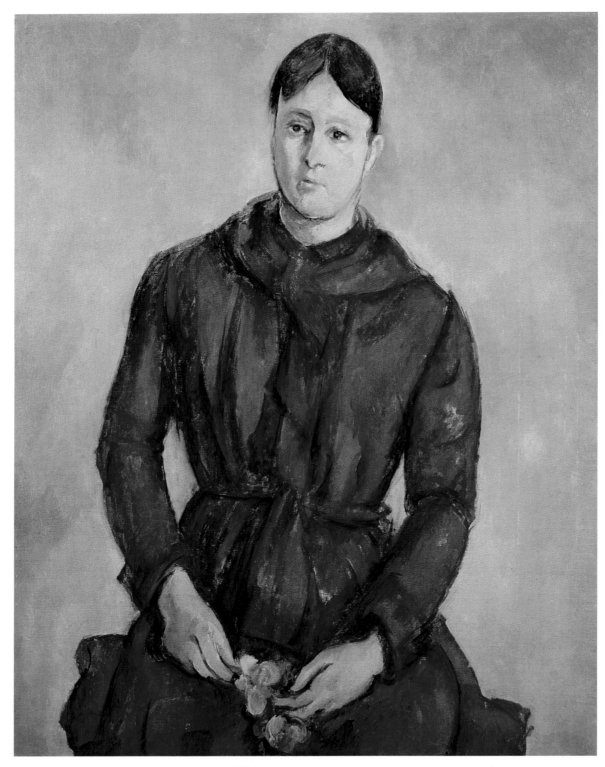

PLATE 21. *Madame Cézanne in a Red Dress*, ca. 1888–90
Oil on canvas, 35 × 27½ in. (89 × 70 cm)
Museu de Arte de São Paulo Assis Chateaubriand (88 P)

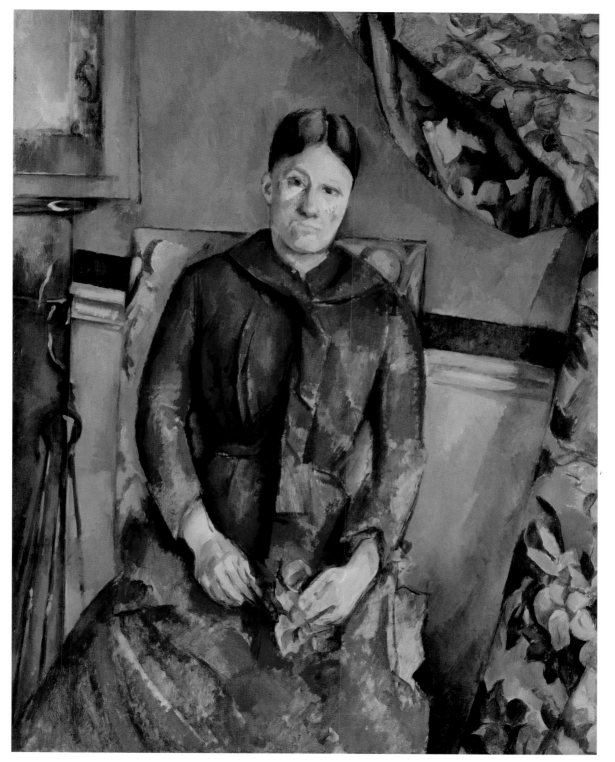

PLATE 22. *Madame Cézanne in a Red Dress*, ca. 1888–90
Oil on canvas, 45⁷/₈ × 35¼ in. (116.5 × 89.5 cm)
The Metropolitan Museum of Art, New York,
The Mr. and Mrs. Henry Ittleson Jr. Purchase Fund, 1962 (62.45)

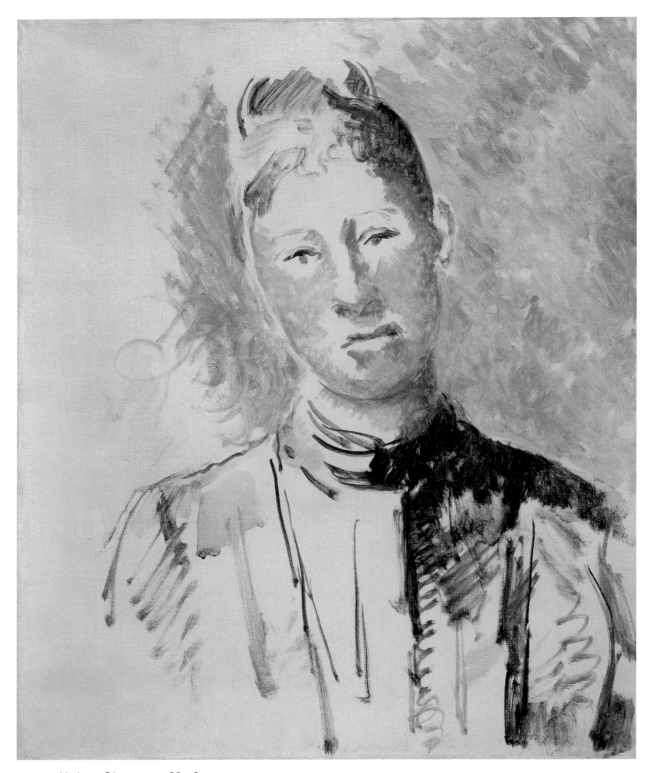

PLATE 23. *Madame Cézanne*, ca. 1885–87
Oil on canvas, 21⁷⁄₈ × 18 in. (55.6 × 45.7 cm)
Solomon R. Guggenheim Museum, New York, Thannhauser Collection,
Gift, Justin K. Thannhauser, 1978 (78.2514.5)

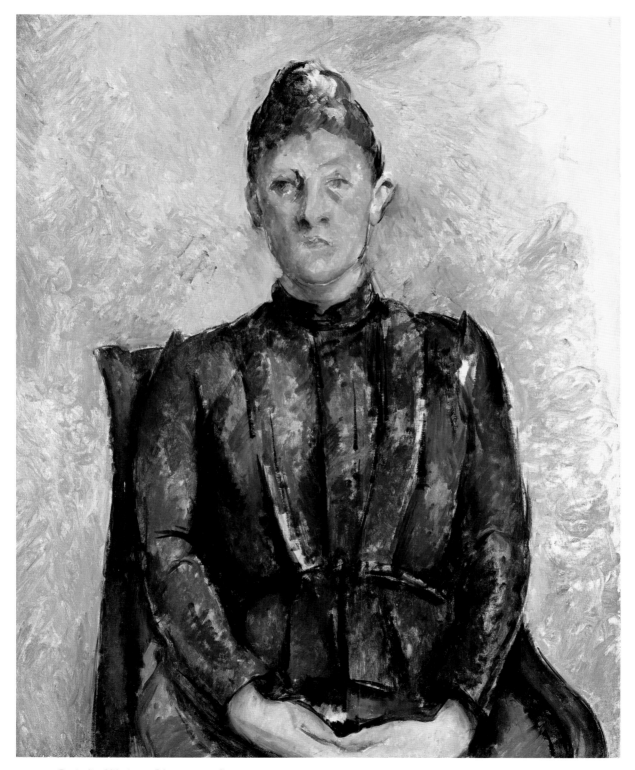

PLATE 24. *Portrait of Madame Cézanne*, ca. 1890
Oil on canvas, 31⁷/₈ × 25⁵/₈ in. (81 × 65 cm)
Musée de l'Orangerie, Paris, Collection Walter Guillaume (RF 1960-9)

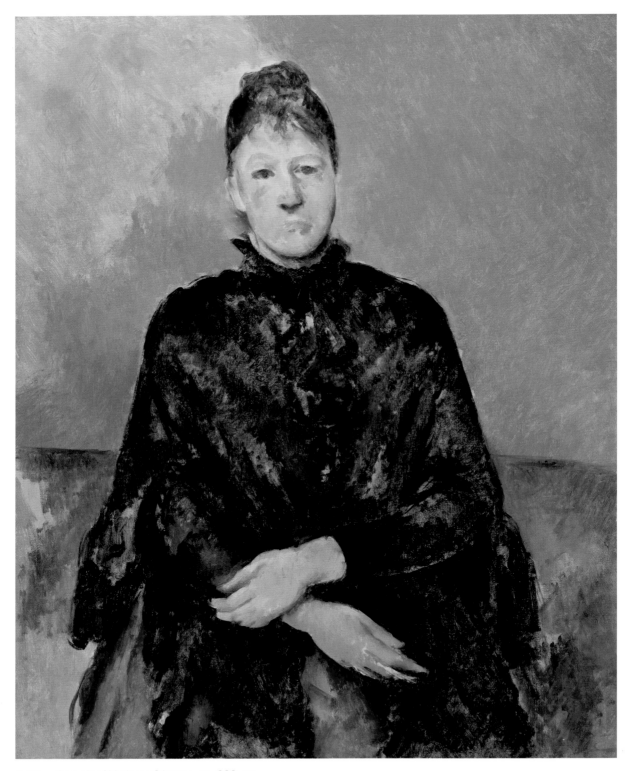

PLATE 25. *Portrait of Madame Cézanne*, ca. 1888–90
Oil on canvas, 36½ × 28¾ in. (92.7 × 73 cm)
Barnes Foundation, Philadelphia (BF710)

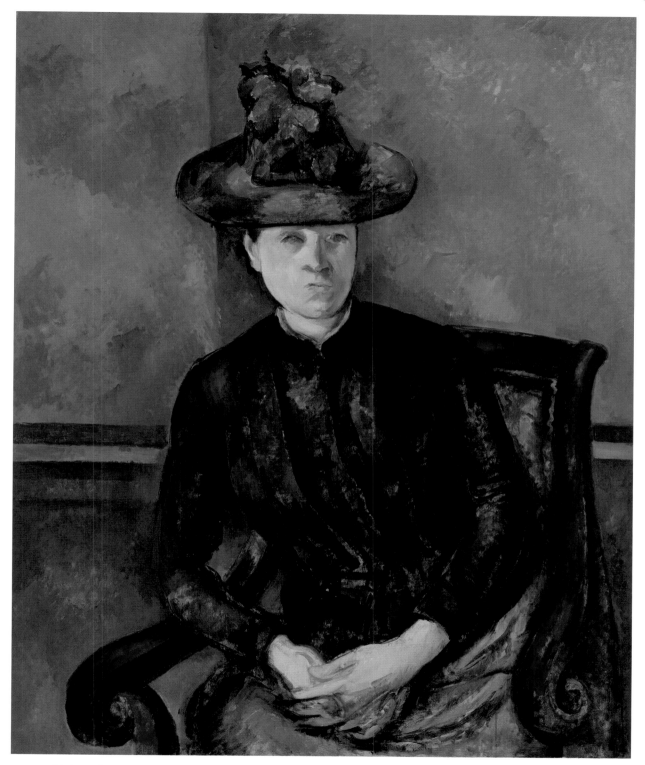

PLATE 26. *Madame Cézanne with Green Hat*, ca. 1891–92
Oil on canvas, 39½ × 32 in. (100.3 × 81.3 cm)
Barnes Foundation, Philadelphia (BF141)

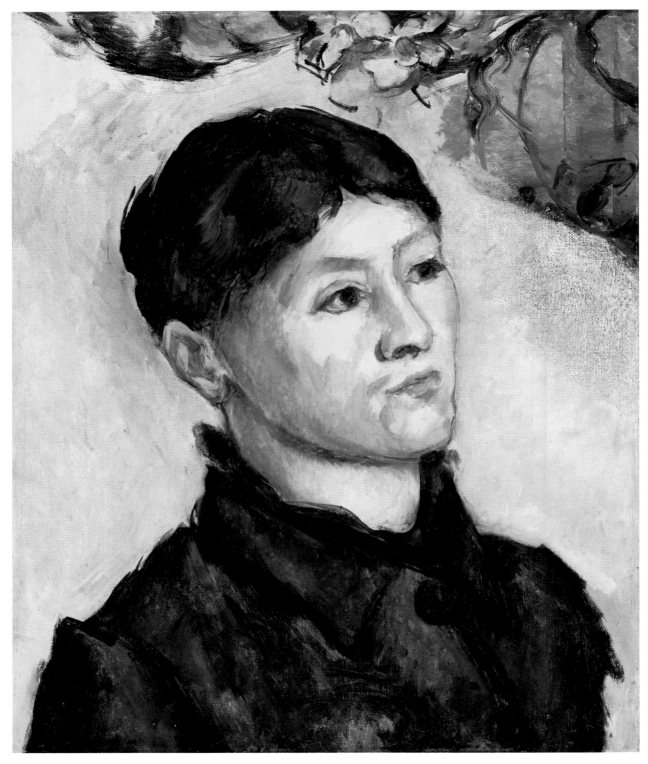

PLATE 27. *Portrait of Madame Cézanne*, ca. 1885–87
Oil on canvas, 18¼ × 15⅛ in. (46.4 × 38.4 cm)
Philadelphia Museum of Art, The Louis E. Stern Collection, 1963 (1963-181-6)

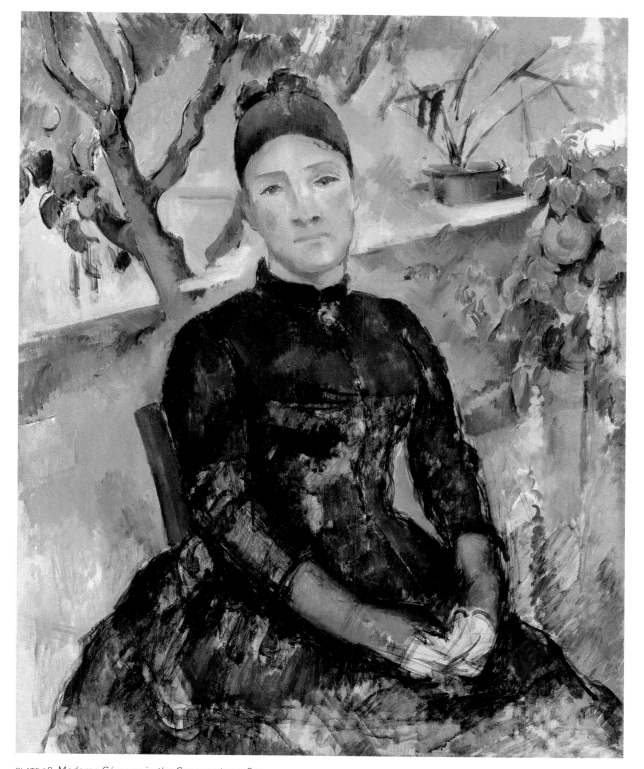

PLATE 28. *Madame Cézanne in the Conservatory*, 1891
Oil on canvas, 36¼ × 28¾ in. (92.1 × 73 cm)
The Metropolitan Museum of Art, New York, Bequest of Stephen C. Clark, 1960 (61.101.2)

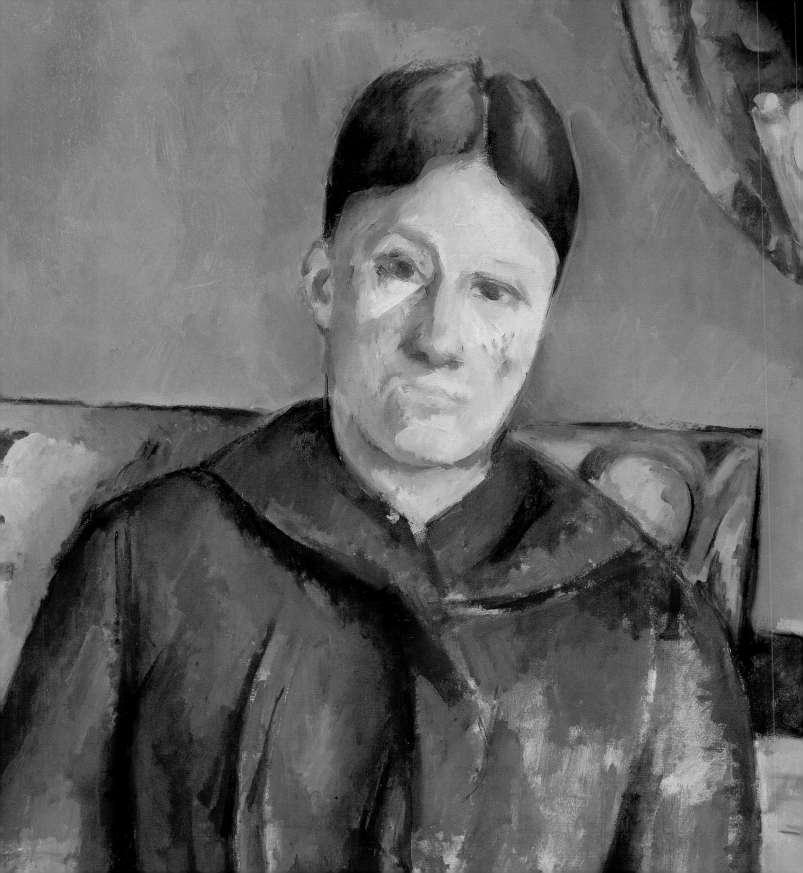

Ann Dumas

The Portraits of Madame Cézanne
Changing Perspectives

Paul Cézanne's wife, Hortense Fiquet, was the artist's most constant subject. He looked at her longer and more intensely than at anyone else in his life except himself. Yet for most of their history, Cézanne's twenty-nine portraits of his wife, painted between 1872 and about 1892, have attracted far less comment than his landscapes and still lifes. A persistent theme in the early writing on Cézanne is the masklike detachment of the portraits, and the cliché that his faces are no more animated than his apples. This trope has created a barrier discouraging exploration and new hypotheses, and as a result, critical responses to the works have until recently been strikingly rare. Opinion about the portraits of Hortense has also been colored by a negative view of the woman herself, one that is not improved by the scarcity of known facts about her life and her relationship with Cézanne. In the words of the artist's recent biographer: "Biographically [Hortense] seems immune to treatment."[1]

WHO WAS HORTENSE?
The established facts are quickly told. Marie-Hortense Fiquet came from a modest rural background and met Cézanne in Paris, where she was working as a bookbinder and possibly a model. Her social status, low relative to his, was not helped by the fact that Cézanne kept their liaison and the existence of their child, Paul, born in 1872, secret from his stern banker father until

their marriage in 1886, seventeen years after the couple had met. There are no extant letters from Cézanne to her, though in other letters, particularly to his beloved son, the artist often sends greetings to Hortense or inquires solicitously after her health.[2] We know next to nothing of her friendships, if there were any, and her son, to whom she was obviously close, left no memoir. The couple often spent periods apart: Hortense, usually accompanied by young Paul, would live in Paris, where she could indulge her taste for fashionable clothes, while the painter would live with his mother and sisters in Aix-en-Provence. Cézanne's well-known aversion to touch and his need for isolation have contributed to an idea that there was estrangement between the couple, which some have tried to link to the blank, withdrawn expression that Hortense wears in the portraits. Cézanne's family, for their part, disliked her, calling her "La Reine Hortense," and considered her a spendthrift gold digger.[3] The dislike appears to have been mutual: Maurice Denis recounted how Hortense coldly disposed of Cézanne's mother's possessions after her death.[4] Cézanne's literary friends also disparaged her, calling her "La Boule."[5] Paul Alexis, a writer and a friend of both Cézanne and Emile Zola in Aix, exclaimed: "For La Boule! For Le Boulet! And for him [Cézanne]! Except that La Boule, who is apparently none too scrupulous, continually tends to spend more than her share. Now, backed by his mother and his sister—who have a special hatred for her—he feels he has the strength to resist."[6] Cézanne himself supposedly joked once that all Hortense liked was "Switzerland and lemonade."[7] John Rewald, even in the latest edition of his biography of Cézanne, repeated the rumor that Hortense had failed to attend her husband's deathbed in Aix because she did not want to miss an appointment with her Paris dressmaker.[8] The general sentiment was that Hortense had little appreciation for her husband's art and after his death used the profits from the sale of his paintings to finance a life of comfort and gambling.[9]

Most of Cézanne's earlier biographers dismissed Hortense as either irrelevant to her husband or a hindrance. Rewald described Cézanne's meeting her in Paris as a non-event, claiming that his changed circumstances seemed to have no effect on his art.[10] A recent biographer of Zola, Cézanne's childhood friend, condemned Hortense's passivity and her inability to fathom her husband's position or his needs; she behaved more like a servant than a companion.[11] A few glimmers of sympathy lighten

this dim view of her. Gerstle Mack commended her tireless patience and availability in sitting for an artist who worked slowly and required numerous sittings.[12] When Cézanne was unable to sleep, Hortense apparently read to him in the night, sometimes for hours at a time.[13] But in the main, these fragmentary impressions add up to an unflattering view of Hortense Fiquet, which for many years affected the reception of the portraits.

EARLY RECEPTION

From the extant records we have of Cézanne's early exhibition history, it is clear that virtually no portraits of Hortense were on public view in the 1870s and 1880s. None was included in Cézanne's submissions to the first and third Impressionist exhibitions, in 1874 and 1877 respectively,[14] after which, discouraged by scathing reviews, he withdrew from Paris and the exhibiting sphere.[15] Thereafter, more or less the only public venue where one could see works by Cézanne was the little artists' materials shop run by Julien "Père" Tanguy on rue Clauzel in Montmartre. Here Tanguy displayed works by Cézanne, Vincent van Gogh, and other unsuccessful artists, which he took on consignment in exchange for canvases and paints.

Over time, Cézanne's absence from the capital added a certain mystique to him and his work. The critic Gustave Geffroy, who described him as "at once unknown and famous," assessed the situation in 1894: "For some time now Paul Cézanne has had a singular artistic destiny. . . . From the paucity of information about his biography, the quasi-secrecy of his production, and the scarcity of his canvases, which seemed resistant to all accepted laws of publicity, there resulted a bizarre kind of renown, distant before the fact; his person and his oeuvre were enveloped in mystery."[16]

But all this changed in November of the following year, when an enterprising dealer, Ambroise Vollard, took the bold step of giving Cézanne his first one-man exhibition. Held in Vollard's modest gallery on rue Laffitte, the exhibition was a revelation for contemporary artists and collectors. The 1895 show not only put the fifty-six-year-old Cézanne on the map but also enabled Vollard to gain a monopoly over the artist's output and to begin selling it to an international clientele.

There were certainly three portraits of Madame Cézanne in this landmark show. Vollard's own list of "the most important canvases" exhibited includes *Madame Cézanne with Green Hat, Madame Cézanne in the*

Conservatory (pls. 26, 28), and *Portrait of Madame Cézanne*—probably *Portrait of Madame Cézanne in a Striped Dress* (pl. 7).[17] "The advent of these masterpieces, or of these monstrosities, whichever you prefer," Vollard later commented, "created the most profound excitement among the enlightened collectors and eclectics who . . . came and went every day in front of the shop windows in Rue Laffitte."[18]

Undoubtedly there were more portraits of Hortense in this exhibition, but it is difficult to ascertain which, because there was no catalogue and works were probably replaced by others from Vollard's stock as they were sold. Robert Jensen's investigation of the Vollard stock books indicates that *Sketch of a Portrait of Madame Cézanne* (pl. 11), which Gustave Geffroy purchased, was one of a group of twenty-six works that Vollard bought from Cézanne before August 1896, thus making it a likely candidate for the exhibition.[19] Jensen also examined Cézanne's canvases for evidence that they had been rolled; he argued convincingly that these works were transported from Cézanne's studio in Aix to the gallery in Paris for the exhibition.[20] Among the works that were clearly rolled are *Madame Cézanne in a Red Armchair*, the two titled *Madame Cézanne in a Yellow Chair*, and *Portrait of Madame Cézanne* (pls. 4, 19, 20, 27).[21]

Reviews of the show were mixed, and a sampling reveals no specific references to the portraits of Madame Cézanne. However, the exhibition did elicit the first wholehearted appreciation of Cézanne, written by Thadée Natanson, critic for *La Revue blanche* and an intimate of the Nabi circle. "The fifty or so [sic] exhibited canvases are divided in about equal measure among figures or figure compositions, still lifes, and landscapes," he wrote. But like most critics at the time, Natanson spoke in broad terms with no discussion of specific works and drew particular attention to the still lifes: "[Cézanne] can already lay claim to being the French school's new master of the still life. . . . He has made apples his own. Through his magisterial grasp they now belong to him. They are his just as much as any object belongs to its creator."[22] A few years later, Maurice Denis would place a still life, not a portrait, at the center of his 1900 painting *Homage to Cézanne* (fig. 38).

After the 1895 show, there is a hiatus in the commentary on Cézanne until July 1904, when Emile Bernard published a key article—the longest to that date—based largely on his conversations with and letters from the artist.[23] Significantly, though, the only reference to Hortense is oblique, a mention of

Fig. 38. Maurice Denis (1870–1943), *Homage to Cézanne*, 1900. Oil on canvas, 70⁷/₈ × 94¹/₂ in. (180 × 240 cm). Musée d'Orsay, Paris, Gift of André Gide, 1928 (RF 1977-137, LUX 48)

Cézanne's preference for unpretentious subjects. A few months later, a room of thirty-one paintings by Cézanne at the 1904 Salon d'Automne attracted considerable favorable attention and at last brought the artist fame. Again, the reviews of the exhibition privileged Cézanne's still lifes. "More than anything else, it is the excellent still-lifes that give the measure of M. Paul Cézanne," wrote the distinguished critic Roger Marx, encapsulating a widely held view.[24] Nevertheless, *Portrait of the Artist's Wife* and *Madame Cézanne* (pls. 6, 17) were both included in the show; shortly thereafter, Gertrude and Leo Stein bought the former from Vollard (fig. 39).[25] Gertrude Stein later wrote, "Vollard said that of course, ordinarily a portrait of a woman is always more expressive than a portrait of a man, but, said he looking at the picture carefully, I suppose with Cézanne it does not make any difference"[26]—thus anticipating later commentators' views about the androgyny of Cézanne's portraits of his wife.

The first truly eloquent voice to respond directly and in depth to the portraits of Madame Cézanne was that of the poet Rainer Maria Rilke. Rilke became obsessed with Cézanne and went almost every day to the retrospective exhibition of fifty-six works by him at the Salon d'Automne in 1907, the year

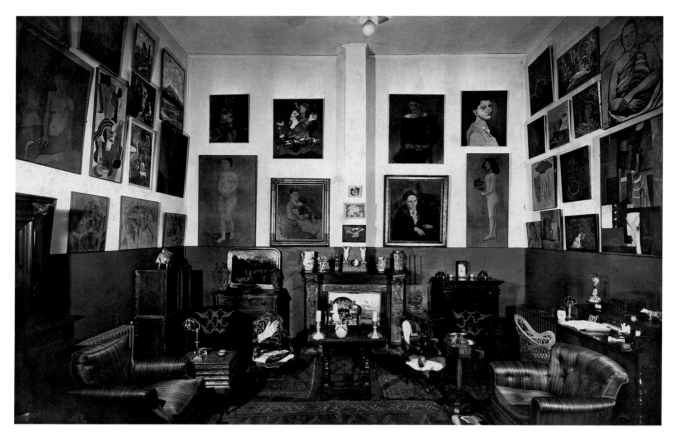

Fig. 39. The atelier of Gertrude Stein's apartment in rue de Fleurus, Paris, 1933–34. Cézanne's *Portrait of the Artist's Wife* (pl. 6) hangs to the left of the fireplace. Department of Modern and Contemporary Art, The Metropolitan Museum of Art, New York, Gift of Edward Burns, 2011

after the artist's death. In letters to his wife, the sculptor Clara Westhoff, Rilke left a record of his profound responses to these paintings.

Rilke was particularly impressed by the equilibrium he discerned in Cézanne and his realistic and unmediated transcription of the world, through color, onto canvas. On October 18, 1907, he described Cézanne's capacity to test the "minutest component . . . on the scales of an infinitely responsive conscience," a capacity "which so incorruptibly reduced a reality to its color content that it resumed a new existence in a beyond of color, without any previous memories. It is this limitless objectivity, refusing any kind of meddling in an alien unity, that strikes people as so offensive and comical in Cézanne's portraits."[27]

The fashionable Parisian women visiting the show provided Rilke with a foil for the truth he perceived in Cézanne's portraits of his wife: "And the women, how beautiful they appear to themselves as they pass by; they recall

that just a little while ago they saw their reflections in the glass doors as they stepped in, with complete satisfaction, and now, with their mirror image in mind, they plant themselves for a moment, without looking, next to one of those touchingly tentative portraits of Madame Cézanne, so as to exploit the hideousness of this painting for a comparison which they believe is so favorable to themselves."[28]

The portraits at the 1907 exhibition that caught Rilke's attention were *Madame Cézanne in a Red Dress* (pl. 22) and *Madame Cézanne in a Red Armchair* (pl. 4), for which he saved his most exultant account.[29] In a poignant letter to Clara written just after the exhibition closed, he gave one of the most sensitive and searching analyses of a painting by Cézanne ever written:

> And already, as I'm leaving it, on the way home for the last time,
> I want to go back to look up a violet, a green or certain blue tones
> which I believe I should have seen better, more unforgettably.
> Already, even after standing with such unremitting attention in
> front of the great color scheme of the woman in the red armchair,
> it is becoming as irretrievable in my memory as a figure with
> many digits. And yet I memorized it, digit by digit. In my feeling,
> the consciousness of their presence has become a heightening
> which I can feel even in my sleep; my blood describes it within
> me, but the naming of it passes by somewhere outside and is not
> called in. Did I write about it?—A red, upholstered low armchair
> has been placed in front of an earthy-green wall in which a cobalt-
> blue pattern . . . is very sparingly repeated; the round bulging
> back curves and slopes forward and down to the armrests (which
> are sewn up like the sleeve-stump of an armless man). The left
> armrest and the tassel that hangs from it full of vermilion no
> longer have the wall behind them but instead, near the lower edge,
> a broad stripe of greenish blue, against which they clash in loud
> contradiction. Seated in the red armchair, which is a personality
> in its own right, is a woman, her hands in the lap of a dress with
> broad vertical stripes that are very lightly indicated by small,
> loosely distributed flecks of green yellows and yellow greens, up to
> the edge of the blue-gray jacket, which is held together in front by
> a blue, greenly scintillating silk bow. In the brightness of the face,

the proximity of all these colors has been exploited for a simple modeling of form and features: even the brown of the hair roundly pinned up above the temples and the smooth brown of the eyes has to express itself against its surroundings. *It's as if every part were aware of all the others*—it participates that much; that much adjustment and recognition is happening in it; that's how each daub plays its part in maintaining equilibrium and in producing it: just as the whole picture finally keeps reality in equilibrium. For if one says, this is a red armchair (and it is the first and ultimate red armchair in the history of painting): it is that only because it contains latently within itself an experienced sum of color which, whatever it may be, reinforces and confirms it in this red. To reach the peak of its expression, it is very strongly painted around the light human figure, so that a kind of waxy surface develops; and yet the color does not preponderate over the object, which seems so perfectly translated into its painterly equivalents that, while it is fully achieved and given as an object, its bourgeois reality at the same time relinquishes all its heaviness to a final and definitive picture-existence. Everything . . . has become an affair that's settled among the colors themselves.[30]

FRY AND FORMALISM

Rilke's account is emotional, yet his emphasis on "equilibrium," the "painterly equivalents" of the "object," and "a final and definitive picture-existence" at least partially prefigures the more stringently formalist approach to Cézanne pioneered by the English critic Roger Fry in the 1920s. In *Cézanne: A Study of His Development*, first published in 1927, Fry discussed the same two portraits of Hortense that Rilke singled out in 1907: *Madame Cézanne in a Red Armchair* and the Metropolitan's *Madame Cézanne in a Red Dress* (pls. 4, 22). For Fry, the first illustrates the gravitas and formal balance of the artist's mature work, "the monumental repose, the immense duration of the objects represented, a feeling which is conveyed to us by the passionate conviction of each affirmation. That passion, no doubt, was always present, but whereas in the earlier works it was hasty and overbearing, its force is all the greater from being thus held in and contained."[31]

Given the importance that Fry ascribed to Cézanne's suppression of personal feelings—a "genius" such as his "could only attain its true development through the complete suppression of his subjective impulses"[32]—his thinking on the portraits of Hortense cannot extend beyond the purely formal. His lengthy exposition of the Metropolitan *Madame Cézanne in a Red Dress* exemplifies Fry's careful looking and analysis and is expressed in his typically resonant prose. Although indifferent to the subject of the portrait, he is clearly moved by the pictorial and spiritual power of this great work:

> The transposition of all the data of nature into values of plastic color is complete. The result is as far from the scene it describes as music. There is no inducement to the mind to retrace the steps the artist has taken and to reconstruct from his image the actual woman posing in her salon. We remain too completely held in the enchantment of this deep harmony. Though all comes by the interpretation of actual visual sensations, though the desire to remain absolutely loyal to them was an obsession with Cézanne, the word realism seems as impertinent as idealism would be in reference to such a creation.[33]

Echoing Cézanne's own stated aim to create "a harmony parallel to nature," Fry continued: "It belongs to a world of spiritual values incommensurate but parallel with the actual world."[34] Despite his undoubted admiration for this portrait, Fry's feelings about Hortense herself slipped out in a letter he wrote to his companion, Helen Anrep, complaining about the difficulties he encountered in writing his study of Cézanne: "It's complicated to begin with, and life changed him enormously. Perhaps that sour-looking bitch of a Madame counts for something in the tremendous repression that took place."[35]

Fry included twenty-one paintings by Cézanne, among them *Portrait of Madame Cézanne in a Striped Dress* (pl. 7), in a groundbreaking exhibition of contemporary French art, "Manet and the Post-Impressionists," at London's Grafton Galleries in 1910–11. Charles Holmes, future director of the National Gallery, applauded the work's "intense sincerity of vision" but not its "heaviness of touch."[36] Fry noted, however, that an elderly stout gentleman was so overcome with mirth that he had to be taken out for air.[37]

An original interpretation of the formalist approach appears in an introduction by D. H. Lawrence to a book on his own paintings. Exploring Cézanne's struggle to endow his figures with the immobility of apples without diminishing their life force, Lawrence observed: "When he makes Madame Cézanne most *still*, most appley, he starts making the universe slip uneasily about her. It was part of his desire: to make the human form, the *life* form, come to rest." By "appley" Lawrence implies Cézanne's ability to seize the essence of the subject, to still it without robbing it of its life force: "Mobile but come to rest."[38]

WIDER APPROACHES

In 1936, the distinguished Italian art historian Lionello Venturi published *Cézanne: Son Art—son oeuvre*, the first systematic dating of Cézanne's work. Venturi's introduction echoes the by now standard formalist view that the portraits of Hortense are largely "une recherche de forme."[39] However, his comments on individual works sometimes betray a more empathetic response.

Thirty years later, Anne H. van Buren's article "Madame Cézanne's Fashions and the Dates of Her Portraits" set out terminus post quem dates for certain paintings based on changing trends in fashion.[40] Of *Madame Cézanne Leaning on a Table* (pl. 1), van Buren wrote: "The dress with full sleeves, closed at the wrist, belted waist and such 'military' details as dark velvet bands was fashionable in the 1870s during the Franco-Prussian War."[41] The nineteenth century saw frequent and radical changes in dress for women, all of which were well documented in fashion magazines. "[Hortense] must have had *La Mode Illustrée* around the house," according to van Buren, "for her husband copies at least one [issue]. . . . He also drew on the back of a piece of another one."[42]

More recently, Nina Maria Athanossoglou-Kallmyer has considered the shapeless clothes Madame Cézanne wears in the later portraits, along with her discontented expression, as reflecting the resentment of a displaced fashionable Parisienne consigned to living for long stretches in provincial Aix: "Trapped in her claustrophobic environment, the provincial woman nurtured one dream only: to go to Paris."[43]

Moving beyond the predominating formalist approach of the 1930s, Meyer Schapiro embraced a much broader range of artistic and philosophical

ideas, introducing a psychological interpretation that opened new approaches to understanding Cézanne.[44] He nevertheless acknowledged the seeming lack of human interest in Cézanne and the importance of purely pictorial qualities in creating a contained "picture-world": "The mature paintings of Cézanne offer at first sight little of human interest in their subjects. We are led at once to his art as a colorist and composer. He has treated the forms and tones of his mute apples, faces, and trees with the same seriousness that the old masters brought to a grandiose subject in order to dramatize it for the eye."[45]

"Many writers," Schapiro noted, "have remarked on the mask-like character of Cézanne's portraits. The subject seems to have been reduced to a still life. He does not communicate with us; the features show little expression and the posture tends to be rigid. It is as if the painter has no access to the interior world of the sitter, but can only see him from outside. Even in representing himself, Cézanne often assumes an attitude of extreme detachment, immobilized and distant in contemplating his own mirror image."[46]

But Schapiro qualified this assertion: "This impersonal aspect of the portraits is less constant than appears from our description. If their abstractness determines the mood of some portraits, there are others of a more pathetic, responsive humanity."[47] Schapiro found this "responsive humanity" in *Portrait of Madame Cézanne* (pl. 9): "The pure oval of the face, its vague eyes and lips, and the cool tones of the painting, suggest a detached, abstract conception of the model. Yet it appears to us a very human portrait, sensitive to the passive and frail in this feminine nature—traits conveyed by delicate means."[48] Despite this, Schapiro concluded that it is difficult to assess the effect that Hortense had on Cézanne's art, if any.[49]

Schapiro commended Cézanne's avoidance of the more ingratiating and obvious feminine qualities that sometimes characterize Impressionist portraiture, at the expense of "the inner life of the woman." But he conceded that "in retaining from this art the softness of the features and the beauty of the skin, Cézanne has produced a tender image of ascetic feeling." Anticipating later writers' ideas about reciprocity in Cézanne, Schapiro added: "It is as if he transferred to his wife his own repression and shyness."[50] Formal qualities were linked to the subject herself: "The remarkable egg shape of the head is no simple reduction of a more complex

form, but a subtle line expressive of the object, an approach to the perfection of a refined withdrawn nature." Schapiro found a similar tenderness in *Madame Cézanne in the Conservatory* (pl. 28), "a portrait unusual for Cézanne in the search for a tender, idealized, graceful expression," and he noted the figure's place in the abstract pictorial construct: "The inclination of the head—the bearer of a delicate submissiveness and reverie—belongs as much with the tilted lines of the wall and trees as with her own body."[51]

In 1968, Schapiro published his now famous essay "The Apples of Cézanne: An Essay on the Meaning of Still-Life," in which he gave new and specific meaning to the oft-repeated adage that Cézanne's portrait heads have no more animation than an apple.[52] Pursuing a Freudian, psychobiographical approach, Schapiro interpreted Cézanne's apples, with their rounded, sensual, and colorful forms, as expressions of displaced eroticism: "Cézanne's prolonged dwelling with still-life may be viewed also as the game of an introverted personality who has found for his art of representation an objective sphere in which he feels self-sufficient, masterful, free from disturbing impulses and anxieties aroused by other human beings, yet open to new sensation."[53] Yet Schapiro had difficulty linking Hortense to his psychoanalytic theory; it "ignore[d] the changed situation of Cézanne in his thirties, the circumstances in which the apples became a favored and constant theme. One cannot overlook his permanent liaison with Hortense Fiquet and new domestic state, especially after the birth of his son."[54]

It is, however, in his discussion of a portrait not of Hortense but of young Louis Guillaume, the son of a friend, that we find Schapiro expressing Cézanne's reconciliation of the demands of art with his humanity. His words are equally relevant to many of the Hortense portraits:

> It has been said that Cézanne painted the heads of his friends and family as if they were apples; but an artist so closed to the physiognomic would ordinarily content himself with still life or landscape or views of buildings. There is in Cézanne an evident desire for the human being; his retreats, his shyness, his often hysterical anxiety at encounters, never abolished this desire. He returns to man with hopes of understanding or love, but painting as a discipline governed by his need for a private world of mastership is already so strongly set in his nature as to impress

its most characteristic methods upon his portraits. Yet he often surmounts this influence of the still life and the landscape and creates portraits of great insight and fellow feeling.[55]

Hortense Fiquet finally achieved centrality in Sidney Geist's idiosyncratic and highly subjective psychobiographical analysis of Cézanne's art, *Interpreting Cézanne*, in which Geist deciphered hidden symbols as well as verbal puns that he believed offer clues to Cézanne's inner life and relationships.[56] The opening paragraph of the chapter on Hortense, "The Girl from Paris," gives an idea of his approach:

> In the period 1874–7 Cézanne painted a scene of Paris rooftops (*toits de Paris*) under a bald sky. A short time later he painted another such scene, under a cloud-filled sky. In the second work it is possible to see, in the central cloud formation, the reclining head of a woman who faces the viewer, the top of her head to the right. . . . There is no reason to think she is other than Hortense, *toi de Paris* (you of Paris). The *toits/toi* pun tells us that the work is an (unconscious) designation of Hortense as a Parisienne; it was of course in Paris that she and Cézanne had met.[57]

Geist's concluding paragraph leaves us with no doubt that, in his mind, Hortense is everywhere present in Cézanne's art:

> The constancy of his imaginative focus was such that he transformed all things and relations into signs for Hortense. She is indicated by apples, a basket handle, a jar, a fig, a lemon, a flower, a conch, a house; as a bather, a beauty, a bourgeoise, a prostitute, a mother; in a tree, in a cloud, by being on the left, and near a creek or tree; by the letters *H* and *F*, the color red—and the list will grow. Hortense is implicated, by allusion, metaphor, cryptomorphism, and manifest portraiture, in a fifth of the paintings Cézanne made after they met.[58]

Although it is hard to take Geist's often far-fetched and unsupported conclusions seriously, he is to be credited as one of few writers, until recently, to have accorded Hortense a central place in his study.

The preeminent Cézanne scholar John Rewald based his extensive research firmly on documentation rather than abstract theorizing. Among numerous publications on the artist, he was the author of an edition of the letters, a biography, a catalogue raisonné of the watercolors, and a catalogue raisonné of the paintings; his scholarship laid the ground for all subsequent work on the artist.[59] Rewald's dating of the portraits of Madame Cézanne remains key to our understanding of their sequence and their place in Cézanne's development, and his research on the works' provenances and exhibition histories has clarified their early exposure. As we have seen, in his biography Rewald was dismissive of Hortense personally, but in his commentaries on some of the individual portraits in the catalogue raisonné, he displayed more sympathy toward Hortense and more understanding of Cézanne's purpose. About *Madame Cézanne in a Red Armchair* (pl. 4), he wrote: "So many of Cézanne's portraits are not physiognomical resemblances and his models often look 'impersonalized,' partly as a result of many working sessions and partly because the artist's attention was not primarily focused on the features of his sitters. Madame Cézanne, one of the painter's most frequent though not necessarily most eager models, seldom escaped this abstracted treatment. Yet here he seems to have observed her with something of the tenderness he usually reserved for likenesses of his son."[60] Rewald discerned this tenderness particularly in *Portrait of the Artist's Wife* (pl. 6). Admiring the work's gravity, deep color, and grandeur, Rewald concluded: "This is a masterpiece."[61]

HORTENSE DISCOVERED

More recently, there has been a significant shift in the writing about the portraits of Madame Cézanne. Some scholars have sought to rehabilitate her, to enlarge the compass of their inquiry, and to arrive at a more nuanced appreciation of Hortense, her relationship with Cézanne, and his portraits of her. Ruth Butler, in *Hidden in the Shadow of the Master: The Model-Wives of Cézanne, Monet, and Rodin*, uses what historical records remain (generally letters) and, as she describes it, "imagination," to bring a subjective understanding to the consideration of these artists' wives.[62] Butler's method is primarily biographical, and her readings of the historical information are amplified by personal speculation. A typical passage reads:

Hortense would have understood right away that Cézanne was well educated. Given the eleven-year difference in their ages, perhaps it was the quality of an older man's strength that made the liaison desirable for a young woman in Paris. How soon was it before she understood his strange combination of enormous self-reliance and terrible insecurity? She must have also seen the tender side of Paul's character. . . . And it can't have escaped her that he was not having much success. But somehow Hortense, a provincial girl without means, semi-adrift in the nervous, sophisticated, fast-paced world of Second Empire Paris, recognized that this man was powerfully drawn to her. That counted for a lot.[63]

Butler acknowledges the predominantly formal qualities of the Hortense portraits, but believes that they nevertheless evoke a strong sense of the sitter's character: "her calm grace, her lack of exaggeration, her consistency, and especially . . . her patient willingness to be there (fig. 40)."[64]

Tamar Garb's *The Painted Face: Portraits of Women in France, 1814–1914* explores a wider terrain, looking at the nineteenth-century female portrait as a major site for artistic experimentation in the context of modernism.[65] In her chapter "Touching Sexual Difference," Garb presents a dense reading of the four portraits of Madame Cézanne in a red dress, all completed between 1888 and 1890: *Madame Cézanne in a Yellow Chair* (pl. 19); *Madame Cézanne in a Yellow Chair* (pl. 20); *Madame Cézanne in a Red Dress* (pl. 21); and *Madame Cézanne in a Red Dress* (pl. 22). Establishing that the portraits of Hortense defy the conventions of nineteenth-century female portraiture, Garb argues that she is "not securely gendered as feminine" in these paintings.

According to Garb, Cézanne turned away from traditional demands to beautify or eroticize the female subject. He rejected Impressionism's quick, lively touch of color and Jean Auguste Dominique Ingres's glossy representations of silken stuffs in favor of a more conceptual notion of rendering sensation as paint.[66] Cézanne's portraits of Hortense "came to stand for the portrait as pure presence."[67] For Garb, *Madame Cézanne in a Red Dress* (pl. 22) is "denuded of textural specificity: fabric, flesh, flower and metal signify primarily as paint. . . . As a portrait, therefore, Cézanne's image of his wife seduces (if it seduces at all) by other means than those conventionally assigned to female portraiture."[68]

Fig. 40. Portrait photograph of Madame Cézanne, ca. 1905. John Rewald Papers, Gallery Archives, National Gallery of Art, Washington, D.C.

Garb focuses on the unfinished, even deformed appearance of Hortense's hands in the painting, arguing that Cézanne was not pursuing mimesis but that he regarded touch and hands as metaphors for his painting process. Citing his professed aversion to touch, Garb favors a Freudian reading. She finds that his handling reveals anxiety and sexual guilt.[69] The index finger evokes a phallus that makes specific the androgyny and hermaphroditic aura suggested by the figure as a whole.[70]

Garb ultimately finds Cézanne suffering from a castration complex, wherein the boy imposes a penis on the mother as a psychic defense: "He furnished her with an erect posture and a miniature penis as if to stave off the fear that her castration (and difference) provoked. . . . Confronting his wife 'like an apple' in all her palpable physicality and specificity, and refusing the pictorial clichés that would make her a mere spectacle, he could not, at the same time, avoid confronting her as the damaged and singular exile from Eden for whom temptation was only a hand-reach away."[71] Like Schapiro before her, Garb interprets Cézanne's apples as symbols of displaced sexual desire. Indicating the apples on the curtain behind Hortense in the Metropolitan's portrait, Garb notes the significance of the fruit in biblical and classical narratives.[72]

No one has looked longer and more closely at the portraits of Madame Cézanne than Susan Sidlauskas. Her ambitious and admirable book *Cézanne's Other: The Portraits of Hortense* is by far the most extensive study of the Hortense portraits and the first to be devoted exclusively to the subject.[73] Sidlauskas employs an astonishingly wide range of cultural, historical, and philosophical sources. For her the portraits of Hortense Fiquet are a lens through which to examine different contexts and interpretations of "the ever-contested relation of form and meaning in Cézanne, and in modern art more generally."[74]

In her first chapter, "The Counter-Muse: A Brief History," Sidlauskas summarizes the reception of the Hortense portraits within the framework of the lingering presumptions and expectations about portraiture of women. She notes the generally negative view in the literature of Hortense as an individual. She then challenges the standard narrative that sees the portraits as abstract and Cézanne as estranged from his subjects. On the contrary, she centers on the artist's perceptual engagement with the sitter and refers to the philosopher Maurice Merleau-Ponty's notion that for Cézanne the body of the other became a site for invention and ideas that offered a particular vision of the world.[75]

Sidlauskas relates Cézanne's ongoing reflection on the communion between self and other to late-nineteenth- and early-twentieth-century writers, notably William James in *The Principles of Psychology* (1890).[76] She observes that the modern persona comprising multiple selves is expressed in Hortense's constantly changing appearance in the portraits. This, Sidlauskas proposes, is the subject of the portraits and reflects the elusive and fluid nature of individuality and human interaction.[77] Hortense thus became "a shifting force against which Cézanne could measure his mutating self."[78]

Sidlauskas argues that in his portraits of Hortense, Cézanne holds in balance vision, expressed as transparent passages of paint, and touch, conveyed in dense, opaque areas—an observation that she supports with exceptionally close readings of the paintings, vividly described.[79] Her discussion of *Madame Cézanne in a Yellow Chair* (pl. 19) is a case in point: "Each indistinct segment of her eerie visage seems unfinished, set adrift in a vacuum of unprimed canvas. We are left with the distinct impression that she might disintegrate into dust if she were touched. She does not simply appear fragile in this portrait; she is almost not there. . . . It distills the uncertainty of *all* human presence."[80] Sidlauskas concludes by observing that the portraits of Hortense most profoundly embody Cézanne's "ambivalence about touch: a yearning for contact married to an equally profound need for isolation."[81]

In her final chapter, "Toward an Ideal," Sidlauskas uses the scholarship on the Bather paintings to reflect on how Cézanne thought of and expressed sexuality and gender. In certain paintings and drawings, she asserts, he depicted his wife in order to challenge accepted notions of gender and

sexuality, especially in female portraits, in the context of an interest in androgynes and hermaphrodites in contemporary life and art history.[82] *Madame Cézanne in a Red Dress* (pl. 22), Sidlauskas says, is characterized by extreme bifurcation, emphasized by the body's leaning to the left, the unsettling perspective, and the inconsistency of the facial features in the two halves of the face. The painting, she ventures, discreetly presents the theme of gender ambiguity that is more assertively present in the Bather paintings.[83]

Sidlauskas ends this comprehensive and perceptive book with the observation that although Cézanne often preferred to be alone, "at times, he seemed to enter into a kind of partnership with his wife. Whether she played a role in shaping that dyad, we shall never know. She is, however, indisputably, stubbornly, *there*, over and over—a constant figure who inspired an array of variations that present her as newly made every time. . . . By being there, Hortense Fiquet Cézanne sat with her husband, and became his art."[84]

Cézanne's recent biographer, Alex Danchev, has continued the current interest in Hortense, devoting a chapter to her titled "La Boule."[85] He mentions the dearth of information about Hortense's life and the familiar unflattering descriptors—"sullen, parasite, unresponsive, shallow"—that have clung to her.[86] His investigation succeeds in establishing a more complete idea of her than any previous biographer of the artist has done. His scrupulous examination of the facts has demolished some of the unjust accusations leveled against her, among others the aforementioned claim that an appointment with her dressmaker preempted her attendance at her husband's deathbed in Aix. It appears instead that Cézanne's sister Marie, who strongly disapproved of her sister-in-law, wrote to Paul *fils* asking him to come to Aix to help care for his father but specifically requested that his mother not accompany him.[87]

Danchev publishes two extant letters written by Hortense, one to Marie Chocquet, wife of the collector Victor Chocquet, and the other to Emile Bernard. Both reveal unexpected qualities in her: that "she was better at expressing herself than one would think," that she was competent at managing business affairs, and that she could be witty.[88]

Like Sidlauskas, Danchev notes the diversity of Cézanne's images of his wife, which makes them both fascinating and disturbing. Hortense was always changing yet was always the same.[89] "In fact," Danchev writes, "she

is always recognizable. Through the gusts of sensation and the myriad disguises, one part of her held constant: the upper lip. The soul of Madame Cézanne is encoded in the upper lip."[90]

Danchev challenges the received view about the detachment of the portraits and affirms their emotional content.[91] He discerns a delicacy in her that is at odds with "La Reine Hortense." From Cézanne's letters, a picture emerges of her delicate health.[92] Perhaps, Danchev suggests, she was just a hypochondriac, but perhaps she was genuinely frail, vulnerable rather than imperious, and Cézanne's portraits convey more sympathy for her than is generally supposed.[93] Rilke, Danchev believes, intuited this when he spoke of the "light human figure" in describing *Madame Cézanne in a Red Armchair* (pl. 4). For Danchev, Hortense had more significance for Cézanne than an enclosed, unresponsive figure or a formal arrangement of colors and shapes. "Absent or present, she was a permanent fixture. No one ever took her place."[94]

In the end, perhaps, the portraits of Hortense elude analysis. They are works that are essentially private, experimental, and open-ended. Whatever the limitations of the Cézannes' marriage, Hortense was the sitter whom the artist knew far better than anyone else. His deep familiarity with her, combined with her patient willingness to pose, made her a unique subject for the artist's profound explorations. We know from Ambroise Vollard's account of sitting for Cézanne that it was an exasperating task; as Merleau-Ponty noted: "Each brushstroke must satisfy an infinite number of conditions. Cézanne sometimes pondered for hours before putting down a certain stroke."[95]

The Hortense portraits break with all conventional ideas. In them, Cézanne seems to have been posing far larger questions, about the very nature of portraiture itself. As he himself indicated, he was feeling his way very slowly to a final goal.[96] His portraits—especially those of his wife—are so vividly compelling primarily because of their lack of resolution.

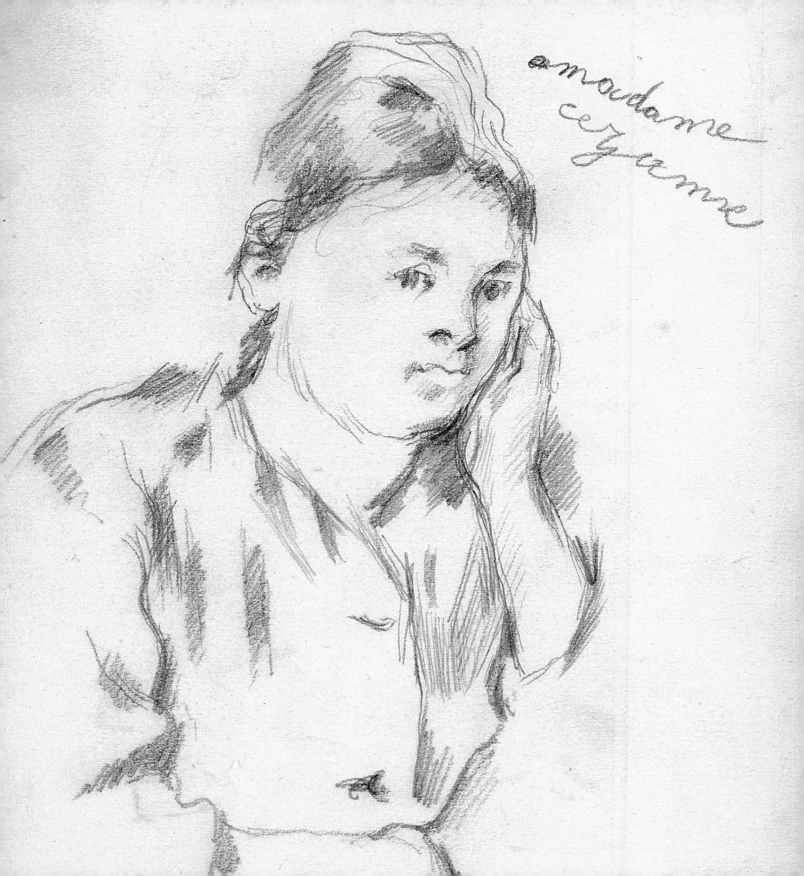

à madame
cézanne

Marjorie Shelley

Cézanne as Draftsman
Sketchbooks and Graphite Drawings

Paul Cézanne's art was rooted in his personal response to nature. At the most intimate level, his means of expressing these *sensations* were his sketchbook drawings, works that were never exhibited and probably never shared with others. Filling these small *carnets* was integral to his daily practice, and from the 1860s to the late 1890s they played an important role in his creative process. They were readily portable, and he carried them to the Louvre, the Luxembourg, and the Trocadéro museums to copy sculpture and paintings by the masters he revered and plaster casts after the antique. He used the sketchbooks by daylight and by lamplight to portray himself, family and friends, domestic objects, imaginary bathers, and his own collection of casts, and *en plein air* in Paris and Provence and on journeys between to draw landscapes, architecture, and city views. His sketchbooks occasionally served as well for jotting down memos, drafts of letters, and lists of pigments, and for noting such practical matters as addresses of models. With the most expedient of media—graphite pencil and plain white paper—and for the most part indifferent to their potential, but interested instead in recording his feelings and expression, Cézanne often repeated and revised his subjects, but with few stylistic changes. They are rendered as isolated motifs or in compositional studies, with handling that ranges from rapid notations to drawings executed with the deliberation he applied to his oils and large watercolors. Few of these sketches were intended as preliminary studies for

larger autonomous works, but many embody ideas he would later elaborate in them. Working reciprocally with these media, he used his *carnets* to refine his pictorial ideas and artistic vocabulary: his distinctive blocklike stroke, the subtle tonal gradations that he would also develop chromatically, the agitated line characteristic of his bathers, the representation of light with voids, and the solidity that informs his numerous renderings of his wife, Hortense Fiquet. It was in his sketchbooks that he transformed into his personal style the methods of academic drawing learned as a young artist and techniques gathered from lifelong visits to the Louvre.

It is estimated that Cézanne had about eighteen sketchbooks, each with drawings in watercolor, pen and ink, and graphite. He is known to have torn out a number of sheets from these books, and after his death Hortense and their son, Paul, removed the significant watercolors and pencil studies to sell. Over time, most of the sketchbooks were dismantled and the pages dispersed; only seven were left intact. Approximately 1,250 graphite drawings—the medium he most often used in them—are known today. Those belonging to these few surviving sketchbooks are the focus of this essay.[1] There is little information about their materials or the sketchbooks themselves. Cézanne was reluctant to discuss his oil paints and brushes, and never commented on his tools for sketching; yet when viewed in the artistic and cultural climate of his era, his *carnets* and pencil drawings reveal much about his methods.[2] This essay reflects on Cézanne as a draftsman. It looks at the sustained importance of his early academic training in informing his imagery and modernist vision. It also considers his use of his sketchbooks, pencils, and paper in the context of the reforms in pedagogy and the corresponding popularization and introduction of new artists' materials in the second half of the nineteenth century.

In the early 1870s, having renounced academic methods, and abandoning his imaginary erotic and tumultuous scenes, Cézanne was introduced to Impressionism and painting directly from nature by Camille Pissarro. Realizing his *sensations* at this time, Cézanne turned from dark tonalities and crude facture to new imagery and handling that was refined and lyrical, an aesthetic transformation that was expressed also in his drawing materials. From the strong contrasting chiaroscuro of his *académies*—drawings of the male nude executed in charcoal and conté crayon according to the doctrinaire French instructional system—and the dark and heavily inked

brooding subjects of his earliest extant sketchbook (1857–71; Musée du Louvre, Paris, Cabinet des Dessins, RF 29949.1), he shifted to the delicate gray tones of graphite pencil. Employing this medium for his entire range of motifs, his subsequent sketchbook drawings are notable for their light-suffused atmosphere, structural clarity, and silvery-gray tonal range.

Despite these salient changes, and despite his declaring decades later that the Ecole des Beaux-Arts "profoundly blocks our aesthetic insights" and "returns everyone to a uniform mold,"[3] the disciplined methodology of Cézanne's early career in the atelier had a lasting impact on his working practices and his representation of subject matter. But in fact, his formal artistic training was limited. His brief schooling at the Ecole Gratuite de Dessin in Aix (1856–58; he later resumed classes there until 1861) was followed by repeated rejection from the Ecole des Beaux-Arts and minimal instruction at the private Académie Suisse, both in Paris. Yet his determination to meet the criteria of academic art is evidenced in his personal struggles as revealed in his correspondence, and his carefully rendered *académies* of the 1860s (fig. 41). These highly finished studies in black powdery media applied in seamless gradations and exacting continuous contours were produced within the confines of the studio on large sheets of laid paper propped upright on easels, far unlike his future sketchbook drawings, but containing the foundation of his eventual process.[4]

Whether at the highest tier, the Ecole des Beaux-Arts, or at municipal industrial design schools, such as the one Cézanne attended in Provence, the discipline of drawing was upheld as the foundation of art. This pedagogy instilled in him an enduring reverence for the sculpture and painting of the past, a mind-set intimately associated with a basic tenet of classical instruction: the entrenched discipline of copying, imitation, and repetition to train the eye and the hand in the mechanics of draftsmanship and approved facture. To achieve this, one learned the complexities of three-dimensional form, advancing from drawing after a graphic model to drawing the live model. It was at the critical middle stage, *après la bosse*, or drawing after plaster casts of statuary, that the artist arduously attained skill in rendering these immobile forms according to prescribed

Fig. 41. Paul Cézanne (1839–1906), *Academic Nude, Seen from the Back*, 1862. Charcoal and black chalk, with stumping and erasing, graphite sketches and notations, on tan laid paper, laid down on wove paper, 23¾ × 17⅛ in. (62.7 × 43.5 cm). Art Institute of Chicago, Gift of Dorothy Braude Edinburg to the Harry B. and Bessie K. Braude Memorial Collection (2013.910)

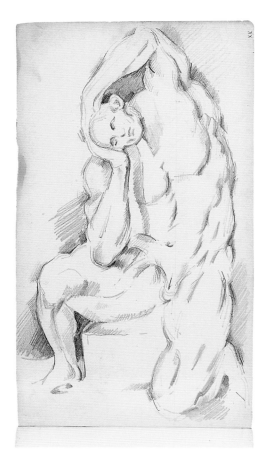

Fig. 42. Paul Cézanne, *After "L'Ecorché."* Graphite on wove paper, 8½ × 4⅞ in. (21.7 × 12.4 cm). *Sketchbook No. 2 (L'Estaque)*, 1875–86, p. XX. Art Institute of Chicago, Arthur Heun Purchase Fund, 1951 (1951.1)

methods, carefully selecting from and simplifying "nature." This theoretical and practical methodology was the basis of Cézanne's youthful training. Although he would subsequently paint nature "according to his own inspiration and not the principles of art itself,"[5] he referenced its concepts throughout his life—including the rigorous, slow work it demanded—and transposed its canons to his personal vision.[6]

Suffusing all his imagery, these canons of academic art are exemplified in his graphite portraits of Hortense. Among them are the multiple revisions of his sitter, the repetition reflecting the academic insistence on copying as a means of mastery. Years before she became his constant model, Cézanne demonstrated this traditional approach in a series of three nudes, each slightly different in position.[7] Decades later, he similarly interpreted this process in his sketchbooks in drawings of sculpture that progress, like an academic sequence, from a loose outline (*dessin au trait*) to a solid, modeled form (*dessin ombre*), such as his studies after Jean Antoine Houdon's *Ecorché* (fig. 42).[8] But in contrast to the atelier method, which demanded that student and easel remain in a fixed position in order to produce an exact rendition without distortion, Cézanne's "repeated" drawings of Hortense, such as those with her head lowered and foreshortened (fig. 43), indicate that he constantly made slight adjustments, rendering the motif from various angles by shifting his position and the direction of light. This controlled process, applied to all subjects, remained in his thoughts throughout his life. Only months before he died, he described how it was possible to capture multiple views of the same subject by "turning now more to the right, now more to the left."[9]

Cézanne's portraits of Hortense also exemplify his preference for immobile objects, which, though perhaps inherent to his sensibility, was reinforced by the slow and controlled discipline of drawing *après la bosse* during his student years and throughout his maturity, copying sculpture in museums and casts in his personal collection. Hortense is invariably depicted as sedentary: at rest, sleeping, absorbed in reading or sewing, and inattentive to the artist's gaze (pls. 39, 44). Evoking the dignity of classical statuary, her sense of quiet pervades all his genres, from the mass of Mont

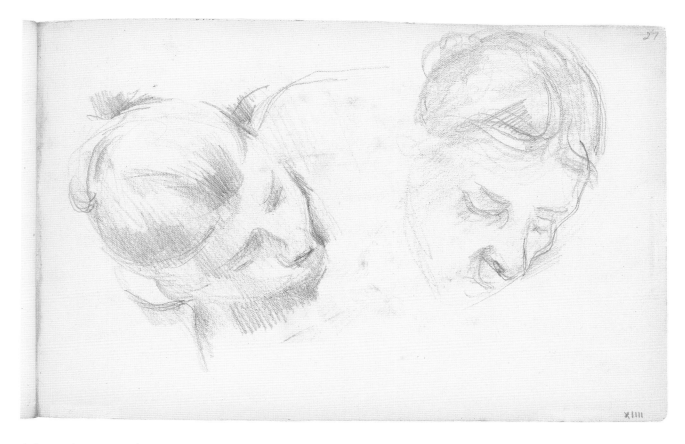

Sainte-Victoire to the sensitive depictions of pitchers and chairs, in his favoring artificial fruit and silk flowers, and in commanding his sitters to remain as still as apples.[10] Rather than an eccentricity, his insistence on the stillness of his subjects recalls his early years of training; it was a way of studying a single pose and its lighting, and a means of achieving accuracy in capturing his impressions.

The solidity and three-dimensionality with which Cézanne invests his motifs similarly suggest academic precepts. Cézanne's aesthetic, commonly upheld as the precursor of Cubism, stemmed from the pedagogical emphasis on geometry as the basis of drawing, a concept that was widespread in France at the Ecole des Beaux-Arts and industrial design schools from the late 1830s to well beyond the 1880s.[11] Inescapable for an aspiring artist, this methodology had a profound impact on Cézanne's interpretation of subject matter. He may have learned of it firsthand in the atelier, or even from

Fig. 43. Paul Cézanne, *Two Heads of Women*, 1890–94. Graphite on wove paper, 6 × 9⅜ in. (15.2 × 23.7 cm). *Sketchbook*, ca. 1877–1900, p. XIIII [*sic*]. National Gallery of Art, Washington, D.C., Collection of Mr. and Mrs. Paul Mellon, in Honor of the 50th Anniversary of the National Gallery of Art (1992.51.9.t)

Fig. 44. François Hippolyte Lalaisse (1810–1884), *Two Horses' Heads*. Lithograph on fine-textured paper, 9³/₈ × 12³/₈ in. (23.8 × 31.4 cm). Ashmolean Museum of Art and Archaeology, Oxford. Recto of Cézanne's *Studies of a Child's Head, a Woman's Head, a Spoon, and a Longcase Clock* (pl. 30)

the broadly disseminated course of study, the *cours de dessin*, a series of lithographed plates (*modèles estampes*) intended for copying and directed to design students and those without masters.[12] While there is no evidence that he ever copied such plates,[13] he was definitely aware of this teaching method, as one such plate was in his possession and he used its blank verso for a group of eight studies, two of which are of Hortense, executed about 1873–75 (pl. 30). Modeled on academic principles taught in the classroom, such prints depict two images: a linear schema and a fully realized form based on its geometric components (fig. 44).[14] Such pervasive concepts, fundamental to classical art and the basis of introductory drawing curricula,[15] must have inspired Cézanne's simplification of motifs to their basic structure and his occasional use of subtle reference lines in various pencil sketches (pl. 48) and oils (see fig. 16). As in all his genres, this means of construction is evident in images of Hortense in the interplay of solid shapes, arcs, and circles (fig. 45; see pl. 49). Endowed with a sense of mass and volume, they exemplify his assertion years later that the sphere, the cone, and the cylinder were the building blocks from which all forms were modeled.[16] It is perhaps significant that he often relied on this mode of construction, for according to Emile Bernard, Cézanne "did not know how to draw without a model."[17]

Camille Pissarro's influence was the immediate impetus for Cézanne's adoption of contemporary subject matter and new drawing materials, a shift that emerged in a climate of widespread and deeply rooted opposition to academic practices: its rigid conventions of rote copying, repetition, and prescribed subject matter. This discontent had started percolating before mid-century among educators, artists, and entrepreneurs who had sought reform and simplification of art instruction to encourage spontaneity and individuality. Their demands for new methodology in the schools were accompanied by growing commercial interest in materials for artists; both would affect Cézanne's work. Of the former, numerous alternative teaching courses were introduced to challenge the constraints imposed by drawing after the cast or the flat image, among them ideas based on memory, tracing,

and geometry.[18] As he indicated to a friend, Cézanne knew of the Drawing Reforms of 1863, which by imperial decree revised instruction at the Ecole des Beaux-Arts and its extreme classicism.[19] He likely was aware also of the changes in curriculum taking place throughout France, including the ideas proposed by Thomas Couture. It is not known whether Cézanne had direct contact with the older reformist academic artist, but his admiration for Couture—from his sketchbook copy (ca. 1880) of Couture's painting *Romans during the Decadence* (*Les Romains de la décadence*) to letters written to protégés in his final year, invoking Couture's mastery—is without question.[20] Couture urged the student to go outside the studio, always with a small *carnet* in hand, and record in a few lines whatever beauty caught the eye, striking effects, and natural poses, as an exercise in developing originality and intuitive responses to subject matter. ("Vous devez toujours porter sur vous un petit album et retrace en quelques lignes les beautés qui vous frappent, les effets saisissants, les poses naturelles."[21]) Intended for quick sketches, the *carnet de poche*, or pocket sketchbook, was an antidote to excessive detail and the static atmosphere of the atelier, a means of capturing the immediacy of the first impression and a sense of the ensemble.[22] Cézanne was not a spontaneous artist, he engaged thoughtfully with the motif, yet many of Couture's ideas resonate in his sketches. Couture's encouragement to make drawings from nature, wherein one could "find types very similar to the antique," lies behind the classic forms of Cézanne's most ordinary subjects, as does Couture's insistence in valuing one's personal response to nature, which "revives the artistic sensations that live within us."[23] Cézanne's decision to record his motifs in sketchbooks rather than on large, loose sheets of paper indeed reflects modernist thinking, as their portability implied immediacy

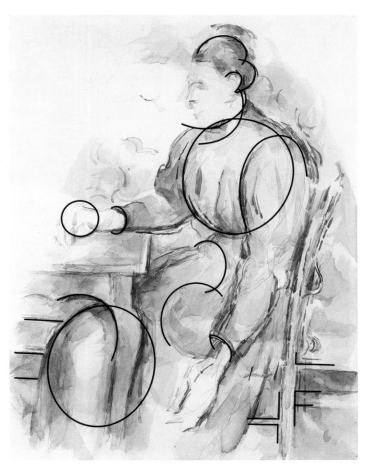

Fig. 45. Diagrammatic tracing, *Seated Woman (Madame Cézanne)* (pl. 49), illustrating its geometric components. Cézanne utilized overlapping geometric elements in constructing the figure and the motifs of the interior setting: arcs, circles, verticals, and horizontals.

and they allowed one the freedom to work face-to-face with nature and explore varieties of subject matter not possible in the studio. For him, they became vital to his artistic method.

However fleeting, Couture's comments about sketchbooks speak of their importance in artistic practices and of the reforms taking place in the nation's schools. At the same time that educators were revamping the doctrinaire policies of the academy and popularizing art instruction, entrepreneurs and government officials were voicing their own objections provoked by the demands of commerce.[24] Seeing an inextricable link between industry and applied art, they attributed the lagging quality of French consumer goods, made evident at World's Fairs beginning in 1851, to poor training of students of design and ornament.[25] Among the businessmen responsive to the continuing wave of educational revisions were French and British manufacturing colormen. Prompted by commercial opportunities generated by changing practices in academies, by programs for the multitudes of working-class artisans in state schools, and by the surge in *plein air* painting among professionals and the ranks of amateurs in the bourgeois leisure class, they met their market not only at international trade fairs but also by direct marketing and with catalogues. They offered innumerable new and traditional products to artists, ranging from pigments, moist watercolors, and brushes to papers, canvases, and boards. Two supplies that had a direct bearing on the corpus of Cézanne's drawings were sketchbooks and pencils.

Long part of artists' paraphernalia, sketchbooks and pencils were targeted to new consumers. Previously, "blank books"—which were sold principally by stationers and bookbinders, not colormen—were seldom advertised for sketching (or as *albums de dessin*) but were more often promoted for other commonplace purposes, as memo books, scrapbooks, and autograph books.[26] Unlike letterpress books made for printed text or reading, "stationery bindings," which were intended for writing, were engineered to open flat. Cézanne's earliest known sketchbook, used from 1857 to 1871, is typical of this type of book. It is fully bound in embossed greenish black leather, and gilt-edged, with "ALBUM" gold-tooled on the front cover. Made for indoor use, this and similar decorative bindings would not have withstood the vagaries of rough handling *en plein air*.

The type of sketchbook that Cézanne adopted in the early 1870s, as his surviving ones indicate, started to appear with frequency in colormen's

catalogues only at about this time—the period corresponding to his transformative experiences with Pissarro. Advertised expressly for drawing for artists of all persuasions, these sketchbooks were unembellished and durable. They were made of boards covered with calendared (mill-pressed) linen impregnated with dyed brown starch, were impermeable to moisture, and could withstand the rigors of use (fig. 46).[27] This type of binding, developed in about 1825 in Britain for printed texts, was the most radical innovation in book structure in centuries,[28]

Fig. 46. Cover of Paul Cézanne's *Sketchbook*, 1875–85. Morgan Library & Museum, New York, Thaw Collection, Gift in Honor of the 75th Anniversary of the Morgan Library and the 50th Anniversary of the Association of Fellows (1999.9)

and befitting the era, it was the first to be made almost entirely by machine, a factor contributing to its modest cost. Attentive to the commercial opportunities the product offered for new artistic practices, colormen adapted the cloth-cased book for stationery bindings; their purpose as sketchbooks was made unmistakable by the addition of a fabric loop to hold a pencil and an elastic twill band to keep the book closed. Both accessories remain intact on two of Cézanne's *carnets*. Such sketchbooks became a standard item in the many catalogues published in the last quarter of the century, and Cézanne used them regularly through the late 1890s, his casual handling of their covers evidenced by paint splatters and fingerprints.

As with his canvases, the size of Cézanne's *carnets* did not vary appreciably over his career.[29] Of his eighteen sketchbooks, most were pocket-size, and thus convenient for private drawings, ranging from about 18 to 24 centimeters (7 to 9½ inches) on their long side.[30] Although they were essential to his method, Cézanne never commented on his sources of supply. Parisian trade labels remain inside two covers in this group of seven sketchbooks, allowing the period when he purchased them to be roughly established from their business locations, but none can be connected to his color merchants.[31] That the books were purchased probably from various sellers is suggested by slight discrepancies in their dimensions, variations corroborated by catalogue advertisements of diverse colormen and reflecting the lack of standardization among manufacturers and bookbinders (fig. 47). Compounding the difficulty in tracking their provenance is the fact that such bindings were introduced by British

Fig. 47. Advertisement for clothbound sketchbooks, *Catalogue général illustré de G. Sennelier fabricant de couleurs fines et matériel d'artistes* (Paris, 1904; originally published 1895), p. 94. Courtesy of Dominique Sennelier, Magasin Sennelier

colormen who actively traded with France during this era of intense international competition. British sketchbooks, which are not readily identifiable, often appeared in French catalogues along with locally made ones.[32]

The appeal of the clothbound *carnet* to Cézanne undoubtedly was its functionality. It was useful because of the variety of sizes and formats in which it was available—including his preferred *forme longue à l'italienne*, with the width greater than the spine height[33]—and the type of paper it contained—gelatin-sized and suited to each of his drawing media—and for its supple structure as well: a free, unlined spine, with six to eight sections sewn onto two tape supports.[34] Opening flat, the sketchbook offered several advantages. It permitted an expansive double-page format, an important feature for the panoramic landscapes currently popular among *plein air* artists, but which Cézanne executed only occasionally, favoring instead a single page positioned vertically or horizontally for his subject matter. More significant, the sketchbook's flexibility, far exceeding that of a conventional blank book, meant that the covers could be folded back on themselves and the *carnet* used as a tablet. In doing so, the ability to differentiate front from back was easily lost, the confusion exacerbated if the twill band and pencil loop had torn off. The format must have provoked Cézanne to open these books randomly. As the drawings attest, he skipped pages rather than follow a sequence, haphazardly oriented drawings relative to the covers, and drew on one side of a leaf, or in blank spaces with unrelated studies as they presented themselves (pl. 36).[35] His use of the *carnets* in this manner may explain their vexing lack of coherent order and the puzzling placement of repeated motifs within one or several of them. In the absence of stylistic shifts, this has made their chronology difficult to track and has contributed to the broad and fluid ranges in dating them.[36] Quite unlike the deliberation that accompanied the execution of the drawings, his management of

these sketchbooks—several being employed simultaneously, and then returned to only after a lapse of years—presumably suited the moment of inspiration.

The majority of Cézanne's sketchbook drawings are executed in graphite pencil. He occasionally employed the medium for his early works on paper, but it became his primary drawing material at about the time he adopted clothbound sketchbooks. Widespread in use, graphite had surpassed pen and ink for sketching over the course of the nineteenth century, a change generated both by industrial advances and by new teaching practices. Historically, the best-quality graphite fashioned into pencils had come from Britain and was sold at high prices and subject to regulated trade. This monopoly ended in 1795, when the French engineer Nicolas-Jacques Conté patented a technology for manufacturing *crayons artificiels* combining low-quality pulverized graphite with clay, firing the mixture into rods, and encasing them in cedar. Becoming the ubiquitous fabrication method, it made low-cost pencils readily available. Like sketchbooks, pencils were marketed to fine artists as well as working-class students enrolled in design schools throughout France.[37]

Achieving prominence as an academic medium in the 1830s and 1840s, as exemplified by the drawings of Jean Auguste Dominique Ingres, graphite was valued for its refined qualities: tight control, clean hatchwork, and precise articulation. However, under the policies instituted by the Drawing Reforms of 1863, which promoted somewhat greater artistic freedom, charcoal became the preeminent medium of the academy and was habitually employed by students, including Cézanne during his novice years. In contrast to graphite with its compact structure, the brittle particles of charcoal were easily spread into gradations of tone, ranging from intense blackness to transparent grays, while its broadness inspired freer handling and conferred a unifying ensemble—qualities in accordance with prevailing standards of academic aesthetics (fig. 48).[38] Yet for Cézanne, by 1870 its inevitable darkness and proclivity to yield chiaroscuro effects and strong relief were properties antithetical to his new direction.

Fig. 48. Charcoal and graphite photomicrographs (AF Nikkor 60mm macro lens). Particles of charcoal (left) are brittle and readily splinter when stroked across paper, making the medium suitable for chiaroscuro effects: broadly blended or stumped passages of tone worked into the grain of the paper from intense black to diaphanous grays. The particles of graphite (right) in the middle-range pencils Cézanne customarily used are relatively compact, do not crumble, and are not readily stumped, and thus allow greater precision in the stroke. Graphite pencils are available in many degrees of hardness and tones of gray but are never a strong black. In this image of graphite, broad areas of tone are achieved by stroking the side of the pencil point across the paper; subtle voids are created by the irregularities in the sheet. The samples illustrated are willow charcoal and No. 2 graphite pencil.

Fig. 49. Advertisement for graphite pencils, *Catalogue général illustré de G. Sennelier fabricant de couleurs fines et matériel d'artistes* (Paris, 1904; originally published 1895), p. 119. Courtesy of Dominique Sennelier, Magasin Sennelier

Cézanne must have viewed graphite as he did his new, lighter palette: not for its potential for detail but as a means of "giving concrete expression to his sensory experiences," the role he had assigned to drawing and color.[39] Entirely modern in its simplicity and portability, graphite theoretically allowed him to render motifs spontaneously in his pliant sketchbooks, and its capacity for varied handling enabled him to work directly from nature. As with his shift in oils from a dark, earthy palette to one that was bright and spectral, the technical possibilities graphite offered for a subtle but nuanced range of tones and a means of making structured marks would underlie his distinctive manner of drawing.[40]

This versatility was due to the unique nature of the medium. Adjusting the proportion of clay to graphite in the fabrication process produced a scale of tones and textures from soft and dark to hard and silvery gray. Manufacturers sold pencils in as many as sixteen grades, each identified by particular letters or a number; for example, the midpoint of hardness and blackness was designated then, as today, HB or 2.[41] Analysis reveals that Cézanne used such generic pencils.[42] But despite the abundance of choices available, as a page from a colorman's catalogue shows (fig. 49), the physical characteristics of his marks (tonal intensity, degree of hardness, and luster) indicate that he almost invariably chose pencils in the middle range, fairly dark, semi-hard, and wearing down to a relatively broad tip.[43] Equally uncomplicated is that Cézanne executed each of his drawings with just one pencil, never combining pencils of different grades. Only in sheets to which he returned repeatedly, filling empty spaces, can several different pencil tones occasionally be discerned, as, for instance, in two portraits of Hortense and a standing figure (fig. 50). The simplicity of Cézanne's means underscores the remarkable range of his results, which were never achieved by manipulating the medium with reductive techniques that employed knives and erasers, or by stumping (spreading the particles

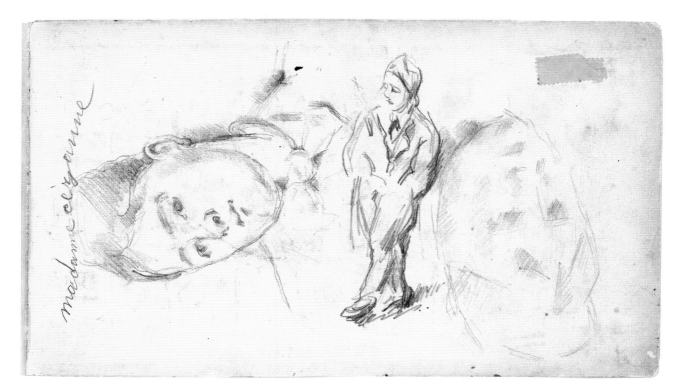

with the fingers or a coil of paper or chamois to produce continuous broad passages). This restraint in handling was not unlike his abandonment of the palette knife in his oils of the early 1870s.

Just as Cézanne conceptually drew upon the academic example for his modern imagery, his graphic vocabulary relied on standard pictorial devices—tonal gradations, varied mark-making, and white paper—but interpreted according to his own response to nature. These devices may have served him as a substitute for color, supporting his claim that "drawing and color cannot be separated."[44] He also insisted that he was "not an artist who deals in values" (gradations of color or tone),[45] yet in almost all of his drawings he transposed the inherent linearity and monochromatic nature of the pencil into a painterly tool that yielded multiple shades of gray. The effect of this subdued tonal range in the drawings, far from the strong contrasts of nineteenth-century academic draftsmanship, is not dissimilar to the lighter, uniform saturation of his oil paintings beginning in the early 1870s, and to the relatively diffuse hues of his landscape watercolors later on; both evoke the model he recommended to Emile Bernard for organizing his

Fig. 50. Paul Cézanne, *Madame Cézanne and Another Sketch*, ca. 1877–80. Graphite on wove paper, 5 × 8³/₄ in. (12.4 × 21.7 cm). *Sketchbook No. 2 (L'Estaque)*, 1875–86, p. L (verso). Art Institute of Chicago, Arthur Heun Purchase Fund, 1951 (1951.1)

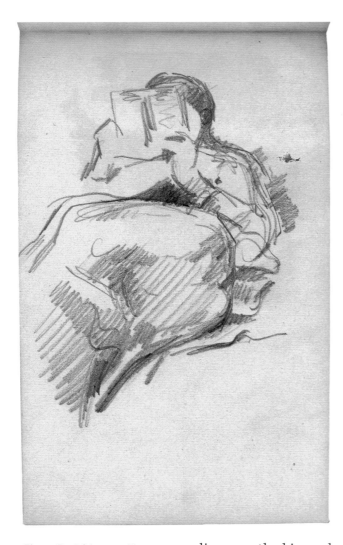

Fig. 51. Paul Cézanne, *Figure Reading*, 1883–86. Graphite on wove paper, 8½ × 5 in. (21.6 × 12.6 cm). *Sketchbook*, 1875–85, p. 26 (verso). Morgan Library & Museum, New York, Thaw Collection, Gift in Honor of the 75th Anniversary of the Morgan Library and the 50th Anniversary of the Association of Fellows (1999.9)

palette.[46] Like his narrow range of oil colors, which served as a way of "deliberately restricting variables and establishing boundaries," enabling him to "efficiently carry out what he referred to . . . as his 'experiments,'"[47] Cézanne's grisaille palette gave him the same opportunities. Its limited array of grays must have suited his interest in painting "the delicate transitions which model objects by almost imperceptible degrees" rather than painting "violent contrasts."[48]

Unlike watercolor, which can be diluted to different intensities, each pencil grade has a restricted tonal value. To expand the range of this monochromatic tool, to make a particular pencil darker, strokes must be layered or applied by adjusting the pressure of the hand more heavily; to make light gray passages, the touch must be less robust or areas of the white paper left visible between the strokes. The subtle and diverse tonal effects Cézanne achieved with pencils of a single grade are exemplified in his drawings of Hortense. In the most summary compositions, such as *Figure Reading* (fig. 51) and *Head of Madame Cézanne* (pl. 47), the pervading sense of light and airiness is created with tonally unvaried, widely spaced lines. In the more complex portraits, such as *Portrait of Madame Cézanne* (pl. 46), this simple linear method is used with several other techniques to model the form. The broad transparent middle grays of her hair, flesh, and blouse were produced by graining: applying the pencil at a sharp angle with repetitive marks so closely spaced as to appear to be a continuous tonal passage, and so lightly applied that they reveal the subtle texture of the paper (fig. 52). For the darks and shadows, Cézanne used firmer pressure, placing strokes close together or superimposing them, but allowing them to remain distinct. Very often he intensified contours with emphatic marks deeply impressed into the sheet with the point of the pencil, almost as if it were

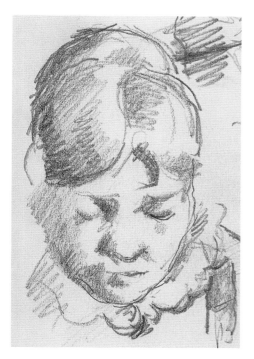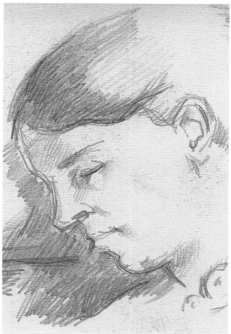

Fig. 52. Detail, Paul Cézanne, *Landscape with Bare Trees, Portrait of Madame Cézanne,* ca. 1880–85. Graphite on wove paper, 8½ × 5 in. (21.6 × 12.6 cm). *Sketchbook,* 1875–85, p. 36. Morgan Library & Museum, New York, Thaw Collection, Gift in Honor of the 75th Anniversary of the Morgan Library and the 50th Anniversary of the Association of Fellows (1999.9)

Fig. 53. Detail, *Head of Madame Cézanne, Two Chairs* (pl. 32)

a stylus (fig. 53).[49] Viewed in raking light, the resultant metallic-like marks produced by compressing the graphite under the action of the pencil often evoke the dark arced strokes that define and separate areas of color in his oils and watercolors (pl. 49). Cézanne rarely stumped graphite. He avoided this chiaroscuro-like effect by choosing semi-hard pencils. These allowed his strokes to remain discrete, but occasionally he employed a softer pencil (containing a relatively high proportion of clay to graphite), as in *Woman Leaning Forward* (fig. 54). In this sheet the overall veil of gray was not intentional but the result of offsetting of the weakly held particles as they rubbed against the facing page, thereby obscuring the definition of the lines and the contrast of light and shadow. The sketchbooks reveal that he similarly rejected very hard pencils, presumably because their compact nature (a very high ratio of graphite to clay) precluded the nuanced tonal variations of middle-range pencils.

Cézanne's technique is varied not only by the pressure of his hand but also by his mark-making, the means to convey the shape and corporeality of his sitter. Though employing traditional methods, his pictorial devices challenge academic ideas of relief, contour, and invisibility of stroke. His

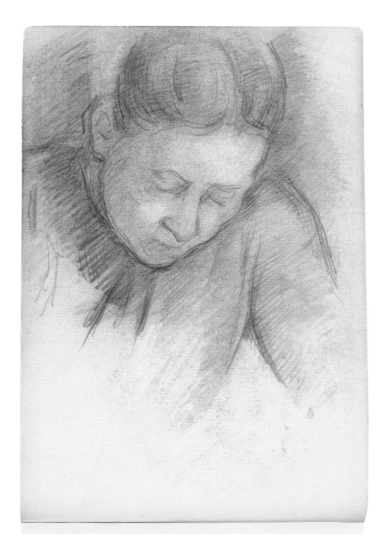

Fig. 54. Paul Cézanne, *Woman Leaning Forward*, 1890–94. Graphite on wove paper, 9³⁄₈ × 6 in. (23.7 × 15.2 cm). *Sketchbook*, ca. 1877–1900, p. XIIII [*sic*] (verso). National Gallery of Art, Washington, D.C., Collection of Mr. and Mrs. Paul Mellon, in Honor of the 50th Anniversary of the National Gallery of Art (1992.51.9.υ)

simplest graphic device is his use of line, its characteristics generally associated with a particular genre. For example, bathers are represented with successive agitated lines as if in movement; the contours of buildings are described with defined yet softened architectonic qualities. Sometimes line is continuous, recalling academic practices for separating areas of light and shadow when copying casts, as in Hortense's cheek (pl. 33), but more often it is rendered in short arced or arabesque strokes and redrawn several times to form a broken contour, a technique that characterizes many of his copies after sculpture (see fig. 42). These rhythmic curves are repeatedly transposed to portraits of Hortense to convey the softness of her face, sinuous hairline, and the waves of her hair and collar (fig. 55). Cézanne's tendency to use a type of stroke with particular subject matter, suggesting that he established fundamental ideas at the start, is not unlike his tendency to carry on parallel studies from nature and from the imagination.[50] This methodical practice is similarly evident in his watercolors, in which his still-life palette is comparatively saturated, whereas his palette for landscape, a genre in which he sought to capture a sense of broken planes of light and atmosphere, almost invariably is highly transparent.

Cézanne's most frequent graphic device is hatching, roughly parallel straight or curved strokes, spaced farther apart for middle tones and compressed for shadows and solid forms. Far more diverse in the *carnet* drawings than in the graphite component of his watercolors, this means of building three-dimensional form is used primarily in subjects after nature. This is exemplified in the intimately observed portraits of Hortense. His varied technique includes closely spaced orderly lines (pl. 43), open and

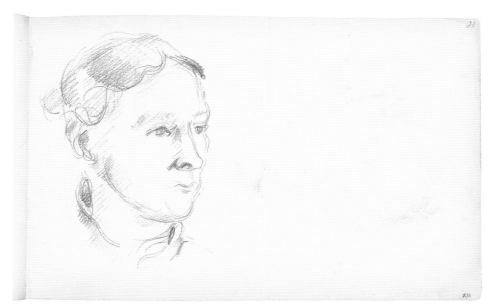

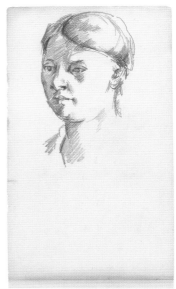

irregular parallel strokes (fig. 56), summary zigzags, diffuse hatching, and hatching applied with uniform pressure and in contrasting densities of graphite. These marks contain the foundation of his distinctive "constructive stroke," a method of building form in his paintings from the late 1870s to the late 1880s with overlapping "blocks" of hatching in gradations of tone arrayed in different directions.[51] Comparable to the modulated color patches in his oils, they underscore his insistence on geometric structure. Evident in the graphite renderings of Hortense during this period (pl. 43; fig. 50), it is used with greater restraint in her depictions than in his self-portraits and portraits of Paul (fig. 57), often confined to modeling the hair, not as a means of developing the entire image.

Cézanne's tonal and mark-making techniques can be seen in a series of images of Hortense made with reflectance transformation imaging, or RTI (fig. 58).[52] This process enables visualization of the topography of the graphite resulting from differences in the pressure of the hand and in the thickness of the layers of the medium. Digitally the method can capture stages of the drawing procedure and provide a sense of its development. In the deconstructed portrait of Hortense, her profile and collar are composed of narrow and lightly applied strokes, redrawn more forcefully in the mouth and nostrils, sharply impressed along the elongated curvilinear sweep of her hair, and gently encircling the ear. At a subsequent stage, the broad middle

Fig. 55. Paul Cézanne, *Madame Cézanne*, 1882–87. Graphite on wove paper, 6 × 9³/₈ in. (15.2 × 23.7 cm). *Sketchbook*, ca. 1877–1900, p. XII. National Gallery of Art, Washington, D.C., Collection of Mr. and Mrs. Paul Mellon, in Honor of the 50th Anniversary of the National Gallery of Art (1992.51.9.p)

Fig. 56. Paul Cézanne, *Portrait of a Young Woman*, ca. 1881. Graphite on wove paper, 8¹/₂ × 5 in. (21.6 × 12.6 cm). *Sketchbook*, 1875–85, p. I (verso). Morgan Library & Museum, New York, Thaw Collection, Gift in Honor of the 75th Anniversary of the Morgan Library and the 50th Anniversary of the Association of Fellows (1999.9)

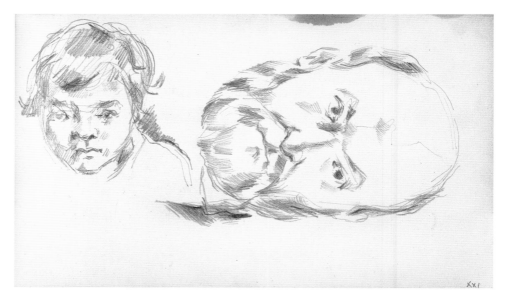

Fig. 57. Paul Cézanne, *Self-Portrait and Portrait of the Artist's Son*, 1880–82. *Sketchbook No. 2 (L'Estaque)*, 1875–86, p. XXI. Graphite on paper, 5 × 8¾ in. (12.4 × 21.7 cm). Art Institute of Chicago, Arthur Heun Purchase Fund, 1951 (1951.1)

gray tone of the hair and background are applied. Last, selected areas are enhanced with firm, dark strokes that are closely spaced and layered. The dark collar on her left consists of linear strokes applied over a broad gray passage; and on her right, reflected light is conveyed by open crosshatching, one of the few instances in which Cézanne uses this technique. Whereas in the oils and watercolors an underdrawing shows the preliminary phase of the composition, the pencil drawings generally do not provide clues to their genesis, or the process is obscured by repeated layers of the medium. Insight into how this composition may have developed is suggested by the initial rendering of the chair rail as seen under RTI. Cézanne may have used its several horizontal components as a starting point to divide the profile into zones to organize the composition and the position of the head. Such construction lines were integral to academic drawing practices, and the likely source, reinterpreted by Cézanne, for developing his more complex sketches. Simply rendered aids as these are similarly present in other depictions of Hortense in an interior setting (pl. 32) and in many drawings in which directional elements such as chairs, tables, wall edges, baseboards, and diagonals are employed.

During the final decades of the nineteenth century, sketchbooks could be purchased containing any one of a range of paper types, but the sameness of Cézanne's *carnets* speaks to the purposeful basis of his selection. The paper in his sketchbooks is plain: medium weight, machine-made, white wove

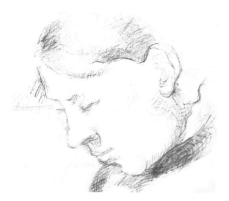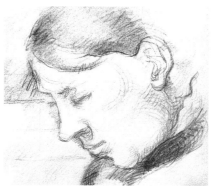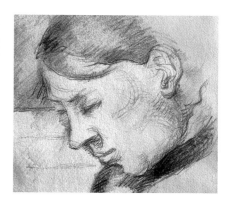

with a uniform, imperceptible grain.[53] Unlike the sheets for his charcoals and early watercolors, in which laid lines break the stroke and provide subtle tactile effects, in its material properties this type of support did not serve as an aesthetic vehicle. In its working properties, however, it offered him several advantages. Its opacity allowed both sides of the page to be used without show-through, and the sizing and uniform surface were receptive to each of his media: pencil and pen easily glided over the smooth topography, and it withstood the moisture of his wet-into-dry watercolor process.[54] Three of the seven extant sketchbooks (the *album de jeunesse* and the sketchbooks in the Morgan Library & Museum and the National Gallery of Art) also contain sections of about sixteen colored pages, a format known as *album à dessin en papier blanc et teinte*.[55] Such papers had become readily available and popular for drawing by the mid–nineteenth century with the introduction of synthetic colorants and advances in dyeing technology. The lightly sized and moderately fibrous *"crayon"* paper in Cézanne's albums, in hues of buff, green, gray, and blue (now all faded except for the last[56]), gave one the option of using powdery media such as pastel, charcoal, or soft pencil on these pages, as well as providing color. Not having a predisposition for colored paper in his graphic work, Cézanne left most of these blank. Presumably, he would have rejected toned paper for watercolor, as did many artists, because it deadened the jewel-like transparency of the medium, and perhaps for a similar reason he limited its use for his graphite sketches, as it would have obscured the subtle gradations of the pencil. His decision, as well, may have been driven by the lingering influence of his academic schooling and its decided preference for white paper.[57] Comparable to his restricted range of pencils, Cézanne's choice of one type of *carnet* with rather ordinary sheets

Fig. 58. Reflectance transformation images, *Madame Cézanne* (pl. 45)

These images were taken in raking light from multiple angles using reflectance transformation imaging (RTI). They reveal differences in the density or topography of the graphite, resulting from the varied pressure of Cézanne's hand and the layering of the medium as he developed the composition from a linear to a volumetric portrait. Collectively they provide a sense of his working process and technical vocabulary, comprising lightly applied strokes that are repeated several times, heavily impressed lines, and hatching applied with the pencil held at its side to produce open strokes or dense masses to create gradations of light and shadow.

in preference to papers having unusual surface qualities or color—features signifying modernity and technical innovation at the time—surely reflects his repeated claim to respond only to his sensations and to the motif, rather than a need to experiment with materials that would compromise his imagery.

But apart from its functional role as a support, Cézanne's sketchbook paper had a pictorial purpose. As he used it to evoke the play of light, this simple white support was, in fact, essential to his draftsmanship. White paper provided luminosity beneath layered passages of graphite; for example, in *Figure Reading* (fig. 51), broadly spaced hatches and "transparent" graining reveal the underlying bright ground, an effect that is similar to the diffuse broken planes of light in his watercolors. The white support also established gradations, the intensity of each half-tone depending on the amount of paper exposed between and through the strokes, and its blank expanses served for highlights. But distinctively, the reserves were also employed to construct solid form. Abstract voids, used in renderings of Hortense sewing, are among his most innovative and dramatic pictorial devices (see pl. 44), and as in his other media, they challenge notions of completion—the "unfinished" element characterizing many of his oils and watercolors. Showing no evidence of erasures or other corrections, the blank areas in these drawings suggest that they were methodically planned. A traditional technique that Cézanne exaggerates, the voids reveal the geometry and volume of the form by their relation to the darks and middle tones. Exceptionally, as these drawings demonstrate, the voids are often placed at a point closest to the eye of the viewer, at the center or projecting part of a motif (fig. 59), where they confer the brightest reflection, as if the form were flooded with light and the details not possible to discern, or they are positioned at the edge of the subject, leading the eye inward.

Unlike Impressionist light, with its transformative or shifting quality, the light in Cézanne's drawings is focused. This controlled light (rejected by the Impressionists, who maintained that it undermined coloristic unity) had been favored by academic and Romantic practitioners, the nineteenth-century *clair-obscur* painters, for drawing indoors after plaster casts and modeling figures.[58] Modifying the strong contrasts and tonal gradations of these artists, Cézanne reinterpreted their dramatic technique in many of his drawings after sculpture, in drawings after paintings portraying

figures from the antique, and in his renderings of Hortense. It is likely that the chiaroscuro tradition to which he was exposed in his early training inspired his distinctive management of the broad voids of paper as a means of representing reflected light. For him, blank areas of paper were as purposeful as the strokes surrounding them. As a graphic device, they evoke the words of the fictional painter Frenhofer in Honoré de Balzac's story "Le Chef-d'oeuvre inconnu" ("The Unknown Masterpiece"), with whom Cézanne identified: "To begin a figure in the middle, starting with the protuberances which receive the most light and proceeding thence to the darker parts."[59] Such voids—the protuberances receiving the most light— recall, as well, Cézanne's description of his "culminating point": the point always closest to the eye, an idea inspired by the academic principles of Couture.[60] The device informs his sketchbook drawings and remained a part of his expressive means to the end of his oeuvre. The year before he died, Cézanne told Emile Bernard that "the sensations of light create abstractions in my paintings that keep me from covering my canvases or defining the edges of objects where they delicately touch other objects, with the result that my image or picture is incomplete."[61] It was through this abstraction and his distinctive graphic devices, both inextricably linked to his brief academic training and to his sketchbooks, that Cézanne created visual equivalents to his *sensations.* These sensations were expressed as profoundly with pencil and paper as with his other media and laid the foundation for a radically different means of perception in the twentieth century.

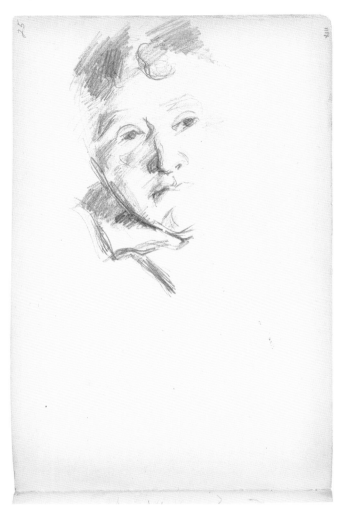

Fig. 59. Paul Cézanne, *Madame Cézanne,* 1897–1900. Graphite on wove paper, 9³/₈ × 6 in. (23.7 × 15.2 cm). *Sketchbook,* ca. 1877–1900, p. XIII. National Gallery of Art, Washington, D.C., Collection of Mr. and Mrs. Paul Mellon, in Honor of the 50th Anniversary of the National Gallery of Art (1992.51.9.r)

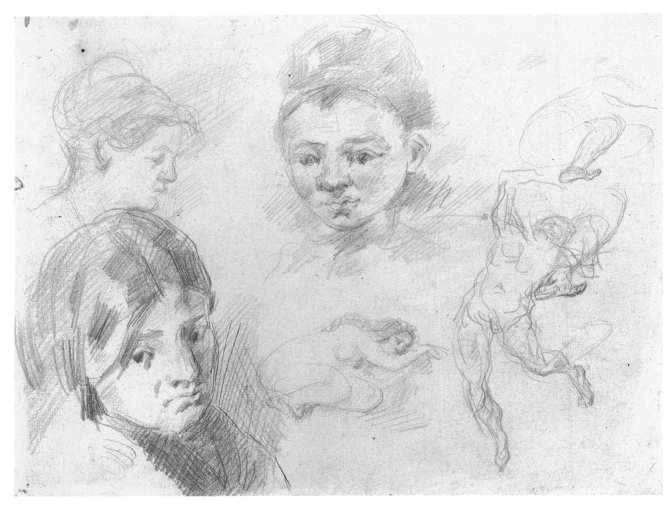

PLATE 29. *Page of Studies* (recto), 1871–74
Graphite on laid paper, 8³/₄ × 11¹/₄ in. (22.2 × 28.5 cm)
Museum of Fine Arts, Budapest (1935-2678)

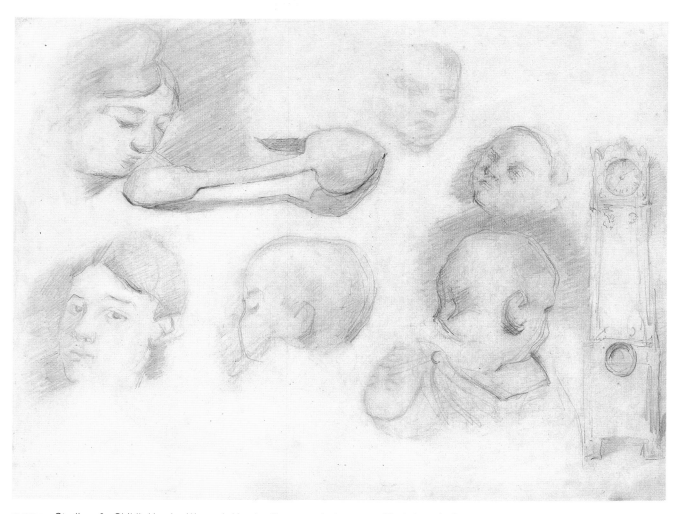

PLATE 30. *Studies of a Child's Head, a Woman's Head, a Spoon, and a Longcase Clock* (verso), 1873–75
Graphite with touches of black crayon on fine-textured paper, 9³/₈ × 12³/₈ in. (23.8 × 31.4 cm)
Ashmolean Museum of Art and Archaeology, Oxford, Bequeathed by Dr. Grete Ring, 1954 (WA1954.70.2)

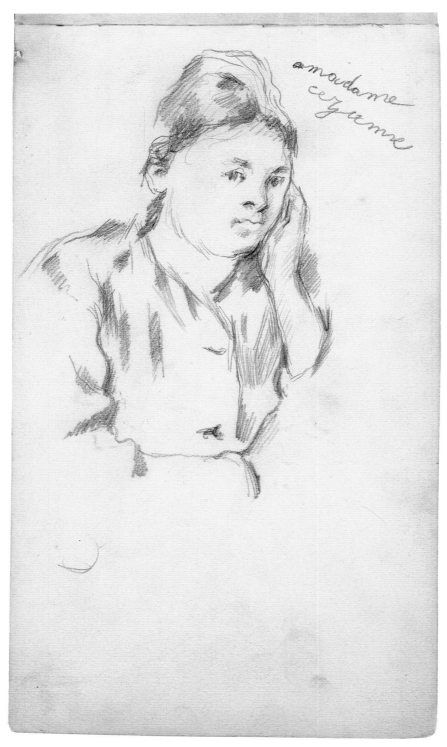

PLATE 31. *Portrait of Madame Cézanne*, 1876–79
Graphite on wove paper, 8³/₄ × 5 in. (21. 7 × 12.4 cm). *Sketchbook No. 2*
(L'Estaque), 1875–86, p. XLIX (verso)
Art Institute of Chicago, Arthur Heun Purchase Fund, 1951 (1951.1)

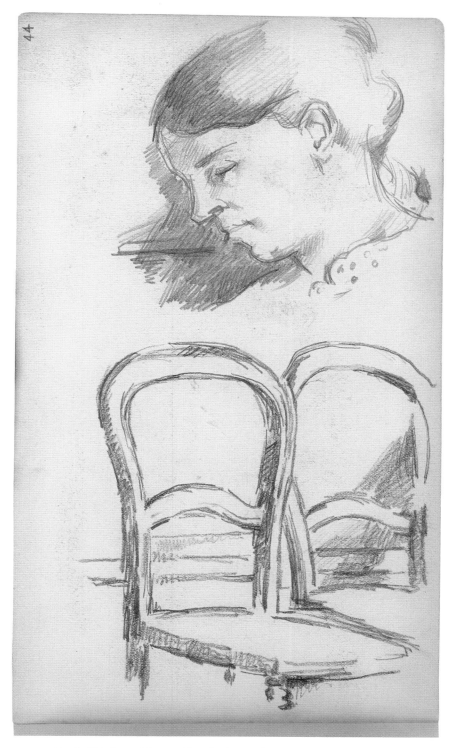

PLATE 32. *Head of Madame Cézanne, Two Chairs*, ca. 1876–80
Graphite on wove paper, 8½ × 5 in. (21.6 × 12.6 cm). *Sketchbook*, 1875–85, p. 44 (recto)
Morgan Library & Museum, New York, Thaw Collection, Gift in Honor of the 75th Anniversary
of the Morgan Library and the 50th Anniversary of the Association of Fellows (1999.9)

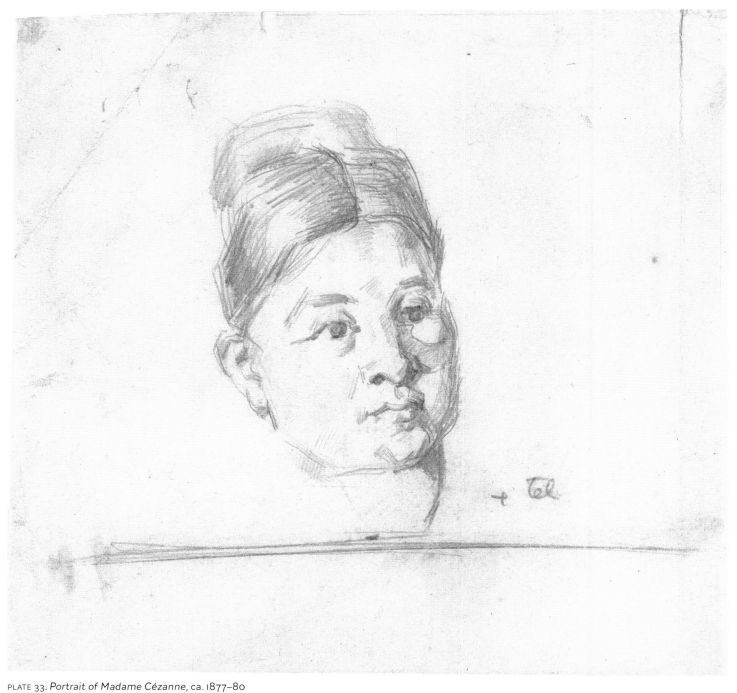

PLATE 33. *Portrait of Madame Cézanne*, ca. 1877–80
Graphite on wove paper, 7¹⁄₈ × 7¹⁄₂ in. (18.2 × 19.2 cm)
Museum of Modern Art, New York, The William S. Paley Collection (SPC 8.90)

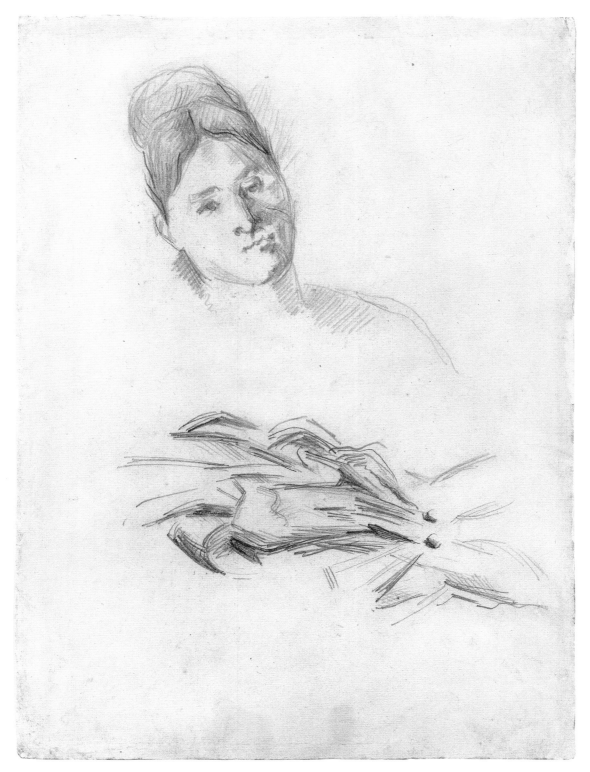

PLATE 34. *Page of Studies, Including One of Madame Cézanne*, 1873–76
Graphite on wove paper, 10³/₈ × 7⁷/₈ in. (26.5 × 20 cm)
Private collection, on loan to Staatliche Museen zu Berlin, Nationalgalerie, Museum Berggruen

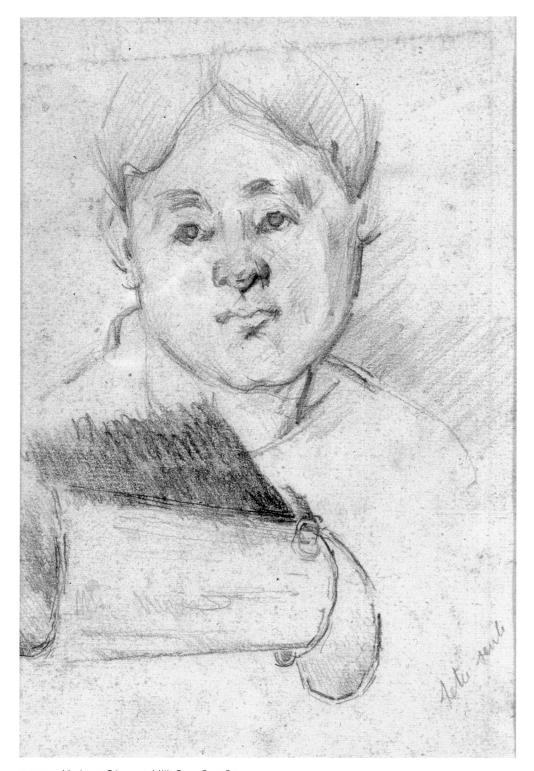

PLATE 35. *Madame Cézanne, Milk Can*, 1877–80
Graphite on gray-brown laid paper, 9 × 5⅞ in. (23 × 15 cm)
Prat Collection, Paris

PLATE 36. *Page of Studies*, 1874–75
Graphite on laid paper, 9³/₈ × 12¹/₄ in. (23.8 × 31 cm)
Museum Boijmans Van Beuningen, Rotterdam (F II 118r [PK])

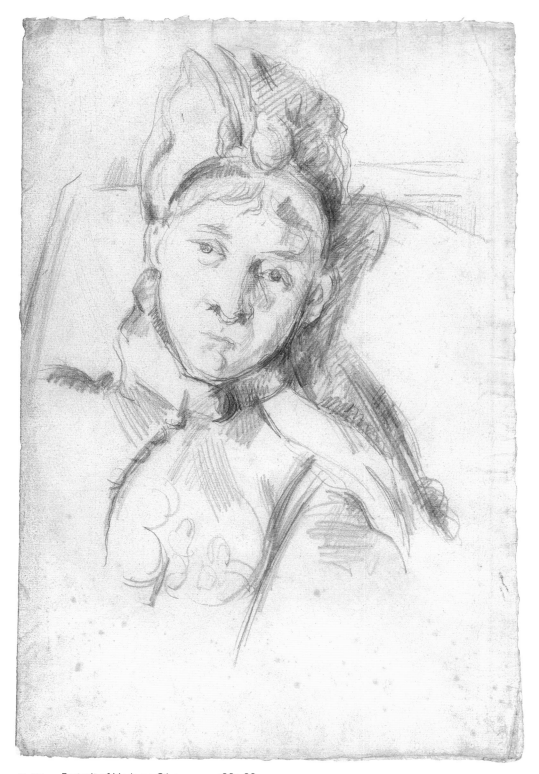

PLATE 37. *Portrait of Madame Cézanne*, ca. 1881–88
Graphite on laid paper, 19⅛ × 12⅝ in. (48.5 × 32.2 cm)
Museum Boijmans Van Beuningen, Rotterdam, Gift of D. G. van Beuningen, 1940 (F II 220 [PK])

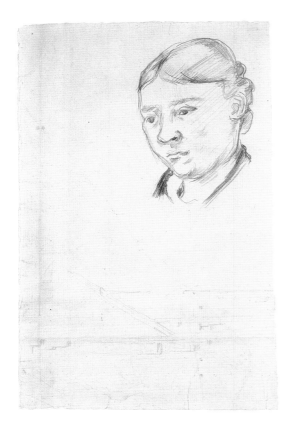

PLATE 38. *Head of Madame Cézanne*, ca. 1880
Graphite on laid paper,
6³/₄ × 4³/₄ in. (17.2 × 12 cm)
Collection of Jasper Johns

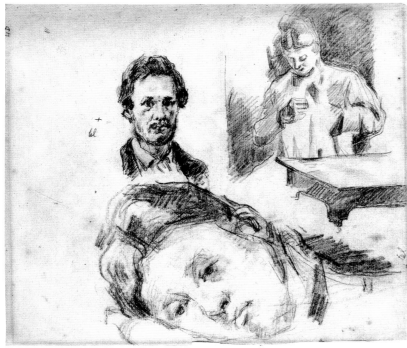

PLATE 39. *Page of Studies, Including Madame Cézanne Sewing* (recto), 1877–80
Graphite (conté crayon?)
on wove paper, 7⁷/₈ × 9¹/₄ in.
(20 × 23.5 cm)
Collection of Jasper Johns

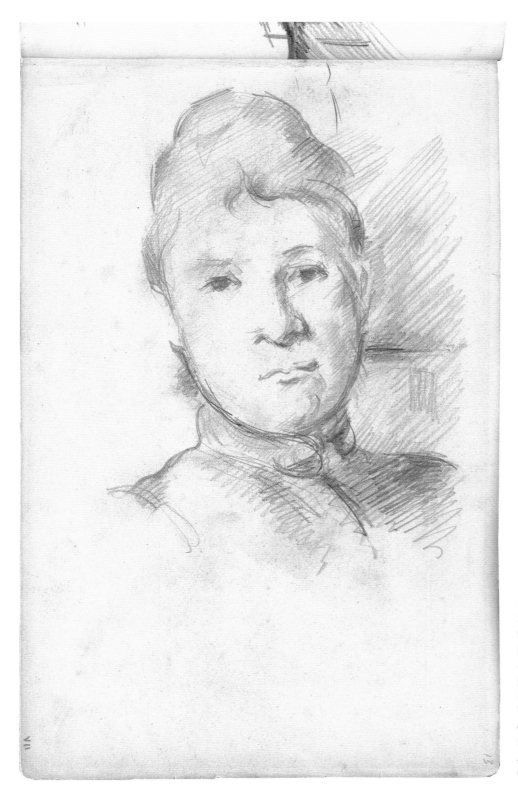

PLATE 40. *Madame Cézanne,*
1888–91
Graphite on wove paper,
9³/₈ × 6 in. (23.7 × 15.2 cm).
Sketchbook, ca. 1877–1900,
p. VII
National Gallery of Art,
Washington, D.C., Collection
of Mr. and Mrs. Paul Mellon,
in Honor of the 50th
Anniversary of the National
Gallery of Art (1992.51.9.h)

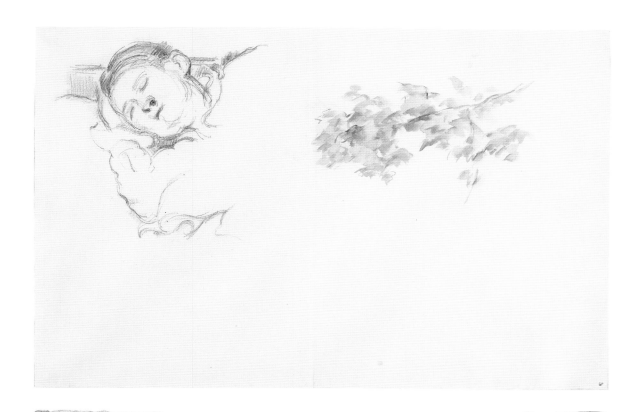

above

PLATE 41. *Madame Cézanne,*
Study of a Tree, 1897–1900
Graphite and watercolor on
wove paper, 12¼ × 18½ in.
(31.2 × 47 cm)
Collection of Georges
Pébereau

right

PLATE 42. *Madame Cézanne*
with Hortensias, 1885
Graphite and watercolor
on paper, 12 × 18⅛ in.
(30.5 × 46 cm)
Private collection

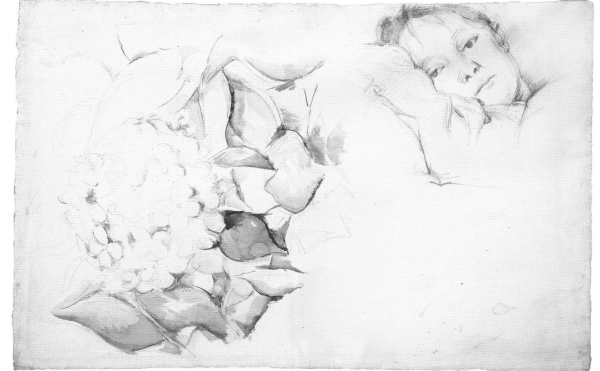

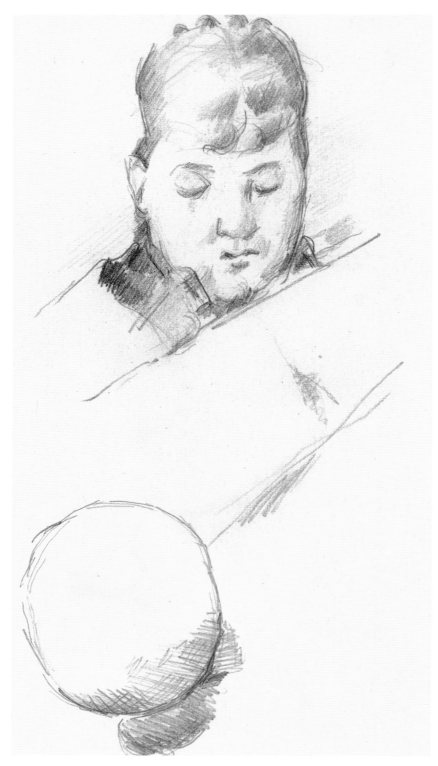

PLATE 43. *Bust of Madame Cézanne* (verso), 1884–85
Graphite on wove paper, 8⅝ × 4⅞ in. (21.8 × 12.5 cm)
National Gallery of Art, Washington, D.C., Collection of Mr. and Mrs. Paul Mellon
(1985.64.83.b)

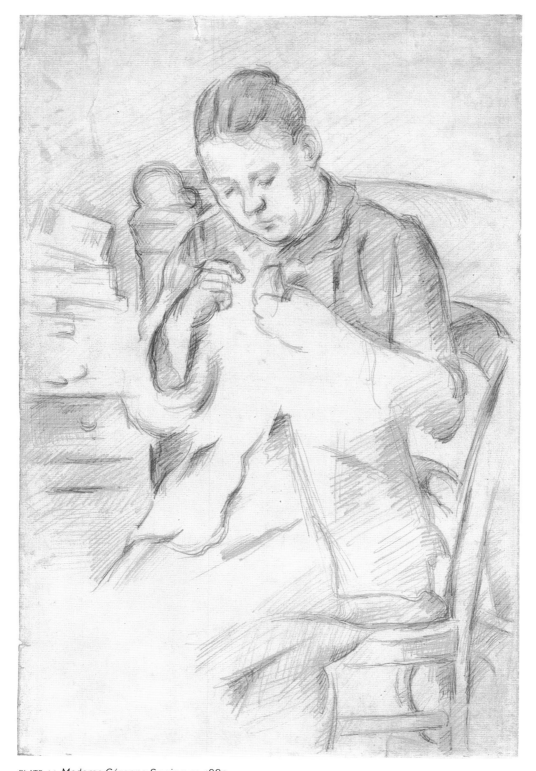

PLATE 44. *Madame Cézanne Sewing*, ca. 1880
Graphite on laid paper, 18⅝ × 12⅛ in. (47.2 × 30.9 cm)
Courtauld Institute of Art, London, Bequest of Count Antoine Seilern, 1978 (D.1978.PG.239)

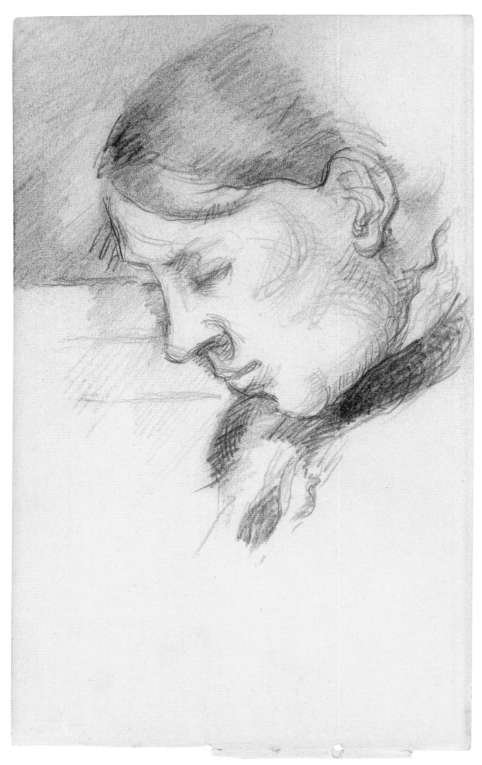

PLATE 45. *Madame Cézanne*, 1884–87
Graphite on wove paper, 7⅝ × 4¾ in. (19.4 × 11.8 cm)
Collection of Isabel Stainow Wilcox

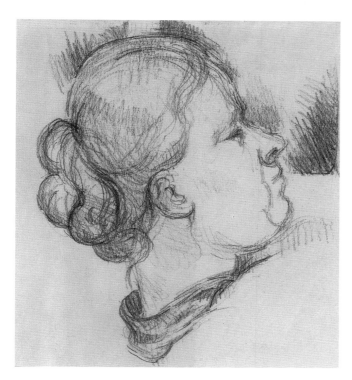

PLATE 46. Detail, *Portrait of Madame Cézanne* (verso)
Graphite on wove paper, overall 13 × 18½ in. (33 × 47 cm)
Private collection, New York

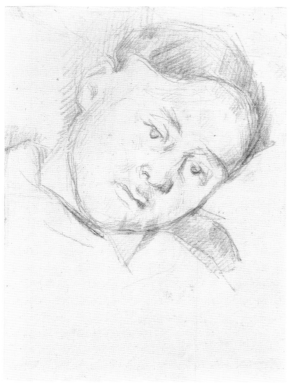

PLATE 47. *Head of Madame Cézanne* (recto), ca. 1880
Graphite on laid paper, 5⅜ × 4 in. (13.5 × 10 cm)
Collection of Ralph Fassey

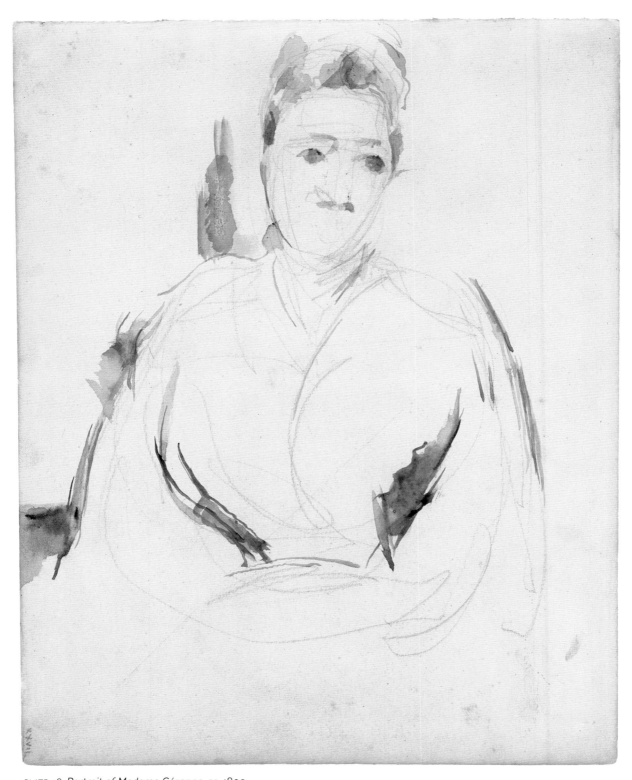

PLATE 48. *Portrait of Madame Cézanne*, ca. 1890
Graphite and watercolor on paper, 10³/₄ × 8¹/₄ in. (27.3 × 21 cm)
Private collection, on loan to Staatliche Museen zu Berlin, Nationalgalerie, Museum Berggruen

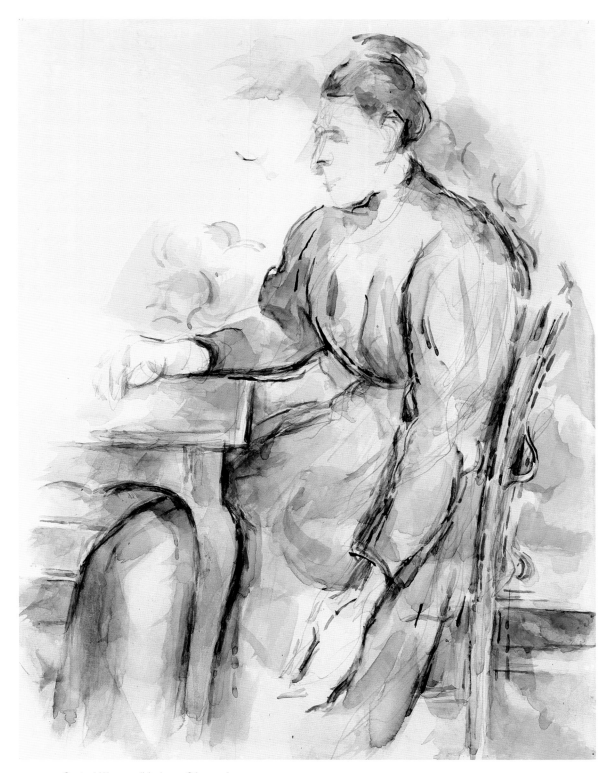

PLATE 49. *Seated Woman (Madame Cézanne)*, ca. 1902–4
Graphite and watercolor on wove paper, 19½ × 14⅝ in. (48 × 36 cm)
Judy and Michael Steinhardt Collection, New York

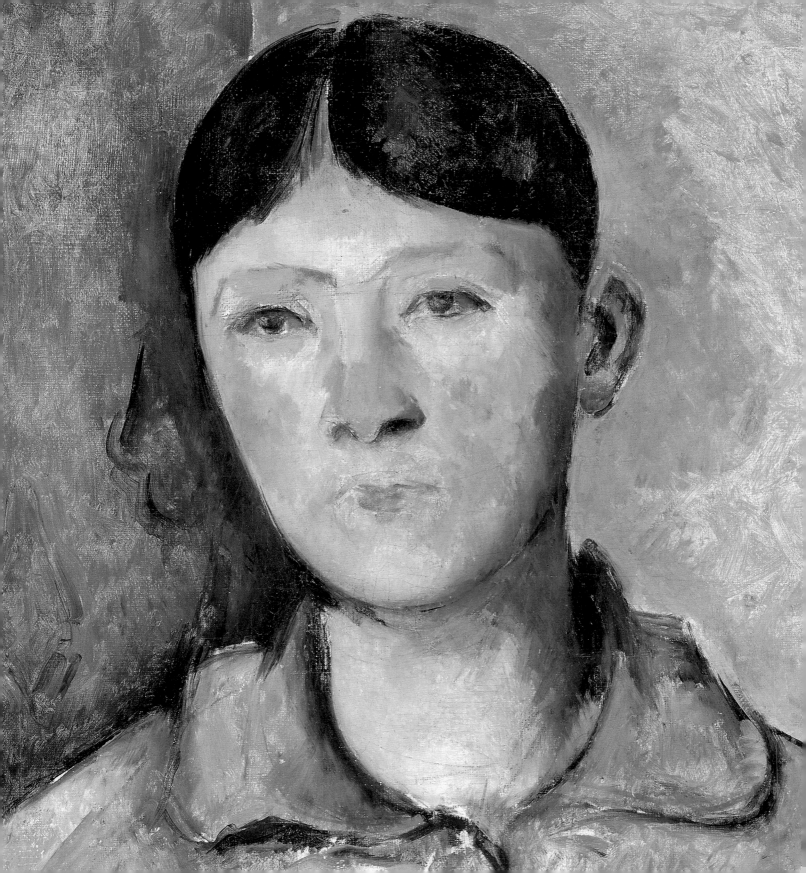

Hilary Spurling

Cézanne and Matisse Paint Their Wives

"You have to know how to take them, coax them, those fellows," Paul Cézanne said of his sugar bowl and its companions, the knife, plate, soup tureen, and fruit stand from which he coaxed so many still lifes.[1] Remarks like this helped legitimize the standard view that Cézanne's wife meant no more to him than a still-life object—"one of the earliest and saddest misconceptions to enter the Cézanne mythology," in the words of Joseph Rishel.[2] Admittedly, the woman who eventually became the painter's wife posed as regularly, as uncomplainingly, and with the same absolute immobility as his kitchen crockery. Although he could never tolerate anyone else looking on while he painted, she watched him at work week after week, day after day, for hours on end, in sittings that continued over more than twenty years. Even Cézanne's hypercritical family acknowledged Hortense Fiquet's tireless patience, and the innate stability of her temperament.

She must also have needed considerable courage to pose for portraits that struck virtually everyone who saw them as comically offensive. Their ugliness was self-evident to the Parisian women at the Salon d'Automne in 1907, the year after Cézanne's death, who seemed to the poet Rainer Maria Rilke to draw attention to their own sleek good looks by standing deliberately in front of one or another of the portraits of Madame Cézanne.[3]

Critics and public had been outraged by Henri Matisse's paintings of his own wife, on show for the first time at the same Salon two years earlier. These portraits represent by far the most strenuous work session the Matisses had embarked on together in seven years of marriage, and they were explosive. *Portrait of Madame*

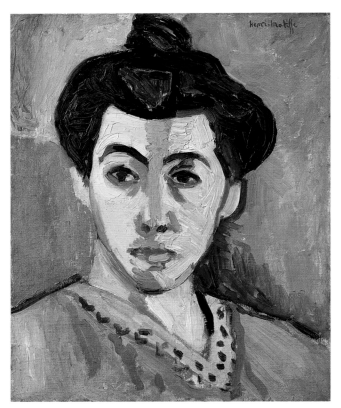 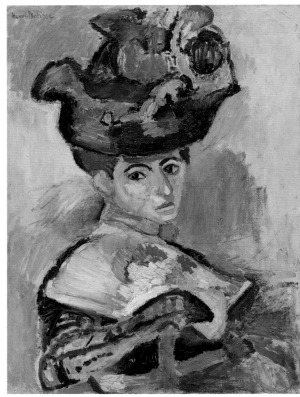

Fig. 60. Henri Matisse (1869–1954), *Portrait of Madame Matisse, The Green Line*, 1905. Oil on canvas, 16 × 12¾ in. (40.5 × 32.5 cm). Statens Museum for Kunst, Copenhagen, Gift, Engineer J. Rump and Wife's Fund, 1936 (KMSr171)

Fig. 61. Henri Matisse, *Woman with Hat*, 1905. Oil on canvas, 31¾ × 23½ in. (80.7 × 59.7 cm). San Francisco Museum of Modern Art, Bequest of Elise S. Haas (91.161)

Matisse, The Green Line and *Woman with Hat* (figs. 60, 61), both from 1905, violated every current rule of aesthetic and political correctness. The painter himself was initially startled, but the sitter seems to have responded with characteristic sangfroid as her plain black dress and matching hat caught fire in the Fauve conflagration of color that autumn. For the next five or six years, Matisse regularly painted his wife sewing, reading, or resting, on canvases that spoke a pictorial language as infuriating as it was incomprehensible to his contemporaries.

Like Cézanne, he made exorbitant demands on the strength and stamina of his wife, who posed for him with a compliance beyond anything that could have been expected from a professional model, and who got small thanks for her pains at the time or after. Neither Hortense Fiquet nor Amélie Parayre fit comfortably into the conventional contours of a painter's muse. Posterity has responded with condescension, dismissing Madame Cézanne by and large as a bovine nonentity, and treating Madame Matisse, until relatively recently, as a male chauvinist's punching bag.

Nothing could be further from the truth in the case of Amélie Matisse, who was by inclination and upbringing a fierce idealist, largely indifferent to material gain, intolerant of bourgeois respectability, more than capable of sacrificing herself and her family to a cause she was among the first to recognize as authentic. It was Amélie who raised the money to buy a small Cézanne painting she and her husband could not conceivably afford the year after they were married. The purchase was concluded on December 7, 1899,[4] at a point when the best and boldest of Matisse's rising generation had still not fully registered the presence, let alone absorbed the impact, of "the obscure and enigmatic Aixois assumed by some of us to be already dead."[5] The transaction was an affirmation of faith in themselves and in their future by both husband and wife. Amélie herself could see nothing at this stage in Cézanne's *Three Bathers* (fig. 62), but she understood the painting's

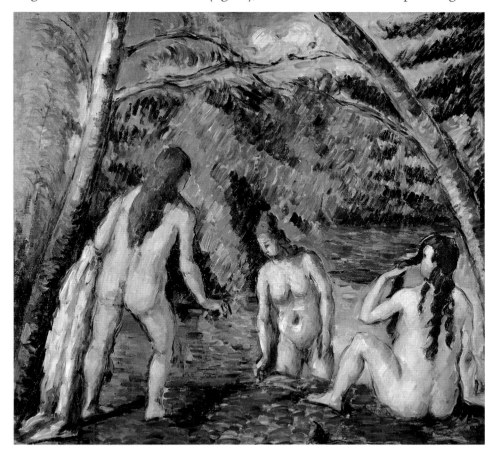

Fig. 62. Paul Cézanne (1839–1906), *Three Bathers*, 1879–82. Oil on canvas, 21⁵/₈ × 20¹/₂ in. (55 × 52 cm). Musée des Beaux-Arts de la Ville de Paris, Petit Palais, Gift of M. and Mme. Henri Matisse, 1936 (PPP 2099)

importance for her husband in the face of rising panic and corrosive self-doubt. "If Cézanne is right, then I am right" became Matisse's private mantra against comprehensive rejection by dealers, critics, and public—"and I know Cézanne made no mistake."[6]

That canvas remained for Matisse ever after a source of stimulus and renewal, weaving itself with time into the imaginative fabric of his entire family.[7] Cézanne supplied a standard by which the younger painter judged himself as well as his work when he later looked back to his own early struggles for survival, exacerbated by paternal opposition and years of abject poverty in Paris. Where Cézanne lived for more than two decades on his father's monthly allowance of 100 francs (rising at one point to 200), Matisse received 100 francs a month for one year only, and doubled the time at his disposal by learning to get by on half the money. He remembered serving his friends boiled rice from a sack supplied by his parents in the north, capping his own rice diet with stories of the young Cézanne and Emile Zola moistening their bread with oil brought back to Paris from their native Provence.[8]

Matisse had begun looking seriously at Cézanne's work at the Gustave Caillebotte legacy exhibition of 1897 in a tumult of mockery and derision that

Fig. 63. Henri Matisse, *The Gulf of Saint-Tropez*, 1904. Oil on canvas, 28⅝ × 19⅞ in. (65.1 × 50.5 cm). Kunstsammlung Nordrhein-Westfalen, Düsseldorf

Fig. 64. Henri Matisse, *Luxe, calme et volupté*, 1904. Oil on canvas, 38¾ × 46⅝ in. (98.5 × 118.5 cm). Centre Pompidou, Musée National d'Art Moderne, Paris, on extended loan to the Musée d'Orsay, Paris (AM 1982–96)

prepared him perhaps for his own disastrous Salon showing a few weeks later.[9] It was a salutary introduction to the painter who held out above all the possibility of triumph over the forces of destruction, madness, and chaos that Matisse felt always lapping at the edges of his consciousness. Cézanne, he said, taught him to organize the turmoil in his mind: "If there is a large measure of order and clarity on his canvas, it is because this order and clarity were present from the start in the painter himself."[10] The years when Cézanne took possession of him as a painter were also the years when Matisse came to value portraiture beyond either still life or landscape for its expressive power.[11] His only regular model in these years was his wife, who posed for or presided over almost all his most radical canvases in the first decade of the twentieth century.

The Gulf of Saint-Tropez (fig. 63), a small painting of Madame Matisse on a beach picnic at sunset with their four-year-old son, grew into the majestically unsettled and unsettling *Luxe, calme et volupté* (fig. 64), a painting from 1904 with so little precedent that Matisse himself could scarcely grasp at first what he had done. Whether or not she fully understood the implications of the strange new language evolving under his brush at the start of the twentieth century, Amélie Matisse knew well enough that she played a key part in an enterprise whose primary aim was not representational. Already in *The Convalescent Woman (The Sick Woman)* (fig. 65), the third of three portraits her husband made of her on their honeymoon, her image had begun to decompose and reshape itself as a mosaic of shimmering color. By the time of the two major Fauve portraits, any recognizable external human traits had been consumed in a blaze of red, blue, turquoise, and green: all that remained of the sitter was an unshakable fixity of purpose. Her identity was subsumed altogether in *The Joy of Life*, of 1905–6 (fig. 66), based on another family beach picnic, and she appeared positively inhuman to her closest friends a year later in the distortions of the

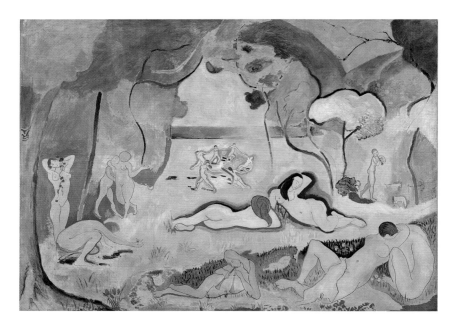

Fig. 66. Henri Matisse, *The Joy of Life*, 1905–6. Oil on canvas, 69½ × 94¾ in. (176.5 × 240.7 cm). Barnes Foundation, Philadelphia (BF719)

Blue Nude (fig. 67). Madame Matisse in person radiated confidence and calm, but her painted image caused consternation at successive Salons in 1905, 1906, and 1907, on canvases that seemed strange and terrible even to potential supporters.[12]

In each of them, Matisse struggled for the lucidity he prized in Cézanne. Composure, clarity, and order are central to the austere and beautiful *Portrait of Madame Cézanne* (pl. 16) that he eventually owned.[13] It was painted about 1885–88, and is now in the Musée d'Orsay in Paris. Its almost hypnotic power lies in the simplicity and sobriety of the sitter's pose, the slight graceful tilt of her head, her steady gaze, straight nose, and unsmiling lips. Light runs down the center of the canvas from the creamy patch between her brows through the glimmering brushstrokes on her chin and columnar neck to the glints of white down the fastening of her dress. A strict binary scheme emphasizes the pure oval of the head with its two wings of scraped-back hair, arched brows, scrubbed cheeks, and unemphatic eyes. Even the single ear sticking out like a jug handle on the right of the canvas is balanced on the left by a shadowy triangular shape, all that remains of a carved wooden cabinet reduced to a band of lively brown brushstrokes forming one side of the bisected background.[14] The whole might have been designed to demonstrate the architectural laws Matisse said a young painter could

Fig. 67. Henri Matisse, *Blue Nude*, 1907. Oil on canvas, 36 × 55¼ in. (92.1 × 140.3 cm). Baltimore Museum of Art, The Cone Collection, formed by Dr. Claribel Cone and Miss Etta Cone of Baltimore, Maryland (1950.228)

usefully derive from Cézanne.[15] Perhaps one of the lessons Matisse learned from him was that a degree of abstraction intensifies the sitter's personality: in this case, something unflinching, still, and self-contained secreted in the luminous soft pale blues of the dress and the wall behind it, warmed by spring greens and the clear fresh pinks of face and neck. The impact, as Matisse said of Giotto's frescoes in Padua, lies not in anything that could be expounded or explained but "in the lines, in the composition, in the color."[16]

Cézanne's twenty-nine portraits of Hortense Fiquet contain almost all that can be known or guessed about relations between the two, apart from a few external facts and the disobliging gossip of the painter's male friends, who avidly reported the marital grumblings of his middle age, by which time the couple had long been semi-detached. The only detailed firsthand testimony about their early life together comes in fictional form from Zola, who had grown up with Cézanne, met Hortense soon after her initial contact with his friend in 1869, and arranged for their two households to spend a summer together at the seaside. (Young Madame Zola turned out to be yet another hostile witness, perhaps because she came from the same sort of social background as the future Madame Cézanne, and was keen to forget it.)

The story of the painter Claude Lantier, told by Zola in his novel *L'Oeuvre*, has had a pervasive, perhaps disproportionate, influence on attempts to

interpret Cézanne's character, especially his sexual pathology.[17] Given the weight routinely attached by scholars, following John Rewald, to Lantier's behavior as a guide to Cézanne's, it is perhaps legitimate to see at any rate a grain of truth in Zola's sympathetic and persuasive portrait of Christine Hallegrain, Lantier's companion. She certainly looks like the young and supple, dark-haired, dark-eyed Hortense, specifically in the gentleness and delicacy of her face with its "limpid brow, smooth as a bright, clear mirror," broad pale cheeks, and slightly too heavy jaw.[18] Christine first appears on the novel's second page, orphaned like Hortense, lonely and vulnerable, accustomed to an emotional solitude that answers to a corresponding isolation in the painter. The minute precautions Christine takes not to be seen with Lantier for fear of compromising her reputation, and his protective attempts to keep her existence secret from his friends, sound like fact rather than fiction.

What is interesting in the present context is, first, the mutual attraction that initially consumes them both, especially—for the light it casts on the portraits—the extent of Christine's identification with Claude as a painter; and, second, her shyness when it comes to acting as his model. When she finally succumbs to his urgent need to paint her, both are painfully aware of violating a deep-rooted prohibition: their first portrait session, strictly confined to the head only, takes place in an atmosphere of guilt and nervous constraint on both sides. Later Christine overcomes her reluctance sufficiently to pose naked, "making him the gift of her modesty," white-faced, barely breathing, with her eyes shut: "Occasionally she opened her clear eyes, fixed them on a point in space and stayed like that for a moment without his being able to read her thoughts, then closed them again."[19]

Zola's Lantier is of course a composite portrait, based as much on Edouard Manet as on Cézanne, with a generous admixture of the novelist himself (particularly in the book's melodramatic second half, which owes more to his self-projection than to either painter). But Zola often wrote "Paul" instead of "Claude" in his original notes for the early chapters of *L'Oeuvre*, which, as Cézanne himself acknowledged, were transposed directly from life. Zola's account of Christine's physical reticence could explain the relative paucity of images of Hortense in the first seven years of their affair, as well as her veiled or downcast eyes in most of the surviving portraits from the period before their marriage in 1886. Sensual and sexual

inhibitions were perfectly normal, indeed rigidly enforced by the taboos that governed young women of all social levels at the time. Nearly thirty years after Cézanne, Matisse's first portrait of his wife shows her with her back demurely turned, and he himself admiringly described her timidity and reserve when they first met, a hesitancy that rapidly gave way (as in the case of Lantier's Christine) to passionate commitment.[20]

Madame Cézanne remains silent as far as posterity is concerned on her marriage or practically anything else, seeming, as her husband's most recent biographer ruefully remarked, biographically immune to treatment.[21] Few of her letters have survived; one is a friendly note to the wife of the collector Victor Chocquet, with whom Madame Cézanne clearly got on well, and another shows her acting as her husband's business manager in transactions with galleries and dealers.[22] Neither tallies with the traditionally dismissive view of her as socially inept and professionally irrelevant. The posthumous legend that rapidly grew among members of the succeeding generation like Matisse was fed by the handful of young admirers who made their way to Aix in the painter's last years.[23] They saw his wife, insofar as they noticed her at all, as an unforthcoming old woman with absolutely no social or intellectual claim on their attention. Their attitude was uningratiating, and she responded in kind. When Matisse sat next to her at dinner with Jean Renoir not long before she died in 1922, she told him that her husband was an old fool who couldn't paint.[24] She was repeating a judgment she had heard on all sides for much of her life, and Matisse dismissed her in return as humble, ignorant, and menial, which was the view commonly taken in her lifetime and afterward by her husband's supporters.

But Matisse, who knew more than most how much an artist needs a wife, also understood that the relationship functioned on many levels, impersonal and pictorial as well as pitifully human. His wife, like Cézanne's, had had to evolve strategies to deal with the internal and external pressure inherent in this sort of marital and working partnership. Madame Matisse, like Madame Cézanne, habitually read aloud to her husband for hours in the long nights of insomnia.[25] Both women learned to live not only with the humiliation of seeing themselves repeatedly exposed to public ridicule on canvas but also with the unrelenting barrage of abuse directed at their husbands.

Not long after his disconcerting encounter with Madame Cézanne, Matisse's family rearranged the Renoirs and Cézannes hanging in their

family salon to make way for his own latest batch of newly painted canvases, with the largest in pride of place beside *Portrait of Madame Cézanne* (fig. 68).[26] There is no way of knowing for sure how many other portraits Matisse came across at the Paris dealers—Vollard, Rosenberg, Bernheim-Jeune, Barbazanges—whose stockpiles he inspected at intervals before and during World War I. He taught the Norwegian artist Walther Halvorsen, who may have bought *Portrait of Madame Cézanne* (pl. 9); he went to Moscow in 1911 to see Ivan Morosov, who owned *Madame Cézanne in the Conservatory* (pl. 28), subsequently acquired

by The Metropolitan Museum of Art; and he often visited Gertrude Stein's flat on rue de Fleurus, where *Portrait of the Artist's Wife* (pl. 6) hung to the right of the fireplace (fig. 69). He also made a point in these years of regularly examining the constantly changing collection of Auguste Pellerin, whose more than ninety Cézannes included a majestic *Madame Cézanne in a Red Dress* (pl. 22), also now in the Metropolitan Museum. It belongs to a grave, almost impersonal group of nine or ten canvases in which Madame Cézanne, formally posed with the erect carriage and dignified bearing of a court portrait, undergoes scrutiny of a directness and intensity that make these late portraits the grandest he ever painted of his wife.

Four of them depict her in the same red dress: Matisse almost certainly knew the Metropolitan version from his many visits to Pellerin; he probably saw *Madame Cézanne in a Yellow Chair* (pl. 20), now in Chicago; and he definitely looked at a third in this series, *Madame Cézanne in a Yellow Chair* (pl. 19), now in Basel, at the Salon de Mai in 1912, the year before he painted his last portrait of his own wife.[27] Seated with limp or clasped hands on a richly patterned yellow thronelike chair, Hortense wears an elaborate and voluminous dress of heavy plum-colored material, and gazes impassively at or over the head of the observer in each of these three portraits, all of them charged with powerful emotion. Her pose is stern, with a hint of confrontation, the equivalent in its own calm and monolithic way of the

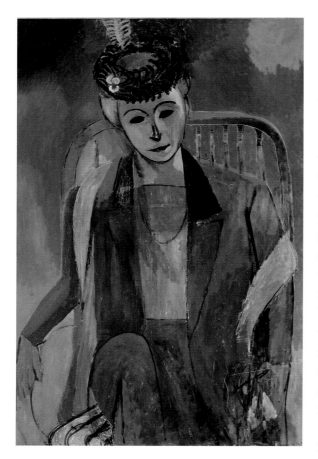

Fig. 70. Henri Matisse, *Portrait of Madame Matisse*, 1913. Oil on canvas, 57 × 38⅛ in. (145 × 97 cm). State Hermitage Museum, Saint Petersburg

taut, impassioned figure of Amélie Matisse in 1905, challenging her husband in a blaze of color on canvas at the start of what proved a turbulent decade. Toward the end of it Amélie posed again, for a final portrait that would take more than three months to complete, and drive them both to the limits of endurance. *Portrait of Madame Matisse*, of 1913 (fig. 70), confronts the spectator with stony, unseeing black eyes in a masklike gray face. The structural engineering of this canvas is a homage to Cézanne. The jaunty curves of the little feathered hat, perched so incongruously on the somber face beneath it, owe something to *Madame Cézanne with Green Hat* (pl. 26), and more to the haunting *Woman in Blue* (fig. 71), which Matisse had seen in Moscow.[28] But the derivation from the Red Dress series is plain to see in the high-backed chair, the formal clothes, the blank stare, and the skewed angle of the head: even the orange stole framing Madame Matisse's upright torso echoes the enclosing loop made by Madame Cézanne's two red-sleeved arms. Of all Matisse's paintings of his wife, this is the most inscrutable, and the most moving.

Painting a portrait, like writing a biography, has a hard, exacting, searching, even surgical aspect. There is obdurate and unrelenting pressure on the part of both painter and sitter, extreme calculation, pitiless exposure, secretions of pain and suffering, as well as great tenderness, in Matisse's elegiac portrait. It exemplifies in a darker mood what Cézanne meant when he said that the hearts of both painter and sitter were beating in Camille Corot's portrait of Honoré Daumier.[29] He said something similar when he painted his old friend Henri Gasquet, telling Gasquet's son Joachim that each brushstroke mixed a little of the painter's blood with the sitter's: "There's a mysterious exchange which he isn't aware of which goes from his soul to my eye."[30] Matisse felt much the same, explaining what he made of even the coarsest and most sensual of the poor Italian peasants who scraped a living modeling in Paris studios: "I still find essential aspects, I discover lines on his face that suggest the deep gravity that persists in every human being."[31]

Portraits like the various versions of Madame Cézanne in a red dress or the 1913 *Portrait of Madame Matisse* (fig. 70) were achieved only at great cost on both sides. Painting and posing for works of this intimacy and depth became an exacting, even brutal, physical and emotional ordeal. Cézanne's tyranny over sitters who posed on a less heroic scale was well attested by, among others, his son, who dreaded work sessions with his father.[32] Even Ambroise Vollard got a tongue-lashing when he dozed off: "Does an apple move?" Cézanne asked scathingly.[33] The models Matisse hired in relays to replace his wife in later years complained bitterly of the monastic severity of his discipline, and the bodily as well as mental exhaustion entailed by the work. The strain was inhuman, and could not be sustained indefinitely. After a relatively short period of living together, the Cézannes reached a compromise whereby they rarely stayed for long under the same roof. The Matisses' marriage ended in legal separation.

The portraits of Madame Cézanne as of Madame Matisse bear witness to a collaboration that took all that the painters and their sitters had to give. Rilke phrased it with characteristic elegance and perspicacity when he said that the love Cézanne felt for his subjects was so completely consumed and contained in the act of painting that there was no feeling left over. Cézanne's contact with other people became increasingly morose, superficial, and one-sided in his last years, when the devouring love that could not be shown to another human being found its purest, most intense and durable expression in his work: "He turned to nature and knew how to swallow back his love for every apple and put it to rest in the painted apple forever."[34]

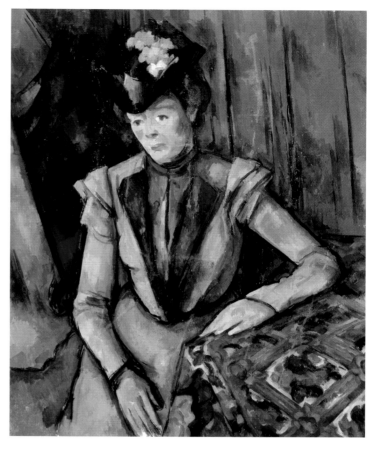

Fig. 71. Paul Cézanne, *Woman in Blue*, 1902. Oil on canvas, 34⅝ × 28⅜ in. (88 × 72 cm). State Hermitage Museum, Saint Petersburg

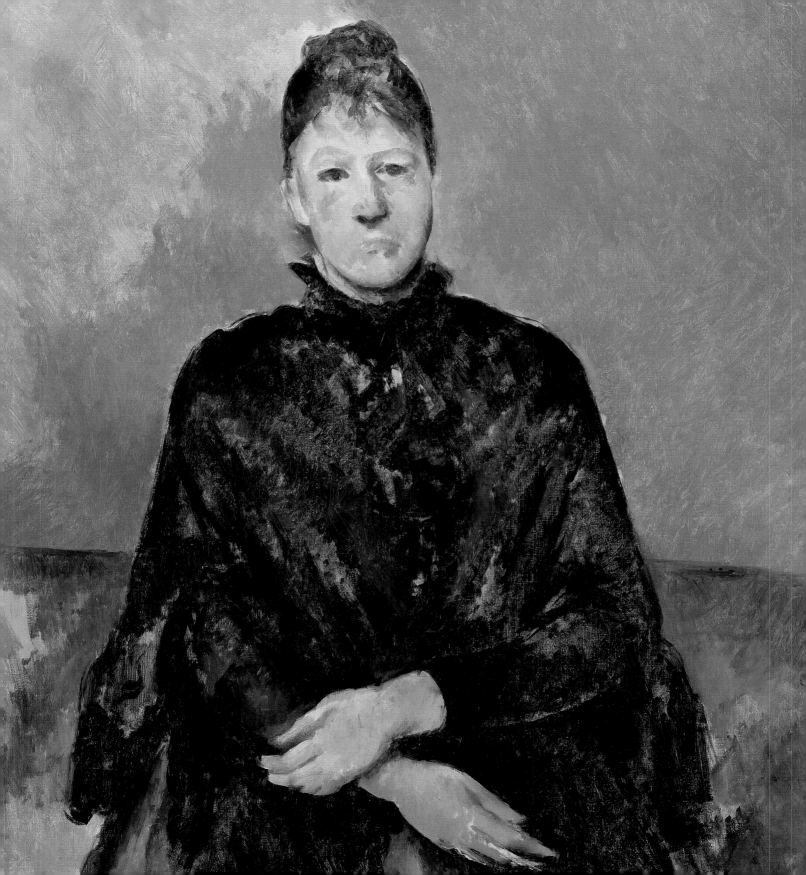

Dita Amory and
Kathryn Kremnitzer

Re-Imaging Cézanne

In 1881, Paul Gauguin wrote a letter to Camille Pissarro shamelessly confessing his wish to paint like Paul Cézanne: "If he finds the recipe for compressing the exaggerated expression of all his sensations into a single and unique procedure, I beg of you to make him talk about it in his sleep, by giving him one of those homeopathic drugs, and come to Paris as soon as possible to tell me about it."[1] The story of that dialogue, and rivalry, is well told. Cézanne is said to have written to the journalist Octave Mirbeau expressing lighthearted resentment that Gauguin had "stolen his little *sensation*."[2] Gauguin was enthralled with Cézanne. He emulated his brushstrokes and collected his paintings. When financial peril caused Gauguin to sell off his fine collection of Impressionist oils, Cézanne's pictures were the last to go. Writing to his wife, Mette, in Copenhagen in late 1885, Gauguin cautioned against parting with the Cézannes. "I cherish my two Cézannes, which are rare of their kind, as he finished but few, and one day they will be very valuable."[3] While these few words acknowledge his fascination with Cézanne, even more important is their prescient identification of the state of "unfinish" (*peu achevé*) found in so many of Cézanne's painted surfaces, especially in later years. Indeed, this aspect of his approach to painting is central to the very modernism with which we have come to laud his achievements.

Gauguin owned four landscapes, a female nude, and a still life by Cézanne. Among these, it is the now celebrated *Still Life with Fruit Dish*, of 1879–80 (fig. 72), that links the artist to the subject of our narrative.[4] A decade later, Gauguin painted *Woman in Front of a Still Life by Cézanne* (fig. 73), a

portrait of a seated female in a diagonal pose facing proper left. The identity
of the model is still debated, but the still life in the background framing
her person is decidedly Cézanne's *Still Life with Fruit Dish*. Compressed
against the picture plane, the still life, figure, and chair merge into a
spatially compact environment where the motifs of the still life butt up
against the sitter in a most disarming way. The knife nearly perforates her
sleeve, the flattened pear squeezes her shoulder, and the *compotier* seems to
hover between illusory space and actual canvas. The plasticity of still-life
motifs vies with the weight and power of the sitter, whose impenetrable
eyes and remote expression give few clues to her being. The portrait is an
investigation of relational form, upended by the grand presence of a Cézanne
still life. Analyzed dimensionally, the portrait's still life is actually larger
than its prototype. Joseph Rishel has noted that Gauguin reconsidered *Still
Life with Fruit Dish* in several of his own still lifes, some painted years later
in Tahiti.[5]

Although we have no clear evidence that Gauguin studied the portraits of Hortense Fiquet before embarking on his own homage to their maker, it is very likely that he knew of these pictures in the 1880s, when Cézanne quietly exhibited his canvases in the shop of the color merchant Père Tanguy.[6] In pose, opaque expression, and commanding presence, Gauguin's female takes many cues from the painted Hortense Fiquet. Beyond the obvious parallels, Gauguin aimed to capture Cézanne's language of painting, distilling the "exaggerated expression of all his sensations into a single and unique procedure."[7] Often hard-won, Cézanne's painting does capture in a single brushstroke that mark of genius which so eluded, and aggravated, his contemporaries.

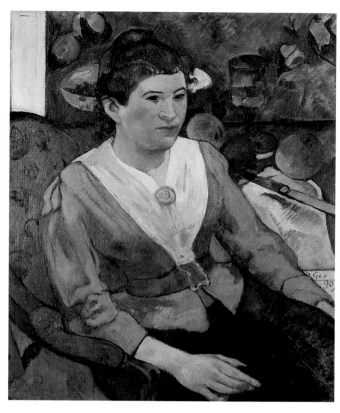

Fig. 73. Paul Gauguin (1848–1903), *Woman in Front of a Still Life by Cézanne*, 1890. Oil on canvas, 25¾ × 21⅝ in. (65.3 × 54.9 cm). Art Institute of Chicago, Joseph Winterbotham Collection (1925.753)

The portraits of Hortense Fiquet were painted in a concentrated period between 1872 and roughly 1892. We know that Cézanne worked slowly on his canvases. He likely had several canvases in progress at once, some in Paris and some in studios around Aix. Interruptions were built into his peripatetic lifestyle. We know, too, from exhibition records that few of these paintings were disseminated to the public, or to collectors, before Vollard's legendary exhibition in November 1895.[8] So, with few exceptions, it is not until the twentieth century that artists could assess the portraits of Hortense Fiquet, could study their mysterious brushwork, and could finally take stock of Cézanne's immense contribution to the unfolding narrative of modernism.

A number of twentieth-century artists were moved by Hortense Fiquet's portraits in one way or another, moved by the example of Paul Cézanne. Elizabeth Murray appropriated the image of Hortense in lighthearted redundancies; Erle Loran diagrammatically illustrated her form, giving way to Roy Lichtenstein's subsequent approximation; Juan Gris translated Hortense's image in Cubist planar abstraction; and Alberto Giacometti looked to Cézanne's surface brushwork in the many portraits of his mother,

Fig. 74. Alberto Giacometti (1901–1966), *Portrait of Madame Cézanne in the Greenhouse*, ca. 1965. Ballpoint pen on paper, 19⅝ × 12⅞ in. (49.9 × 32.6 cm). Collection Fondation Alberto et Annette Giacometti (AAG860571)

Fig. 75. Alberto Giacometti, *After Cézanne, Portrait of Madame Cézanne*, ca. 1934. Pen and ink on paper, dimensions unknown. Whereabouts unknown

Annetta. Giacometti's contemplation of Hortense Fiquet portraiture was no passing exercise. He made several ink drawings after her portraits: among them, a delicate study of *Madame Cézanne in the Conservatory* (fig. 74) and a more considered transcription of *Madame Cézanne in a Red Dress* (fig. 75), both paintings now in The Metropolitan Museum of Art (pls. 28, 22). The energetic Red Dress drawing captures the unsettled geometry of the painted composition as it alludes to the stiffened pose of the sitter.

The art of Cézanne would have a profound impact on Giacometti throughout his life. Perhaps as much as for any other artist of the past century, Giacometti's ideas about his own art emerged from what he saw in Cézanne. "Plus vraie que toute autre peinture," he once stated.[9] "Art interests me greatly, but truth interests me infinitely more."[10] The assertive brushwork—the scaffolding of linear mark-making that defines Annetta's visage (see, for example, *The Artist's Mother*, from 1937; fig. 76)—takes on a vigor and presence of disarming force, much as Cézanne's canvases track his own aesthetic explorations. One might use the words cited elsewhere in this volume—"explosive paintings about painting"—to describe these artists and their respective portrait practices. Much as Gauguin sought to know how Cézanne could transcribe his *sensations* in just a few brilliant, reductive brushstrokes, so Giacometti noted his own shortcomings as a painter of portraits. While painting his biographer James Lord in 1965, Giacometti invoked the genius of Cézanne, confessing that "if only Cézanne were here, he would set everything right with two brushstrokes."[11]

And what of the artist-model dialogue? James Lord corroborated Giacometti's assertion that the model matters, that the sitter actively participates in that exchange. Lord is famously quoted as saying, "Well, it's true that I feel my participation has been an active one in some way. I haven't felt that I was just an apple, like Madame Cézanne."[12] Such a glib remark does a disservice to Hortense Fiquet, and to Paul Cézanne, whose studio dialogue with his most famous model was deeply nuanced and complex. In literal language, Giacometti's portrait of his mother models the seated posture of many of Hortense Fiquet's portraits, for instance, *Portrait of Madame Cézanne* (pl. 24). Frontal, seated, hands clasped—the parallels are inescapable. These paintings also share something more powerful. Their sitters gaze directly at their makers. Annetta's scratched, hollowed eyes look squarely at Giacometti in close spatial contact. There is no tilt of the head, no off-center gaze, no mark

of inner being in the lens of sight, no personal idiosyncrasy. And yet for many of the black-almond-eyed images of Hortense Fiquet, there are few clues to underlying expression. The intensity of that partnership, logging in hours and hours of posing, is ultimately undermined by the distance of her gaze, and a seemingly remote temperament.

Juan Gris's variations on the theme of Madame Cézanne are the Cubist response to Cézanne's call for *réalisation* substantiating a series of transformations, from Cézanne's *sensations* to Gris's purely pictorial component parts, redefined and recombined in ideal formal terms within an ideal pictorial space.[13] Though a Spanish citizen, Gris remained principally in Paris during World War I; in 1916 he signed a contract with Léonce Rosenberg, whose Galerie de l'Effort Moderne championed Pablo Picasso, Fernand Léger, Gino Severini, and Diego Rivera, among others. Gris's wartime drawings include graphite studies after works by Cézanne, Camille Corot, and Velázquez, many of which were based on postcards or other reproductions, and some of which were later realized in oil on canvas.[14] *Portrait of Madame Cézanne after Cézanne*, the more robust of two drawings (figs. 77, 78) done after a photographic reproduction of Cézanne's *Madame Cézanne in a Yellow Chair* (pl. 20), then in the collection of the dealer Paul Rosenberg, Léonce's brother, focuses the viewer's attention on intersecting planes within and surrounding the seated figure.[15]

Gris was fascinated with the underlying geometry of Cézanne's composition, especially the relationship of the sitter's oval head to the sharply angled chair, which is accentuated in his interpretation by a second parallelogram anchored atop Madame Cézanne's hair.[16] This superimposed surface functions as a layer of light both in the drawing and in a related painting, *Madame Cézanne after a Painting by Cézanne* (fig. 79), executed in March 1918 after the same reproduction as the drawings.[17] Gris preserves several characteristics common across Cézanne's portraits of Madame Cézanne, notably the center part of her hair, the fluttering ruffle of her dress, and most recognizable, her vacant expression. Gris similarly struggles to articulate the sitter's clasped hands, which are entirely absent or fluidly indicated in the drawings, and left largely unfinished in his painted

Fig. 76. Alberto Giacometti, *The Artist's Mother*, 1937. Oil on canvas, 23⅝ × 19¾ in. (60 × 50 cm). Private collection

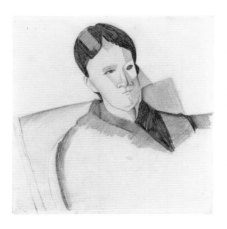

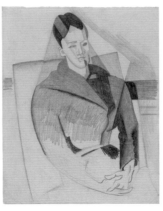

portrait. Madame Cézanne, by Gris's transformation, becomes an archetypal Cubist subject: the leveling of large, overlapping planes and in some cases inversions of form make for shallow, compressed space whereby the chair passes through the sitter, her features divided and dominated by diagonals. In both graphite and oil, bust and setting seem to flatly coalesce, faceted only by a heightened sense of chiaroscuro, anticipating the very synthesis that would later define Synthetic Cubism.[18]

Erle Loran lived in Cézanne's studio in Aix-en-Provence for more than two years before writing *Cézanne's Composition* in 1943. Accompanied by photographs of Cézanne's many motifs, Loran's analysis of the artist's forms is a combination of textual explanation and diagrammatic illustration. Loran's investigation centers on the organization of space in Cézanne's paintings, using photographic evidence of, for instance, Mont Sainte-Victoire, to resolve confounding compositional questions left unanswered by careful examination of the canvas itself. Intending to extrapolate general principles of drawing and composition from Cézanne's oeuvre for creative, critical, and instructive purposes, Loran's diagrams constitute a reductive pictorial language of arrows, lines, and letters, complete with an illustrated glossary. In a chapter devoted to "the problem

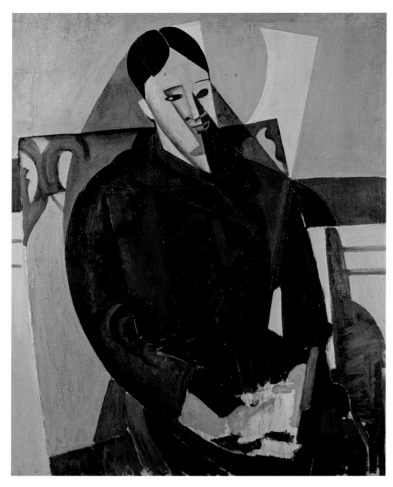

Fig. 80. Erle Loran (1905–1999), *Diagram of Cézanne's "Portrait of Madame Cézanne,"* ca. 1943. Mixed media on paper, 10¼ × 8¼ in. (26 × 21 cm). Erle Loran Papers, Archives of American Art, Smithsonian Institution, Washington, D.C.

Fig. 81. Roy Lichtenstein (1923–1997), *Portrait of Madame Cézanne*, 1962. Magna on canvas, 68 × 56 in. (172.7 × 142.2 cm). Private collection

of distortion through tipping axes," specifically "paintings that express dynamic tension," Loran considers a portrait of Madame Cézanne (pl. 25), the subject's singular mention in his study. In his diagram (fig. 80), expressly titled as such, Loran diagonally bisects a thick outline of the seated figure with a double-sided arrow to illustrate the sitter's falling volumetric axis. The sitter is recognizable as Madame Cézanne only by comparison to the painting. Contested by art historians and critics, Loran's models were met with considerable resistance and arguably run contrary to Cézanne's own view: "There is neither outline nor modeling; there are only contrasts."[19]

In 1962, Roy Lichtenstein converted Loran's diagram into a painting of his own, proprietarily titled *Portrait of Madame Cézanne* (fig. 81). While some critics regarded Lichtenstein's painting as a creative "transformation," others, including Loran, called it plagiarism. In an interview with the artist John Coplans, Lichtenstein explained why he chose this diagram in particular:

> The Cézanne is such a complex painting. Taking an outline and calling it Madame Cézanne is in itself humorous, particularly the idea of diagramming a Cézanne when Cézanne said, ". . . the outline escaped me." There is nothing wrong with making outlines of paintings. I wasn't trying to berate Erle Loran because when you talk about paintings you have to do something, but it

Fig. 82. Elizabeth Murray (1940–2007), *Madame Cézanne Falling out of Chair*, 1972. Oil on canvas, 35¼ × 36 in. (89.5 × 91.4 cm). Private collection

is such an oversimplification trying to explain a painting by A, B, C and arrows and so forth. . . . I am equally guilty of this. Cartoons are really meant for communication. You can use the same forms, almost, for a work of art.[20]

Although Lichtenstein's painting is conceptually critical of Loran's diagram, the two are almost compositionally identical. Lichtenstein's "transformation," by his own assessment, was seen by Loran and others as a "copy." To account for the augmented scale of Lichtenstein's image, in addition to the variant quality of its line, compared with Loran's diagram, is to see difference, transformation; to focus on the literal content of the image and its formal composition is to see sameness, copy.[21] After Lichtenstein's first Pop exhibition in Los Angeles, which featured his *Portrait of Madame Cézanne*, Loran published two incendiary articles in the September 1963 issues of *ARTnews* and *Artforum* and even attempted to sue the artist. Underlying this personal dispute was a mounting critical debate in defense of and against Pop Art as transformative rather than appropriationist.[22]

Taking Cézanne's portraits of his wife as a generic motif, Elizabeth Murray borrowed the seated Madame Cézanne for comic-strip-like stop-motion animation in a number of gridded paintings from 1972 (figs. 82–84). Murray's illustrations advance, from upright to upside down, echoing the instability that kept Cézanne's paintings from being "solid and durable, like the art in the museums," as he so devotedly sought to realize.[23] "It was about paying homage," Murray said of her variations on the theme of Madame Cézanne. "It's a riff on his portraits of his wife, and my idea of her. . . . I think Madame Cézanne is me, kooky as that may sound. I think that's what I was thinking, that I was her and I was falling forward in the rocking chair or making that gesture."[24] Cézanne's portraits of his wife, "whom he both had a lot of trouble with and was very attracted to, are rather erotic pictures, even if she looks unhappy and a little unwilling."[25] These "tender" portraits, painted with "such ambivalence,"

are for Murray "exquisite paintings," paintings "really about the joy of looking at painting."[26] Standing in front of the Metropolitan Museum's *Madame Cézanne in a Red Dress* (pl. 22), Murray noted a "mixture of fear and love" in a picture "all about uncertainty."[27] Using stick figures to establish a narrative sequence, Murray shows Madame Cézanne sitting for her portrait, gradually dozing off, falling out of the chair, reseating herself, and remaining still. Frame by frame, Murray's paintings after Madame Cézanne articulate a working relationship between artist and model, model and surroundings, still life and *un*still life.[28]

These second-generation portraits are not portraits at all, but rather investigations of form: synthesis and deconstruction. Collectively they take possession of Cézanne, appropriating his model and adapting his pictorial structure. Gauguin and Giacometti pay homage to Cézanne imagistically. Gris plays with our iconic female portraits, overlaying the figure in prismatic Cubist geometry. Loran's diagram of volumetric axis translates to theoretical abstraction in Lichtenstein's variation. These riffs on Hortense Fiquet's portraits ultimately reinforce the resonating power of Paul Cézanne. Unable to capture the essence of his process, artists have found other means to align themselves in pencil, ink, and paint. More than a century later, Cézanne continues to bewitch, beguile, and confound. Gauguin was not alone in his puzzlement.

Fig. 83. Elizabeth Murray, *Madame Cézanne in a Rocking Chair*, 1972. Oil on canvas, 35¼ × 35½ in. (89.5 × 90.2 cm). Private collection

Fig. 84. Elizabeth Murray, *Madame Cézanne Seated in an Armchair Turning On Light*, 1972. Oil on canvas, 35¾ × 35¾ in. (90.7 × 90.7 cm). Whereabouts unknown

NOTES

Dita Amory, "Newly Seeing the Familiar: Paul Cézanne, Hortense Fiquet, and the Portraits"

1. *The Masterpiece* (*L'Oeuvre*) is the fourteenth novel in the Rougon-Macquart series by Emile Zola. It was serialized in the periodical *Gil Blas* beginning in December 1885 before being published as a novel by Gervais Charpentier in 1886. Emile Zola, *The Masterpiece*, trans. Thomas Walton, rev. Roger Pearson (Oxford, UK: Oxford University Press, 2008), p. 239.

2. Paul Cézanne, letter to Emile Zola, Aix, March 28, 1878, in John Rewald, ed., *Paul Cézanne: Letters*, trans. Marguerite Kay (New York: Da Capo Press, 1995), p. 155.

3. Paul Cézanne, letter to Emile Zola, Aix, June 1, 1878, in Rewald, *Paul Cézanne: Letters*, p. 161.

4. Louis-Auguste Cézanne was born on June 28, 1798, in Saint-Zacharie and died on October 23, 1886, at the Jas de Bouffan, near Aix, six months after his son's wedding.

5. In December 1858, Cézanne wrote to Zola in Paris, asking for information about entry to the Ecole des Beaux-Arts there. In September 1861, after failing to qualify for a place at the school, he returned to Aix to work in his father's bank. In early November 1862, Cézanne went back to Paris and was again rejected by the Ecole on the grounds that his paintings were "clumsy and unconventional." Ulrike Becks-Malorny, *Paul Cézanne, 1839–1906: Pioneer of Modernism*, trans. Phil Goddard in association with First Edition Translations (Cologne: Taschen, 2001), p. 10.

6. Gerstle Mack, *Paul Cézanne* (New York: Alfred A. Knopf, 1935), p. 232; Anne H. van Buren, "Madame Cézanne in Oil and Pencil" (master's thesis, University of Texas at Austin, 1964), p. 32; Ruth Butler, *Hidden in the Shadow of the Master: The Model-Wives of Cézanne, Monet, and Rodin* (New Haven: Yale University Press, 2008), p. 41.

7. See Philippe Cézanne's essay "My Great-Grandmother Marie-Hortense Fiquet" in this volume.

8. Hortense's mother, Catherine Déprez, died on July 23, 1867, in the family's home on rue Childebert in Paris, when Hortense was seventeen.

9. There are twenty-nine known painted portraits of Hortense Fiquet, spanning some twenty-five years. There are more than fifty drawings of her, nearly a third of which are bound in sketchbooks, and several extant watercolors. See Marjorie Shelley's essay "Cézanne as Draftsman: Sketchbooks and Graphite Drawings" in this volume for a discussion of the sketchbooks.

10. Like his son, Cézanne was born out of wedlock.

11. In February 1879, Cézanne described Hortense to Victor Chocquet as one "on whom rests the burden of attending to our daily food and who well knows the trouble and bother it causes." Paul Cézanne, letter to Victor Chocquet, L'Estaque, February 7, 1879, in Rewald, *Paul Cézanne: Letters*, p. 177.

12. In L'Estaque, Cézanne and Hortense rented a fisherman's cottage on place de l'Eglise apparently underwritten by the artist's mother. Anne-Elisabeth Cézanne evidently shared her son's belief that the relationship should remain a secret from his father, even after the birth of his own son. Butler, *Hidden in the Shadow of the Master*, p. 25.

13. Paul *fils* was born in an apartment at 45, rue Jussieu in Paris; Cézanne acknowledged paternity. Birth certificate, Archives de Paris. See Isabelle Cahn, "Chronology," in Françoise Cachin and Joseph J. Rishel, *Cézanne*, trans. John Goodman, exh. cat. (Paris: Galeries Nationales du Grand Palais; London: Tate Gallery; Philadelphia: Philadelphia Museum of Art; New York: Harry N. Abrams in association with Philadelphia Museum of Art, 1996), p. 537.

14. Jules Borély, interview with Paul Cézanne, July 1902, in "Cézanne à Aix" (from *L'Art vivant*, 1926), in *Conversations avec Cézanne*, ed. Michael Doran (1978; Paris: Macula, 2011), p. 51.

15. Pissarro commented to his fellow artist Gustave Guillaumet in a letter of 1872: "Our Cézanne is giving us much hope. . . . I have in my house a painting of remarkable vigour, remarkable strength. If, as I hope, he remains for some time in Auvers, where he is going to take up residence, many artists who condemned him much too hastily will be astonished." Matthew Simms, *Cézanne's Watercolors: Between Drawing and Painting* (New Haven: Yale University Press, 2008), p. 45.

16. Denis Coutagne, ed., *Cézanne and Paris*, exh. cat. (Paris: Musée du Luxembourg; Editions de la Réunion des Musées Nationaux–Grand Palais, 2011), p. 23.

17. The Salon rejected Cézanne's submissions each year from 1864 to 1870 and again in 1872, and from 1876 to 1879. His work was accepted by the Salon for the first and only time in 1882, when he exhibited *The Artist's Father, Reading "L'Evénement."* In an August 1861 letter to Baptistin Baille, a professor and close friend of Cézanne's in Paris, Zola wrote: "Paul may have the genius of a great painter, [but] he'll never have the genius to become one." Later, in his review of the 1896 Salon, published in *Le Figaro* on May 2, Zola observed: "I had grown up almost in the same cradle as my friend, my brother, Paul Cézanne, whose genius is only now being recognized as that of a great painter who has failed." Rewald, *Paul Cézanne: Letters*, pp. 92, 246–47na.

18. Ambroise Vollard recounted that Cézanne often checked his paintings at night, on occasions when insomnia interrupted his sleep. If he was pleased, he would awaken Hortense for a game of checkers. Letter in the Archives of the Musée d'Orsay, cited in Butler, *Hidden in the Shadow of the Master*, pp. 78–79.

19. Hortense reportedly once told Henri Matisse, "You understand, Cézanne didn't know what he was doing. He didn't know how to finish his pictures. Renoir and Monet, they knew their craft as painters." Marie-Alain Couturier, *Se garder libre: Journal (1947–1954)* (Paris: Cerf, 1962), p. 116, cited in John Rewald, *Cézanne: A Biography* (New York: Harry N. Abrams, 1986), p. 266.

20. Joachim Gasquet, "Ce qu'il m'a dit . . ." (from *Cézanne*), in Doran, *Conversations avec Cézanne*, pp. 186–87.

21. Paul Cézanne, letter to Paul Cézanne *fils*, Aix, September 8, 1906, in Rewald, *Paul Cézanne: Letters*, p. 327.

22. Anne H. van Buren graphed the Hortense Fiquet portrait in time, using costume as a measure, in "Madame Cézanne's Fashions and the Dates of Her Portraits," *Art Quarterly* 29, no. 2 (1966), pp. 111–27.

23. Emile Zola, "Mon salon: L'Ouverture," *L'Evénement illustré*, May 2, 1868.

24. Linda Nochlin, "Impressionist Portraits and the Construction of Modern Identity," in Colin B. Bailey, with the assistance of John B. Collins, *Renoir's Portraits: Impressions of an Age*, exh. cat. (Ottawa: National Gallery of Canada; New Haven: Yale University Press, 1997), p. 66.

25. Scholars still debate the identity of the sitter in Cézanne's *Seated Woman (Madame Cézanne)* (R. 411), often thought to be Madame Cézanne.

26. Gasquet, "Ce qu'il m'a dit," pp. 254–55. Joachim Gasquet, a friend of Cézanne's, was a poet and art critic, and the author of a 1921 book on the artist.

27. Zola, *The Masterpiece*, pp. 239–40.

28. Susan Sidlauskas, *Cézanne's Other: The Portraits of Hortense* (Berkeley: University of California Press, 2009).

29. Hortense Fiquet, letter to Marie Chocquet, Emagny, August 1 (no year), Musée des Lettres et Manuscrits, Paris, no. 37119. Hortense Fiquet, letter to Emile Bernard, September 10, 1905, Musée d'Orsay, Service Culturel Documentation. Hortense Fiquet, letter to Aline Renoir, Paris, June 24 (no year), private collection.

30. Hortense Fiquet, letter to Marie Chocquet, August 1 (no year), in Alex Danchev, ed. and trans., *The Letters of Paul Cézanne* (Los Angeles: J. Paul Getty Museum, 2013), no. 150, pp. 254–55.

31. M.C. [Marthe Conil?], "Quelques Souvenirs sur Paul Cézanne, par une de ses nièces," *Gazette des beaux-arts*, ser. 6, vol. 56, no. 1102 (November 1960), pp. 299–302. In an interview published in 1995, Cézanne's great-niece Aline reprised material from the 1960 article; see Laurence Mouillefarine, "A la une: Nous avons retrouvé des Cézannes," *Madame Figaro*, September 23, 1995, pp. 14–18.

32. According to Raymond Hurtu, it was Zola's wife, Alexandrine, who coined the nickname "La Boule" (the Ball, or the Dumpling), which surfaces in several letters. The name appears in the literature long after Hortense Fiquet's death in 1922, always pejoratively. Raymond Hurtu, "Quand Cézanne vient peindre au pays de Courbet . . . ," in Denis Coutagne, *Courbet/Cézanne: La Vérité en peinture*, exh. cat. (Ornans, France: Musée Gustave Courbet; Lyon: Fage, 2013), p. 119; Rewald, *Paul Cézanne: Letters*, pp. 234–35.

33. Hortense Fiquet was known to be very gregarious and a great conversationalist; see Rewald, *Cézanne*, p. 125.

34. Roger Fry, letter to Helen Anrep, May 1, 1925, in *Letters of Roger Fry*, ed. Denys Sutton (London: Chatto and Windus, 1972), p. 568.

35. Matisse owned *Portrait of Madame Cézanne*, from about 1885–88, now in the Musée d'Orsay, Paris (pl. 16). A second painting, *Portrait of Madame Cézanne*, from about 1886–87, in the Philadelphia Museum of Art (pl. 13) may also have been in Matisse's collection. While Hilary Spurling rejects this suggestion (see n13 in her essay in this volume), there is plausible evidence to support the notion that Matisse owned two portraits of Madame Cézanne. In preparing his 1936 catalogue raisonné, *Cezanne: Son Art—son oeuvre*, Lionello Venturi consulted Paul Rosenberg's photographic archive and found a photograph of the Philadelphia portrait. On the reverse of the photograph—still visible today in the archive—was written, in Rosenberg's hand: "M[m]e Cézanne / Col. P. R / Henri Matisse."

36. Henri Matisse, letter to André Rouveyre, Venice, June 3, 1947, in *Matisse, Rouveyre: Correspondance*, ed. Hanne Finsen (Paris: Flammarion, 2001), p. 445.

37. M.C. [Marthe Conil?], "Quelques Souvenirs," p. 300.

38. Rainer Maria Rilke, letter to Clara Westhoff, Paris, October 22, 1907, in Rainer Maria Rilke, *Letters on Cézanne*, ed. Clara Rilke, trans. Joel Agee (New York: North Point Press, 2002), p. 70.

39. Gris executed this and other Cézanne studies—among them, *Portrait of Madame Cézanne after Cézanne*, Beaulieu (Beaulieu-lès-Loches) (1916) and *Portrait of Madame Cézanne (after a Painting by Cézanne)* (ca. 1916)—in preparation for his own figure paintings of 1916, most notably one of his wife, *Portrait of Madame Josette Gris* (Museo del Prado, Madrid). In 1916, Cézanne's *Madame Cézanne in a Yellow Chair* (pl. 20) was in the collection of the gallery owner Paul Rosenberg, the brother of Gris's dealer, Léonce Rosenberg. Although Gris plausibly saw the painting in person, he most likely worked on his renderings from a reproduction. *Impressionist and Twentieth Century Works on Paper*, sale cat. (New York: Christie's, New York, May 9, 2000), lot 331.

40. See Dita Amory and Kathryn Kremnitzer's essay "Re-Imaging Cézanne" in this volume.

41. D. H. Lawrence, *Late Essays and Articles*, ed. James T. Boulton (Cambridge, UK: Cambridge University Press, 2004), pp. 211–14.

42. John Rewald calls the red armchair "a personality," speaking of the painting, while Susan Sidlauskas, referring to Rilke's prose, calls the crimson chair the true "protagonist" of the painting. John Rewald, in collaboration with Walter Feilchenfeldt and Jayne Warman, *The Paintings of Paul*

Cézanne: A Catalogue Raisonné (New York: Harry N. Abrams, 1996), vol. 1, p. 219; Sidlauskas, *Cézanne's Other*, p. 11.

43. Paul Cézanne, letter to Emile Zola, L'Estaque, September 24, 1878, in Rewald, *Paul Cézanne: Letters*, p. 168.

44. Paul Cézanne, letter to Emile Zola, L'Estaque, March 23, 1878, in Rewald, *Paul Cézanne: Letters*, p. 154.

45. Paul Cézanne, letter to Emile Zola, Aix, March 28, 1878, in Rewald, *Paul Cézanne: Letters*, p. 155.

46. See Paul Cézanne, letter to Emile Zola, L'Estaque, September 14, 1878, in Rewald, *Paul Cézanne: Letters*, p. 167.

47. Ibid.

48. Paul Cézanne, letter to Emile Zola, L'Estaque, December 19, 1878, in Rewald, *Paul Cézanne: Letters*, pp. 173–74.

49. In a letter to Victor Chocquet, Renoir related: "At lunch, Madame Cézanne gave me a *brandade de morue*. I believe it's the nectar of the Gods rediscovered. One must eat it and die." Renoir would later say that Cézanne was unique among painters, citing that Hortense had one of Cézanne's recipes for baked tomatoes and that she would tell the cook to be "a little more generous with the olive oil." Auguste Renoir, letter to Victor Chocquet, L'Estaque, March 2, 1882, in Alex Danchev, ed. and trans., *The Letters of Paul Cézanne* (London: Thames and Hudson, 2013), pp. 222–23n1.

50. Paul Cézanne, letter to Emile Zola, Jas de Bouffan, Aix, November 27, 1882, in Rewald, *Paul Cézanne: Letters*, p. 204.

51. Rewald, *Cézanne*, p. 251.

52. Paul Cézanne, letter to Emile Zola, Jas de Bouffan, Aix, May 14, 1885, in Rewald, *Paul Cézanne: Letters*, pp. 214–15.

53. "I saw you and you allowed me to kiss you; from that moment a profound emotion has not stopped exciting me. You will excuse the liberty that a friend, tortured by anxiety, takes in writing to you. I do not know how to explain to you this liberty that you may find so great, but could I have remained under this burden which oppresses me? Is it not better to give expression to a sentiment rather than to conceal it? Why, I said to myself, suppress the cause of your agony? Is it not a relief granted to suffering, to be allowed to express itself? And if physical pain seems to find relief in the cries of the afflicted, is it not natural, Madame, that moral sadness seeks some consolation in the confession made to an adored being? I know well that this letter, the hasty and premature sending of which may appear indiscreet, has nothing to recommend me to you but the goodness of . . ." Paul Cézanne, rough draft of a letter to an unknown woman, spring 1885, written on the back of a drawing now in the Albertina, Vienna, in Rewald, *Paul Cézanne: Letters*, pp. 214–15.

54. Sidlauskas, *Cézanne's Other*, p. 27.

55. Jack Lindsay, *Cézanne: His Life and Art* (Greenwich, Conn.: New York Graphic Society, 1969), p. 218.

56. See Charlotte Hale's essay "A Template for Experimentation: Cézanne's Process and the Paintings of Hortense Fiquet" in this volume.

57. Paul Cézanne, letter to Emile Zola, Gardanne, April 4, 1886, in Rewald, *Paul Cézanne: Letters*, p. 223.

58. Claude Monet, letter to Camille Pissarro, ca. April 10, 1886, and see also letter to Emile Zola, April 5, 1886, in Daniel Wildenstein, *Claude Monet: Biographie et catalogue raisonné* (Lausanne and Paris: Bibliothèque des Arts, Fondation Wildenstein, 1974), vol. 2, nos. 664, 667, pp. 274, 74.

59. See Hortense Fiquet's letter to Marie Chocquet, p. 9.

60. Henri Perruchot, *La Vie de Cézanne* (Paris: Hachette, 1958), pp. 318–19.

61. Paul Alexis, letter to Emile Zola, February 1891, in Rewald, *Paul Cézanne: Letters*, pp. 234–35 (translation edited).

62. Coutagne, *Courbet/Cézanne*, p. 123.

63. "I, only I have the temperament, only I know how to paint a real red!" Paul Cézanne, quoted in Camille Pissarro, letter to Lucien Pissarro, Rouen, January 20, 1896, in John Rewald, ed., with the assistance of Lucien Pissarro, *Camille Pissarro: Lettres à son fils Lucien* (Paris: Albin Michel, 1950), p. 397.

64. It was not Cézanne's habit to finish one passage of his canvas and then move on to another. His brush marks always searched for the appropriate balance of tone as that color field harmonized through the rectangle. In the portraits, the final facial expression materializes only when the canvas is deemed finished, when the entirety of the image is perfectly balanced in the eyes and hand of the artist.

65. "Chaque fois que je me mets devant mon chevalet, je suis un autre homme, moi, et toujours Cézanne." Gasquet, "Ce qu'il m'a dit," p. 256.

66. Zola, *The Masterpiece*, pp. 239–40.

67. Paul *fils* inscribed "91" on the back of a photograph of the painting. Rewald with Feilchenfeldt and Warman, *Paintings of Paul Cézanne: Catalogue Raisonné*, vol. 1, pp. 441–42.

68. See Charlotte Hale's essay "A Template for Experimentation: Cézanne's Process and the Paintings of Hortense Fiquet" in this volume.

69. Natalia Semionova, "Ivan Morozov's Life and Collection," 2010, www.morozov-shchukin.com/html/sa_vie_anglais.html.

70. Léo Larguier, excerpt from *Le Dimanche avec Paul Cézanne* (1925), in Doran, *Conversations avec Cézanne*, p. 36. The portraits are *Woman in Blue*, from 1902 (State Hermitage Museum, Saint Petersburg), and *Seated Woman in Blue*, from 1902–6 (Phillips Collection, Washington, D.C.).

71. Entry for November 1901, Maurice Denis, *Journal* (Paris: La Colombe, 1957), vol. 1, pp. 175–76.

72. Paul Cézanne, letter to Paul Cézanne *fils*, Aix, July 25, 1906, in Rewald, *Paul Cézanne: Letters*, p. 319.

73. Marie Cézanne, letter to Paul Cézanne *fils*, October 20, 1906, in Lionello Venturi, *Cézanne* (New York: Rizzoli, 1978), pp. 333–34.

74. "Come at once both of you father ill." Venturi, *Cézanne*, p. 334.

75. An undocumented, oft-told story has it that Hortense missed the first train to Aix on that fateful day because she had an

appointment with her seamstress. Paul Cézanne died at seven a.m. at his home at 23, rue Boulegon. Death certificate, Archives, Hôtel de Ville, Aix-en-Provence; register of the cathedral of Saint-Sauveur, Archdiocesan Archives, Aix-en-Provence, no. 98 (Cézanne is erroneously identified as "husband Aubert," his mother's family name). Cahn, "Chronology," p. 569.

76. Lacking the necessary funds, Vollard approached the brothers Josse Bernheim-Jeune and Gaston Bernheim de Villers to jointly purchase Cézanne's estate; even then, they had to pay in several installments. See Rewald, *Cézanne*, p. 265.

77. Hortense Fiquet, letter to Emile Bernard, September 10, 1905, in Alex Danchev, *Cezanne: A Life* (New York: Pantheon), p. 171.

78. Rewald, *Cézanne*, p. 265.

79. In an apparently unpublished letter to Aline Renoir, the artist's second wife, Hortense discusses travel plans, family visits, and the warm summer weather. She hopes for a visit from the Renoirs and addresses Aline affectionately:

Ma Chère Aline,

Je sais par Mr Rivière que ton Jean est à Besançon. Je dois aller en Savoie ou peut-être en Suisse. Je passerai par Besançon et j'y resterai quelques jours. J'aurai donc le plaisir de voir Jean. Je suis heureuse de voir qu'on a pu l'évacuer. Je préfère le voir a Besançon qu'à Gérardmer. Vous irez sans doute le voir et qui sait vous trouverez peut-être à vous installer par là, le pays est joli et plaira certainement à Renoir. Si cela se produit je m'y établirai moi-même, car je serai heureuse d'être auprès de vous. Vous devez avoir chaud à Cagnes. Ici nous avons des alternatives de chaud, temps orageux et raffraichissement de la température. Je vais passer trois jours à Nantes. Je pense partir pour Besançon vers le 12 juillet. Je suis Hôtel de la Hte [Haute] Loire, [Boulevard] Raspail jusqu'à mardi. J'espère que vous allez bien et que tu es un peu plus rassurée, ma pauvre Aline. Conserver ses enfants tout est là.

Au revoir donc, ma bonne amie. Mes meilleurs souvenirs pour Renoir, un gros baiser pour Claude

Je t'embrasse tendrement
Ta vieille amie
M. Cézanne

Si tu peux m'envoyer un petit mot pour me dire ce que tu penses faire, tu peux l'adresser [Boulevard] Montparnasse 119, car où que je sois, il me parviendra. Hortense Fiquet, letter to Aline Renoir, Paris, June 24 (no year), private collection.

Philippe Cézanne, "My Great-Grandmother Marie-Hortense Fiquet"

1. In a letter dated February 8, 1922, to her father, Georges Rivière, my grandmother Renée Cézanne recounted: "We had a very simple wedding for Claude. You will see the newlyweds, Paul [Cézanne *fils*], and Jean [Renoir] soon. They're leaving for Paris to finish the division [of Auguste Renoir's inheritance]."

2. Jean de Beucken, *Un Portrait de Cézanne* (Paris: Gallimard, 1955).

3. In addition to Hortense, the Fiquets had a son, François-Jules, and a daughter, Marie-Eugénie-Ernestine.

4. Cézanne did a portrait of Louis Guillaume in about 1882 (National Gallery of Art, Washington, D.C. [1963.10.101]). Guillaume is also the Pierrot in the 1888 painting *Pierrot and Harlequin (Mardi Gras)*, with young Paul as Harlequin (The Pushkin State Museum of Fine Arts, Moscow [3335]).

5. A dynasty of art publishers and international gallery owners from 1827 to 1920, the Goupil family reproduced primarily famous paintings from public collections and Salon exhibitions. Members of the family were partners in Goupil & Cie, a leading international art dealership based in Paris, active from its founding in 1850 through the late 1880s. Victor Chocquet, a minor French government official and notable patron of the Impressionists, had his portrait painted by Cézanne twice between 1876 and 1877; he is also the subject of several pencil studies.

6. See Paul Cézanne, letter to Achille Emperaire, Paris, January 1872, in John Rewald, ed., *Paul Cézanne: Letters*, trans. Marguerite Kay (New York: Da Capo Press, 1995), p. 133n.a.

7. Paul Cézanne, letter to Emile Zola, Aix, June 1, 1878, in Rewald, *Paul Cézanne: Letters*, p. 161.

8. Paul Cézanne, letter to Victor Chocquet, L'Estaque, February 7, 1879, in Rewald, *Paul Cézanne: Letters*, p. 177. Although Cézanne refers to Hortense as his "wife," the couple would not marry until 1886.

9. On the back of a drawing in the Albertina is a fragmentary rough draft of a letter to an unnamed woman, sometimes identified as Fanny, with whom Cézanne appears to have had an affair in 1885, the year before he married Hortense. See Rewald, *Paul Cézanne: Letters*, p. 214, and n. 53 in Dita Amory's essay "Newly Seeing the Familiar: Paul Cézanne, Hortense Fiquet, and the Portraits" in this volume.

10. On February 23, an earthquake shook Liguria and Piedmont in Italy, causing at least 630 deaths. It was felt on the Côte d'Azur and as far away as Marseille, Aix, and the surrounding region.

11. Hortense Fiquet, letter to Marie Chocquet, August 1 (no year), in Alex Danchev, *Cézanne: A Life* (New York: Pantheon, 2012), p. 170.

12. Raymond Hurtu, "Quand Cézanne vient peindre au pays de Courbet . . . ," in Denis Coutagne, *Courbet/Cézanne: La Verité en peinture*, exh. cat. (Ornans, France: Musée Gustave Courbet; Lyon: Fage, 2013), pp. 108–17.

13. Paul Cézanne, letter to Joachim Gasquet, Talloires, July 21, 1896, in Rewald, *Paul Cézanne: Letters*, pp. 250–51.

Charlotte Hale, "A Template for Experimentation: Cézanne's Process and the Paintings of Hortense Fiquet"

I am indebted to many colleagues who generously made it possible to examine paintings of Madame Cézanne in their collections, as well as conservation records: Emily Beeny, Rhona

MacBeth, and Irene Konefal at the Museum of Fine Arts, Boston; Joseph Rishel and Mark Tucker at the Philadelphia Museum of Art; Judith Dolkart, Barbara Buckley, and Anya Shutov at the Barnes Foundation; Gloria Groom, Frank Zuccari, and Kelly Keegan at the Art Institute of Chicago; Salvador Salort-Pons and Alfred Ackerman at the Detroit Institute of Arts; Gary Tinterow, Helga Aurisch, David Bomford, and Zahira Véliz at the Museum of Fine Arts, Houston; Isabelle Cahn and Bénédicte Trémolières at the Musée d'Orsay; Frédérique Thomas-Maurin and Julie Delmas at the Musée Courbet; Stéphanie Lardez at the Musée Granet; Oliver Wick, Markus Gross, and Friederike Steckling at the Fondation Beyeler; Lukas Gloor, Ruth Nagel, and Thomas Becker at the Foundation E. G. Bührle Collection; Kyllikki Zacharias and Felicia Rappe at the Berggruen Museum; and private collectors. For discussion of Cézanne's technique, I am particularly grateful to Elisabeth Reissner at the Courtauld Institute of Art. I would also like to thank Karen Barbosa, Aviva Burnstock, Susannah Rutherglen, and Jayne Warman, and, at the Metropolitan Museum, Dita Amory, Susan Stein, Keith Christiansen, Rebecca Rabinow, Michael Gallagher, Silvia Centeno, Mark Wypyski, Julie Arslanoglu, Evan Read, and Kathryn Kremnitzer.

1. Léo Larguier, "Excerpt from *Sunday with Paul Cézanne*" (1901–2; 1925), in *Conversations with Cézanne*, ed. Michael Doran, trans. Julie Lawrence Cochran (Berkeley: University of California Press, 2001), p. 18.
2. Cézanne's Bather subjects are anomalous: while some figures were based on early studies from life, and after works of art, these compositions derived largely from his imagination.
3. Paul Cézanne, letter to Paul Cézanne *fils*, Aix, September 8, 1906, in John Rewald, ed., *Paul Cézanne: Letters*, trans. Marguerite Kay (New York: Da Capo Press, 1995), p. 327.
4. For example, see Anne H. van Buren, "Madame Cézanne's Fashions and the Dates of Her Portraits," *Art Quarterly* 29, no. 2 (1966), pp. 111–27; Lawrence Gowing, "Notes on the Development of Cézanne," *Burlington Magazine* 98, no. 639 (June 1956), pp. 185–92.
5. Indeed, a number of these pictures were earlier given generic titles, as her identity was not obvious. Gertrude Stein, for instance, described as "a big portrait of a woman by Cézanne" the painting here called *Portrait of the Artist's Wife* (pl. 6). Gertrude Stein, *The Autobiography of Alice B. Toklas*, in *Writings 1903–1932* (New York: Library of America, 1998), p. 668.
6. Ambroise Vollard, who sat for Cézanne in 1899, recounted: "From the moment that he put down the first brush stroke until the end of the sitting he treated the model like a simple still-life." Ambroise Vollard, *Paul Cézanne: His Life and Art*, trans. Harold L. Van Doren (New York: Crown, 1937), p. 83. See also Susan Sidlauskas, *Cézanne's Other: The Portraits of Hortense* (Berkeley: University of California Press, 2009), pp. 34–36.
7. On Cézanne's *sensation*, see Richard Shiff, "Sensation, Cézanne," in *Cézanne and the Past: Tradition and Creativity*, ed. Judit Geskó (Budapest: Museum of Fine Arts, 2012), pp. 35–47.
8. Joachim Gasquet, "What He Told Me . . ." (from *Cézanne*, 1921), in Doran, *Conversations with Cézanne*, pp. 151–52.
9. Vollard, *Paul Cézanne*, p. 76.
10. According to Joachim Gasquet, "It was one of his usual procedures, especially when he was beginning a portrait, to go on working after the model had left." Gasquet stressed this point, noting that it was often claimed that Cézanne never painted without the model in front of him. See Joachim Gasquet, *Joachim Gasquet's Cézanne: A Memoir with Conversations*, trans. Christopher Pemberton (London: Thames and Hudson, 1991), p. 113–14.
11. Emile Bernard, "Memories of Paul Cézanne" (from *Mercure de France*, 1904–6; 1907), in Doran, *Conversations with Cézanne*, p. 61; see also Vollard, *Paul Cézanne*, pp. 79, 81–82.
12. Vollard, *Paul Cézanne*, chap. 8, pp. 76–88; Gasquet, "What He Told Me," pp. 147–60; Bernard, "Memories of Paul Cézanne," pp. 50–79.
13. Vollard, *Paul Cézanne*, pp. 78–79, 88.
14. For Emile Bernard's photographs of Cézanne in his studio about 1904, see Isabelle Cahn, "Chronology," in Françoise Cachin and Joseph J. Rishel, *Cézanne*, trans. John Goodman, exh. cat. (Paris: Galeries Nationales du Grand Palais; London: Tate Gallery; Philadelphia: Philadelphia Museum of Art; New York: Harry N. Abrams in association with Philadelphia Museum of Art, 1996), p. 563. For Ker Xavier Roussel's photographs of Cézanne on the hill of Les Lauves, see John Rewald, *Cézanne: A Biography* (New York: Harry N. Abrams, 1986), pp. 258–59. For Maurice Denis's 1906 painting *A Visit to the House of Cézanne in Aix*, see Cachin and Rishel, *Cézanne*, p. 44.
15. John Rewald, in collaboration with Walter Feilchenfeldt and Jayne Warman, *The Paintings of Paul Cézanne: A Catalogue Raisonné* (New York: Harry N. Abrams, 1996), vol. 1, pp. 441–42.
16. Gasquet, "What He Told Me," p. 122.
17. On Cézanne's "ways of deliberately restricting variables," see Elisabeth Reissner, "Ways of Making: Practice and Innovation in Cézanne's Paintings in the National Gallery," *National Gallery Technical Bulletin* 29 (2008), p. 19.
18. Cézanne is known to have obtained materials from a number of suppliers, including Julien Tanguy and Chabod; see ibid., pp. 7–8. For a table of standard-size formats from 1889, see Anthea Callen, *The Art of Impressionism: Painting Technique and the Making of Modernity* (New Haven: Yale University Press, 2000), p. 15. The numbers of standard-size formats refer to the price in sous when these formats became the norm, in the late seventeenth century; see Callen, *Art of Impressionism*, p. 18. In letters, Cézanne often refers to paintings by their numbered format; see, for example, Rewald, *Paul Cézanne: Letters*, pp. 110, 195, 232, 236. Graphite lines with

which Cézanne marked the edges of the composition at the bottom and right edges of one portrait (pl. 8) prior to painting indicate that he used part of a larger canvas for this small work.

19. The Lefranc & Cie catalogue of 1889 (see Callen, *Art of Impressionism*, p. 15) lists the dimensions of a standard size 8 *figure* as 46 × 38 centimeters (18⅛ × 15 inches); this format was used for a number of portraits (pls. 1, 13, 14, 15, 16, 27; fig. 9 on p. 38). *Madame Cézanne in the Conservatory* is a standard size 30: 92.1 × 73 centimeters (36¼ × 28¼ inches).

20. Emile Bernard noted several paintings "drying without their stretchers," pinned up on the wall of Cézanne's studio; see Bernard, "Memories of Paul Cézanne," p. 59.

21. For example, *Antoine Dominique Sauveur Aubert (born 1817), the Artist's Uncle* and *Antoine Dominique Sauveur Aubert (born 1817), the Artist's Uncle, as a Monk*, both in The Metropolitan Museum of Art, New York (53.140.1 and 1993.400.1, respectively), were painted on olive-green-colored primings.

22. Pigment analysis of the Metropolitan Museum's paintings was undertaken by Silvia A. Centeno and Mark Wypyski, Department of Scientific Research, using Raman spectroscopy, and energy-dispersive X-ray spectrometry in the scanning electron microscope (SEM-EDS). Local distortions, or "cusping," from initial stretching are seen on all edges of this and other paintings (pls. 4, 10, 14, 15, 16, 17, 19, 20, 24). Other canvases, where there is cusping on only one or two sides, or none at all, were more likely cut from large bolts preprimed by a supplier, or may have started out on larger, individually primed canvases. On the artist's grounds, see Reissner, "Ways of Making," pp. 8–9, and Reissner, "Transparency of Means: Drawing and Colour in Cézanne's Watercolours and Oil Paintings in the Courtauld Gallery," in *The Courtauld Cézannes*, ed. Stephanie Buck, John House, Ernst Vegelin van Claerbergen, and Barnaby Wright (London: Courtauld Gallery in association with Paul Holberton, 2008), pp. 66, 68, and 71n68.

23. For other drawings associated with specific paintings, see Wayne Andersen, *Cézanne's Portrait Drawings* (Cambridge, Mass.: MIT Press, 1970), no. 30, p. 72, in relation to *Portrait of Madame Cézanne* (fig. 9 on p. 38 in this volume), and no. 33, p. 75 (pl. 39 in this volume), in relation to *Madame Cézanne Sewing* (pl. 5). The connection between sketches and paintings is seldom clear with Cézanne, and research in this area is hampered because studies associated with his paintings likely have been lost or were destroyed by the artist.

24. The Raman spectrum recorded for a sample of underdrawing material was found to be consistent with that of a carbon-based black relatively more crystalline than lamp black or charcoal. Visually, the underdrawing material has the character of soft graphite pencil or conté crayon (see n22). Infrared reflectography was undertaken using an Indigo Systems Merlin near-infrared camera (InGaAs; wavelength range: 900–1700 nanometers) with a StingRay Optics macro lens optimized for this range.

25. The underdrawings in the Musée Granet and Musée d'Orsay paintings were imaged by the author with a Canon EOS 5D camera, modified for infrared use, with an internal 830-nanometer bandpass filter. Infrared reflectography of *Portrait of Madame Cézanne* was carried out by the Conservation Department of the Philadelphia Museum of Art.

26. Registration lines in the eyes are seen in the following drawings of Hortense catalogued in Adrien Chappuis, *The Drawings of Paul Cézanne: A Catalogue Raisonné*, 2 vols., trans. Paul Constable et al. (Greenwich, Conn.: New York Graphic Society, 1973): nos. 332, 830, 838. Registration lines are used in some drawings of his son, and other works.

27. Paul Cézanne, letter to Emile Zola, Aix, ca. October 19, 1866, in Rewald, *Paul Cézanne: Letters*, p. 112.

28. The artist changed course on the background early on, as the curtain was also underdrawn.

29. Raman analysis confirmed ultramarine as the blue pigment used in both underdrawing and overdrawing in *Madame Cézanne in the Conservatory* (see n22).

30. "Quand je commence je peins facilement, et après je corrige." Entry for January 1906, Maurice Denis, *Journal* (Paris: La Colombe, 1957), cited in Robert William Ratcliffe, "Cézanne's Working Methods and Their Theoretical Background" (PhD diss., Courtauld Institute of Art, University of London, 1960), p. 125.

31. Gasquet, "What He Told Me," p. 153.

32. Ibid., p. 125.

33. Ibid., p. 110.

34. Paul Cézanne, letter to Emile Bernard [Aix, 1905], in Doran, *Conversations with Cézanne*, p. 47.

35. On Cézanne's study of Rubens, see Mary Tompkins Lewis, "Cézanne and the Louvre," in Geskó, *Cézanne and the Past*, pp. 105–7.

36. Shortly after Cézanne arrived in Paris, Zola described the artist's mounting frustration as he worked on Zola's portrait, starting over, and finally destroying it: Emile Zola, letter to Baptistin Baille, early August 1861, in Rewald, *Paul Cézanne: Letters*, pp. 91–92. Vollard describes Cézanne destroying canvases he was unhappy with: Vollard, *Paul Cézanne*, pp. 62–63, 77.

37. Paul Cézanne, letter to Emile Bernard, Aix, May 26, 1904, in Rewald, *Paul Cézanne: Letters*, p. 303.

38. Gasquet, "What He Told Me," p. 125.

39. Emile Bernard described his palette thus: *yellows*: brilliant yellow (a mixture of chrome yellow and lead white), Naples yellow, chrome yellow, yellow ocher, raw sienna; *reds*: vermilion, red earth, burnt sienna, madder lake, carmine lake, burnt crimson lake; *greens*: viridian, emerald green, green earth; *blues*: cobalt blue, ultramarine, Prussian blue; peach black; see Bernard, "Memories of Paul Cézanne," p. 72.

For published studies of Cézanne's pigments, see Marigene H. Butler, "An Investigation of the Materials and Techniques Used by Paul Cézanne," in *Preprints of Papers Presented at the Twelfth Annual Meeting, Los Angeles, California, 15–19 May 1984* (Los Angeles: American Institute for Conservation of Historic and Artistic Works, 1984), pp. 20–33; Reissner, "Ways of Making," pp. 9–10, 25, and "Transparency of Means," pp. 63–64, 69. From selective analysis of the paintings in the Metropolitan, the following pigments were identified in both *Madame Cézanne in the Conservatory* and *Madame Cézanne in a Red Dress*: chrome yellow, iron earth, vermilion, emerald green, ultramarine blue, lead white, and zinc white.

40. See n. 22. The detection of aluminum, silicon, iron, and zinc, using SEM-EDS, points to the presence of an iron ocher and zinc white in these samples.

41. Collection of Philippe Cézanne. See Denis Coutagne, *Courbet/Cézanne: La Vérité en peinture*, exh. cat. (Ornans, France: Musée Gustave Courbet; Lyon: Fage, 2013), p. 12.

42. Vollard, *Paul Cézanne*, p. 81.

43. The mediums that have been identified could be from the tube paint or from an additional medium added by the artist. Medium analysis of the Metropolitan's paintings of Madame Cézanne was undertaken by Julie Arslanoglu, Department of Scientific Research, using pyrolysis-gas chromatography/mass spectrometry (Py-GC/MS). In *Madame Cézanne in the Conservatory*, limited analysis showed the use of poppy-seed and linseed oils as well as heat-treated linseed oil, and in *Madame Cézanne in a Red Dress*, poppy-seed and linseed oils. A distinctively fluorescent paint layer in one cross section taken from *Madame Cézanne in a Red Dress* suggests a possible addition to the binding medium, for example a natural resin or a drier. See also Reissner, "Ways of Making," p. 10.

44. He ordered a bottle of *siccatif de Haarlem* from a color merchant in a letter of March 23, 1905: see Rewald, *Paul Cézanne: Letters*, p. 314. On this popular commercial drier, see Raymond White, Jennifer Pilc, and Jo Kirby, "Analyses of Paint Media," *National Gallery Technical Bulletin* 19 (1998), p. 82. The original *siccatif de Haarlem* is reported to be a dilute copal oil varnish, while other driers can contain dammar resin and oil or metal salts (cobalt or lead acetate, for example). In the limited sampling of the two paintings, no marker compounds for copal or dammar resin were observed by Py-GC/MS using either the Scan or the Selected Ion Monitoring (SIM) detection mode. Other driers based on metal salts do not exhibit marker compounds for characterization by GC/MS.

45. Several of the portraits of Madame Cézanne exhibit parallel cracks that derive probably from rolling (pls. 16, 19, 20, 27). Describing works shipped by the artist for exhibition in 1895, Vollard wrote: "He sent them rolled up to spare them as much as possible, because he decided that in transportation the stretchers took up too much space." Vollard, *Paul Cézanne*, p. 52.

46. Vollard is known to have varnished Impressionist paintings to make them more salable to potential buyers who were more comfortable with the traditional even, shiny surface that varnish provided. See Reissner, "Ways of Making," pp. 11 and 29nn55–57.

47. Paul Cézanne, letter to Joachim Gasquet, September 26, 1897, in Alex Danchev, ed. and trans., *The Letters of Paul Cézanne* (London: Thames and Hudson, 2013), p. 287.

48. Gasquet, "What He Told Me," p. 110.

49. Bernard, "Memories of Paul Cézanne," p. 60.

50. This device, used by many painters, was noted by Ratcliffe in "Cézanne's Working Methods and Their Theoretical Background," p. 85. See also Reissner, "Ways of Making," p. 26.

51. Rainer Maria Rilke, letter to Clara Westhoff, Paris, October 22, 1907, in Rainer Maria Rilke, *Letters on Cézanne*, ed. Clara Rilke, trans. Joel Agee (New York: North Point Press, 2002), p. 72.

52. See Joseph J. Rishel, *Cézanne in Philadelphia Collections* (Philadelphia: Philadelphia Museum of Art, 1983), p. 32.

53. See R. P. Rivière and J. F. Schnerb, "Cézanne's Studio" (from *La Grande Revue*, December 25, 1907), in Doran, *Conversations with Cézanne*, p. 86. See also Paul Smith, "Cézanne's 'Primitive' Perspective, or the 'View from Everywhere,'" *Art Bulletin* 95, no. 1 (March 2013), pp. 102–19.

54. See Rishel, *Cézanne in Philadelphia Collections*, p. 19; and Butler, "Investigation of the Materials and Techniques," p. 23.

55. See Rishel, *Cézanne in Philadelphia Collections*, p. 27.

56. The brushwork and floral motifs read plausibly in a horizontal orientation, and in this context the dark ocher band could be seen as the bar of a stretcher positioned behind the arrangement: compare, for example, *Pot of Primroses and Fruit* (Courtauld Gallery, London).

57. I am very grateful to Mark Tucker at the Philadelphia Museum of Art for his willingness to explore the idea of self-appropriation in this painting and for his generosity in sharing the discovery of the underlying figure visible in the infrared reflectogram.

58. Another intriguing self-appropriation across genres is seen in *Female Nude (Leda II)* (Von der Heydt-Museum, Wuppertal, Germany), where the background constitutes an inverted still life; see Ferenc Tóth's entry on this painting in Geskó, *Cézanne and the Past*, pp. 314–15.

59. Quoted by Richard Shiff in Doran, *Conversations with Cézanne*, p. xxix. See also Emile Bernard, "Paul Cézanne" (from *L'Occident*, 1904), in Doran, *Conversations with Cézanne*, p. 36.

60. See Rewald with Feilchenfeldt and Warman, *Paintings of Paul Cézanne: Catalogue Raisonné*, vol. 1, pp. 402–3; van Buren, "Madame Cézanne's Fashions," pp. 117, 120.

61. Paul Cézanne, letter to Emile Bernard, Aix, May 12, 1904, in Doran, *Conversations with Cézanne*, p. 30.

62. Gasquet, "What He Told Me," p. 153. Cézanne refers to "mes recherches" in letters; see John Rewald, ed., *Paul Cézanne: Correspondance* (Paris: Bernard Grasset, 1937), pp. 249–50, 289.

63. Bernard went on: "I saw him agonize this way over the painting of the skulls.... The colors and shapes in this painting changed almost every day, and each day when I arrived at his studio, it could have been taken from the easel and considered a finished work of art. In truth, his method of study was a meditation with a brush in hand." Bernard, "Memories of Paul Cézanne," pp. 58–59.

64. Marie-Alain Couturier, *Se garder libre: Journal (1947–1954)* (Paris: Cerf, 1962), cited in Rewald, *Cézanne*, p. 266.

65. Joachim Gasquet recorded him as saying: "Each time I attack a canvas, I remember that I have always failed before. Then I worry myself sick." Gasquet, "What He Told Me," p. 148. And Emile Bernard quoted him: "I would like to be received at the salon of Bouguereau. I know very well what the obstacle would be: it's that I do not achieve enough realization." Bernard, "Memories of Paul Cézanne," p. 58.

66. For in-depth analysis of this aspect of Cézanne's paintings, see Felix Baumann, Evelyn Benesch, Walter Feilchenfeldt, and Klaus Albrecht Schröder, eds., *Cézanne: Finished—Unfinished*, exh. cat. (Vienna: Kunstforum Wien; Zurich: Kunsthaus Zürich; Ostfildern, Germany: Hatje Cantz, 2000).

67. "I have to work all the time, not to reach that final perfection which earns the admiration of imbeciles." Paul Cézanne, letter to his mother, Anne-Elisabeth Cézanne, September 26, 1874, in Rewald, *Paul Cézanne: Letters*, p. 142.

68. From 1888 to 1890, Cézanne rented an apartment at 15, quai d'Anjou on the Ile Saint-Louis; the pale wainscoting surmounted by a deep red or black band, and the blue-gray walls of this space, as well as a patterned curtain, appear variously in his series of paintings of a boy wearing a red waistcoat (National Gallery of Art, Washington, D.C.; Barnes Foundation, Philadelphia; Museum of Modern Art, New York; and Foundation E. G. Bührle Collection, Zurich), and in the 1888 painting *Pierrot and Harlequin (Mardi Gras)* (Pushkin State Museum of Fine Arts, Moscow). See Mary Tompkins Lewis, "The Path to Les Lauves: A History of Cézanne's Studios," in *Atelier Cézanne, 1902–2002: Le Centenaire* (Aix-en-Provence: Société Paul Cézanne; Arles: Actes Sud, 2002), p. 20. Isabelle Cahn, in Cachin and Rishel, *Cézanne*, p. 430n6, lists thirteen paintings depicting the same curtain.

69. Camille Pissarro, letter to his son, Lucien Pissarro, January 20, 1896, in Rewald, *Paul Cézanne: Letters*, p. 241.

70. For example, *Woman with a Coffeepot* (Musée d'Orsay, Paris); *Young Man and Skull* (Barnes Foundation, Philadelphia); *Young Italian Woman at a Table* (J. Paul Getty Museum, Malibu).

71. Götz Adriani, *Cézanne: Paintings*, trans. Russell M. Stockman, exh. cat. (Tübingen, Germany: Kunsthalle Tübingen; New York: Harry N. Abrams, 1995), pp. 147–51, while acknowledging the difficulty of determining the order of these works, considers this the first of the series.

72. Both paintings are a standard size 25 *figure*: 81 × 65 centimeters (31⅞ × 25⅝ inches). A "25" stenciled on the reverse of the original canvas of the Chicago painting was imaged through the lining canvas with transmitted light infrared photography. My thanks to Kelly Keegan at the Art Institute of Chicago for bringing this to my attention.

73. Van Buren, "Madame Cézanne's Fashions," p. 124n17.

74. Bernard notes his use of paper flowers in "Memories of Paul Cézanne," p. 78.

75. See Dita Amory and Kathryn Kremnitzer's essay "Re-Imaging Cézanne" in this volume, and n39 in Dita Amory's essay "Newly Seeing the Familiar: Paul Cézanne, Hortense Fiquet, and the Portraits."

76. Emile Bernard, "Paul Cézanne," *Les Hommes d'aujourd'hui* 8, no. 387 (February–March 1891), n.p.

Ann Dumas, "The Portraits of Madame Cézanne: Changing Perspectives"

I would like to thank Baillie Card for her assistance with this essay.

1. Alex Danchev, *Cézanne: A Life* (London: Profile, 2012), p. 161.

2. No letters from Cézanne to Hortense are included in the new edition of the letters: Alex Danchev, ed. and trans., *The Letters of Paul Cézanne* (London: Thames and Hudson, 2013). Danchev notes in his introduction (p. 34) that the artist was in the habit of destroying unwanted papers at the end of each year, which may explain why there are so few surviving letters to him.

3. Danchev, *Cézanne*, p. 154.

4. Entry for November 1901, Maurice Denis, *Journal* (Paris: La Colombe, 1957), vol. 1, pp. 175–76, cited in Danchev, *Cézanne*, p. 162 and p. 409n32.

5. Danchev, *Cézanne*, p. 157.

6. Paul Alexis, letter to Emile Zola, February 13, 1891, in *"Naturalisme par mort": Lettres inédites de Paul Alexis à Emile Zola*, ed. B. H. Bakker (Toronto: University of Toronto Press, 1971), p. 400, cited in Danchev, *Cézanne*, p. 160 and p. 408n17 (translation edited).

7. Danchev, *Cézanne*, p. 154.

8. John Rewald, *Cézanne: A Biography* (New York: Harry N. Abrams, 1986), pp. 264–65, cited in Danchev, *Cézanne*, pp. 162–63 and p. 409n26. Rewald's biography was first published in 1948.

9. Danchev, *Cézanne*, p. 154.

10. Rewald, *Cézanne*, p. 78, cited in Danchev, *Cézanne*, p. 162.

11. Frederick Brown, *Zola: A Life* (New York: Farrar, Straus and Giroux, 1995), p. 97, cited in Ruth Butler, *Hidden in the Shadow of the Master: The Model-Wives of Cézanne, Monet, and Rodin* (New Haven: Yale University Press, 2008), pp. 44–45.

12. Gerstle Mack, *Paul Cézanne* (London: Jonathan Cape, 1935), p. 172.

13. M.C. [Marthe Conil?], "Quelques Souvenirs sur Paul Cézanne, par une de ses nièces," *Gazette des beaux-arts*, ser. 6, vol. 56, no. 1102 (November 1960), pp. 299–302, cited in Françoise Cachin and Joseph J. Rishel, *Cézanne*, trans. John Goodman, exh. cat. (Paris: Galeries Nationales du Grand Palais; London: Tate Gallery; Philadelphia: Philadelphia Museum of Art; New York: Harry N. Abrams in association with Philadelphia Museum of Art, 1996), p. 346.

14. No. 28 in the third exhibition is listed as "Etude de femme," but as far as I am aware, it remains unidentified. See Ruth Berson, *The New Painting*, vol. 2, *Exhibited Works* (San Francisco: Fine Arts Museums of San Francisco, 1996), p. 71.

15. Georges Rivière, one of the first writers to appreciate Cézanne, remarked: "The artist most attacked and maligned by the press and public alike over the last fifteen years is M. Cézanne." See Georges Rivière, "L'Exposition des impressionnistes," *L'Impressionniste*, no. 2 (April 14, 1877), p. 6.

16. Gustave Geffroy, "Paul Cézanne," *Le Journal*, March 25, 1894.

17. Ambroise Vollard, *Cézanne* (New York: Dover, 1984), p. 53; originally published as *Paul Cézanne: His Life and Art*, trans. Harold L. Van Doren (New York: Crown, 1937). John Rewald thinks that *Portrait of Madame Cézanne* may refer to *Portrait of Madame Cézanne in a Striped Dress*. See John Rewald, in collaboration with Walter Feilchenfeldt and Jayne Warman, *The Paintings of Paul Cézanne: A Catalogue Raisonné*, 2 vols. (New York: Harry N. Abrams, 1996), no. 536.

18. Vollard, *Cézanne*, p. 53.

19. Rewald with Feilchenfeldt and Warman, *Paintings of Paul Cézanne: Catalogue Raisonné*, no. 534. Bought by Gustave Geffroy, it is one of a group of twenty-six paintings recorded in the Fonds Vollard, Bibliothèque et Archives des Musées Nationaux, Paris, MS 421 (4,2) and (4,3), as having been purchased from Vollard before August 1896. See Robert Jensen, "Vollard and Cézanne: An Anatomy of a Relationship," in *Cézanne to Picasso: Ambroise Vollard, Patron of the Avant-Garde*, ed. Rebecca A. Rabinow, with Douglas W. Druick, Ann Dumas, Gloria Groom, Anne Roquebert, Gary Tinterow, et al., exh. cat. (New York: The Metropolitan Museum of Art; Chicago: Art Institute of Chicago; Paris: Musée d'Orsay; New Haven: Yale University Press, 2006), p. 47n88.

20. Jensen points out that it is unlikely that canvases would have been taken off their stretchers and rolled if they were merely being moved across town from the artist's Paris studio; see ibid., pp. 30–33.

21. Rewald with Feilchenfeldt and Warman, *Paintings of Paul Cézanne: Catalogue Raisonné*: no. 324, Museum of Fine Arts, Boston; no. 532, Philadelphia Museum of Art; no. 651, Fondation Beyeler, Basel; no. 653, Art Institute of Chicago.

22. Thadée Natanson, "Paul Cézanne," *La Revue blanche*, December 1, 1895, pp. 497–500.

23. Emile Bernard, "Paul Cézanne," *L'Occident*, July 1904, pp. 23–25.

24. Roger Marx, "Le Salon d'Automne," *Gazette des beaux-arts*, ser. 3, vol. 32, no. 570 (December 1904), p. 462.

25. Rewald with Feilchenfeldt and Warman, *Paintings of Paul Cézanne: Catalogue Raisonné*, nos. 606, 607.

26. Gertrude Stein, *The Autobiography of Alice B. Toklas* (New York: Harcourt, Brace, 1933), pp. 38–39.

27. Rainer Maria Rilke, letter to Clara Westhoff, Paris, October 18, 1907, in Rainer Maria Rilke, *Letters on Cézanne*, ed. Clara Rilke, trans. Joel Agee (New York: North Point Press, 2002), pp. 58–59.

28. Rainer Maria Rilke, letter to Clara Westhoff, Paris, October 16, 1907, in Rilke, *Letters on Cézanne*, p. 52.

29. *Madame Cézanne in the Conservatory* (pl. 28) was also in the show, but Rilke, surprisingly perhaps, did not include it in his discussion.

30. Rainer Maria Rilke, letter to Clara Westhoff, Paris, October 22, 1907, in Rilke, *Letters on Cézanne*, pp. 70–72.

31. Roger Fry, *Cézanne: A Study of His Development* (1927; New York: Noonday Press, 1958), p. 30.

32. Ibid., p. 55.

33. Ibid., p. 68.

34. "Art is a harmony parallel to nature." Paul Cézanne, letter to Joachim Gasquet, September 26, 1897, in Danchev, *Letters of Paul Cézanne*, p. 287. See also Fry, *Cézanne*, p. 69.

35. Roger Fry, letter to Helen Anrep, in *Letters of Roger Fry*, ed. Denys Sutton (London: Chatto and Windus, 1972), p. 568.

36. C. J. Holmes, *Notes on the Post-Impressionist Painters: Grafton Galleries, 1910–11*, exh. cat. (Grafton Galleries, London, 1910–11; London: Philip Lee Warner, 1910), p. 20.

37. Fry, "Introduction," *Cézanne*, n.p.

38. D. H. Lawrence, *The Paintings of D. H. Lawrence* (London: Mandrake Press, 1929), p. 30. See also Tamar Garb's perceptive analysis of Lawrence's comments in *The Painted Face: Portraits of Women in France, 1814–1914* (New Haven: Yale University Press, 2007), pp. 150–51.

39. Lionello Venturi, *Cézanne: Son Art—son oeuvre* (Paris: Paul Rosenberg, 1936), vol. 1, p. 36.

40. Anne H. van Buren, "Madame Cézanne's Fashions and the Dates of Her Portraits," *Art Quarterly* 29, no. 2 (1966), pp. 111–27.

41. Ibid., p. 117.

42. Ibid., p. 115.

43. Nina Maria Athanassoglou-Kallmyer, *Cézanne and Provence: The Painter and His Culture* (Chicago: University of Chicago Press, 2003), p. 42.

44. Schapiro first expressed his ideas about the artist in a popular picture book in the Library of Great Painters series, *Paul Cézanne* (New York: Harry N. Abrams, 1952).

45. Meyer Schapiro, *Cézanne* (New York: Harry N. Abrams; London: Thames and Hudson, 1988), p. 9; originally published as *Paul Cézanne* (New York: Harry N. Abrams, 1952).

46. Schapiro, *Cézanne*, p. 15.
47. Ibid.
48. Ibid., p. 70.
49. Ibid., p. 24.
50. Ibid., p. 70.
51. Ibid., p. 36.
52. "The Apples of Cézanne: An Essay on the Meaning of Still-Life" was originally published in *The Avant-Garde*, ed. Thomas B. Hess and John Ashberry (New York: Macmillan, 1968; *Art News Annual* 34, and was reprinted in Schapiro's *Modern Art: 19th and 20th Centuries: Selected Papers* (New York: George Braziller, 1978), pp. 1–38.
53. Ibid., p. 27.
54. Ibid., p. 12.
55. Schapiro, *Cézanne*, p. 68.
56. Sidney Geist, *Interpreting Cézanne* (Cambridge, Mass.: Harvard University Press, 1988).
57. Ibid., p. 128.
58. Ibid., p. 153.
59. The original editions of Rewald's books include *Paul Cézanne: Letters*, trans. Marguerite Kay (London: B. Cassirer, 1941); *Paul Cézanne: A Biography* (New York: Simon and Schuster, 1948); *Paul Cézanne: The Watercolors: A Catalogue Raisonné* (Boston: Little, Brown, 1983; UK edition London: Thames and Hudson, 1983; Boston: Little, Brown, 1973); with Frances Weitzenhoffer, *Cézanne and America: Dealers, Collectors, Artists and Critics, 1891–1921* (Princeton, N.J.: Princeton University Press, 1989); and, with Feilchenfeldt and Warman, *Paintings of Paul Cézanne: Catalogue Raisonné*.
60. Rewald with Feilchenfeldt and Warman, *Paintings of Paul Cézanne: Catalogue Raisonné*, no. 324, vol. 1, p. 219.
61. Ibid., no. 606, vol. 1, p. 402.
62. Butler, *Hidden in the Shadow of the Master*.
63. Ibid., p. 22.
64. Ibid., pp. 39–40.
65. Tamar Garb, *The Painted Face: Portraits of Women in France, 1814–1914* (New Haven: Yale University Press, 2007).
66. Ibid., pp. 149–50.
67. Ibid., p. 139.
68. Ibid., p. 157.
69. Ibid., p. 165.
70. Ibid., p. 173.
71. Ibid., pp. 177–78.
72. Ibid., pp. 178–79.
73. Susan Sidlauskas, *Cézanne's Other: The Portraits of Hortense* (Berkeley: University of California Press, 2009). See also Sidlauskas, "Emotion, Color, Cézanne (The Portraits of Hortense)," *Nineteenth Century Art Worldwide* 3, no. 2 (Autumn 2004), n.p., http://www.19thc-artworldwide.org/autumn04 /67-autumn04/autumn04article/299-emotion-color-cezanne -the-portraits-of-hortense; and "Not Beautiful: A Counter-Theme in the History of Women's Portraiture," in *Re-framing Representations of Women: Figuring, Fashioning, Portraiting and Telling in the 'Picturing' Women Project*, ed. Susan Shifrin (Aldershot, UK: Ashgate, 2008), pp. 183–98.
74. Sidlauskas, *Cézanne's Other*, p. 2.
75. Ibid., p. 9.
76. Ibid., p. 19.
77. Ibid., pp. 28, 10.
78. Ibid., pp. 17–18.
79. Ibid., p. 106.
80. Ibid., p. 132.
81. Ibid., p. 141.
82. Ibid., p. 147.
83. Ibid., p. 183.
84. Ibid., p. 87.
85. Danchev, *Cézanne*, pp. 152–79.
86. Ibid., p. 162.
87. Ibid., p. 163.
88. Ibid., pp. 170–71.
89. Ibid., p. 158.
90. Ibid., p. 178.
91. Ibid., p. 176.
92. Danchev, *Letters of Paul Cézanne*.
93. Danchev, *Cézanne*, p. 173.
94. Ibid., p. 152.
95. Maurice Merleau-Ponty, "Cézanne's Doubt," in *Sense and Non-Sense*, trans. Hubert L. Dreyfus and Patricia Allen Dreyfus (Evanston, Ill.: Northwestern University Press, 1964), p. 15.
96. "Will I reach the goal I've sought so hard and pursued for so long?" Paul Cézanne, letter to Emile Bernard, September 21, 1906, in Danchev, *Letters of Paul Cézanne*, p. 373.

Marjorie Shelley, "Cézanne as Draftsman: Sketchbooks and Graphite Drawings"

My gratitude to Pamela T. Wilson for her boundless resourcefulness and tireless assistance. I also extend my thanks to Yana van Dyke, Mary Jo Carson, and Samantha Hallman.

1. See Adrien Chappuis, *The Drawings of Paul Cézanne: A Catalogue Raisonné*, 2 vols., trans. Paul Constable et al. (London: Thames and Hudson, 1973). The seven sketchbooks are now in collections as follows: Musée du Louvre, Paris: two sketchbooks, 1857–71, 1888–92; Philadelphia Museum of Art: two sketchbooks, 1882–90, 1885–1900; Morgan Library & Museum, New York, 1875–85; Art Institute of Chicago, 1869–70/75–86; National Gallery of Art, Washington, D.C., 1877–1900. The leaves of the Philadelphia *carnets* are now separately mounted; the others have been rebound. The numeration at the lower corner of each page was placed by Hortense Fiquet and other owners. See Chappuis, *Drawings of Paul Cézanne*, vol. 1, p. 9, for provenance, the detached pages, and a suggested chronology; see also n36 below. The delicate binding and miniature scale of the "violet moiré" sketchbook, in addition to its many memos and few pages

of drawings, suggest that it was not subject to the rigors of constant use, as were the sketchbooks under discussion. See Wayne V. Andersen, "Cézanne's *Carnet violet-moiré*," *Burlington Magazine* 107, no. 747 (June 1965), pp. 312–18.

2. Cézanne's few references to his materials and techniques concern painting, his color merchants, and pigments. See John Rewald, ed., *Paul Cézanne: Letters*, trans. Marguerite Kay (New York: Da Capo Press, 1995), pp. 314, 333, 337. Elisabeth Reissner, "Ways of Making: Practice and Innovation in Cézanne's Paintings in the National Gallery," *National Gallery Technical Bulletin* 29 (2008), pp. 6–7, refers to the eight pages of his sketchbooks containing notes on pigments. On Cézanne's philosophy of painting, but pertinent to drawing, see Michael Doran, ed., *Conversations with Cézanne*, trans. Julie Lawrence Cochran (Berkeley: University of California Press, 2001).

3. Emile Bernard, "Paul Cézanne" (from *L'Occident*, 1904), in Doran, *Conversations with Cézanne*, pp. 41–42.

4. Chappuis, *Drawings of Paul Cézanne*, vol. 1, nos. 75–78, each possibly done at the Académie Suisse.

5. Emile Bernard, letter to his mother, Marseille, February 5, 1904, in Doran, *Conversations with Cézanne*, p. 26.

6. A drawing at the middle phase was expected to take at least fifteen hours. See Charles Bargue with Jean-Léon Gérôme, *Drawing Course*, ed. Gerald M. Ackerman (Paris: ACR, 2011), p. 183. See also Paul Cézanne, letter to Emile Bernard, Aix, May 12, 1904, in Doran, *Conversations with Cézanne*, p. 30.

7. Three male nudes, 1863–66; see Chappuis, *Drawings of Paul Cézanne*, vol. 1, nos. 97–99.

8. See the facsimile from the Art Institute of Chicago, *A Cézanne Sketchbook: Figures, Portraits, Landscapes and Still Life* (New York: Dover, 1951; rev. ed. 1985), pp. 34v, 23v.

9. Paul Cézanne, letter to Paul Cézanne *fils*, Aix, September 8, 1906, in Rewald, *Paul Cézanne: Letters*, p. 327.

10. Ambroise Vollard, *Recollections of a Picture Dealer*, trans. Violet M. Macdonald (Boston: Little, Brown, 1936), pp. 4, 222–23.

11. The concept was advanced by Alexandre Dupuis in *De l'enseignement du dessin sous le point de vue industriel* (Paris: Giroux, 1836) and used in academic teaching to facilitate the process of learning to draw, as detailed, for example, in Jacques-Nicolas Paillot de Montabert, *Traité complet de la peinture*, 9 vols. (Paris: J.-F. Delion, 1829–51), and by Eugène Guillaume, director of the Ecole de Beaux-Arts, in "Dessin," *Dictionnaire de pédagogie* (1887), pt. 1, pp. 684–90.

12. See D[aniel] Harlé, "Les Cours de dessin gravés et lithographiés du XIXème siècle conservés au Cabinet des Estampes de la Bibliothèque Nationale: Essai critique et catalogue" (thesis, Ecole du Louvre, Paris, 1975). Such courses were a significant component of policies on educational reform; see Rafael Cardoso, "A Preliminary Survey of Drawing Manuals in Britain c. 1825–1875," in *Histories of Art and Design Education: Collected Essays*, ed. Mervyn Romans (Bristol, UK: Intellect, 2005), p. 20.

13. Two youthful drawings—a classical bust (1858–60) and a female torso (1860)—evoke the *modèles estampes* in their mechanical contours and exacting hatching; see Chappuis, *Drawings of Paul Cézanne*, vol. 2, nos. 73, 74. Few of Cézanne's life drawings survive from this period, as he destroyed them or they were lost; see John Rewald, Introduction, in Lawrence Gowing, *Cézanne: The Early Years 1859–1872*, ed. Mary Anne Stevens, exh. cat. (London: Royal Academy of Arts; Paris: Musée d'Orsay; Washington, D.C.: National Gallery of Art; London: Weidenfeld and Nicolson, 1988), p. 3.

14. On the verso of the lithograph is Cézanne's *Studies of a Child's Head, a Woman's Head, a Spoon, and a Longcase Clock* (pl. 30 in this volume). The lithograph is signed, in the plate, "Hippolyte Lalaisse." For a description of the teaching process that employed such plates, see Cardoso, "Preliminary Survey of Drawing Manuals," p. 23.

15. On drawing curricula, see Patricia Mainardi, *The End of the Salon: Art and the State in the Early Third Republic* (Cambridge, UK: Cambridge University Press, 1973), p. 70.

16. Bernard, "Paul Cézanne," p. 39.

17. Emile Bernard, "Memories of Paul Cézanne" (from *Mercure de France*, 1904–6; 1907), in Doran, *Conversations with Cézanne*, p. 69.

18. These alternative teaching methods were published in, among others, Horace Lecoq de Boisbaudran, *L'Education de la mémoire pittoresque* (Paris: Librairie Sociétaire, 1848), revised as *L'Education de la mémoire pittoresque: Application aux arts du dessin* (Paris: Bance, 1862); Marie-Elisabeth Cavé, *Le Dessin sans maître: Méthode pour apprendre à dessiner de mémoire* (Paris: Susse Frères, 1850; reissued 1851; Aubert, 1852; Bureau du Journal Amusant, 1857), which was reviewed by Eugène Delacroix in the *Revue des deux mondes*, September 15, 1850; Amaranthe Rouillet, *Le David des collèges, ou abrégé élémentaire du dessin, contenant vingt planches de principes progressifs, à l'usage des jeunes gens* (Paris: F. Chavant, 1836), translated as *David for Schools: An Elementary Summary for Drawing, Containing Twenty Plates of Progressive Principles for the Use of Young People* (London: Ch. Tilt, 1836); "Le Procédé Rouillet," *L'Illustration* 1, no. 6 (April 8, 1843), p. 90; Eugène Viollet-le-Duc, "L'Enseignement des arts: Il y a quelque chose à faire," *Gazette des beaux-arts* 12 (May–September 1862).

19. Paul Cézanne, letter to Numa Coste, Paris, February 27, 1864, in Rewald, *Paul Cézanne: Letters*, p. 100.

20. Cézanne may have encountered Couture in 1870 or so, a decade before he copied Couture's 1847 painting in the Louvre (it is now in the Musée d'Orsay, Paris). The graphite drawing—previously in the Philadelphia II (1885–1900) sketchbook, and then in the Kenneth Clark collection—is dated to the early 1880s. See Wayne V. Andersen, "A Cézanne Drawing after Couture," *Master Drawings* 1, no. 4 (Winter 1963), pp. 44–46; Theodore Reff and Innis Howe

Shoemaker, *Paul Cézanne: Two Sketchbooks: The Gift of Mr. and Mrs. Walter H. Annenberg to the Philadelphia Museum of Art*, exh. cat. (Philadelphia: Philadelphia Museum of Art, 1989), p. 19. And see Paul Cézanne, letter to Charles Camoin, September 13, 1903, in Rewald, *Paul Cézanne: Letters*, p. 297. It is not known whether Cézanne heard about Couture's ideas through other artists, but his language and phrasing in conversations with Emile Bernard and others suggest he had read Couture's books *Méthode et entretiens d'atelier* (Paris: privately published, 1867, 1868) and *Paysage* (1869). See Robert William Ratcliffe, "Cézanne's Working Methods and Their Theoretical Background" (PhD diss., Courtauld Institute of Art, University of London, 1960), pp. 351–53.

21. Couture, *Méthode et entretiens d'atelier* (1868), p. 38.

22. Albert Boime, *The Academy and French Painting in the Nineteenth Century* (London: Phaidon, 1971), pp. 33–35.

23. Thomas Couture, *Conversations on Art Methods*, trans. S. E. Stewart (New York: G. P. Putnam's Sons, 1879), pp. 21, 23.

24. Mainardi, *End of the Salon*, pp. 60–62.

25. Albert Boime, "The Teaching Reforms of 1863 and the Origins of Modernism in France," *Art Quarterly*, n.s. 1, no. 1 (Autumn 1977), pp. 1–39.

26. This can be gathered from the relative absence of notices of bookbinders, stationers, and printers in World's Fair inventories from 1851 to 1867. See, for instance, *Rapport sur l'Exposition Universelle de 1855* (Paris: Imprimerie Impériale, 1857); http://catalogue.nal.vam.ac.uk, prospectuses of exhibitors, vol. 16; *Reports on the Paris Universal Exhibition, 1867* (London: George E. Eyre and William Spottiswoode for Her Majesty's Stationery Office, 1868), vol. 2, Class 7, Paper, Stationery, Painting and Drawing Materials, and Bookbinding by J. W. Appell, Esq., p. 135; and colormen's catalogues and drawing treatises. Long-commonplace "solid drawing blocks" advertised by many colormen (*Great Exhibition of the Works of Industry of All Nations, 1851: Official Descriptive and Illustrated Catalogue* [London: Spicer Brothers, 1851], p. 543) were not sketchbooks but pads of paper glued along the four edges, the uppermost sheet released with a knife upon completion of the composition. With the introduction of new products, there were many linguistic changes involving artists' materials, as described by Alexander Katlan, "The American Artist's Tools and Materials for On-Site Oil Sketching," *Journal of the American Institute for Conservation* 38, no. 1 (1999), pp. 21–32. Among these changes, references to albums and blank books decrease at this time, while references to sketchbooks and *albums de dessin* increase.

27. Royal Commission, *Great Exhibition of the Works of Industry of All Nations, 1851*, United Kingdom, Class 17, Paper, Printing and Bookbinding, entry 158, p. 547.

28. Jeff Peachey, "A Few Random Thoughts on 19th Century Books and Machines," accessed March 15, 2013, http://

jeffpeachey.wordpress.com/2010/01/13/deja-vu/. The binding was invented by Archibald Leighton and his publisher, William Pickering; the 1825 date appears in an 1849 trade catalogue. See Douglas Leighton, "Canvas and Bookcloth: An Essay on Beginnings," *The Library: Transactions of the Bibliographical Society*, ser. 5, vol. 3, no. 1 (June 1948), pp. 33–38.

29. Reissner, "Ways of Making," p. 11.

30. Louvre (RF 29949.1; *album de jeunesse*), 1857–71
15 × 23.5 cm [15.8 × 24 cm] | 53 pages
National Gallery of Art, 1877–1900
15.2 × 23.7 cm | 54 leaves
Philadelphia Museum of Art I, 1882–90
Pluchet label | 11.6 × 18.2 cm | 47 leaves
Philadelphia Museum of Art II, 1885–1900
12.7 × 21.6 cm | 52 leaves
Art Institute of Chicago, 1869–70/75–86
12.4 × 21.7 cm | 50 leaves
Morgan (Thaw), 1875–85
12.6 × 21.7 cm | 48 leaves
Louvre (RF 29933.2), 1888–92
Briault stamp | 13.2 × 21.7 cm | 32 leaves

31. Philadelphia I sketchbook (1882–90): The label "Papeterie / Mon[sieur] Michallet / PLUCHET, Succ[esseu]r / 11 et 12 P[assa]ge de Pont Neuf / Paris" dates the sketchbook to 1882–84, when the shop was first taken over by Pluchet. See Françoise Cachin and Joseph J. Rishel, *Cézanne*, trans. John Goodman, exh. cat. (Paris: Galeries Nationales du Grand Palais; London: Tate Gallery; Philadelphia: Philadelphia Museum of Art; New York: Harry N. Abrams in association with Philadelphia Museum of Art, 1996), p. 524. Louvre sketchbook RF 29933.2 (1888–92): "BP [within a palette] à la palette du Louvre / P. Briault / 2, rue du Louvre Paris" (stamped in black ink); the shop first appeared in the Paris business directory *Annuaire du commerce Didot-Bottin* in 1887. Another label is attached to an inside cover in the clothbound sketchbook known as Chappuis II (1872–96; 12.4 × 21.5 cm). The label reads: "Sales Couleurs et vernis, 25 rue Montparnasse [word effaced] registres." The sketchbook contains fourteen leaves remaining from at least twenty-three, and two inside covers with drawings and a listing of pigments. The inside cover with the label is reproduced in *Paul Cézanne Drawings: Carnet de dessins, Chappuis II*, exh. cat. (New York: Peter Findlay Gallery, 2004).

32. See "British Artists' Suppliers, 1650–1950," London: National Portrait Gallery, www.npg.org.uk/research /programmes/directory-of-suppliers, passim; and Clothilde Roth-Meyer, "Les Marchands de couleurs à Paris au XIXe siècle" (PhD diss., Université Paris–Sorbonne, 2004). The sketchbooks have been rebound, and evidence of the places of manufacture removed. The origin of the paper in these books is not known. The Morgan sketchbook, p. 32, contains blue paper watermarked "Montgolfier" (an exceptional

occurrence in small cut-down sheets), probably a fragment of "Canson & Montgolfier Vidalon-les-Annonay Anc[ien]ne Manuf[actu]re" or "Canson & Montgolfier Vidalon-les-Annonay." French paper was actively traded and bound into British sketchbooks, advertised as "French tinted paper."

33. *Catalogue général illustré de G. Sennelier fabricant de couleurs fines et matériel d'artistes* (Paris, quai Voltaire, 3, 1904), p. 94. Cézanne also used the *forme livre à la française* (height greater than width), but his preference for the elongated format is evident also from the majority of surviving unbound sheets that were removed from the sketchbooks.

34. My thanks to Yana van Dyke, paper conservator, The Metropolitan Museum of Art, and Maria Fredericks, book conservator, the Morgan Library & Museum, for their explanations of the structure of clothbound stationery bindings.

35. Similar randomness is evident with the watercolors: some have a graphite drawing or a watercolor on one side; others are blank on the reverse. For example, in The Metropolitan Museum of Art, *Bathers by a Bridge*, a watercolor, has a graphite drawing, *Study after Houdon's Ecorché*, on the verso (55.21.2); *Six Bathers* (recto) and *Still Life* (verso) are both watercolors (64.125.1). Traces of sewing holes indicate that these loose sheets are from sketchbooks.

36. For discussions on dating, see John Rewald, *Paul Cézanne: Carnets de dessins*, 2 vols. (Paris: Quatre Chemins–Editart, 1951); Wayne Andersen, *Cézanne's Portrait Drawings* (Cambridge, Mass.: MIT Press, 1970); Chappuis, *Drawings of Paul Cézanne*; and Lionello Venturi, *Cézanne: Son Art—son oeuvre*, 2 vols. (Paris: Paul Rosenberg, 1936).

37. George Rowney & Co. catalogue, London, n.d. (after 1862), p. 15; T. H. Fielding, *The Knowledge and Restoration of Old Paintings: The Modes of Judging between Copies and Originals and a Brief Life of the Principal Masters in the Different Schools of Painting* (London: Ackermann, 1847), p. 4.

38. From about 1850, charcoal, fabricated black chalks, and conté crayons were frequently advertised in colormen's catalogues and promoted in such drawing instruction books as Charles Bargue and Jean-Léon Gérôme's *Cours de dessin* (Paris, ca. 1870; Bargue with Gérôme, *Drawing Course*); Charles Bargue, *Exercises au fusain* (Paris: Goupil, 1871); Couture, *Méthode et entretiens*; and Georges Karl Robert, *Le Fusain sans maître: Traité pratique et complet sur l'étude de paysage au fusain* (Paris: Georges Meusnier, 1874; published in English as *Charcoal Drawing without a Master*, trans. Elizabeth Haven Appleton [Cincinnati: Robert Clarke, 1880]).

39. Paul Cézanne, letter to Emile Bernard, September 1906, in Doran, *Conversations with Cézanne*, p. 48.

40. Cézanne refrained from using charcoal for sketchbook drawings probably because the smooth-surfaced paper was not receptive to its powdery texture, and its broadness was not suited to the small sheet size. In addition to aesthetic reasons, his limited use of pen and ink, once he started working *en plein air*, may be attributed to its inconvenience as a liquid.

41. British and continental pencil grades ranged from multiple H's to H to BBB, and French pencil grades from multiple D's to M (*moyen*) and T (*tendre*); Conté brand numbers were 1 (the hardest), 2, 3, 4. See Paillot de Montabert, *Traité complet de la peinture*, vol. 9, *Procédés matériels*, chap. 612, "Des crayons," pp. 617–22. On pencil manufacture, see Eric H. Voice, "The History of the Manufacture of Pencils," *Transactions of the Newcomen Society* 27, no. 1 (1949), pp. 131–41; and Alfred Picard, ed., *Exposition Universelle Internationale de 1889 à Paris: Rapports du Jury Internationale*, group 2, pt. 2, Matériel et Procédés des Arts Libéraux (Paris: Imprimerie Nationale, 1891), chap. 6, p. 243, accessed July 18, 2013, http://cnum.cnam.fr/CGI/page.cgi?8XAE348.5/243/100, which mentions *crayons Conté* made by Desvernay et Cie.

42. Marks from Cézanne's pencils (composed of graphite and clay), from *Bathers by a Bridge / Study after Houdon's Ecorché* (55.21.2) and *Bathers / Landscape* (2003.20.3), and comparative nineteenth- and twentieth-century material were analyzed by Silvia Centeno and Mark Wypyski, research scientists, Department of Scientific Research, The Metropolitan Museum of Art, using X-ray fluorescence, Raman, and SEM-EDS. The similarity of worldwide fabrication methods by the late nineteenth century precludes identification of the source of Cézanne's pencils. The carbonaceous nature of graphite and the presence of carbon in clay also limit quantitative analysis as a means of determining the grade of pencils he used.

43. On the basis of visual characteristics, Cézanne's pencils are estimated to be in the region of HB or BB or number 2. In about 1900, a number 2 or HB pencil had approximately 30 percent clay, accounting for its relative softness. See Voice, "History of the Manufacture of Pencils," p. 140. Differences in the hue and the softness or hardness of pencils having the same grade can be attributed to variations in the raw materials and differences in processing.

44. Bernard, "Paul Cézanne," p. 39.

45. R. P. Rivière and J. F. Schnerb, "Cézanne's Studio" (from *La Grande Revue*, December 25, 1907), in Doran, *Conversations with Cézanne*, p. 87.

46. On Cézanne's organization of his palette, see Emile Bernard, "Memories of Paul Cézanne" (from *Mercure de France*, 1904–6), in Doran, *Conversations with Cézanne*, pp. 60, 62. Cézanne's ability to see form in gradations of tone is evident in his statement to Bernard that our optical sensation "causes us to classify by light, half-tones, and quarter-tones, the planes represented by color sensations." Paul Cézanne, letter to Emile Bernard, Aix, December 23, 1904, in Doran, *Conversations with Cézanne*, p. 46.

47. Reissner, "Ways of Making," p. 8.

48. Rivière and Schnerb, "Cézanne's Studio," p. 88.

49. The compression of the graphite produces a luster (evident in raking light) characteristic of this semi-metallic mineral, which results from the slipping of the disklike particles.

50. Described by Rivière and Schnerb, "Cézanne's Studio," p. 90.

51. See Theodore Reff, "Cézanne's Constructive Stroke," *Art Quarterly* 25, no. 3 (Autumn 1962), p. 214.

52. I am grateful to Angela Campbell, assistant conservator, Paper Conservation, The Metropolitan Museum of Art, for performing reflectance transformation imaging on this drawing.

53. Clothbound sketchbook papers were available in a range of types, textures, and colors, in high-end and "school" grades, and were generally referred to as "best" or "good" quality; fiber content was never specified. Among the catalogues consulted: Goupil & Cie, New York, Paris, London, Berlin, 1887; Winsor & Newton, London, n.d., 1860s, 1874, 1887, 1895, 1910; Janentzky & Co., Philadelphia, 1879; George Rowney & Co., London, 1889; G. Sennelier, Paris, 1904. Fiber analysis indicates many sketchbook papers are rag with trace amounts of wood pulp, alum rosin size, and iron; see Faith Zieski, "The Conservation of Two Sketchbooks by Paul Cézanne," in *The Institute of Paper Conservation: Conference Papers Manchester 1992*, ed. Sheila Fairbrass (Worcester, UK: Institute of Paper Conservation, 1992), pp. 54–60. Similar results were found in the Metropolitan Museum's *Bathers by a Bridge / Study after Houdon's Ecorché* (55.21.2) and *Bathers / Landscape* (2003.20.3), the latter having a higher percentage of soft wood, accounting for its darker color and lower integrity (analysis by Yana van Dyke, paper conservator, Metropolitan Museum). White when new, Cézanne's papers have yellowed and weakened because of handling, constituents, and unfavorable environmental conditions.

54. Drawings in pen and ink, and watercolor, such as *Madame Cézanne with Hortensias* (pl. 42), were removed from the sketchbooks, but modest graphite sketches worked up with watercolor remain in several of these *carnets*, among them Philadelphia I, 26r, 18v; Philadelphia II, 29v; and National Gallery of Art 1992.51.9uu. The Louvre *album de jeunesse* contains a drawing in gouache over ink wash; the Morgan sketchbook contains an unfinished watercolor of a seascape. Gouache preparations with watercolors are present in various detached pages, such as *Decanter and Bowl* (1878–80; 17.5 × 11.4 cm), illustrated in John Rewald, *Paul Cézanne: The Watercolors: A Catalogue Raisonné* (Boston: Little, Brown, 1983), no. 107, p. 110.

55. *Catalogue général illustré de G. Sennelier*, p. 94. Such sketchbooks emulated traditional blank books.

56. The relative color stability of the blue papers is possibly due to their being colored with indigo-dyed rags; the faded papers were colored with aniline dyes, invented in 1856.

57. According to the staunch academic teacher and artist Jacques-Nicolas Paillot de Montabert, in *Traité complet de la peinture*, vol. 9, *Procédés matériels*, chap. 610, "Des papiers à dessiner," p. 614, white paper was preferable to colored, and had been used by the great draftsmen, including Jacques Louis David. Among the 1,242 Cézanne drawings catalogued by Chappuis, very few are on blue paper. See Chappuis, *Drawings of Paul Cézanne*, vol. 2, p. 94, nos. 201–4.

58. Anthea Callen, *The Art of Impressionism: Painting Technique and the Making of Modernity* (New Haven: Yale University Press, 2000), pp. 94–95.

59. Quoted in John Rewald, "Cézanne's Theories about Art," *ARTnews* 47, no. 7 (November 1948), p. 31.

60. On Cézanne's "culminating point," see Paul Cézanne, letter to Emile Bernard, Aix, July 25, 1904, in Rewald, *Paul Cézanne: Letters*, p. 306. On Couture's ideas of "dominating light and shadow," see Couture, *Méthode et entretiens* (1868), pp. 28–29.

61. Paul Cézanne, letter to Emile Bernard, Aix, October 23, 1905, in Doran, *Conversations with Cézanne*, p. 48.

Hilary Spurling, "Cézanne and Matisse Paint Their Wives"

1. See Alex Danchev, *Cézanne: A Life* (London: Profile, 2012), p. 108.

2. Françoise Cachin and Joseph J. Rishel, *Cézanne*, trans. John Goodman, exh. cat. (Paris: Galeries Nationales du Grand Palais; London: Tate Gallery; Philadelphia: Philadelphia Museum of Art; New York: Harry N. Abrams in association with Philadelphia Museum of Art, 1996), p. 318.

3. Rainer Maria Rilke, letter to Clara Westhoff, Paris, October 16, 1907, in Rainer Maria Rilke, *Letters on Cézanne*, ed. Clara Rilke, trans. Joel Agee (New York: North Point Press, 2002), p. 52.

4. Information from Wanda de Guébriant, Archives Matisse, Paris. See also Hilary Spurling, *The Unknown Matisse: A Life of Henri Matisse: The Early Years, 1869–1908* (New York: Alfred A. Knopf, 1998), pp. 180–82, 187–88.

5. Francis Jourdain, *Sans remords ni rancune: Souvenirs épars d'un vieil homme né en «76»* (Paris: Corrêa, 1953), p. 54.

6. Dominique Fourcade, *Henri Matisse: Ecrits et propos sur l'art* (Paris: Hermann, 1972), p. 84; and see Spurling, *Unknown Matisse*, pp. 180–82, 190, 210.

7. Hilary Spurling, *Matisse the Master: A Life of Henri Matisse: The Conquest of Colour, 1909–1954* (New York: Alfred A. Knopf, 2005), p. 177.

8. See Spurling, *Unknown Matisse*, p. 73.

9. Matisse's *The Dinner Table (La Desserte)* caused outrage at the opening of the Salon de la Société Nationale des Beaux-Arts on April 24, 1897, six weeks after he visited the Musée du Luxembourg on March 10 to see Caillebotte's Impressionist legacy; see Spurling, *Unknown Matisse*, pp. 134–35.

10. Henri Matisse, "Notes d'un peintre" (1908), in Fourcade, *Henri Matisse*, p. 48.

11. Fourcade, *Henri Matisse*, p. 49.

12. Spurling, *Unknown Matisse*, p. 307.

13. The painting was purchased from Paul Rosenberg, November 2, 1916. I am grateful to Madame de Guébriant for this information, and for confirming that Matisse's collection included, besides *Three Bathers*, only two other Cézanne paintings, *Dish of Fruit (Les Pêches)*, bought from Bernheim-Jeune on April 29, 1911, and *Rocks near the Caves of Château Noir (Paysage [Rochers du Château Noir])*, bought from Barbazanges on January 15, 1917. Matisse is often said to have owned a second *Portrait of Madame Cézanne* (now in the Philadelphia Museum of Art; pl. 13), but this seems unlikely, since there is no reference to any second portrait in the Paris archive or in his family correspondence, and apparently no conclusive documentary corroboration elsewhere.

14. See the companion to this canvas, *Madame Cézanne in Blue* (pl. 18), now in the Museum of Fine Arts, Houston.

15. Fourcade, *Henri Matisse*, p. 84.

16. Ibid., p. 50.

17. For a trenchant account of this cross-fertilization between fact and fiction, see Danchev, *Cézanne*, pp. 78–80, 161–63, 244–49; and Alex Danchev, ed. and trans., *The Letters of Paul Cézanne* (London: Thames and Hudson, 2013), p. 27.

18. Emile Zola, *L'Oeuvre* (Paris: Fasquelle/Bibliothèque-Charpentier, 1950), vol. 1, pp. 13–14.

19. Ibid., p. 145, and see pp. 139–40.

20. Spurling, *Unknown Matisse*, p. 148.

21. Danchev, *Cézanne*, p. 163.

22. Danchev, *Letters of Paul Cézanne*, pp. 254–56, 354–55.

23. Matisse had firsthand reports in 1901 and 1902 from the painter Charles Camoin, and secondhand from Emile Bernard. See Bernard, "Paul Cézanne," *L'Occident*, July 1904, pp. 23–25, and his *Souvenirs sur Paul Cézanne: Une conversation avec Cézanne, la méthode de Cézanne* (Paris: R. G. Michel, 1926); and Spurling, *Unknown Matisse*, pp. 209–10, 284.

24. Fourcade, *Henri Matisse*, p. 193; and see Marie-Alain Couturier, *Se garder libre: Journal (1947–1954)* (Paris: Cerf, 1962), p. 116.

25. Cachin and Rishel, *Cézanne*, p. 346; and Spurling, *Unknown Matisse*, pp. 324–25.

26. Marguerite Matisse's diagram of the 1923 hang at Issy-les-Moulineaux is reproduced in Spurling, *Matisse the Master*, p. 252; the photograph on p. 156 in this volume shows Matisse in his Nice apartment in 1932.

27. The Chicago *Madame Cézanne in a Yellow Chair* passed through Vollard's hands before Bernheim-Jeune acquired it in 1907; the portrait shown at the Salon de Mai in 1912, previously confused with this Chicago portrait, was in fact the *Madame Cézanne in a Yellow Chair* now in the Fondation Beyeler collection, Basel (pl. 19).

28. Ambroise Vollard kept *Madame Cézanne with Green Hat* on view in his shop from 1895 to 1915, according to Joseph J. Rishel, "Paul Cézanne," in Richard J. Wattenmaker, Anne Distel, Françoise Cachin, Joseph J. Rishel, et al., *Great French Paintings from the Barnes Foundation: Impressionist,*

Post-Impressionist, and Early Modern, exh. cat. (Washington, D.C.: National Gallery of Art; New York: Alfred A. Knopf, in association with Lincoln University Press, 1993), p. 140; he sold *Woman in Blue* to Sergei Shchukin, who was Matisse's host in Moscow in 1911.

29. Danchev, *Cézanne*, p. 293.

30. Ibid., p. 167.

31. Fourcade, *Henri Matisse*, p. 49.

32. Danchev, *Cézanne*, p. 284.

33. Ibid., p. 79.

34. Rainer Maria Rilke, letter to Clara Westhoff, Paris, October 13, 1907, in Rilke, *Letters on Cézanne*, p. 46.

Dita Amory and Kathryn Kremnitzer, "Re-Imaging Cézanne"

1. Paul Gauguin, letter to Camille Pissarro, June 1881, in Victor Merlhès, ed., *Correspondance de Paul Gauguin 1873–1888: Documents, témoinages* (Paris: Fondation Singer-Polignac, 1984), p. 21, translated and quoted in Guillermo Solana, "The Faun Awakes: Gauguin and the Revival of the Pastoral," in *Gauguin and the Origins of Symbolism*, ed. Guillermo Solana, exh. cat. (Madrid: Museo Thyssen-Bornemisza and Fundación Caja de Madrid; London: Philip Wilson, 2004), p. 24.

2. Richard Shiff, "Sensation, Cézanne," in *Cézanne and the Past: Tradition and Creativity*, ed. Judit Geskó (Budapest: Museum of Fine Arts, 2012), p. 46.

3. Paul Gauguin, letter to Mette Gauguin, Paris, n.d. [late November 1885], in Maurice Malingue, ed., *Paul Gauguin: Letters to His Wife and Friends*, trans. Henry J. Stenning (Boston: MFA Publications, 2003), p. 56, no. 30 (translation edited).

4. Maurice Denis's *Homage to Cézanne*, of 1900 (Musée d'Orsay, Paris), assembles friends, artists, and critics around Cézanne's *Still Life with Fruit Dish* in the dealer Ambroise Vollard's studio. See fig. 39 on p. 92.

5. For example, Gauguin's *Still Life with Teapot and Fruit*, from 1896, in The Metropolitan Museum of Art (1997.391.2). See Joseph J. Rishel, "Introduction and Acknowledgments," in *Gauguin, Cézanne, Matisse: Visions of Arcadia*, ed. Joseph J. Rishel, exh. cat. (Philadelphia: Philadelphia Museum of Art in association with Yale University Press, 2012), p. 6.

6. Julien Tanguy, known as Père Tanguy, was a color merchant in Montmartre with whom Cézanne traded paintings for supplies. Cézanne gave work to him as early as 1874. See Alex Danchev, *Cézanne: A Life* (New York: Pantheon, 2012), p. 275.

7. Paul Gauguin, letter to Camille Pissarro, June 1881, in Merlhès, *Correspondance de Paul Gauguin*, p. 21, translated and quoted in Solana, "Faun Awakes," p. 24.

8. Vollard's 1895 exhibition of Cézanne's paintings was nothing short of a revelation. Pissarro wrote to his son: "I also thought of Cézanne's show in which there were exquisite things, still lifes of irreproachable perfection, others much worked on and yet unfinished, of even greater beauty,

landscapes, nudes and heads that are unfinished but yet grandiose, and so painted, so supple. . . . Curiously enough, while I was admiring this strange, disconcerting aspect of Cézanne, familiar to me for many years, Renoir arrived. But my enthusiasm was nothing compared to Renoir's. Degas himself is seduced by the charm of this refined savage, Monet, all of us." Camille Pissarro, letter to Lucien Pissarro, November 21, 1895, in John Rewald, ed., with the assistance of Lucien Pissarro, *Camille Pissarro: Letters to His Son Lucien*, trans. Lionel Abel (New York: Pantheon, 1943), pp. 275–76.

9. Tobia Bezzola, " 'Plus vraie que toute autre peintre'—Alberto Giacometti's Theoretical Take on Cézanne," in *Cézanne and Giacometti: Paths of Doubt*, ed. Felix A. Baumann and Poul Erik Tøjner, exh. cat. (Humlebæk, Denmark: Louisiana Museum of Modern Art; Ostfildern, Germany: Hatje Cantz, 2008), p. 281.

10. Ibid., p. 283.

11. Ibid., p. 164.

12. James Lord, *A Giacometti Portrait* (New York: Museum of Modern Art, 1965), p. 78.

13. Christopher Green, *Léger and the Avant-Garde* (New Haven: Yale University Press, 1976), p. 128.

14. Most of these drawings were done in 1916, when Gris and his companion, Josette, spent September and October away from Paris in her hometown of Beaulieu-lès-Loches in Touraine. See Marilyn McCully, "Juan Gris: *Mme Cézanne, after Cézanne, 1916*," in *New York Collects: Drawings and Watercolors 1900–1950*, exh. cat. (New York: Pierpont Morgan Library, 1999), no. 27, p. 84.

15. Both Léonce and Paul Rosenberg were prominent dealers and proponents of modern art in Paris. Paul Rosenberg published the first catalogue raisonné of Cézanne's work, written by Lionello Venturi, *Cézanne—Son Art, son oeuvre* (Paris, 1936). Gris's second drawing (fig. 78) shows only Madame Cézanne's head and shoulders and the top of the chair. There is another drawing of Madame Cézanne by Gris, after Cézanne's *Madame Cézanne in a Red Armchair* (pl. 4). See fig. 4 on p. 12.

16. McCully, "Juan Gris: *Mme Cézanne, after Cézanne, 1916*," no. 27, p. 84.

17. Ibid.

18. Green, *Léger and the Avant-Garde*, pp. 127–28.

19. Emile Bernard, "Paul Cézanne" (from *L'Occident*), in Michael Doran, ed., *Conversations avec Cézanne* (1978; Paris: Macula, 2011), p. 76.

20. John Coplans, "Talking with Roy Lichtenstein," *Artforum* 5, no. 9 (May 1967), p. 36.

21. Richard Shiff, "Absolute Good: Cézanne, Loran, Lichtenstein," in Erle Loran, *Cézanne's Composition: Analysis of His Form with Diagrams and Photographs of His Motifs* (Berkeley: University of California Press, 2006), p. xvi.

22. Erle Loran, "Cézanne and Lichtenstein: Problems of 'Transformation,' " *Artforum* 2, no. 3 (September 1963), pp. 34–35, and "Pop Artists or Copy Cats?" *ARTnews* 62, no. 5 (September 1963), pp. 48–49, 61.

23. John Rewald, *Cézanne: Sa Vie, son oeuvre, son amitié pour Zola* (Paris: Albin Michel, 1939), p. 283.

24. Quoted in Robert Storr, *Elizabeth Murray*, exh. cat. (New York: Museum of Modern Art; Valencia: Institut Valencià d'Art Modern; New York: Museum of Modern Art, 2005), p. 172.

25. Sue Graze and Kathy Halbreich, eds., *Elizabeth Murray: Paintings and Drawings*, exh. cat. (Dallas: Dallas Museum of Art; New York: Harry N. Abrams in association with Dallas Museum of Art and MIT Committee on the Visual Arts, 1987), p. 123.

26. "Tender" . . . "exquisite": ibid.; "really about": Storr, *Elizabeth Murray*, p. 4.

27. Quoted in Michael Kimmelman, "At the Met with Elizabeth Murray: Looking for the Magic in Painting," *New York Times*, October 21, 1994, pp. C1, C28, http://www.nytimes.com/1994/10/21/arts/at-the-met-with-elizabeth-murray-looking-for-the-magic-in-painting.html.

28. Graze and Halbreich, *Elizabeth Murray: Paintings and Drawings*, p. 15.

SELECTED BIBLIOGRAPHY

Adriani, Götz. *Cézanne: Paintings*. Essay by Walter Feilchenfeldt. Translated by Russell M. Stockman. Exh. cat. Tübingen, Germany: Kunsthalle Tübingen; New York: Harry N. Abrams, 1995.

Alarcó, Paloma, and Malcolm Warner. *The Mirror and the Mask: Portraiture in the Age of Picasso*. Essays by Serraller F. Calvo, John Klein, and William Feaver. Exh. cat. Madrid: Museo Thyssen-Bornemisza; Fort Worth: Kimbell Art Museum; New Haven: Yale University Press, 2007.

Andersen, Wayne V. "Cézanne's Sketchbook in the Art Institute of Chicago." *Burlington Magazine* 104, no. 710 (May 1962), pp. 196–201.

———. "A Cézanne Drawing after Couture." *Master Drawings* 1, no. 4 (Winter 1963), pp. 44–46.

———. "Cézanne's *Carnet violet-moiré*." *Burlington Magazine* 107, no. 747 (June 1965), pp. 312–18.

———. *Cézanne's Portrait Drawings*. Cambridge, Mass.: MIT Press, 1970.

Antonini, Luc, and Nicolas Flippe. *La Famille Cézanne: Paul et les autres*. Preface by Philippe Cézanne. Paris: Luc Antonini and Nicolas Flippe, 2006.

Armstrong, Carol. *Cézanne in the Studio: Still Life in Watercolors*. Exh. cat. Los Angeles: J. Paul Getty Museum, 2004.

Atelier Cézanne, 1902–2002: Le Centenaire. English ed. translated by A. J. F. Miller. Aix-en-Provence: Société Paul Cézanne; Arles: Actes Sud, 2002.

Athanassoglou-Kallmyer, Nina Maria. *Cézanne and Provence: The Painter and His Culture*. Chicago: University of Chicago Press, 2003.

Badt, Kurt. *The Art of Cézanne*. Translated by Sheila Anne Ogilvie. Berkeley: University of California Press, 1965.

Bakker, B. H., ed. *"Naturalisme par mort": Lettres inédites de Paul Alexis à Emile Zola*. Toronto: University of Toronto Press, 1971.

Bargue, Charles. *Exercises au fusain*. Paris: Goupil, 1871.

———, with Jean-Léon Gérôme. *Drawing Course*. Edited by Gerald M. Ackerman. Paris: ACR, 2011. Originally published as *Cours de dessin*. Paris, ca. 1870.

Baumann, Felix, Evelyn Benesch, Walter Feilchenfeldt, and Klaus Albrecht Schröder, eds. *Cézanne: Finished—Unfinished*. Exh. cat. Vienna: Kunstforum Wien; Zurich: Kunsthaus Zürich; Ostfildern, Germany: Hatje Cantz, 2000.

Becks-Malorny, Ulrike. *Paul Cézanne, 1839–1906: Pioneer of Modernism*. Translated by Phil Goddard in association with First Edition Translations. Cologne: Taschen, 2001.

Bernard, Emile. "Paul Cézanne." *Les Hommes d'aujourd'hui* 8, no. 387 (February–March 1891), n.p.

———. "Paul Cézanne." *L'Occident*, July 1904, pp. 23–25.

———. *Souvenirs sur Paul Cézanne: Une Conversation avec Cézanne, la méthode de Cézanne*. Paris: R. G. Michel, 1926.

———. "Memories of Paul Cézanne" (from *Mercure de France*, 1904–6; 1907). In Doran, *Conversations with Cézanne*, pp. 50–79.

———. "Paul Cézanne" (from *L'Occident*, 1904). In Doran, *Conversations with Cézanne*, pp. 32–44.

———. "Paul Cézanne" (from *L'Occident*). In Doran, *Conversations avec Cézanne*, pp. 66–86.

Beucken, Jean de. *Un Portrait de Cézanne*. Paris: Gallimard, 1955.

Bezzola, Tobia. "'Plus vraie que toute autre peintre'—Alberto Giacometti's Theoretical Take on Cézanne." In *Cézanne and Giacometti: Paths of Doubt*, edited by Felix A. Baumann and Poul Erik Tøjner, pp. 281–90. Exh. cat. Humlebæk, Denmark: Louisiana Museum of Modern Art; Ostfildern, Germany: Hatje Cantz, 2008.

Boime, Albert. *The Academy and French Painting in the Nineteenth Century*. London: Phaidon, 1971.

———. "The Teaching Reforms of 1863 and the Origins of Modernism in France." *Art Quarterly*, n.s. 1, no. 1 (Autumn 1977), pp. 1–39.

Borély, Jules. "Cézanne à Aix" (from *L'Art vivant*, 1926). In Doran, *Conversations avec Cézanne*, pp. 45–53.

"British Artists' Suppliers, 1650–1950." London: National Portrait Gallery. www.npg.org.uk/research /programmes/directory-of -suppliers/.

Buck, Stephanie, John House, Ernst Vegelin van Claerbergen, and Barnaby Wright, eds. *The Courtauld Cézannes*. Essays by John House, Elizabeth Reissner, and Barnaby Wright. Catalogue by Stephanie Buck, John House, and Joanna Selborne. Exh. cat. London: Courtauld Gallery; London: Courtauld Gallery in association with Paul Holberton, 2008.

Butler, Marigene H. "An Investigation of the Materials and Techniques Used by Paul Cézanne." In *Preprints of Papers Presented at the Twelfth Annual Meeting, Los Angeles, California, 15–19 May 1984*, pp. 20–33. Los Angeles: American Institute for Conservation of Historic and Artistic Works, 1984.

Butler, Ruth. *Hidden in the Shadow of the Master: The Model-Wives of Cézanne, Monet, and Rodin*. New Haven: Yale University Press, 2008.

Cachin, Françoise, and Joseph J. Rishel. *Cézanne*. Contributions by Henri Loyrette, Isabelle Cahn, and Walter Feilchenfeldt. Translated by John Goodman. Exh. cat. Paris: Galeries Nationales du Grand Palais; London: Tate Gallery; Philadelphia: Philadelphia Museum of Art; New York: Harry N. Abrams in association with Philadelphia Museum of Art, 1996.

Callen, Anthea. *The Art of Impressionism: Painting Technique and the Making of Modernity*. New Haven: Yale University Press, 2000.

Cardoso, Rafael. "A Preliminary Survey of Drawing Manuals in Britain c. 1825–1875." In *Histories of Art and Design Education: Collected Essays*, edited by Mervyn Romans, pp. 19–32. Bristol, UK: Intellect, 2005.

Carpenter, James M. "Cézanne and Tradition." *Art Bulletin* 33, no. 3 (September 1951), pp. 174–86.

Catalogue général illustré de G. Sennelier fabricant de couleurs fines et matériel d'artistes. Paris: G. Sennelier, 1904. Originally published 1895.

Cavé, Marie-Elisabeth. *Le Dessin sans maître: Méthode pour apprendre à dessiner de mémoire.* Paris: Susse Frères, 1850. Reissued 1851; Aubert, 1852; Bureau du Journal Amusant, 1857.

A Cézanne Sketchbook: Figures, Portraits, Landscapes and Still Life. New York: Dover, 1951; rev. ed., 1985.

Chappuis, Adrien. *The Drawings of Paul Cézanne: A Catalogue Raisonné.* Translated by Paul Constable et al. 2 vols. Greenwich, Conn.: New York Graphic Society, 1973. UK ed., London: Thames and Hudson, 1973.

Conforti, Michael, James A. Ganz, Neil Harris, Sarah Lees, and Gilbert T. Vincent. *The Clark Brothers Collect: Impressionist and Early Modern Paintings.* Exh. cat. Williamstown, Mass.: Sterling and Francine Clark Art Institute; New York: The Metropolitan Museum of Art; New Haven: Yale University Press, 2006.

Conisbee, Philip, and Denis Coutagne. *Cézanne in Provence.* Contributions by Françoise Cachin, Isabelle Cahn, Bruno Ely, Benedict Leca, Véronique Serrano, and Paul Smith. Exh. cat. Washington, D.C.: National Gallery of Art; Aix-en-Provence: Musée Granet; New Haven: Yale University Press in association with National Gallery of Art, 2006.

Coplans, John. "Talking with Roy Lichtenstein." *Artforum* 5, no. 9 (May 1967), pp. 34–39.

Coquiot, Gustave. *Paul Cézanne.* Paris: Albin Michel, 1919.

Coutagne, Denis, ed. *Cézanne and Paris.* Contributions by Philippe Cézanne, Henri Mitterand, Mary Tompkins Lewis, et al. Exh. cat. Paris: Musée du Luxembourg; Paris: Editions de la Réunion des Musées Nationaux–Grand Palais, 2011.

———. *Courbet/Cézanne: La Vérité en peinture.* Exh. cat. Ornans, France: Musée Gustave Courbet; Lyon: Fage, 2013.

Couture, Thomas. *Méthode et entretiens d'atelier.* Paris: privately published, 1867, 1868. Published in English as *Conversations on Art Methods.* Translated by S. E. Stewart. New York: G. P. Putnam's Sons, 1879.

Couturier, Marie-Alain. *Se garder libre: Journal (1947–1954).* Paris: Cerf, 1962.

Danchev, Alex. *Cézanne: A Life.* New York: Pantheon, 2012. UK ed., London: Profile, 2012.

———, ed. and trans. *The Letters of Paul Cézanne.* Los Angeles: J. Paul Getty Museum, 2013. UK ed., London: Thames and Hudson, 2013.

Denis, Maurice. *Journal.* 2 vols. Paris: La Colombe, 1957.

Doran, Michael, ed. *Conversations with Cézanne.* Translated by Julie Lawrence Cochran. Berkeley: University of California Press, 2001.

———, ed. *Conversations avec Cézanne.* 10th ed. Paris: Macula, 2011. Originally published 1978.

Dupuis, Alexandre. *De l'enseignement du dessin sous le point de vue industriel.* Paris: Giroux et al., 1836.

Fielding, T. H. *The Knowledge and Restoration of Old Paintings: The Modes of Judging between Copies and Originals and a Brief Life of the Principal Masters in the Different Schools of Painting.* London: Ackermann, 1847.

Finsen, Hanne, ed. *Matisse, Rouveyre: Correspondance.* Paris: Flammarion, 2001.

Fourcade, Dominique. *Henri Matisse: Ecrits et propos sur l'art.* Paris: Hermann, 1972.

Fry, Roger. *Cézanne: A Study of His Development.* New York: Noonday Press, 1958. Originally published 1927.

Garb, Tamar. *The Painted Face: Portraits of Women in France, 1814–1914.* New Haven: Yale University Press, 2007.

Gasquet, Joachim. *Joachim Gasquet's Cézanne: A Memoir with Conversations.* Translated by Christopher Pemberton. London: Thames and Hudson, 1991. Originally published as *Cézanne,* 1921.

———. "What He Told Me . . ." (from *Cézanne,* 1921). In Doran, *Conversations with Cézanne,* pp. 107–60.

———. "Ce qu'il m'a dit . . ." (from *Cézanne*). In Doran, *Conversations avec Cézanne,* pp. 183–268.

Geffroy, Gustave. "Paul Cézanne." *Le Journal,* March 25, 1894.

Geist, Sidney. *Interpreting Cézanne.* Cambridge, Mass.: Harvard University Press, 1988.

Geskó, Judit, ed. *Cézanne and the Past: Tradition and Creativity.* Contributions by Isabelle Cahn, Richard Shiff, Mary Tompkins Lewis, et al. Exh. cat. Budapest: Museum of Fine Arts, 2012.

Gowing, Lawrence. "Notes on the Development of Cézanne." *Burlington Magazine* 98, no. 639 (June 1956), pp. 185–92.

———. *Cézanne: The Early Years 1859–1872.* Contributions by Götz Adriani, Mary Louise Krumrine, Mary Tompkins Lewis, Sylvie Patin, and John Rewald. Edited by Mary Anne Stevens. Exh. cat. London: Royal Academy of Arts; Paris: Musée d'Orsay; Washington, D.C.: National Gallery of Art; London: Weidenfeld and Nicolson, 1988.

Graze, Sue, and Kathy Halbreich, eds. *Elizabeth Murray: Paintings and Drawings.* Contributions by Roberta Smith and Clifford S. Ackley. Exh. cat. Dallas: Dallas Museum of Art; New York: Harry N. Abrams in association with Dallas Museum of Art and MIT Committee on the Visual Arts, 1987.

Great Exhibition of the Works of Industry of All Nations, 1851: Official Descriptive and Illustrated Catalogue. London: Spicer Brothers, 1851.

Green, Christopher. *Léger and the Avant-Garde.* New Haven: Yale University Press, 1976.

Harlé, D[aniel]. "Les Cours de dessin gravés et lithographiés du XIXème siècle conservés au Cabinet des Estampes de la Bibliothèque Nationale: Essai critique et catalogue." Thesis, Ecole du Louvre, Paris, 1975.

Holmes, C. J. *Notes on the Post-Impressionist Painters: Grafton Galleries, 1910–11.* Exh. cat. Grafton Galleries, London, 1910–11; London: Philip Lee Warner, 1910.

Hurtu, Raymond. "Quand Cézanne vient peindre au pays de Courbet . . ." In Coutagne, *Courbet/Cézanne: La Verité en peinture*, pp. 108–17.

Impressionist and Twentieth Century Works on Paper. Sale cat. Christie's, New York, May 9, 2000.

Jensen, Robert. "Vollard and Cézanne: An Anatomy of a Relationship." In Rabinow, *Cézanne to Picasso: Ambroise Vollard, Patron of the Avant-Garde*, pp. 29–47.

Jourdain, Francis. *Sans remords ni rancune: Souvenirs épars d'un vieil homme né en «76»*. Paris: Corrêa, 1953.

Katlan, Alexander. "The American Artist's Tools and Materials for On-Site Oil Sketching." *Journal of the American Institute for Conservation* 38, no. 1 (1999), pp. 21–32.

Kimmelman, Michael. "At the Met with Elizabeth Murray: Looking for the Magic in Painting." *New York Times*, October 21, 1994, pp. C1, C28. http://www.nytimes.com/1994/10/21/arts/at-the-met-with-elizabeth-murray-looking-for-the-magic-in-painting.html.

Kirsch, Bob. "Paul Cézanne: *Jeune Fille au Piano* and Some Portraits of His Wife: An Investigation of His Painting of the Late 1870s." *Gazette des beaux-arts*, ser. 6, vol. 110 (July–August 1987), pp. 21–26.

Larguier, Léo. "Excerpt from *Sunday with Paul Cézanne*" (1901–2; 1925). In Doran, *Conversations with Cézanne*, pp. 11–18.

———. Excerpt from *Le Dimanche avec Paul Cézanne* (1925). In Doran, *Conversations avec Cézanne*, pp. 32–44.

Lawrence, D. H. *The Paintings of D. H. Lawrence*. London: Mandrake Press, 1929.

———. *Late Essays and Articles*. Edited by James T. Boulton. Cambridge, UK: Cambridge University Press, 2004.

Lecoq de Boisbaudran, Horace. *L'Education de la mémoire pittoresque*. Paris: Librairie Sociétaire, 1848.

———. *L'Education de la mémoire pittoresque: Application aux arts du dessin*. Paris: Bance, 1862.

Leighton, Douglas. "Canvas and Bookcloth: An Essay on Beginnings." *The Library: Transactions of the Bibliographical Society*, ser. 5, vol. 3, no. 1 (June 1948), pp. 33–38.

Lewis, Mary Tompkins. *Cézanne*. London: Phaidon, 2000.

———. "The Path to Les Lauves: A History of Cézanne's Studios." In *Atelier Cézanne, 1902–2002*, pp. 8–25.

———. "Cézanne and the Louvre." In Geskó, *Cézanne and the Past*, pp. 105–7.

Lindsay, Jack. *Cézanne: His Life and Art*. Greenwich, Conn.: New York Graphic Society, 1969.

Loran, Erle. "Cézanne and Lichtenstein: Problems of 'Transformation.'" *Artforum* 2, no. 3 (September 1963), pp. 34–35.

———. "Pop Artists or Copy Cats?" *ARTnews* 62, no. 5 (September 1963), pp. 48–49, 61.

———. *Cézanne's Composition: Analysis of His Form with Diagrams and Photographs of His Motifs*. Berkeley: University of California Press, 2006. Originally published 1943.

Lord, James. *A Giacometti Portrait*. New York: Museum of Modern Art, 1965.

M.C. [Marthe Conil?]. "Quelques Souvenirs sur Paul Cézanne, par une de ses nièces." *Gazette des beaux-arts*, ser. 6, vol. 56, no. 1102 (November 1960), pp. 299–302.

McCully, Marilyn. "Juan Gris: *Mme Cézanne, After Cézanne, 1916*." In *New York Collects: Drawings and Watercolors 1900–1950*, p. 84. Exh. cat. New York: Pierpont Morgan Library, 1999.

Mack, Gerstle. *Paul Cézanne*. New York: Alfred A. Knopf, 1935. UK ed., London: Jonathan Cape, 1935.

McPherson, Heather. *The Modern Portrait in Nineteenth-Century France*. Cambridge, UK: Cambridge University Press, 2001.

Mainardi, Patricia. *The End of the Salon: Art and the State in the Early Third Republic*. Cambridge, UK: Cambridge University Press, 1973.

Malingue, Maurice, ed. *Paul Gauguin: Letters to His Wife and Friends*. Translated by Henry J. Stenning. Boston: Museum of Fine Arts Publications, 2003.

Marx, Roger. "Le Salon d'Automne." *Gazette des beaux-arts*, ser. 3, vol. 32, no. 570 (December 1904), p. 462.

Matisse, Henri. "Notes d'un peintre" (1908). In Fourcade, *Henri Matisse*, pp. 40–53.

Meier-Graefe, Julius. *Cézanne*. Translated by John Holroyd Reece. London: Ernest Benn, 1927.

Merleau-Ponty, Maurice. "Cézanne's Doubt." In *Sense and Non-Sense*, translated by Hubert L. Dreyfus and Patricia Allen Dreyfus, pp. 9–25. Evanston, Ill.: Northwestern University Press, 1964.

Merlhès, Victor, ed. *Correspondance de Paul Gauguin 1873–1888: Documents, témoinages*. Paris: Fondation Singer-Polignac, 1984.

Mouillefarine, Laurence. "A la une: Nous avons retrouvé des Cézannes" [Interview with Aline Cézanne]. *Madame Figaro*, September 23, 1995, pp. 14–18.

Natanson, Thadée. "Paul Cézanne." *La Revue blanche*, December 1, 1895, pp. 497–500.

Nochlin, Linda. "Impressionist Portraits and the Construction of Modern Identity." In Colin B. Bailey, with the assistance of John B. Collins, *Renoir's Portraits: Impressions of an Age*, pp. 53–75. Exh. cat. Ottawa: National Gallery of Canada; New Haven: Yale University Press, 1997.

Paillot de Montabert, Jacques-Nicolas. *Traité complet de la peinture*. 9 vols. Paris: J.-F. Delion, 1829–51.

Paul Cézanne, Drawings: Carnet de dessins, Chappuis II. Essay "The Historical Line: Cézanne's Sketchbooks" by David Breuer-Weil. Exh. cat. New York: Peter Findlay Gallery, 2004.

Peachey, Jeff. "A Few Random Thoughts on 19th Century Books and Machines." Accessed March 15, 2013. http://jeffpeachey.com/2010/01/13/deja-vu/.

Perruchot, Henri. *La Vie de Cézanne*. Paris: Hachette, 1958.

Picard, Alfred, ed. *Exposition Universelle Internationale de 1889 à Paris: Rapports du jury internationale*. Group 2, pt. 2, Matériel et Procédés des Arts Libéraux. Paris: Imprimerie Nationale,

1891. http://cnum.cnam.fr/CGI/page.cgi?8XAE348.5/ and subsequent pages.

Platzman, Steven. *Cézanne: The Self-Portraits.* Berkeley: University of California Press, 2001.

Rabinow, Rebecca A., ed., with Douglas W. Druick, Ann Dumas, Gloria Groom, Anne Roquebert, and Gary Tinterow. *Cézanne to Picasso: Ambroise Vollard, Patron of the Avant-Garde.* Contributions by Maryline Assante di Panzillo, Isabelle Cahn, Anne Distel, et al. Exh. cat. New York: The Metropolitan Museum of Art; Chicago: Art Institute of Chicago; Paris: Musée d'Orsay; New Haven: Yale University Press, 2006.

Rapport sur l'Exposition Universelle de 1855. Paris: Imprimerie Impériale, 1857.

Ratcliffe, Robert William. "Cézanne's Working Methods and Their Theoretical Background." PhD diss., Courtauld Institute of Art, University of London, 1960.

Reff, Theodore. "Cézanne's Constructive Stroke." *Art Quarterly* 25, no. 3 (Autumn 1962), pp. 214–27.

———, ed. *Cézanne Watercolors: An Exhibition at M. Knoedler and Company, 14 East 57th Street, New York City, 2 April to 20 April, 1963.* Exh. cat. New York: M. Knoedler and Co.; New York: Chanticleer, 1963.

———. Review of *Album de Paul Cézanne* by Adrien Chappuis. *Burlington Magazine* 109, no. 776 (November 1967), pp. 652–53.

———, and Innis Howe Shoemaker. *Paul Cézanne: Two Sketchbooks: The Gift of Mr. and Mrs. Walter H. Annenberg to the Philadelphia Museum of Art.* Exh. cat. Philadelphia: Philadelphia Museum of Art, 1989.

Reissner, Elisabeth. "Transparency of Means: Drawing and Colour in Cézanne's Watercolours and Oil Paintings in the Courtauld Gallery." In Buck et al., *The Courtauld Cézannes,* pp. 49–71.

———. "Ways of Making: Practice and Innovation in Cézanne's Paintings in the National Gallery." *National Gallery Technical Bulletin* 29 (2008), pp. 4–30.

Reports on the Paris Universal Exhibition, 1867. London: George E. Eyre and William Spottiswoode for Her Majesty's Stationery Office, 1868.

Rewald, John, ed. *Paul Cézanne: Correspondance.* Paris: Bernard Grasset, 1937. Reissued 2006.

———. *Cézanne: Sa Vie, son oeuvre, son amitié pour Zola.* Paris: Albin Michel, 1939.

———, ed. *Paul Cézanne: Letters.* Translated by Marguerite Kay. London: B. Cassirer, 1941.

———. "Cézanne's Theories about Art." *ARTnews* 47, no. 7 (November 1948), pp. 31–35.

———. *Paul Cézanne: A Biography.* New York: Simon and Schuster, 1948.

———. *Paul Cézanne: Carnets de dessins.* 2 vols. Paris: Quatre Chemins–Editart, 1951.

———. *Paul Cézanne: The Watercolors: A Catalogue Raisonné.* Boston: Little, Brown, 1983. UK ed., *The Watercolours: A Catalogue Raisonné.* London: Thames and Hudson, 1983.

———, ed. *Paul Cézanne: Letters.* Rev. ed. Translated by Seymour Hacker. New York: Hacker Art Books, 1984.

———. *Cézanne: A Biography.* New York: Harry N. Abrams, 1986.

———, ed. *Paul Cézanne: Letters.* Translated by Marguerite Kay. New York: Da Capo Press, 1995.

———, ed., with the assistance of Lucien Pissarro. *Camille Pissarro: Letters to His Son Lucien.* Translated by Lionel Abel. New York: Pantheon, 1943.

———. *Camille Pissarro: Lettres à son fils Lucien.* Paris: Albin Michel, 1950.

Rewald, John, in collaboration with Walter Feilchenfeldt and Jayne Warman. *The Paintings of Paul Cézanne: A Catalogue Raisonné.* 2 vols. New York: Harry N. Abrams, 1996.

Rewald, John, with Frances Weitzenhoffer. *Cézanne and America: Dealers, Collectors, Artists and Critics, 1891–1921.* Princeton, N.J.: Princeton University Press, 1989.

Rilke, Rainer Maria. *Letters on Cézanne.* Edited by Clara Rilke. Translated by Joel Agee. New York: North Point Press, 2002.

Rishel, Joseph J. *Cézanne in Philadelphia Collections.* Philadelphia: Philadelphia Museum of Art, 1983.

———, ed. *Gauguin, Cézanne, Matisse: Visions of Arcadia.* Contributions by Stephanie D'Alessandro, Charles Dempsey, Tanja Pirsig-Marshall, Joseph J. Rishel, and George T. M. Shackelford. Exh. cat. Philadelphia: Philadelphia Museum of Art in association with Yale University Press, 2012.

———, and Katherine Sachs, eds. *Cézanne and Beyond.* Exh. cat. Philadelphia: Philadelphia Museum of Art, 2009.

Rivière, Georges. "L'Exposition des impressionnistes." *L'Impressionniste,* no. 2 (April 14, 1877), pp. 2–6.

———. *Le Maître: Paul Cézanne.* Paris: H. Floury, 1923.

Rivière, R. P., and J. F. Schnerb. "Cézanne's Studio" (from *La Grande Revue,* December 25, 1907). In Doran, *Conversations with Cézanne,* pp. 84–90.

Robert, Georges Karl. *Le Fusain sans maître: Traité pratique et complet sur l'étude de paysage au fusain.* Paris: Georges Meusnier, 1874. Published in English as *Charcoal Drawing without a Master.* Translated by Elizabeth Haven Appleton. Cincinnati: Robert Clarke, 1880.

Roe, Sue. *The Private Lives of the Impressionists.* New York: HarperCollins, 2006.

Roth-Meyer, Clothilde. "Les Marchands de couleurs à Paris au XIXe siècle." PhD diss., Université Paris–Sorbonne, 2004.

Rouillet, Amaranthe. *Le David des collèges, ou abrégé élémentaire du dessin, contenant vingt planches de principes progressifs, à l'usage des jeunes gens.* Paris: F. Chavant, 1836. Published in English as *David for Schools: An Elementary Summary for Drawing, Containing Twenty Plates of Progressive Principles for the Use of Young People.* London: Ch. Tilt, 1836.

———. "Le Procédé Rouillet." *L'Illustration* 1, no. 6 (April 8, 1843), p. 90.

Schapiro, Meyer. "The Apples of Cézanne: An Essay on the Meaning of Still-Life." In *Modern Art: 19th and 20th Centuries:*

Selected Papers, pp. 1–38. New York: George Braziller, 1978. Originally published in *The Avant-Garde*, edited by Thomas B. Hess and John Ashbery. New York: Macmillan, 1968 (*ARTnews Annual 34*).

———. *Cézanne*. New York: Harry N. Abrams, 1988. UK ed., London: Thames and Hudson, 1988. Originally published as *Paul Cézanne*. New York: Harry N. Abrams, 1952.

———. *Impressionism: Reflections and Perceptions*. New York: George Braziller, 1997.

Schniewind, Carl O. *Paul Cézanne Sketch Book: Owned by the Art Institute of Chicago*. 2 vols. New York: Curt Valentin, 1951.

Schubert, Karsten. "Cézanne, Chappuis and the Limits of Connoisseurship." *Burlington Magazine* 148, no. 1242 (September 2006), pp. 612–20.

Shiff, Richard. "Absolute Good: Cézanne, Loran, Lichtenstein." In Loran, *Cézanne's Composition*, pp. xvi–xx.

———. "Sensation, Cézanne." In Geskó, *Cézanne and the Past*, pp. 35–47.

Sidlauskas, Susan. "Emotion, Color, Cézanne (The Portraits of Hortense)." *Nineteenth Century Art Worldwide* 3, no. 2 (Autumn 2004), n.p. http://www.19thc-artworldwide.org/autumn04/67-autumn04/autumn04article/299-emotion-color-cezanne-the-portraits-of-hortense.

———. "Not Beautiful: A Counter-Theme in the History of Women's Portraiture." In *Re-framing Representations of Women: Figuring, Fashioning, Portraiting and Telling in the 'Picturing' Women Project*, edited by Susan Shifrin, pp. 183–98. Aldershot, UK: Ashgate, 2008.

———. *Cézanne's Other: The Portraits of Hortense*. Berkeley: University of California Press, 2009.

Simms, Matthew. *Cézanne's Watercolors: Between Drawing and Painting*. New Haven: Yale University Press, 2008.

Smith, Paul. *Impressionism beneath the Surface*. New York: Harry N. Abrams, 1995. UK ed., London: Calmann and King, 1995.

———. "Cézanne's 'Primitive' Perspective, or the 'View from Everywhere.'" *Art Bulletin* 95, no. 1 (March 2013), pp. 102–19.

Solana, Guillermo. "The Faun Awakes: Gauguin and the Revival of the Pastoral." In *Gauguin and the Origins of Symbolism*, edited by Guillermo Solana, pp. 15–64. Exh. cat. Madrid: Museo Thyssen-Bornemisza, Fundación Caja de Madrid; London: Philip Wilson, 2004.

Spurling, Hilary. *The Unknown Matisse: A Life of Henri Matisse: The Early Years, 1869–1908*. New York: Alfred A. Knopf, 1998.

———. *Matisse the Master: A Life of Henri Matisse: The Conquest of Colour, 1909–1954*. New York: Alfred A. Knopf, 2005.

Stein, Gertrude. *The Autobiography of Alice B. Toklas*. New York: Harcourt, Brace, 1933. Reprinted in *Writings 1903–1932*. New York: Library of America, 1998.

Stein, Susan Alyson, and Asher Ethan Miller, eds. *The Annenberg Collection: Masterpieces of Impressionism and Post-Impressionism*. Contributions by Colin B. Bailey, Joseph J. Rishel, Mark Rosenthal, and Susan Alyson Stein. New York: The Metropolitan Museum of Art, 2009.

Storr, Robert. *Elizabeth Murray*. Exh. cat. New York: Museum of Modern Art; Valencia: Institut Valencià d'Art Modern; New York: Museum of Modern Art, 2005.

Sutton, Denys, ed. *Letters of Roger Fry*. London: Chatto and Windus, 1972.

van Buren, Anne H. "Madame Cézanne in Oil and Pencil." Master's thesis, University of Texas at Austin, 1964.

———. "Madame Cézanne's Fashions and the Dates of Her Portraits." *Art Quarterly* 29, no. 2 (1966), pp. 111–27.

Venturi, Lionello. *Cézanne: Son Art—son oeuvre*. 2 vols. Paris: Paul Rosenberg, 1936.

———. *Cézanne*. New York: Rizzoli, 1978.

Viollet-le-Duc, Eugène. "L'Enseignement des arts: Il y a quelque chose à faire." *Gazette des beaux-arts* 12 (May–September 1862), pp. 249–55.

Voice, Eric H. "The History of the Manufacture of Pencils." *Transactions of the Newcomen Society* 27, no. 1 (1949), pp. 131–41.

Vollard, Ambroise. *Recollections of a Picture Dealer*. Translated by Violet M. Macdonald. Boston: Little, Brown, 1936. Originally published Paris, 1914.

———. *Paul Cézanne: His Life and Art*. Translated by Harold L. Van Doren. New York: Crown, 1937.

———. *Cézanne*. New York: Dover, 1984. Reissue of *Paul Cézanne: His Life and Art*.

Wattenmaker, Richard J., Anne Distel, Françoise Cachin, Joseph J. Rishel, et al. *Great French Paintings from the Barnes Foundation: Impressionist, Post-Impressionist, and Early Modern*. Exh. cat. Washington, D.C.: National Gallery of Art; New York: Alfred A. Knopf in association with Lincoln University Press, 1993.

White, Raymond, Jennifer Pilc, and Jo Kirby. "Analyses of Paint Media." *National Gallery Technical Bulletin* 19 (1998), pp. 74–95.

Wildenstein, Daniel. *Claude Monet: Biographie et catalogue raisonné*. 5 vols. Lausanne and Paris: Bibliothèque des Arts, Fondation Wildenstein, 1974.

Zieske, Faith. "The Conservation of Two Sketchbooks by Paul Cézanne." In *The Institute of Paper Conservation: Conference Papers, Manchester 1992*, edited by Sheila Fairbrass, pp. 54–60. Worcester, UK: Institute of Paper Conservation, 1992.

Zola, Emile. "Mon salon: L'Ouverture." *L'Evénement illustré*, May 2, 1868.

———. *L'Oeuvre*. Paris: Fasquelle/Bibliothèque-Charpentier, 1950. Originally published 1886.

———. *Correspondance*. Edited by Bard H. Bakker, Colette Becker, Henri Mitterand, and Owen Morgan. Montreal: Presses de l'Université de Montréal, 1978.

———. *The Masterpiece*. Translated by Thomas Walton, revised by Roger Pearson. Oxford, UK: Oxford University Press, 2008. Originally published 1886.

THE PORTRAITS OF HORTENSE FIQUET, MADAME CÉZANNE

Compiled by Kathryn Kremnitzer; Edited by Amelia Kutschbach

ABBREVIATIONS

Andersen, *Cézanne's Portrait Drawings* (1970)
Andersen, Wayne V. *Cézanne's Portrait Drawings*. Cambridge, Mass.: MIT Press, 1970.

Butler, *Hidden in the Shadow of the Master* (2008)
Butler, Ruth. *Hidden in the Shadow of the Master: The Model-Wives of Cézanne, Monet, and Rodin*. New Haven: Yale University Press, 2008.

Cachin and Rishel, *Cézanne* (1996)
Cachin, Françoise, and Joseph J. Rishel. *Cézanne*. Translated by John Goodman. Exh. cat. Paris: Galeries Nationales du Grand Palais; London: Tate Gallery; Philadelphia: Philadelphia Museum of Art. New York: Harry N. Abrams in association with Philadelphia Museum of Art, 1996.

Chappuis, *Drawings of Paul Cézanne* (1973)
Chappuis, Adrien. *The Drawings of Paul Cézanne: A Catalogue Raisonné*. Translated by Paul Constable et al. 2 vols. Greenwich, Conn.: New York Graphic Society, 1973.

C. Feilchenfeldt, "Portraits" (2000)
Feilchenfeldt, Christina. "Portraits." In *Cézanne: Finished—Unfinished*, edited by Felix Baumann, Evelyn Benesch, Walter Feilchenfeldt, and Klaus Albrecht Schröder, pp. 127–207. Exh. cat. Vienna: Kunstforum Wien; Zurich: Kunsthaus Zürich; Ostfildern: Hatje Cantz, 2000.

W. Feilchenfeldt, *By Appointment Only* (2006)
Feilchenfeldt, Walter. *By Appointment Only: Cézanne, Van Gogh and Some Secrets of Art Dealing; Essays and Lectures*. London and New York: Thames and Hudson, 2006.

Meier-Graefe, *Cézanne und sein Kreis*, 1st and 2nd eds. (1918 and 1920), 3rd ed. (1922)
Meier-Graefe, Julius. *Cézanne und sein Kreis: Ein Beitrag zur Entwicklungsgeschichte*. 1st ed. Munich: R. Piper, 1918; 2nd ed., 1920; 3rd ed., 1922.

Meier-Graefe, *Cézanne* (1927)
Meier-Graefe, Julius. *Cézanne*. Translated by J. Holroyd-Reece. London: Ernest Benn, 1927.

Rewald, *Cézanne and America* (1989)
Rewald, John, with Frances Weitzenhoffer. *Cézanne and America: Dealers, Collectors, Artists and Critics, 1891–1921*. Princeton, N.J.: Princeton University Press, 1989.

Rewald, *Paintings of Cézanne* (1996)
Rewald, John, in collaboration with Walter Feilchenfeldt and Jayne Warman. *The Paintings of Paul Cézanne: A Catalogue Raisonné*. 2 vols. New York: Harry N. Abrams, 1996.

Rishel and Sachs, *Cézanne and Beyond* (2009)
Rishel, Joseph J., and Katherine Sachs, eds. *Cézanne and Beyond*. Exh. cat. Philadelphia: Philadelphia Museum of Art; New Haven: Yale University Press, 2009.

Rivière, *Le Maître* (1923)
Rivière, Georges. *Le Maître: Paul Cézanne*. Paris: H. Floury, 1923.

Schapiro, *Paul Cézanne* (1973)
Schapiro, Meyer. *Paul Cézanne*. Translated by Louis Marie Ollivier. Collection des Grands Peintres Modernes. Paris: Nouvelles Éditions Françaises, 1973.

Sidlauskas, "Emotion, Color, Cézanne" (2004)
Sidlauskas, Susan. "Emotion, Color, Cézanne (The Portraits of Hortense)." *Nineteenth Century Art Worldwide* 3, no. 2 (Autumn 2004). http://www.19thc-artworldwide.org/autumn04/67-autumn04/autumn04article/299-emotion-color-cezanne-the-portraits-of-hortense.

Sidlauskas, *Cézanne's Other* (2009)
Sidlauskas, Susan. *Cézanne's Other: The Portraits of Hortense*. Berkeley: University of California Press, 2009.

Van Buren, "Madame Cézanne's Fashions" (1966)
van Buren, Anne H. "Madame Cézanne's Fashions and the Dates of Her Portraits." *Art Quarterly* 29, no. 2 (1966), pp. 111–27.

Venturi, *Cézanne* (1936)
Venturi, Lionello. *Cézanne: Son Art—son oeuvre*. 2 vols. Paris: Paul Rosenberg, 1936.

Works are grouped by medium and arranged chronologically.

PAINTINGS

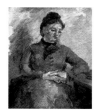

Fig. 9. *Portrait of Madame Cézanne*, ca. 1872
Oil on canvas, 18 1/8 × 14 5/8 in. (46 × 37.4 cm)
Whereabouts unknown

Provenance: Armand Guillaumin, Paris; [Camentron & Martin, Paris]; [Goupil & Cie. (Theo van Gogh), Paris]; [Ambroise Vollard, Paris]; [Galerie E. Bignou, Paris]; [Knoedler Galleries, New York]; Hugo Perls, New York; W. Weinberg, Scarsdale, N.Y. (his sale, London, Sotheby's, July 10, 1957, lot 15); Max Müller, Solothurn, Switzerland; whereabouts unknown

Exhibitions: "A Collection of Paintings by Eugène Boudin and Some Contemporaries," Lefevre Galleries, London, October 1936, no. 19; "Paul Cézanne, 1839–1906," Gemeentemuseum, The Hague, June–July 1956, no. 8, ill., Kunsthaus Zürich, August 22–October 7, 1956, no. 13, and Haus der Kunst, Munich, October–November 1956, no. 9

References: Venturi, *Cézanne* (1936), no. 226, vol. 1, p. 115, vol. 2, p. 62; Van Buren, "Madame Cézanne's Fashions" (1966), p. 117, fig. 3; Andersen, *Cézanne's Portrait Drawings* (1970), no. 31, pp. 14, 73; John Rewald, "Theo van Gogh, Goupil, and the Impressionists," *Gazette des beaux-arts* 81, no. 1249 (February 1973), pp. 66, 86n129, ill. p. 67; Charles Sterling, *Etudes d'art français offertes à Charles Sterling*, edited by Albert Châtelet and Nicole Reynaud (Paris: Presses Universitaires de France, 1975), fig. 211; John Rewald, *Studies in Impressionism*, edited by Irene Gordon and Frances Weitzenhoffer (London: Thames and Hudson, 1985), p. 103, fig. 52; John Rewald, *Studies in Post-Impressionism*, edited by Irene Gordon and Frances Weitzenhoffer (London: Thames and Hudson, 1986), pp. 42, 69, 83, 89; Rewald, *Paintings of Cézanne* (1996), no. 180, vol. 1, p. 142, vol. 2, p. 62; Theodore Reff, [Review of John Rewald, *The Paintings of Paul Cézanne: A Catalogue Raisonné* (London: Thames and Hudson, 1996)], *Burlington Magazine* 139, no. 1136 (November 1997), p. 801; W. Feilchenfeldt, *By Appointment Only* (2006), pp. 243–44, ill.

NOT IN EXHIBITION

Pl. 3. *Woman Nursing Her Child*, ca. 1872
Oil on canvas, 8⅝ × 8⅝ in. (22 × 22 cm)
Whereabouts unknown

Provenance: Henri Rouart, Paris; [Galerie Manzi-Joyant, Paris]; Jos. Hessel, Paris; August Pellerin, Paris; Jean-Victor Pellerin, Paris; Professor D. Carlstrom, Sweden; sale, London, Sotheby's, April 4, 1989, lot 30; private collection; whereabouts unknown

Exhibition: "L'Impressionnisme dans les collections romandes," Fondation de l'Hermitage, Donation Famille Bugnion, Lausanne, June 17–October 21, 1984, no. 103

References: Arsène Alexandre, *Collection Henri Rouart* (Paris: Goupil, 1912), p. 70; Charles Louis Borgmeyer, *The Master Impressionists* (Chicago: Fine Arts Press, 1913), p. 276, ill.; "Cézanne and His Place in Impressionism," *Fine Arts Journal* 35, no. 5 (May 1917), p. 330, ill.; Elie Faure, "Toujours Cézanne," *L'Amour de l'art* 1, no. 8, suppl. (December 1920), p. 269, ill.; Tokuji Saisho, *Pooru Sezannu* [Paul Cézanne] (Tokyo: Rakuyodo, Taisho 10, 1921), pl. 27; Rivière, *Le Maître* (1923), p. 142, ill. p. 201; Elie Faure, *P. Cézanne* (Paris: Crès, 1926), pl. 3; Eugenio d'Ors, *Paul Cézanne*, translated by Francisco Amunategui (Paris: Editions des Chroniques du Jour, 1930), p. 37, ill.; Georges Rivière, *Cézanne, le peintre solitaire*, Anciens et Modernes (Paris: Floury, 1933), p. 29, ill.; Eugenio d'Ors, *Paul Cézanne*, translated by Francisco Amunategui (New York: Weyhe, 1936), pl. 50; G[ualtieri] di San Lazzaro, *Paul Cézanne* (Paris: Editions des Chroniques du Jour, 1936), fig. 50; Venturi, *Cézanne* (1936), no. 233, vol. 1, p. 116, vol. 2, pl. 63; John Rewald, "A propos du catalogue raisonné de l'oeuvre de Paul Cézanne et de la chronologie de cette oeuvre," *La Renaissance* 20, nos. 3–4 (March–April 1937), p. 54; Georges Rivière, *Cézanne, le peintre solitaire* (Paris: Floury, 1942), p. 31, ill.; Paul Gachet, *Deux Amis des impressionnistes: Le Docteur Gachet et Murer* (Paris: Editions de Musées Nationaux, 1956), fig. 21; Rewald, *Paintings of Cézanne* (1996), no. 216, vol. 1, p. 158, vol. 2, ill. p. 72

NOT IN EXHIBITION

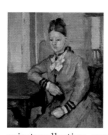

Pl. 1. *Madame Cézanne Leaning on a Table*, ca. 1873–74
Oil on canvas, 18⅛ × 15 in. (46 × 38 cm)
Private collection, care of Faggionato, London

Provenance: Eugène Boch, Monthyon; [Wildenstein Galleries, Paris, London, and New York]; M. Motte, Geneva; Madame Roger Firmenich, Geneva; sale, New York, Christie's, May 9, 2001, lot 23; private collection, Geneva; private collection, care of Faggionato, London

Exhibitions: "Centenaire du peintre indépendant Paul Cézanne, 1839–1906," Grand Palais, Paris, March 17–April 10, 1939, no. 8; "Homage to Paul Cézanne, 1839–1906," Wildenstein, London, July 1939, no. 13; "Centenaire de Paul Cézanne," Musée de Lyon, December 1939–February 1940, no. 13; "Chefs-d'oeuvre des collections suisses: De Manet à Picasso," Palais de Beaulieu, Lausanne, May 1–October 25, 1964, and Musée de l'Orangerie, Paris, 1967, no. 86, ill.

References: Ambroise Vollard, *Paul Cézanne: Huit phototypies d'après Cézanne; Lettres de M. M. Jacques Flach, de l'Institut et André Suarès* (Paris: Crès, 1919), p. 211, ill.; Venturi, *Cézanne* (1936), no. 278, vol. 1, p. 125, vol. 2, pl. 74; Van Buren, "Madame Cézanne's Fashions" (1966), p. 117, fig. 2; C[harles] F[erdinand] Ramuz, *Cézanne: Formes*, Rythmes et Couleurs 2, ser. 2 (Lausanne: International Art Book, 1968), fig. 8; Sandra Orienti, *The Complete Paintings of Cézanne*, introduction by Ian Dunlop, Classics of the World's Great Art (New York: Harry N. Abrams, 1972), no. 230, p. 96, ill. p. 97, pl. XI; Marcel Brion, *Cézanne*, Great Impressionists (London: Thames and Hudson; Garden City, N.Y.: Doubleday, 1974), p. 75; Rewald, *Paintings of Cézanne* (1996), no. 217, vol. 1, pp. 158–59, vol. 2, p. 72, ill.; Philippe Cézanne, "Paul Cézanne, l'homme," in *Cézanne et Paris*, edited by Denis Coutagne (Paris: Musée du Luxembourg; Réunion des Musées Nationaux, Grand Palais, Petit Palais, 2011), p. 30, fig. 6

Pl. 2. *Young Woman with Loosened Hair*, ca. 1873–74
Oil on canvas, 4⅜ × 6 in. (11 × 15.2 cm)
Private collection, on loan to Staatliche Museen zu Berlin, Nationalgalerie, Museum Berggruen

Provenance: [?Ambroise Vollard, Paris]; Charles A. Loeser, Florence; Mrs. M. Loeser Calnan, Florence; sale, London, Sotheby's, May 6, 1959, lot 88; Lady Jamieson, London; private collection, Washington, D.C.; E. V. Thaw, New York; Heinz Berggruen, Paris and Berlin; private collection, on loan to Staatliche Museen zu Berlin, Nationalgalerie, Museum Berggruen

Exhibitions: "Berggruen Collection," Musée d'Art et d'Histoire, Geneva, June 16–October 30, 1988, no. 1, ill.; "Paul Cézanne: Die Badenden," Kunstmuseum Basel, September 10–December 10, 1989, no. 9 (cat. by Mary Louise Krumrine, pl. 117); "Cézanne a Firenze: Due collezionisti e la mostra dell'impressionismo del 1910 / Cézanne in Florence: Two Collectors and the 1910 Exhibition of Impressionism," Palazzo Strozzi, Florence, March 2–July 29, 2007, unnumbered (cat. edited by Francesca Bardazzi, pp. 110, 266, ill. p. 111, fig. 34)

References: Emile Bernard, *Souvenirs sur Paul Cézanne: Une Conversation avec Cézanne, la méthode de Cézanne* (Paris: R. G. Michel, 1926), ill. opp. p. 64; Venturi, *Cézanne* (1936), no. 277, vol. 1, p. 125, vol. 2, pl. 74; John Rewald, *Cézanne: A Biography* (New York: Harry N. Abrams, 1986), p. 136, ill.; Rewald, *Paintings of Cézanne* (1996), no. 230, vol. 1, p. 167, vol. 2, ill. p. 76.

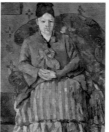

Pl. 4. *Madame Cézanne in a Red Armchair*, ca. 1877
Oil on canvas, 28½ × 22 in. (72.5 × 56 cm)
Museum of Fine Arts, Boston, Bequest of Robert Treat Paine, 2nd (44.776)

Provenance: [Ambroise Vollard, Paris]; Egisto Fabbri, Florence; [Paul Rosenberg, Paris]; Robert Treat Paine, Boston; Museum of Fine Arts, Boston

Exhibitions: "Rétrospective de Cézanne," at "Salon d'Automne," Grand Palais des Champs Elysées, Paris,

October 1–22, 1907, no. 53; "Exposition Cézanne," Bernheim-Jeune, Paris, January 10–22, 1910, no. 18; "Mostra individuale di Paul Cézanne," Venice Biennale, April 15–October 31, 1920, no. 7; "Cézanne," Pennsylvania Museum of Art, Philadelphia, November 10–December 10, 1934, no. 14, ill.; "Cézanne," Musée de l'Orangerie, Paris, May–October 1936, no. 46 (cat., pl. IV); "Paintings, Drawings, Prints, from Private Collections in New England," Museum of Fine Arts, Boston, June 9–September 10, 1939, no. 10 (cat., pl. VII); "Cézanne: Centennial Exhibition, 1839–1939," Marie Harriman Gallery, New York, November 7–December 2, 1939, no. 5; "Modern French Painting: A Loan Exhibition Sponsored by the Poses Institute of Fine Arts for the Benefit of the Art Scholarship and Grants Fund, Brandeis University," Wildenstein, New York, April 11–25, 1962, no. 8, ill.; "One Hundred Paintings from the Boston Museum," The Metropolitan Museum of Art, New York, May 29–July 26, 1970, no. 62, ill.; "Cézanne: An Exhibition in Honor of the Fiftieth Anniversary of the Phillips Collection," Phillips Collection, Washington, D.C., February 27–March 28, 1971, Art Institute of Chicago, April 17–May 16, 1971, and Museum of Fine Arts, Boston, June 1–July 3, 1971, no. 5; "Impressionism: French and American," Museum of Fine Arts, Boston, June 15–October 14, 1973, unnumbered; "Modern Masters: Manet to Matisse," Art Gallery of New South Wales, Sydney, April 10–May 11, 1975, National Gallery of Victoria, Melbourne, May 28–June 22, 1975, and Museum of Modern Art, New York, August 4–September 1, 1975, unnumbered, ill.; "Corot to Braque: French Paintings from the Museum of Fine Arts, Boston," High Museum of Art, Atlanta, Ga., and other venues, April 21, 1979–November 23, 1980, no. 44, ill.; "Cézanne, Gemälde," Kunsthalle Tübingen, January 16–May 2, 1993, no. 14, ill.; "Cézanne," Galeries Nationales du Grand Palais, Paris, September 25, 1995–January 7, 1996, Tate Gallery, London, February 8–April 28, 1996, and Philadelphia Museum of Art, May 26–August 18, 1996, no. 47 (cat., Cachin and Rishel, Cézanne, pp. 170, 172, ill. p. 171); "Pol Sezann i russkiĭ avangard nachala XX veka" [Paul Cézanne and the early twentieth-century Russian avant-garde], State Hermitage Museum, Saint Petersburg, August 8–September 24, 1998, and Pushkin State Museum of Fine Arts, Moscow, October 5–November 15, 1998, no. 8, ill.; "Cézanne: Finished—Unfinished," Kunstforum, Vienna, January 20–April 25, 2000, and Kunsthaus Zürich, May 5–July 30, 2000, no. 3, ill. (cat. edited by Felix Baumann, Evelyn Benesch, Walter Feilchenfeldt, and Klaus Albrecht Schröder, pp. 135–37, ill.); "Cézanne: Aufbruch in die Moderne," Museum Folkwang, Essen, September 18, 2004–January 16, 2005, unnumbered (cat. edited by Felix A. Baumann, Walter Feilchenfeldt, and Hubertus Gassner, pp. 32, 231, ill. p. 33); "Cézanne a Firenze: Due collezionisti e la mostra dell'impressionismo del 1910 / Cézanne in Florence: Two Collectors and the 1910 Exhibition of Impressionism," Palazzo Strozzi, Florence, March 2–July 29, 2007, unnumbered (cat. edited by Francesca Bardazzi, pp. 96, 259, ills. pp. 96 and on cover, fig. 6); "Cézanne and Beyond," Philadelphia Museum of Art, February 26–May 17, 2009, unnumbered (cat., Rishel and Sachs, Cézanne and Beyond, pp. 134, 214, 531, ill. on cover, pl. 60); "Cézanne et Paris," Musée Luxembourg, Paris, October 12, 2011–February 26, 2012, no. 75 (cat. edited by Denis Coutagne, p. 187, ill.); "Cézanne: Paris–Provence," National Arts Center, Tokyo, March 28–June 11, 2012, no. 63; "Cézanne and the Past: Tradition and Creativity," Museum of Fine Arts,

Budapest, October 25, 2012–February 17, 2013, no. 48 (cat. edited by Judit Geskó, p. 300, ill. p. 301)

References: [Letter to Clara Rilke, Paris, October 22, 1907], in Rainer Maria Rilke, *Briefe über Cézanne*, edited by Clara Rilke (Wiesbaden: Insel, 1952), pp. 38–40; Elie Faure, "Paul Cézanne," *Art décoratif* 26, no. 10 ([Semester 2, no. 4] October 5, 1911), p. 122, ill.; Meier-Graefe, *Cézanne und sein Kreis*, 1st and 2nd eds. (1918 and 1920), p. 135, ill., 3rd ed. (1922), p. 165, ill., n.p.; *Cézanne*, Maestri Moderni 1 (Rome: La Voce, 1920), ill.; Lucien Henraux, "I Cézanne della raccolta Fabbri," *Dedalo* 1 (1920–21), p. 61, ill.; L[ucien] H[enraux], "Une Grande collection de Cézanne en Italie: La Collection Egisto Fabbri," *L'Amour de l'art* 5, no. 11 (November 1924), p. 344, ill.; Elie Faure, *P. Cézanne* (Paris: Crès, 1926), pl. 14; Louis Vauxcelles, "A propos de Cézanne," *L'Art vivant* 2, no. 37 (July 1, 1926), p. 485, ill.; Roger Fry, *Cézanne: A Study of His Development* (New York: Macmillan, 1927), p. 55, fig. 21, pl. XIV; Meier-Graefe, *Cézanne* (1927), pl. XLI; Marie Dormoy, "La Collection Courtauld," *L'Amour de l'art* 10, no. 1 (January 1929), ill. p. 18; Giorgio Castelfranco, *La pittura moderna* (Florence: Luigi Gonnelli, 1934), pl. 25; Nina Iavorskaia, *Paul Cézanne*, Arte Moderna Straniera 4 (Milan: Hoepli, 1935), pl. XIV; Gerstle Mack, *Paul Cézanne* (New York: Alfred A. Knopf, 1935), fig. 16; Eugenio d'Ors, *Paul Cézanne*, translated by Francisco Amunategui (New York: Weyhe, 1936), pl. 6; Elie Faure, *Cézanne* (Paris: Braun, 1936), pl. 29; G[ualtieri] di San Lazzaro, *Paul Cézanne* (Paris: Editions des Chroniques du Jour, 1936), fig. 6; Venturi (1936), no. 292, vol. 1, pp. 128–29, vol. 2, pl. 79; René Huyghe, "Cézanne et son oeuvre," *L'Amour de l'art* 17, no. 5 (May 1936), fig. 55; [François] Gilles de la Tourette, "Paul Cézanne," *L'Art et les artistes* 32, no. 169 (July 1936), ill. p. 333; George Besson, "Paul Cézanne: 1839–1906," *Estampes*, November 4, 1936, p. 3; Lionello Venturi, *Cézanne: Son Art—son oeuvre* (Paris: [Paul Rosenberg], 1938), vol. 2, ill. opp. p. 153; Robert J. Goldwater, "Cézanne in America: The Master's Painting in American Collections," in "1938 Annual," special issue, *Art News* 36, no. 26 (March 26, 1938), p. 139, ill.; Rainer Maria Rilke, "Dichter über Kunstwerke, die sie lieben: Rainer Maria Rilke über zwei Bilder von Paul Cézanne," *Die Kunst* 79, no. 1 (October 1938), p. 31, ill.; Albert C[oombs] Barnes and Violette de Mazia, *The Art of Cézanne* (New York: Harcourt, Brace, 1939), no. 72, p. 338, ill. p. 209; Edward Alden Jewell, *Paul Cézanne*, edited by Aimée Crane (New York: Hyperion, 1944), p. 33, ill.; Bernard Dorival, *Cézanne* (Paris: Tisné, 1948), pl. 45; Gotthard Jedlicka, *Cézanne: Abbildungen von Gemälden* (Bern: Scherz, 1948), fig. 19; George Harold Edgell, *French Painters in the Museum of Fine Arts: Corot to Utrillo* (Boston: Museum of Fine Arts, 1949), p. 50, ill.; Maurice Raynal, *Cézanne: Biographical and Critical Studies*, translated by James Emmons, Taste of Our Time 8 (Geneva: Skira, 1954), p. 49, ill.; Henri Perruchot, "Les Quinze logis de Monsieur Cézanne," *L'Oeil*, no. 12 (Christmas 1955), p. 31, ill.; Lawrence Gowing, "Notes on the Development of Cézanne," *Burlington Magazine* 98, no. 639 (June 1956), p. 188; Douglas Cooper, "Cézanne's Chronology," *Burlington Magazine* 98, no. 546 (December 1956), p. 449; Van Buren, "Madame Cézanne's Fashions" (1966), p. 117, fig. 6; Richard W. Murphy, *The World of Cézanne, 1839–1906* (New York: Time-Life Books, 1968), p. 105; Chuji Ikegami, *Cézanne*, Gendai Sekai Bijutsu Zenshu 3 (Tokyo: Shueisha, 1969), pl. 14; Andersen, *Cézanne's Portrait Drawings* (1970), fig. 15; Anne d'Harnoncourt, "The Necessary Cézanne," *Art Gallery* 14, no. 2 (April 1971), p. 37, ill.; John Elderfield,

"Drawing in Cézanne," *Artforum* 9, no. 10 (June 1971), p. 53, ill.; René Huyghe, *Impressionism* (New York: Chartwell Books; G. P. Putnam's Sons, 1973), p. 241, ill.; Janet Hobhouse, *Everybody Who Was Anybody: A Biography of Gertrude Stein* (New York: Putnam, 1975), ill. opp. p. 144 (not portrait that belonged to Gertrude Stein); John Rewald, "Some Entries for a New Catalogue Raisonné of Cézanne's Paintings," *Gazette des beaux-arts* 86, no. 1282 (November 1975), pp. 160–61, ill.; Nicholas Wadley, *Cézanne and His Art* (New York: Galahad, 1975), pl. 88; Sophie Monneret, *Cézanne, Zola: La Fraternité du genie* (Paris: Denoël, 1978), p. 83, ill.; Nello Ponente, ed., *Cézanne e le avanguardie*, La Coscienza e l'Altro, Contributi sull'Arte dell'Ottocento e del Novecento (Rome: Officina, 1981), pls. 19, 3, ill. on cover; Melissa A. McQuillan, *Impressionist Portraits* (London: Thames and Hudson, 1986), pp. 128–29, ill.; John Rewald, *Cézanne: A Biography* (New York: Harry N. Abrams, 1986), p. 120, ill.; Bob Kirsch, "Paul Cézanne: *Jeune Fille au Piano* and Some Portraits of His Wife; An Investigation of His Painting of the Late 1870s," *Gazette des beaux-arts* 110, nos. 1422–23 (July–August 1987), p. 22; Richard Kendall, ed., *Cézanne by Himself: Drawings, Paintings, Writings* (London: Macdonald Orbis, 1988), p. 92, ill.; Rewald, *Cézanne and America* (1989), pp. 25, 306; Hajo Düchting, *Paul Cézanne, 1839–1906: Natur wird Kunst*, edited by Ingo F. Walther (Cologne: Benedikt, 1990), ill. p. 74; William Rubin and Matthew Armstrong, *The William S. Paley Collection*, exh. cat. (New York: Museum of Modern Art, 1992), p. 149, fig. 7; Friederike Kitschen, *Cézanne: Stilleben* (Ostfildern: Hatje, 1995), fig. 34; Rewald, *Paintings of Cézanne* (1996), no. 324, vol. 1, pp. 219–20, vol. 2, ill. p. 104; Görel Cavalli-Björkman, *Cézanne i blickpunkten*, essay by Ulf Linde, exh. cat., Nationalmusei Utställningskatalog 602 (Stockholm: Nationalmuseum, 1997), ill., p. 34; Sona Johnston with Susan Bollendorf, *Faces of Impressionism: Portraits from American Collections*, exh. cat. (Baltimore: Baltimore Museum of Art; New York: Rizzoli, 1999), p. 70, fig. 16A; Nina Maria Athanassoglou-Kallmyer, *Cézanne and Provence: The Painter in His Culture* (Chicago: University of Chicago Press, 2003), p. 44, fig. 1.32; Anne Robbins, *Cézanne in Britain*, essay by Ann Dumas and contributions by Nancy Ireson (London: National Gallery, 2006), p. 9, fig. 2; Butler, *Hidden in the Shadow of the Master* (2008), pp. 10–12; Jean Arrouye, "Les Descendants de *Madame Cézanne à la jupe rayée*," in *Picasso, Cézanne*, exh. cat., Petit Journal des Grandes Expositions 423 (Paris: Réunion des Musées Nationaux, 2009), p. 125, fig. 1; Sidlauskas, *Cézanne's Other* (2009), pp. 2, 10–11, 174, 178, fig. 1; Pavel Machotka, "I ritratti di Cézanne: Il volto umano della grande pittura," in *Cézanne: Les Ateliers du midi*, edited by Rudy Chiappini, exh. cat. (Milan: Skira, 2011), p. 83, fig. 51

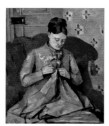

Pl. 5. *Madame Cézanne Sewing*, ca. 1877
Oil on canvas, 23⅝ × 19⅝ in. (60 × 49.7 cm)
Nationalmuseum, Stockholm, Bequest of Grace and Philip Sandblom, 1970 (NM 6348)

Provenance: Alphonse Kann, Saint-Germain-en-Laye; Wilhelm Hansen, Ordrupgaard, Copenhagen; Jos. Hessel, Paris; [Paul Rosenberg, Paris]; [Durand-Ruel, Paris and New York]; Philip Sandblom, Stockholm; Nationalmuseum, Stockholm

Exhibitions: "[Paul Cézanne:] Ausstellung, XII. Jahrgang," Paul Cassirer, Berlin, November 17–December 12, 1909, no. 4; "Französische Kunst des XIX. und XX. Jahrhunderts," Kunsthaus Zürich, October 5–November 14, 1917, no. 9, ill.; "Portraits et figures de femmes: Ingres à Picasso," A La Renaissance, Paris, June 1–30, 1928, no. 29; "Cézanne, Gauguin, Seurat, Van Gogh," Museum of Modern Art, New York, November 8–December 7, 1929, no. 6, ill.; "Exposition Cézanne, 1839–1906," Galerie Pigalle, Paris, December (?) 1929, no. 22; "Important Paintings by Great French Masters of the Nineteenth Century," Durand-Ruel, New York, and Paul Rosenberg, New York, February 12–March 10, 1934, no. 2; "Masterpieces by Cézanne," Durand-Ruel, New York, March 29–April 16, 1938, no. 9; "Cézanne till Picasso: Fransk konst i svensk ägo," Liljevalchs Konsthall, Stockholm, September 1954, no. 67, ill.; "Cézanne i blickpunkten," Nationalmuseum, Stockholm, October 17, 1997–January 11, 1998, no. 3 (cat. by Görel Cavalli-Björkman, p. 32, ill. p. 33); "Cézanne & Giacometti: Tvivlens veje / Cézanne and Giacometti: Paths of Doubt," Louisiana Museum of Modern Art, Humlebæk, February 20–June 29, 2008, no. 7; "Cézanne et Paris," Musée Luxembourg, Paris, October 12, 2011–February 26, 2012, no. 56 (cat. edited by Denis Coutagne, p. 117, ill.)

References: Théodore Duret, "Paul Cézanne," *Kunst und Künstler* 5, no. 3 (March 1907), p. 103, ill.; Julius Meier-Graefe, *Paul Cézanne*, 3rd ed. (Munich: Piper, 1910), pl. 40; Meier-Graefe, *Cézanne und sein Kreis*, 1st and 2nd eds. (1918 and 1920), p. 134, ill., 3rd ed. (1922), p. 164, ill.; Elie Faure, *Histoire de l'art: L'Art modern* (Paris: Crès, 1921), p. 415, ill.; Rivière, *Le Maître* (1923), p. 204; Meier-Graefe, *Cézanne* (1927), pl. XL; Edward Alden Jewell, "Was Cézanne an Industrious 'Painter Without Taste?'" *New York Times Book Review*, January 22, 1928, p. 5, ill.; Tristan Bernard, "Jos Hessel," *La Renaissance de l'art français et des industries de luxe* 13, no. 1 (January 1930), p. 13, ill.; Mary Morsel, "French Paintings of the XIXth Century in Benefit Show: Mr. Rosenberg and Durand-Ruel Organize Remarkable Show Emphasizing French Loans Never Shown in America," *Art News* 32, no. 20 (February 17, 1934), p. 3, ill.; Maurice Raynal, *Initiation à l'Art Moderne* (Paris: Editions de Cluny, 1936), pl. LXXI; Venturi, *Cézanne* (1936), no. 291, vol. 1, p. 128, vol. 2, pl. 79; Alfred M. Frankfurter, "Cézanne: Intimate Exhibition; Twenty-one Paintings Shown for the Benefit of Hope Farm," *Art News* 36, no. 26, section 2 (March 26, 1938), p. 15, ill.; Raymond Cogniat, *Cézanne* (Paris: Tisné, 1939), pl. 40; Erik Blomberg, "Fransk-svensk konstallians," *Konstrevy* 17, no. 4 (1941), p. 132, ill.; Carlo Ludovico Ragghianti, *Impressionisme*, translated by A. Chanoux, 2nd ed. (Turin: Chiantore, 1947), pl. XLV; Bernard Dorival, *Cézanne* (Paris: Tisné, 1948), pl. 47; Liliane Guerry, *Cézanne et l'expression de l'espace* (Paris: Flammarion, 1950), pp. 65–66; Kurt Badt, *Die Kunst Cézannes* (Munich: Prestel-Verlag, 1956), pl. 31; Van Buren, "Madame Cézanne's Fashions" (1966), p. 127n20; Schapiro, *Paul Cézanne* (1973), p. 57, ill.; Frank Elgar, *Cézanne* (New York: Praeger Publishers, 1975), fig. 38; Ulf Able, ed., *The Grace and Philip Sandblom Collection* (Stockholm: Nationalmuseum, 1981), p. 16, ill. p. 82; Bob Kirsch, "Paul Cézanne: *Jeune Fille au Piano* and Some Portraits of His Wife; An Investigation of His Painting of the Late 1870s," *Gazette des beaux-arts* 110, nos. 1422–23 (July–August 1987), p. 24, ill.; Mary Tompkins Lewis, *Cézanne's Early Imagery* (Berkeley: University of California Press, 1989), pp. 147–48;

Marianne Wirenfeldt Asmussen, *Wilhelm Hansens oprindelige franske samling på Ordrupgaard / Wilhelm Hansen's Original French Collection at Ordrupgaard* (Copenhagen: Munksgaard, 1993), pp. 280–81, ill.; Cachin and Rishel, *Cézanne* (1996), p. 170, fig. 1; Rewald, *Paintings of Cézanne* (1996), no. 323, vol. 1, pp. 217–18, vol. 2, ill. p. 104; Theodore Reff, [Review of John Rewald, *The Paintings of Paul Cézanne: A Catalogue Raisonné* (London: Thames and Hudson, 1996)], *Burlington Magazine* 139, no. 1136 (November 1997), p. 800; Terence Maloon, ed., *Classic Cézanne*, exh. cat. (Sydney: Art Gallery of New South Wales, 1998), p. 62, fig. 28; C. Feilchenfeldt, "Portraits" (2000), p. 135, fig. 1; Nina Maria Athanassoglou-Kallmyer, *Cézanne and Provence: The Painter in His Culture* (Chicago: University of Chicago Press, 2003), p. 45, fig. 1.33; Benedict Leca, "Le Monde est une pomme: Nature mortes et portraits parisiens de Cézanne," in *Cézanne et Paris*, edited by Denis Coutagne (Paris: Musée du Luxembourg, Réunion des Musées Nationaux, Grand Palais, Petit Palais, 2011), p. 117, ill.

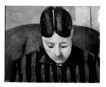

Pl. 8. *Portrait of Madame Cézanne*, ca. 1877
Oil on canvas, 10¼ × 12¼ in. (26 × 31 cm)
Private collection

Provenance: [Ambroise Vollard, Paris]; [Galerie Bernheim-Jeune, Paris]; Georges Renand, Paris; Sam Salz, New York; Mr. and Mrs. Leigh B. Block, Chicago; E. V. Thaw, New York; private collection

Exhibitions: "3e Exposition de peinture" [Third Impressionist Exhibition], [6 Rue Le Peletier], Paris, April 1–30, 1877, no. 28; "Cézanne and Gauguin," Toledo Museum of Art, Ohio, November 1–December 13, 1936, no. 33, ill.; "Moderne französische malerei: Vom impressionismus bis zur gegenwart," Berliner Schloss, Berlin, October 22–November 6, 1946, no. 54 (?); "Les Origines de l'art contemporain: La Peinture française de Manet à Bonnard," Musée des Beaux-Arts, Strasbourg, Musée des Beaux-Arts et d'Archéologie, Besançon, and Musée des Beaux-Arts, Nancy, November 1947–March 1948, no. 50; "La Femme, 1800–1930," Galerie Bernheim-Jeune, Paris, April–June 1948, no. 14; "Cézanne: Paintings, Watercolors, and Drawings; A Loan Exhibition," Art Institute of Chicago, February 7–March 16, 1952, and The Metropolitan Museum of Art, New York, April 4–May 18, 1952, no. 21; "Cézanne: Peintures, aquarelles, dessins," Musée des Beaux-Arts, Grenoble, September 15–18, 1953, unnumbered; "One Hundred European Paintings and Drawings from the Collection of Mr. and Mrs. Leigh B. Block," National Gallery of Art, Washington, D.C., May 4–June 11, 1967, Los Angeles County Museum of Art, September 21–November 2, 1967, no. 8, ill., and Museum of Fine Arts, Boston, February 2–April 14, 1968, no. 10, ill.; "Cézanne: Finished—Unfinished," Kunstforum, Vienna, January 20–April 25, 2000, and Kunsthaus Zürich, May 5–July 30, 2000, no. 15, ill.

References: *L'Art modern et quelques aspects de l'art d'autrefois: 173 Planches d'après la collection privée de MM. J. et G. Bernheim-Jeune*, poems by Henri de Régnier (Paris: Bernheim-Jeune, 1919), vol. 2, pl. 16; Rivière, *Le Maître* (1923), p. 204, ill. p. 95; Elie Faure, *P. Cézanne* (Paris: Crès, 1926), pl. 10; Christian Zervos, "Idéalisme et naturalisme dans la peinture moderne: II—Cézanne, Gauguin, Van Gogh," *Cahiers d'art* 2 (1927), p. 329, ill.; Georges Rivière, *Cézanne, le peintre solitaire*, Anciens et Modernes (Paris: Floury, 1933), p. 43, ill.; Venturi,

Cézanne (1936), no. 228, vol. 1, p. 115, vol. 2, pl. 62; Georges Rivière, *Cézanne, le peintre solitaire* (Paris: Floury, 1942), p. 43, ill.; Bernard Dorival, *Cézanne* (Paris: Tisné, 1948), pl. 46; Liliane Guerry, *Cézanne et l'expression de l'espace* (Paris: Flammarion, 1950), p. 67; *Peintures de Cézanne*, introduction by Pierre Marie Auzas (Paris: Les Editions du Chêne, 1950), pl. III; Liliane Brion-Guerry, *Cézanne et l'expression de l'espace* (Paris: A. Michel, 1966), pl. 20; Van Buren, "Madame Cézanne's Fashions" (1966), p. 124n5; Cachin and Rishel, *Cézanne* (1996), p. 247, fig. 1; Rewald, *Paintings of Cézanne* (1996), no. 387, vol. 1, p. 255, vol. 2, ill. p. 120

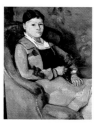

Pl. 6. *Portrait of the Artist's Wife*, ca. 1879–82, possibly reworked ca. 1886–88
Oil on canvas, 36³⁄₈ × 28¾ in. (92.5 × 73 cm)
Foundation E. G. Bührle Collection, Zurich (16)

Provenance: [Ambroise Vollard, Paris]; Leo and Gertrude Stein, Paris; Gertrude Stein, Paris; César Mange de Hauke, Paris; Jacques Dubourg, Paris; Fritz and Peter Nathan, Zurich; Emil G. Bührle, Zurich; Foundation E. G. Bührle Collection, Zurich

Exhibitions: "Paul Cézanne," Paul Cassirer, Berlin, April–June 1904, unnumbered; "Salon d'Automne," Grand Palais des Champs-Elysées, Paris, October 15–November 15, 1904, no. 9; "Exposition Cézanne," Bernheim-Jeune, Paris, January 10–22, 1910, no. 40; "Sammlung Emil G. Bührle," Kunsthaus Zürich, June 7–end of September 1958, no. 223 (cat., pl. XLIII); "Französische Malerei von Manet bis Matisse aus der Sammlung Emil G. Bührle, Zürich," Schloss Charlottenburg, Berlin, October 5–November 23, 1958, no. 52, ill.; "Hauptwerke der Sammlung Emil Georg Bührle, Zürich," Haus der Kunst, Munich, December 1958–February 15, 1959, no. 18; "De Géricault à Matisse: Chefs-d'oeuvre d'art français des collections suisses," Musée du Petit Palais, Paris, March–May 1959, no. 16 (cat., pl. 33); "Masterpieces of French Painting from the Bührle Collection," National Gallery, London, September 29–November 5, 1961, no. 32 (cat., pl. 146); "Chefs-d'oeuvre des collections suisses: De Manet à Picasso," Palais de Beaulieu, Lausanne, May 1–October 25, 1964, no. 89, ill.; "The Passionate Eye: Impressionist and Other Master Paintings from the Collection of Emil G. Bührle, Zurich," National Gallery of Art, Washington, D.C., and other venues, May 6, 1990–April 9, 1991, no. 39, ill.; "Cézanne: Aufbruch in die Moderne," Museum Folkwang, Essen, September 18, 2004–January 16, 2005, unnumbered (cat. edited by Felix A. Baumann, Walter Feilchenfeldt, and Hubertus Gassner, pp. 32, 36, 231, ill. p. 34)

References: Walter Pach, "The Point of View of the 'Moderns,'" *Century Magazine* 87, no. 6 (April 1914), p. 862, ill.; Ambroise Vollard, *Paul Cézanne* (Paris: Galerie Vollard, 1914), pl. 45; Joachim Gasquet, *Cézanne, 24 Phototypies*, Albums d'Art Druet 1 (Paris: Librairie de France, 1930), ill. n.p. [7]; Gertrude Stein, *The Autobiography of Alice B. Toklas* (New York: Harcourt, Brace, 1933), pp. 180, 182; Venturi, *Cézanne* (1936), no. 369, vol. 1, p. 145, vol. 2, pl. 101; Ambroise Vollard, *Recollections of a Picture Dealer*, translated by Violet M. Macdonald (Boston: Little, Brown, 1936), p. 137; *Dr. Fritz Nathan und Dr. Peter Nathan: 25 Jahre, 1936–1961* (Winterthur: Buchdruckerei Winterthur, 1961), p. 44, ill.; Fritz Novotny, *Cézanne* (London: Phaidon, 1961), pl. 17;

Van Buren, "Madame Cézanne's Fashions" (1966), fig. 5; Richard W. Murphy, *The World of Cézanne: 1839–1906* (New York: Time-Life Books, 1968), p. 105; Chuji Ikegami, *Cézanne*, Gendai Sekai Bijutsu Zenshu 3 (Tokyo: Shueisha, 1969), pl. 15; Andersen, *Cézanne's Portrait Drawings* (1970), fig. 23; *Four Americans in Paris: The Collections of Gertrude Stein and Her Family*, exh. cat. (Baltimore: Baltimore Museum of Art; San Francisco: San Francisco Museum of Art; New York: Museum of Modern Art, 1970), pp. 26, 32n47, 61, 89, 93, ills. pp. 61, 89, 95 (the painting hanging at 27, rue de Fleurus); *Dr. Fritz Nathan und Dr. Peter Nathan, 1922–1972* (Zurich: Peter Nathan, 1972), no. 86, ill.; Schapiro, *Paul Cézanne* (1973), p. 14, ill.; James R. Mellow, *Charmed Circle: Gertrude Stein and Company* (New York: Praeger, 1974), p. 91; Frank Elgar, *Cézanne* (New York: Praeger Publishers, 1975), fig. 39; Rewald, *Cézanne and America* (1989), pp. 56, 63, 72, 94, fig. 59, pl. v; Rewald, *Paintings of Cézanne* (1996), no. 606, vol. 1, pp. 402–3, vol. 2, ill. p. 202; W. Feilchenfeldt, *By Appointment Only* (2006), pp. 178, 196, ill. p. 178; Paloma Alarcó and Malcolm Warner, *The Mirror and the Mask: Portraiture in the Age of Picasso*, exh. cat. (Fort Worth: Kimbell Art Museum; Madrid: Museo Thyssen-Bornemisza; Fundación Caja Madrid, 2007), p. 111; Butler, *Hidden in the Shadow of the Master* (2008), pp. 50–52; Elizabeth Cowling, "'Le Drame de l'homme': Le Cézannisme de Picasso en 1906–08," in *Picasso, Cézanne*, exh. cat., Petit Journal des Grandes Expositions 423 (Aix-en-Provence: Musée Granet; Paris: Réunion des Musées Nationaux, 2009), p. 44, fig. 5; Sidlauskas, *Cézanne's Other* (2009), pp. 4, 134, 136, 149, 180, fig. 2; Robert McD. Parker, "Catalogue of the Stein Collections," in *The Steins Collect: Matisse, Picasso, and the Parisian Avant-Garde*, edited by Janet Bishop, Cécile Debray, and Rebecca Rabinow, exh. cat. (San Francisco: San Francisco Museum of Modern Art; New Haven: Yale University Press, 2011), no. 10, p. 396

NOT IN EXHIBITION

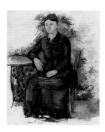

Pl. 10. *Madame Cézanne in the Garden*, ca. 1880
Oil on canvas, 34⅝ × 26 in. (88 × 66 cm)
Musée de l'Orangerie, Paris, Collection Walter Guillaume, 1959 (RF 1960-8)

Provenance: Paul Guillaume, Paris; Madame Paul Guillaume (Madame Jean Walter), Paris; Musée du Louvre, Paris (Collection Walter Guillaume); Musée de l'Orangerie, Paris

Exhibitions: "Exposition Cézanne, 1839–1906," Galerie Pigalle, Paris, December (?) 1929, no. 11; "Cézanne, Corot, Manet, Renoir," Galerie Bernheim-Jeune, Paris, October 1931, unnumbered; "Homage to Paul Cézanne, 1839–1906," Wildenstein, London, July 1939, no. 24; "Centenaire de Paul Cézanne," Musée de Lyon, December 1939–February 1940, no. 26; "Collection Jean Walter–Paul-Guillaume," Musée de l'Orangerie, Paris, 1966, no. 6, ill.; "Cézanne dans les musées nationaux," Musée de l'Orangerie, Paris, July 19–October 14, 1974, no. 27 (cat., p. 77, ill. p. 76); "Impressionnistes des musées français de Manet à Matisse," Georgian State Museum of Fine Arts, Tbilisi, and other venues, 1981, no. 5, ill.; "Cézanne," Musée Saint-Georges, Liège, March 12–May 9, 1982, and Musée Granet, Aix-en-Provence, June 12–August 31, 1982, no. 8, ill.; "Cézanne, Renoir: 30 capolavori dal Musée de l'Orangerie,

I 'classici' dell'Impressionismo dalla collezione Paul Guillaume," Accademia Carrara, Bergamo, March 22–July 3, 2005, unnumbered

References: Jacques Mauny, "Paris Letter," *Arts* 13, no. 5 (May 1928), p. 326, ill.; Waldemar George [pseud.], *La Grande Peinture contemporaine à la collection Paul Guillaume*, exh. cat. (Paris: Editions des "Arts à Paris," 1929), p. 174, ill.; Waldemar George [pseud.], *La Grande Peinture contemporaine à la collection Paul Guillaume*, exh. cat. (Paris: Editions des "Arts à Paris," 1930), p. 49, ill.; Venturi, *Cézanne* (1936), no. 370, vol. 1, p. 145, vol. 2, pl. 101; Waldemar George [pseud.], "La Femme: Mesure de l'art français, la peinture," *L'Art et les artistes* 35, no. 184 (February 1938), p. 173, ill.; Van Buren, "Madame Cézanne's Fashions" (1966), p. 122, fig. 17; Michel Hoog with Hélène Guicharnaud and Colette Giraudon, *Musée de l'Orangerie: Catalogue de la collection Jean Walter et Paul Guillaume* (Paris: Ministère de la Culture, Editions de la Réunion des Musées Nationaux, 1984), no. 8, p. 28, ill. p. 29; Michel Hoog with Hélène Guicharnaud and Colette Giraudon, *Musée de l'Orangerie: Catalogue of the Jean Walter and Paul Guillaume Collection*, translated by Barbara Shuey (Paris: Ministère de la Culture et de la Communication, Editions de la Réunion des Musées Nationaux, 1987), no. 8, pp. 28–29, ill.; Rewald, *Paintings of Cézanne* (1996), no. 462, vol. 1, pp. 311–12, vol. 2, ill. p. 148; Butler, *Hidden in the Shadow of the Master* (2008), p. 52; Sidlauskas, *Cézanne's Other* (2009), p. 205, fig. 61

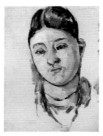

Pl. 11. *Sketch of a Portrait of Madame Cézanne*, ca. 1883
Oil on canvas, 8 × 5½ in. (20.3 × 14 cm)
Richard and Mary L. Gray and the Gray Collection Trust

Provenance: [Ambroise Vollard, Paris]; Gustave Geffroy, Paris; Prince de Wagram (Alexandre Berthier), Paris; [Galerie Bernheim-Jeune, Paris]; [Alfred Flechtheim, Düsseldorf]; Hugo Simon, Berlin (?his sale, Berlin, Paul Cassirer, October 20, 1932, lot 114, ill.); Eugene Weissner, Hamburg; Eric Alport, Oxford; [Acquavella Galleries, New York]; sale, London, Christie's, June 29, 1999, lot 1, ill. (sold) [Acquavella Galleries, New York]; Richard and Mary L. Gray, Chicago

Exhibitions: "Exposition Paul Cézanne," Galerie Vollard, Paris, November–December 1895, unnumbered; "Internationale Kunstausstellung des Sonderbundes westdeutscher Kunstfreunde und Künstler," Städtische Ausstellungshalle, Aachener Tor, Cologne, May 25–September 30, 1912, no. 149; "Beiträge zur Kunst des 19. Jahrhunderts und unserer Zeit," Galerie Alfred Flechtheim, Düsseldorf, 1913, unnumbered (cat., p. 58, ill.); "Cézanne-Ausstellung; Cézannes Werke in deutschem Privatbesitz: Gemälde, Aquarelle, Zeichnungen," Paul Cassirer, Berlin, November–December 1921, no. 23; "Nineteenth Century French Paintings," National Gallery, London, December 1942–January 1943, no. 29; "Paintings by Cézanne," Royal Scottish Academy, Edinburgh, 1954, Tate Gallery, London, September 29–October 27, 1954, and National Gallery, Millbank, London, opened late October 1954, no. 28; "The French Impressionists and Some of Their Contemporaries: In Aid of the National Playing Fields Association and the Jewish National Fund," Wildenstein, London, April 24–May 18, 1963, no. 23, ill.;

"1912, Mission moderne: Die Jahrhundertschau des Sonderbundes," Wallraf-Richartz-Museum and Fondation Corboud, Cologne, August 31–December 30, 2012, no. 18 (cat. edited by Barbara Schaefer, p. 340, ills. pp. 341, 556)

References: Jean Royère, "Paul Cézanne: Erinnerungen," *Kunst und Künstler* 10, no. 10 (October 1912), p. 481, ill.; Hans von Wedderkop, *Paul Cézanne*, Bibliothek der Junge Kunst 4, Junge Kunst 30 (Leipzig: Klinkhardt & Biermann, 1922), ill. on frontispiece; "Wesentliche Bücher," *Kunst und Künstler* 31, no. 11 (November 1932), p. 424, ill.; *Sezan o daigashu: Genshokuban / Recueil important des oeuvres de Paul Cézanne: Reproductions en couleurs*, vol. 2, *Portraits et nus* (Tokyo: Atoriesha, 1935), pl. 4; Venturi, *Cézanne* (1936), no. 533, vol. 1, p. 179, vol. 2, pl. 166; Van Buren, "Madame Cézanne's Fashions" (1966), p. 122; Rewald, *Paintings of Cézanne* (1996), no. 533, vol. 1, p. 360, vol. 2, ill. p. 174; C. Feilchenfeldt, "Portraits" (2000), p. 139, fig. 2

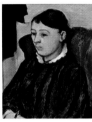

Pl. 7. *Portrait of Madame Cézanne in a Striped Dress*, ca. 1883–85
Oil on canvas, 22³/₈ × 18¹/₂ in. (56.8 × 47 cm)
Yokohama Museum of Art (87-OF-001)

Provenance: Amédée Schuffenecker, Paris; [Ambroise Vollard, Paris]; Baron Denys Cochin, Paris; [Galerie Bernheim-Jeune, Paris]; Auguste Pellerin, Paris; [Galerie Bernheim-Jeune, Paris]; [Ambroise Vollard, Paris]; John Quinn, New York, January 1913; John Quinn Estate, 1924–26; Mrs. Cornelius Sullivan, New York (her sale, New York, Parke-Bernet Galleries, Inc., December 6–7, 1939, lot 181, ill.); Walter P. Chrysler Jr., Provincetown, Mass. (his sale, London, Sotheby's, July 1, 1959, lot 14, ill.); G. David Thompson, Pittsburgh; [Galerie Beyeler, Basel]; [Wildenstein Galleries, New York]; Mr. and Mrs. Algur Meadows, Dallas; sale, New York, Christie's, November 3, 1982, lot 6, ill.; [Private Asset Management Group, Inc.]; sale, London, Sotheby's, December 2, 1986, lot 35, ill.; private collection; [Art Salon Takahata, Osaka]; Yokohama Museum of Art, Japan

Exhibitions: "Exposition Paul Cézanne," Galerie Vollard, Paris, November–December 1895, unnumbered; "Salon d'Automne," Grand Palais des Champs-Elysées, Paris, October 18–November 25, 1905, no. 323; "International Exhibition of Modern Art" [The Armory Show], Armory of the Sixty-ninth Regiment, New York, February 17–March 15, 1913, no. 580, Art Institute of Chicago, March 24–April 16, 1913, no. 46, and Copley Hall, Copley Society of Art, Boston, April 28–May 19, 1913, no. 21; "Cézanne," Arden Gallery, New York, March 1917, unnumbered; "Fiftieth Anniversary Exhibition," The Metropolitan Museum of Art, New York, May 1920, unnumbered (cat., p. 9); "Impressionist and Post-Impressionist Paintings," The Metropolitan Museum of Art, New York, May 3–September 15, 1921, no. 7; "Memorial Exhibition of Representative Works Selected from the John Quinn Collection," Art Center, New York, January 7–30, 1926, no. 17 (cat., ill. on cover); "Paintings by Paul Cézanne, 1839–1906," Wildenstein, New York, January 1928, no. 24; "Cézanne, Gauguin, Seurat, Van Gogh," Museum of Modern Art, New York, November 8–December 7, 1929, no. 5, ill.; "Opening Exhibition in Honor of James Philip and Julia Emma Gray," Springfield Museum of Art, Mass., October 7–November 2,

1933, no. 105, ill.; "Origins of Modern Art," Arts Club of Chicago, April 2–30, 1940, no. 9; "The Collection of Walter P. Chrysler," Virginia Museum of Fine Arts, Richmond, January 16–March 4, 1941, and Philadelphia Museum of Art, March 29–May 11, 1941, no. 32, ill.; "La Femme: Peintures et sculptures," Galerie Beyeler, Basel, May–June 1960, no. 2, ill.; "G. David Thompson Collection, Pittsburgh, USA," Kunsthaus Zürich, no. 18, ill., Solomon R. Guggenheim Museum, New York, unnumbered, ill., and other venues, October 15, 1960–November 1961; "Armory Show: Fiftieth Anniversary Exhibition, 1913–1963," Munson-Williams-Proctor Institute, Utica, N.Y., February 17–March 31, 1963, and Armory of the Sixty-ninth Regiment, New York, April 6–28, 1963, no. 580 (cat., p. 50, ill.); "Faces from the World of Impressionism and Post-Impressionism: A Loan Exhibition for the Benefit of the New York Chapter of the Arthritis Foundation," Wildenstein, New York, November 2–December 9, 1972, no. 17, ill.; "Sezannu ten / Exposition Cézanne," National Museum of Western Art, Tokyo, March 30–May 19, 1974, Museum of the City of Kyoto, June 1–July 17, 1974, and Cultural Center of Fukuoka, July 24–August 18, 1974, no. 33, ill.; "Dallas Collects: Impressionist and Early Modern Masters, An Exhibition Celebrating the Seventy-fifth Anniversary of the Dallas Museum of Fine Arts," Dallas Museum of Fine Arts, January 24–February 26, 1978, no. 19, ill.; "Paris Cafés: Their Role in the Birth of Modern Art," Wildenstein, New York, November 13–December 20, 1985, unnumbered, ill.; "Maîtres français, XIXe–XXe siècles: 25e Exposition," Galerie Schmit, Paris, May 6–July 18, 1987, no. 10, ill.; "Cézanne, Gemälde," Kunsthalle Tübingen, January 16–May 2, 1993, no. 37, ill.; "Impressionism: Twentieth Anniversary Exhibition Celebrating a Population of Two Million in Gunma Prefecture," Museum of Modern Art, Gunma, Japan, September 21–November 6, 1994, no. 60; "Sezannu ten / Cézanne," Kasama Nichido Museum of Art, October 4–November 30, 1997, no. 13, ill.; "Sezannu ten / Cézanne and Japan," Yokohama Museum of Art, September 11–December 19, 1999, and Aichi Prefectural Museum of Art, Nagoya, January 5–March 12, 2000, no. 54, ill.; "Cézanne: Il padre dei moderni," Complesso del Vittoriano, Rome, March 7–July 7, 2002, unnumbered, ill.; "Sezannu shugi: Chichi to yobareru gaka e no raisan / Homage to Cézanne: His Influence on the Development of Twentieth-Century Painting," Yokohama Museum of Art, November 15, 2008–January 25, 2009, and Hokkaido Museum of Modern Art, Sapporo, February 7–April 12, 2009, no. 7 (cat. by Yasuhide Shimbata, Agnès Delannoy, and Takanori Nagai, pp. 36, 215, ill. p. 37); "Picasso, Cézanne," Musée Granet, Aix-en-Provence, May 25–September 27, 2009, no. 35, ill.; "Cézanne: Paris–Provence," National Arts Center, Tokyo, March 28–June 11, 2012, no. 64, ill.

References: Emile Bernard, "Paul Cézanne," *Coeur* 9 (December 1894), pp. 3–5, ill.; "The Exhibitions at '291,'" *Camera Work* 36 (October 1911), p. 30; Ambroise Vollard, *Paul Cézanne* (Paris: Galerie Vollard, 1914), pl. 39; Gustave Coquiot, *Paul Cézanne* (Paris: A. Michel, 1919), ill. opp. p. 232; Rivière, *Le Maître* (1923), p. 123, ill.; Sheldon Cheney, *A Primer of Modern Art* (New York: Boni and Liveright, 1924), p. 94, ill.; Emile Bernard, *Souvenirs sur Paul Cézanne: Une Conversation avec Cézanne, la méthode de Cézanne* (Paris: R. G. Michel, 1926), ill. opp. p. 48; Elie Faure, *P. Cézanne* (Paris: Crès, 1926), pl. 12; Forbes Watson, *John Quinn, 1870–1925: Collection of Paintings, Watercolors, Drawings, and Sculpture* (Huntington, N.Y.: Pidgeon Hill, 1926), pp. 7,

35, ill.; Forbes Watson, "The John Quinn Collection," *Arts* 9, no. 1 (January 1926), p. 9, ill.; Forbes Watson, "La Collection John Quinn," *Bulletin de la vie artistique* 7, no. 4 (February 15, 1926), p. 56, ill.; Kurt Pfister, *Cézanne: Gestalt, Werk, Mythos* (Potsdam: Gustav Kiepenheuer, 1927), fig. 35; Christian Zervos, "Idéalisme et naturalisme dans la peinture moderne: II—Cézanne, Gauguin, Van Gogh," *Cahiers d'art* 2 (1927), p. 335, ill.; Edward Alden Jewell, "The New Museum of Modern Art Opens; A Superb Showing of Work by Four Pioneers: Cézanne, Gauguin, Van Gogh and Seurat—Contemporary Frenchmen," *New York Times*, November 10, 1929, p. X14, ill.; Maurice Boudot-Lamotte, "Souvenirs sur les artistes, le peintre et collectionneur: Claude-Emile Schuffenecker (1851–1934)," *L'Amour de l'art* 17, no. 8 (October 1936), p. 284; Venturi, *Cézanne* (1936), no. 229, vol. 1, p. 116, vol. 2, pl. 62; Elizabeth McCausland, "Exhibitions in New York," *Parnassus* 11, no. 7 (November 1939), p. 21, ill.; [Paul Cézanne: Portrait of Mme. Cézanne, Oil], *Magazine of Art* 32, no. 11 (November 1939), ill. on cover; "Masterpieces on the Block," *New York Times*, December 17, 1939, p. 114, ill.; "Art: Pioneer," *Time* 35, no. 25 (December 18, 1939), ill.; Rosamund Frost, *Contemporary Art: The March of Art from Cézanne until Now* (New York: Crown, 1942), p. 41, ill.; Sanka Knox, "Paintings Rejected by Pittsburgh Are Sold Abroad for $6,000,000," *New York Times*, May 20, 1961, p. 6, ill.; Milton W[olf] Brown, *The Story of the Armory Show* (New York: New Spirit, 1963), no. 580, p. 229; Peter H. Feist, *Paul Cézanne* (Leipzig: Seemann, 1963), pl. 13; Van Buren, "Madame Cézanne's Fashions" (1966), p. 122; Wesley Towner with Stephen Varble, *The Elegant Auctioneers* (New York: Hill and Wang, 1970), p. 576; Marcel Brion, *Cézanne*, Great Impressionists (London: Thames and Hudson; Garden City, N.Y.: Doubleday, 1972), pp. 27–29, ill.; Judith Zilczer, "John Quinn and Modern Art Collectors in America, 1913–1924," *American Art Journal* 14, no. 1 (Winter 1982), p. 61, ill.; Rewald, *Cézanne and America* (1989), pp. 130, 133, 165, 175, 198, 216, 306, 327, pl. XI; *Yokohama Bijutsukan korekushon sen / Yokohama Museum of Art: Selected Works from the Collection*, translated by Kimiko Steiner (Yokohama: Yokohama Museum of Art, 1989), no. 2, ill.; Rewald, *Paintings of Cézanne* (1996), no. 536, vol. 1, pp. 362–64, vol. 2, ill. p. 175; C. Feilchenfeldt, "Portraits" (2000), p. 158, fig. 1; Yasuhide Shimbata, "On *Mme. Cézanne in Striped Dress* (R.536/ V.229), a Painting by Paul Cézanne in the Collection of the Yokohama Museum of Art," *Bulletin of Yokohama Museum of Art* 1, no. 4 (2002), pp. 70–92; Sidlauskas, *Cézanne's Other* (2009), p. 172, pl. 18; Lukas Gloor, "Art History in the Making: The Reception of Cézanne between 1920 and 1950," in *Cézanne and the Past: Tradition and Creativity*, edited by Judit Geskó, exh. cat. (Budapest: Museum of Fine Arts, 2012), pp. 200–202, fig. 113

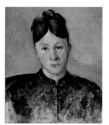

Pl. 14. *Portrait of Madame Cézanne*, ca. 1885
Oil on canvas, 18⅛ × 15 in. (46 × 38 cm)
Private collection, on loan to Staatliche Museen zu Berlin, Nationalgalerie, Museum Berggruen

Provenance: [Stephan Bourgeois Gallery, New York]; William Van Horne, Montreal (his sale, New York, Parke-Bernet, January 24, 1946, no. 12, ill.); Mr. and Mrs. George Garde da Sylva, Los Angeles; Max Moos, Geneva; Heinz Berggruen, Paris and Berlin; private collection, on loan to Staatliche Museen zu Berlin, Nationalgalerie, Museum Berggruen

Exhibitions: "International Exhibition of Modern Art" [The Armory Show], Armory of the Sixty-ninth Regiment, New York, February 17–March 15, 1913, Art Institute of Chicago, March 24–April 16, 1913, and Copley Hall, Copley Society of Art, Boston, April 28–May 19, 1913, no. 51; "The Sir William Van Horne Collection," Art Association of Montreal, October 16–November 5, 1933, no. 146a; "Paul Cézanne, 1839–1906," Kunsthaus Zürich, August 22–October 7, 1956, no. 54 (cat., pl. 24); "Berggruen Collection," Musée d'Art et d'Histoire, Geneva, June 16–October 30, 1988, no. 4, ill.; "Cézanne: Finished—Unfinished," Kunstforum, Vienna, January 20–April 25, 2000, and Kunsthaus Zürich, May 5–July 30, 2000, no. 16, ill.; "Cézanne: Il padre dei moderni," Complesso del Vittoriano, Rome, March 7–July 7, 2002, unnumbered (cat. edited by Maria Teresa Benedetti, p. 148, ills. p. 149 and on cover)

References: Venturi, *Cézanne* (1936), no. 520, vol. 1, p. 176, vol. 2, pl. 160; A. B. L., "Buddy da Sylva: Gift to Hollywood," *Art News* 45, no. 7 (September 1946), p. 28, ill.; Arthur Miller, "Da Sylva Collection Enriches Los Angeles," *Art Digest* 21, no. 2 (October 15, 1946), p. 13; Van Buren, "Madame Cézanne's Fashions" (1966), fig. 8; Yvon Taillandier, *P. Cézanne* (New York: Crown, 1979), p. 63, ill.; Yvon Taillandier, *P. Cézanne* (Paris: Flammarion, 1979), p. 65, ill.; John Rewald, *Cézanne: A Biography* (New York: Harry N. Abrams, 1986), p. 156, ill.; Janet M. Brooke, *Discerning Tastes: Montreal Collectors, 1880–1920*, exh. cat. (Montreal: Montreal Museum of Fine Arts, 1989), fig. 24; Rewald, *Cézanne and America* (1989), pp. 175, 198–99, fig. 100; Richard Kendall, *Van Gogh to Picasso: The Berggruen Collection at the National Gallery*, with essays by Lizzie Barker and Camilla Cazalet (London: National Gallery, 1991), no. 17, ill.; Rewald, *Paintings of Cézanne* (1996), no. 580, vol. 1, p. 390, vol. 2, ill. p. 193; Sidlauskas, "Emotion, Color, Cézanne" (2004), n.p.; W. Feilchenfeldt, *By Appointment Only* (2006), p. 199, ill.; Butler, *Hidden in the Shadow of the Master* (2008), pp. 63, 66; Sidlauskas, *Cézanne's Other* (2009), pp. 7, 10, 54–55, 94–95, 96, pl. 6

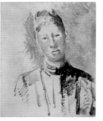

Pl. 23. *Madame Cézanne*, ca. 1885–87
Oil on canvas, 21⅞ × 18 in. (55.6 × 45.7 cm)
Solomon R. Guggenheim Museum, New York, Thannhauser Collection, Gift, Justin K. Thannhauser, 1978 (78.2514.5)

Provenance: [Ambroise Vollard, Paris]; [Marie Harriman Gallery, New York]; Vladimir Horowitz, New York; Cincinnati Art Museum; Justin K. Thannhauser, New York; Solomon R. Guggenheim Museum, New York

Exhibitions: "French Paintings," Marie Harriman Gallery, New York, opened February 21, 1933, no. 2; "Cézanne," Philadelphia Museum of Art, Pa., November 10–December 10, 1934, no. 34; "Opening Exhibition, San Francisco Museum of Art: The Museum of the San Francisco Art Association," San Francisco Museum of Art, January 18–February 24, 1935, no. 1; "Paul Cézanne, André Derain, Walt Kuhn, Henri Matisse, Pablo Picasso, Auguste Renoir, Vincent van Gogh," Marie Harriman Gallery, New York, February 17–March 14, 1936, no. 5; "Paul Cézanne: Exhibitions of Paintings, Water-Colors, Drawings, and Prints," San Francisco Museum of Art, September 1–October 4, 1937, no. 22; "Cézanne: Centennial Exhibition, 1839–1939," Marie Harriman Gallery,

New York, November 7–December 2, 1939, no. 12; "Modern French Paintings," Randolph-Macon Woman's College, Lynchburg, Va., May 6–June 5, 1940, no. 1; "Modern French Paintings," Dudley Peter Allen Memorial Art Museum, Oberlin College, Ohio, November 1–25, 1940, unnumbered; "Advisory Committee Exhibition: Techniques of Painting," Museum of Modern Art, New York, August 4–October 15, 1941, unnumbered; "Cézanne: For the Benefit of the New York Infirmary," Wildenstein, New York, March 27–April 26, 1947, no. 38; "French Painting of the Last Half of the Nineteenth Century," North Carolina Museum of Art, Raleigh, June 15–July 29, 1956, unnumbered, ill.; "Cézanne and Structure in Modern Painting," Solomon R. Guggenheim Museum, New York, June–August 1963, unnumbered; "Cézanne: Finished—Unfinished," Kunstforum, Vienna, January 20–April 25, 2000, and Kunsthaus Zürich, May 5–July 30, 2000, no. 18, ill.; "Cézanne & Giacometti: Tvivlens veje / Cézanne and Giacometti: Paths of Doubt," Louisiana Museum of Modern Art, Humlebæk, February 20–June 29, 2008, no. 25, ill.

References: Venturi, *Cézanne* (1936), no. 525, vol. 1, p. 177, vol. 2, pl. 163; [Illustration: Head of a Woman, Cézanne], *Parnassus* 8, no. 3 (March 1936), p. 4, ill.; "Museum Acquires Cézanne," *Cincinnati Art Museum News* 2, no. 7 (November 1947), p. i, ill.; *Masterpieces of Modern Art* [Thannhauser Collection], exh. cat. (New York: Solomon R. Guggenheim Museum, 1965), pl. II; Vivian Endicott Barnett, *The Guggenheim Museum, Justin K. Thannhauser Collection* (New York: Solomon R. Guggenheim Museum, 1978), no. 5, p. 32, ill.; Rewald, *Paintings of Cézanne* (1996), no. 582, vol. 1, p. 390, vol. 2, ill. p. 192; Sidlauskas, *Cézanne's Other* (2009), pp. 74, 75, fig. 28

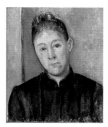

Pl. 15. *Portrait of Madame Cézanne*, ca. 1885–87
Oil on canvas, 18⅛ × 15 in. (46 × 38 cm)
Musée d'Orsay, Paris, on deposit at Musée Granet, Aix-en-Provence, Gift of Philippe Meyer, 2000 (RF 1982-47)

Provenance: [?Ambroise Vollard, Paris]; [?Galerie Bernheim-Jeune, Paris]; Auguste Pellerin, Paris; Jean-Victor Pellerin, Paris; Musée d'Orsay, Paris, on deposit at Musée Granet, Aix-en-Provence

Exhibitions: "French Drawings and Watercolors," Chelsea Book Club, London, 1920, unnumbered; "Paul Cézanne," Museo Español de Arte Contemporáneo, Madrid, March–April 1984, no. 32; "Anciens et nouveaux: Choix d'oeuvres acquises par l'Etat ou avec sa participation de 1981 à 1985," Galeries Nationales du Grand Palais, Paris, November 5, 1985–February 3, 1986, no. 129; "Classic Cézanne," Art Gallery of New South Wales, Sydney, November 28, 1998–February 28, 1999, no. 68, ill.; "Cézanne: Finished—Unfinished," Kunstforum, Vienna, January 20–April 25, 2000, and Kunsthaus Zürich, May 5–July 30, 2000, no. 17, ill.; "Cézanne: Aufbruch in die Moderne," Museum Folkwang, Essen, September 18, 2004–January 16, 2005, unnumbered (cat. edited by Felix A. Baumann, Walter Feilchenfeldt, and Hubertus Gassner, pp. 40, 231, ills. pp. 41, 208); "Cézanne & Giacometti: Tvivlens veje / Cézanne and Giacometti: Paths of Doubt," Louisiana Museum of Modern Art, Humlebæk, February 20–June 29, 2008, no. 23, ill.; "Picasso, Cézanne," Musée Granet, Aix-en-Provence, May 25–September 27, 2009, no. 19;

"Cézanne, Picasso, Mondriaan: In nieuw perspectif," Gemeentemuseum, The Hague, October 17, 2009–January 24, 2010, no. 12

References: Ambroise Vollard, *Paul Cézanne* (Paris: Galerie Vollard, 1914), pl. 46; Tancred Borenius, "French Drawings and Watercolours at the Chelsea Book Club," *Burlington Magazine* 36, no. 202 (January 1920), p. 47, ill.; Rivière, *Le Maître* (1923), p. 208; Venturi, *Cézanne* (1936), no. 524, vol. 1, p. 177, vol. 2, pl. 163; Maurice Raynal, ed., *Cézanne: Reproductions of His Paintings*, Masterpieces of French Painting (London: Zwemmer, 1939), ill.; Van Buren, "Madame Cézanne's Fashions" (1966), fig. 16; *Cézanne au Musée d'Aix* (Aix-en-Provence: Musée Granet, 1984), no. 6, p. 8; Sylvie Gache-Patin, "Acquisitions; Musée d'Orsay, Galerie du Jeu de Paume: 12 Oeuvres de Cézanne de l'ancienne collection Pellerin," *La Revue du Louvre et des musées de France* 34, no. 2 (1984), no. 8, p. 137; Michel Hoog with Hélène Guicharnaud and Colette Giraudon, *Musée de l'Orangerie: Catalogue de la collection Jean Walter et Paul Guillaume* (Paris: Ministère de la Culture, Editions de la Réunion des Musées Nationaux, 1984), p. 32, ill.; Rewald, *Paintings of Cézanne* (1996), no. 583, vol. 1, pp. 390–91, vol. 2, ill. p. 194; Sidlauskas, "Emotion, Color, Cézanne" (2004), n.p.; Sidlauskas, *Cézanne's Other* (2009), pp. 7, 74, 77, 89, pl. 5

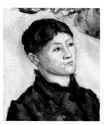

Pl. 27. *Portrait of Madame Cézanne*, ca. 1885–87
Oil on canvas, 18¼ × 15⅛ in. (46.4 × 38.4 cm)
Philadelphia Museum of Art, The Louis E. Stern Collection, 1963 (1963-181-6)

Provenance: [Ambroise Vollard, Paris]; [Galerie Bernheim-Jeune, Paris]; [Paul Rosenberg, Paris]; Dikran K. Kelekian, Paris (his sale, New York, American Art Association, January 30–31, 1922, lot 112, ill.); Lillie P. Bliss, New York; Museum of Modern Art, New York (Lillie P. Bliss Bequest); sale, New York, Parke-Bernet, May 11, 1944, lot 82, ill.; Sam Salz, New York; Louis E. Stern, New York; Philadelphia Museum of Art

Exhibitions: "Paintings by Modern French Masters, Representing the Post-Impressionists and Their Predecessors," Brooklyn Museum, New York, March 26–April 1921, no. 24; "Impressionist and Post-Impressionist Paintings," The Metropolitan Museum of Art, New York, May 3–September 15, 1921, no. 13; "Summer Exhibition of Modern French and American Painters," Brooklyn Museum, New York, June 12–October 14, 1926, unnumbered; "Memorial Exhibition: The Collection of the Late Miss Lizzie P. Bliss, Vice-President of the Museum," Museum of Modern Art, New York, May 17–September 27, 1931 (extended to October 6), and Addison Gallery of American Art at Phillips Academy, Andover, Mass., October 17–December 15, 1931, no. 7, ill.; "The Lillie P. Bliss Collection," Museum of Modern Art, New York, May 14–September 12, 1934, no. 7 (cat., p. 25, ill.); "Cézanne," Pennsylvania Museum of Art, Philadelphia, November 10–December 10, 1934, no. 27; "Paintings from the Lillie P. Bliss Collection, Lent by the Museum of Modern Art," City Art Museum of Saint Louis, February 4–March 4, 1935, unnumbered, and Smith College Museum of Art, Northampton, Mass., April 18–May 19, 1935, no. 4; "Paintings, Drawings and Water Colors from the Lillie P. Bliss Collection," Carnegie Institute, Pittsburgh, March 13–April 10, 1935, no. 10;

"Watercolors and Drawings from the Lillie P. Bliss Collection, Lent by the Museum of Modern Art," Arts Club of Chicago, May 21–June 11, 1935, no. 10; "Five Major Paintings by Paul Cézanne," Columbus Gallery of Fine Arts, Ohio, December 16, 1936–January 15, 1937, and Modern Art Gallery, Washington, D.C., 1937, unnumbered; "The Age of Impressionism and Objective Realism," Detroit Institute of Arts, May 3–June 2, 1940, no. 2; exhibited, Philbrook Art Center, Tulsa, Okla., 1942, unnumbered; "Nineteenth Century French Painting," Virginia Museum of Fine Arts, Richmond, January 1–February 20, 1944, no. 30; "Cézanne: For the Benefit of the New York Infirmary," Wildenstein, New York, March 27–April 26, 1947, no. 27, ill.; "Cézanne," Wildenstein, New York, November 5–December 5, 1959, no. 30, ill.; "Louis E. Stern Collection," Philadelphia Museum of Art, 1964, no. 19 (cat., p. 181, ill. on cover); "Sezannu ten / Exposition Cézanne," National Museum of Western Art, Tokyo, March 30–May 19, 1974, Museum of the City of Kyoto, June 1–July 17, 1974, and Cultural Center of Fukuoka, July 24–August 18, 1974, no. 34, ill.; "Cézanne in Philadelphia Collections," Philadelphia Museum of Art, June 19–August 21, 1983, no. 12 (cat. by Joseph J. Rishel, pp. 26–27, ill.); "Pol Sezann i russkiĭ avangard nachala XX veka" [Paul Cézanne and the early twentieth-century Russian avant-garde], State Hermitage Museum, Saint Petersburg, August 8–September 24, 1998, and Pushkin State Museum of Fine Arts, Moscow, October 5–November 15, 1998, no. 19, ill.; "Cézanne: Finished—Unfinished," Kunstforum, Vienna, January 20–April 25, 2000, and Kunsthaus Zürich, May 5–July 30, 2000, no. 14 (cat. edited by Felix Baumann, Evelyn Benesch, Walter Feilchenfeldt, and Klaus Albrecht Schröder, p. 158, ills. pp. 155, 157 [detail]); "Sezannu shugi: Chichi to yobareru gaka e no raisan / Homage to Cézanne: His Influence on the Development of Twentieth-Century Painting," Yokohama Museum of Art, November 15, 2008–January 25, 2009, and Hokkaido Museum of Modern Art, Sapporo, February 7–April 12, 2009, no. 6 (cat. by Yasuhide Shimbata, Agnès Delannoy, and Takanori Nagai, p. 215, ill. p. 38); "Cézanne and American Modernism," Montclair Art Museum, N.J., September 13, 2009–January 3, 2010, Baltimore Museum of Art, February 14–May 23, 2010, and Phoenix Art Museum, June 6–September 26, 2010, no. 5, ill.

References: Frederick Lawton, "Paul Cézanne," *Art Journal*, no. 2 (February 1911), p. 60, ill.; Charles Louis Borgmeyer, *The Master Impressionists* (Chicago: Fine Arts Press, 1913), p. 139, ill.; "Cézanne and His Place in Impressionism," *Fine Arts Journal* 35, no. 5 (May 1917), p. 337, ill.; Meier-Graefe, *Cézanne und sein Kreis*, 1st and 2nd eds. (1918 and 1920), p. 164, ill., 3rd ed. (1922), p. 196, ill.; *Collection Kélékian: Tableaux de l'école française moderne* (Paris: [Kelekian], 1920), pl. 8; Alan Burroughs, "Making History of Impressionism," *Arts* 1, no. 4 (April 1921), p. 16, ill.; Emile Bernard, *Souvenirs sur Paul Cézanne: Une Conversation avec Cézanne, la méthode de Cézanne* (Paris: R. G. Michel, 1926), ill. opp. p. 100; Elie Faure, *P. Cézanne* (Paris: Crès, 1926), p. 11; Frank Rutter, *Evolution in Modern Art: A Study of Modern Painting, 1870–1925* (London: Harrap, 1926), pl. 5; Meier-Graefe, *Cézanne* (1927), pl. LXVI; Kurt Pfister, *Cézanne: Gestalt, Werk, Mythos* (Potsdam: Gustav Kiepenheuer, 1927), fig. 73; Christian Zervos, "Idéalisme et naturalisme dans la peinture moderne: II—Cézanne, Gauguin, Van Gogh," *Cahiers d'art* 2 (1927), p. 338, ill.; Anthony Bertram, *Paul Cézanne, 1839–1906*, World's Masters 6 (London: The Studio, 1929), pl. 4; James Johnson Sweeney, "The Bliss Collection," *Creative Art* 8

(May 1931), p. 354, ill.; Guy Pène du Bois, "The Lizzie P. Bliss Collection," *Arts* 17, no. 9 (June 1931), p. 607; Elie Faure, *Cézanne* (Paris: Braun, 1936), pl. 34; Léo Larguier, *Paul Cézanne: Ou, Le Drame de la peinture* (Paris: Denoël et Steele, 1936), p. 31, ill.; Venturi, *Cézanne* (1936), no. 526, vol. 1, p. 177, vol. 2, pl. 163; "Two New Museums Open in New York and Washington," *Art News* 36, no. 8 (November 20, 1937), p. 9, ill.; *Twelve Paintings: Reproduced from Fortune, December 1938* (New York: Museum of Modern Art, 1938), pl. 1; Raymond Cogniat, *Cézanne* (Paris: Tisné, 1939), pl. 68; Edward Alden Jewell, *Paul Cézanne*, edited by Aimée Crane (New York: Hyperion, 1944), p. 47, ill.; Edward Alden Jewell with Aimée Crane, *French Impressionists and Their Contemporaries Represented in American Collections* (New York: Hyperion, 1944), p. 126, ill.; Theodore Reff, "A New Exhibition of Cézanne," *Burlington Magazine* 102, no. 684 (March 1960), pp. 117–18; Van Buren, "Madame Cézanne's Fashions" (1966), p. 123; Schapiro, *Paul Cézanne* (1973), p. 58, ill.; Jean Arrouye, *La Provence de Cézanne* (Aix-en-Provence: Edisud, 1982), p. 70, ill.; Rewald, *Cézanne and America* (1989), p. 327; Rewald, *Paintings of Cézanne* (1996), no. 532, vol. 1, pp. 359–60, vol. 2, ill. p. 174; Sidlauskas, "Emotion, Color, Cézanne" (2004), n.p.; Sidlauskas, *Cézanne's Other* (2009), pp. 7–8, 79, 87, 89–91, 96, pl. 8

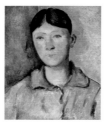

Pl. 16. *Portrait of Madame Cézanne,*
ca. 1885–88
Oil on canvas, 18¼ × 15⅛ in. (46.5 × 38.5 cm)
Musée d'Orsay, Paris, Gift of Pierre Matisse, 1991 (RF 1991-22)

Provenance: Paul Cézanne *fils*, Paris; [Paul Rosenberg, Paris]; Henri Matisse, Nice; Pierre Matisse, son of the artist, New York; Musée d'Orsay, Paris

Exhibitions: "Exposition Paul Cézanne," Galerie Bernheim-Jeune, Paris, March 3–24, 1924, unnumbered; "La Provence et ses peintres au XIXe siècle," Musée des Beaux-Arts, Cannes, March 18–April 13, 1929, no. 7; "Cézanne, 1839–1906," Paul Rosenberg, Paris, February 21–April 1, 1939, no. 17, ill.; "Cézanne (1839–1906), to Celebrate His Centenary: In Aid of the Rebuilding Fund of Saint George's Hospital," Rosenberg and Helft, London, April 19–May 29, 1939, no. 11, ill.; "Cézanne," Galeries Nationales du Grand Palais, Paris, September 25, 1995–January 7, 1996, Tate Gallery, London, February 8–April 28, 1996, and Philadelphia Museum of Art, May 26–August 18, 1996, no. 126 (cat., Cachin and Rishel, *Cézanne*, p. 320, ill. p. 321); "De l'Impressionnisme à l'art nouveau: Acquisitions du Musée d'Orsay, 1990–1996," Musée d'Orsay, Paris, October 16, 1996–January 5, 1997, unnumbered; "Rêve et réalité: Collections du Musée d'Orsay," Municipal Museum of Kobe, June 19–August 29, 1999, and National Museum of Western Art, Tokyo, September 14–December 12, 1999, no. 118, ill.; "Paris–Barcelone, 1888–1937," Museu Picasso, Barcelona, February 28–May 26, 2002, unnumbered; "Van Gogh, Gauguin, Cézanne, and Beyond: Post-Impressionist Masterpieces from the Musée d'Orsay / Oruse Bijutsukan ten 2010: Posuto inshoha," National Gallery of Australia, Canberra, December 4, 2009–April 5, 2010, National Art Center, Tokyo, May 26–August 16, 2010, and de Young Museum, San Francisco, September 25, 2010–January 18, 2011, no. 22, ill.; "Courbet / Cézanne:

La Vérité en peinture," Musée Gustave Courbet, Ornans, June 29–
October 14, 2013, no. 23, ill.

References: Ambroise Vollard, *Paul Cézanne* (Paris: Galerie Vollard,
1914), pl. 46; Elie Faure, "Toujours Cézanne," *L'Amour de l'art* 1,
no. 8, suppl. (December 1920), p. 270, ill.; André Fontainas and
Louis Vauxcelles, *Histoire générale de l'art français de la Révolution
à nos jours* (Paris: Librairie de France, 1922), p. 234, ill.; [Adolphe]
Tabarant, [Commentary], *Bulletin de la vie artistique* 5, no. 5 (March 1,
1924), p. 114, ill.; Venturi, *Cézanne* (1936), no. 530, vol. 1, p. 178, vol. 2,
pl. 165; Adrien-Pierre Bagarry, "Le Centenaire de Paul Cézanne,"
La Renaissance 22, no. 1 (March 1939), p. 7; Georges Grappe,
"Cézanne," special issue, *L'Illustration* (Christmas 1939), ill.; Bernard
Dorival, *Cézanne* (Paris: Tisné, 1948), pl. 110; Van Buren, "Madame
Cézanne's Fashions" (1966), p. 124n5; Rewald, *Paintings of Cézanne*
(1996), no. 581, vol. 1, p. 390, vol. 2, ill. p. 194; Rishel and Sachs,
Cézanne and Beyond (2009), pp. 34, 116, fig. 4.9; Sidlauskas, *Cézanne's
Other* (2009), pp. 21, 41, 129–30, 233n75, pl. 12

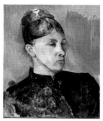

Pl. 13. *Portrait of Madame Cézanne*,
ca. 1886–87
Oil on canvas, 18³/₈ × 15³/₈ in. (46.8 × 38.9 cm)
Philadelphia Museum of Art, The Samuel S.
White 3rd and Vera White Collection, 1967
(1967-30-17)

Provenance: [?Ambroise Vollard, Paris];
?Henri Matisse, Nice; [Paul Rosenberg, Paris
and New York]; [Reid and Lefevre, London];
[Knoedler Galleries, New York]; Mr. and Mrs. Samuel S. White III,
Ardmore, Pa.; Philadelphia Museum of Art

Exhibitions: "Exposition d'oeuvres de grands maîtres du 19éme
siécle," Paul Rosenberg, Paris, May 3–June 3, 1922, no. 12;
"Masterpieces of French Art of the Nineteenth Century: In Aid of
the Lord Mayor's Appeal for the Hospitals," Thomas Agnew and
Sons, Manchester, October 1923, no. 13; "Paintings by Paul Cézanne,
1839–1906," Wildenstein, New York, January 1928, no. 23; The New
Museum of Art Inaugural Exhibition," Pennsylvania Museum of
Art, Philadelphia, opened March 26, 1928, unnumbered; "Cézanne,"
Pennsylvania Museum of Art, Philadelphia, November 10–
December 10, 1934, no. 44; "Cézanne: Centennial Exhibition, 1839–
1939," Marie Harriman Gallery, New York, November 7–December 2,
1939, no. 7; "Paintings by Cézanne (1839–1906)," Paul Rosenberg, New
York, November 19–December 19, 1942, no. 13, ill.; "Cézanne: For the
Benefit of the New York Infirmary," Wildenstein, New York, March 27–
April 26, 1947, no. 37, ill.; "Masterpieces of Philadelphia Private
Collections," Philadelphia Museum of Art, May 30–September 14,
1947, no. 23; "Cézanne: Paintings, Watercolors, and Drawings; A Loan
Exhibition," Art Institute of Chicago, February 7–March 16, 1952,
and The Metropolitan Museum of Art, New York, April 4–May 18,
1952, no. 44, ill.; "Cézanne in Philadelphia Collections," Philadelphia
Museum of Art, June 19–August 21, 1983, no. 13 (cat. by Joseph J.
Rishel, pp. 28–29, ill.); "Cézanne, Gemälde," Kunsthalle Tübingen,
January 16–May 2, 1993, no. 40, ill.; "Pol Sezann i russkiĭ avangard
nachala XX veka" [Paul Cézanne and the early twentieth-century
Russian avant-garde], State Hermitage Museum, Saint Petersburg,
August 8–September 24, 1998, and Pushkin State Museum of Fine

Arts, Moscow, October 5–November 15, 1998, no. 21, ill.; "Cézanne &
Giacometti: Tvivlens veje / Cézanne and Giacometti: Paths of Doubt,"
Louisiana Museum of Modern Art, Humlebæk, February 20–June 29,
2008, no. 28, ill.; "Sezannu shugi: Chichi to yobareru gaka e no raisan /
Homage to Cézanne: His Influence on the Development of Twentieth-
Century Painting," Yokohama Museum of Art, November 15, 2008–
January 25, 2009, and Hokkaido Museum of Modern Art, Sapporo,
February 7–April 12, 2009, no. 8 (cat. by Yasuhide Shimbata, Agnès
Delannoy, and Takanori Nagai, p. 215, ill. p. 39); "Cézanne and
American Modernism," Montclair Art Museum, N.J., September 13,
2009–January 3, 2010, Baltimore Museum of Art, February 14–May 23,
2010, and Phoenix Art Museum, June 6–September 26, 2010, no. 6, ill.

References: Elie Faure, "Toujours Cézanne," *L'Amour de l'art* 1, no. 8,
suppl. (December 1920), p. 269, ill.; André Fontainas and Louis
Vauxcelles, *Histoire générale de l'art français de la Révolution à nos jours*
(Paris: Librairie de France, 1922), p. 231, ill.; Guillaume Janneau,
"Les Grandes Expositions: Maîtres du siècle passé," *La Renaissance
de l'art français et des industries de luxe* 5, no. 5 (May 1922), p. 338, ill.;
"Kunstausstellungen," *Kunst und Künstler* 20, no. 11 (November 1922),
p. 397, ill.; Tilly Wencker, "Chateau Noir," *Kunst und Künstler* 27, no. 6
(June 1929), p. 228, ill.; Joachim Gasquet, *Cézanne* (Berlin: Cassirer,
1930), ill. opp. p. 152; Fritz Neugass, "Paul Cézanne," *Creative Art* 9,
no. 4 (October 1931), p. 276, ill.; John Rewald, *Cézanne et Zola* (Paris:
Sedrowski, 1936), fig. 58; Venturi, *Cézanne* (1936), no. 521, vol. 1,
p. 176, vol. 2, pl. 161; *Cézanne*, introduction by Fritz Novotny (Vienna:
Phaidon; New York: Oxford University Press, 1937), pl. 57; James
Laver, *French Painting and the Nineteenth Century* (London: Batsford,
1937), pl. 117; Christian Zervos, *Histoire de l'art contemporain*, preface
by Henri Laugier (Paris: Editions "Cahiers d'Art," 1938), p. 29, ill.;
Art News 38, no. 6 (November 11, 1939), ill. on cover; John Rewald,
Cézanne: Sa Vie, son oeuvre, son amitié pour Zola (Paris: Albin Michel,
1939), fig. 60; Edward Alden Jewell, *Paul Cézanne*, edited by Aimée
Crane (New York: Hyperion, 1944), p. 40, ill.; Göran Schildt, *Cézanne*
(Stockholm: Wahlström & Widstrand, 1946), fig. 36; Bernard Dorival,
Cézanne (Paris: Tisné, 1948), pl. 109; John Rewald, *Paul Cézanne: A
Biography*, translated by Margaret H. Liebman (New York: Simon
and Schuster, 1948), fig. 67; Maurice Raynal, *Cézanne: Biographical
and Critical Studies*, translated by James Emmons, Taste of Our
Time 8 (Geneva: Skira, 1954), p. 72, ill.; Kurt Leonhard, *Paul Cézanne
in Selbstzeugnissen und Bilddokumenten*, Rowohlts Monographien 114
(Reinbek: Rowohlt, 1966), p. 120, ill.; Van Buren, "Madame Cézanne's
Fashions" (1966), fig. 10; Jack Lindsay, "Cézanne and Zola," *Art
and Artists* 4, no. 6 (September 1969), p. 24, ill.; Lionello Venturi,
Cézanne, preface by Giulio Carlo Argan (Geneva: Skira, 1978),
p. 105, ill.; Bruce Bernard, ed., *The Impressionist Revolution* (London:
Orbis, 1986), p. 122, ill.; Richard Kendall, ed., *Cézanne by Himself:
Drawings, Paintings, Writings* (London: Macdonald Orbis, 1988),
p. 168, ill.; Rewald, *Cézanne and America* (1989), p. 200; Cachin and
Rishel, *Cézanne* (1996), p. 293, fig. 1; Rewald, *Paintings of Cézanne*
(1996), no. 576, vol. 1, pp. 388–89, vol. 2, ill. p. 192; C. Feilchenfeldt,
"Portraits" (2000), p. 164, fig. 1; Sidlauskas, "Emotion, Color,
Cézanne" (2004), n.p.; Butler, *Hidden in the Shadow of the Master*
(2008), p. 66; Rishel and Sachs, *Cézanne and Beyond* (2009), p. 116,
fig. 4.8; Sidlauskas, *Cézanne's Other* (2009), pp. 7, 79, 92, 93, 96, pl. 7;
Jayne S. Warman, "Cézanne, peintre des peintres," in *Cézanne et
Paris*, edited by Denis Coutagne (Paris: Musée du Luxembourg;

Réunion des Musées Nationaux, Grand Palais, Petit Palais, 2011), p. 171, fig. 89

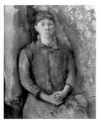

Pl. 17. *Madame Cézanne*, ca. 1886–88
Oil on canvas, 39⅝ × 32 in. (100.6 × 81.3 cm)
Detroit Institute of Arts, Bequest of Robert H. Tannahill, 1970 (70.160)

Provenance: [Ambroise Vollard, Paris]; Prince de Wagram (Alexandre Berthier), Paris; [Durand-Ruel, Paris and New York]; [Ambroise Vollard, Paris]; Dr. Albert C. Barnes, Merion, Pa.; Barnes Foundation, Merion, Pa.; Etienne Bignou, Paris; [Knoedler Galleries, New York]; Robert H. Tannahill, Grosse Pointe Farms, Mich.; Detroit Institute of Arts

Exhibitions: "Salon d'Automne," Grand Palais des Champs-Elysées, Paris, October 15–November 15, 1904, no. 3; "[Paul Cézanne:] Ausstellung, XII. Jahrgang," Paul Cassirer, Berlin, November 17–December 12, 1909, no. 10; "Die klassische Malerei Frankreichs im 19. Jahrhundert: Ein Überblick über die Entwicklung der modernen französischen Malerei in ausgewählten Werken der führenden Meister," Kunstverein, Frankfurt, July 18–October 20, 1912, no. 8; "A Nineteenth Century Selection: French Paintings," Bignou Gallery, New York, March 1935, no. 2, ill.; "A Collector's Treasure: The Tannahill Bequest," Detroit Institute of Arts, May 13–August 13, 1970, unnumbered (cat., *The Robert Hudson Tannahill Bequest to the Detroit Institute of Arts: A Catalogue*, p. 27, ill. on frontispiece); "Cézanne, Gemälde," Kunsthalle Tübingen, January 16–May 2, 1993, no. 39, ill.; "Cézanne und die Moderne: Picasso, Braque, Léger, Mondrian, Klee, Matisse, Giacometti, Rothko, De Kooning, Kelly," Fondation Beyeler, Basel, October 10, 1999–January 9, 2000, no. 15, ill.; "Cézanne: Finished—Unfinished," Kunstforum, Vienna, January 20–April 25, 2000, and Kunsthaus Zürich, May 5–July 30, 2000, no. 21, ill.; "El espejo y la máscara: El retrato en el siglo de Picasso / The Mirror and the Mask: The Portrait in the Age of Picasso," Museo Thyssen-Bornemisza, Madrid, and Fundación Caja Madrid, February 6–May 20, 2007, and Kimbell Art Museum, Fort Worth, June 17–September 16, 2007, no. 40 (cat. by Paloma Alarcó and Malcolm Warner, p. 112, ill. p. 121); "Cézanne and Beyond," Philadelphia Museum of Art, February 26–May 17, 2009, unnumbered (cat., Rishel and Sachs, *Cézanne and Beyond*, pp. 103–35, 532, ill. p. 130, pls. 36, 135)

References: Guy Pène du Bois, "A Modern American Collection: The Paintings," *Arts and Decoration* 4, no. 8 (June 1914), p. 305, ill.; Ambroise Vollard, *Paul Cézanne* (Paris: Galerie Vollard, 1914), pl. 45; Albert C[oombs] Barnes, "Cézanne: A Unique Figure among the Painters of His Time," *Arts and Decoration* 14, no. 1 (November 1920), p. 40, ill.; Mary Mullen, *An Approach to Art* (Merion, Pa.: Barnes Foundation, 1923), p. 37; Albert C[oombs] Barnes, "Cézanne," *Journal of the Barnes Foundation* 1, no. 3 (October 1925), p. 14, ill.; Christian Zervos, "Idéalisme et naturalisme dans la peinture moderne: II—Cézanne, Gauguin, Van Gogh," *Cahiers d'art* 2 (1927), p. 336, ill.; Nina Iavorskaia, *Paul Cézanne*, Arte Moderna Straniera 4 (Milan: Hoepli, 1935), pl. xxv; Forbes Watson, "The Innocent Bystander: The Bignou Opening," *American Magazine of Art* 28, no. 4 (April 1935), p. 244, ill.; Venturi, *Cézanne* (1936),

no. 528, vol. 1, p. 178, vol. 2, pl. 164; Robert J. Goldwater, "Cézanne in America: The Master's Painting in American Collections," in "1938 Annual," special issue, *Art News* 36, no. 26 (March 26, 1938), p. 138, ill.; Christian Zervos, *Histoire de l'art contemporain*, preface by Henri Laugier (Paris: Editions "Cahiers d'Art," 1938), p. 30, ill.; Albert C[oombs] Barnes and Violette de Mazia, *The Art of Cézanne* (New York: Harcourt, Brace, 1939), no. 113; Frederick Cummings, "Tannahill Taste," *Art News* 69, no. 3 (May 1970), p. 32, ill.; Theodore Reff, "Painting and Theory in the Final Decade," in *Cézanne: The Late Work*, edited by William Rubin, exh. cat. (New York: Museum of Modern Art, 1977), p. 19, ill.; Richard Shiff, "Seeing Cézanne," *Critical Inquiry* 4, no. 4 (Summer 1978), p. 785, fig. 7; Richard Kendall, ed., *Cézanne by Himself: Drawings, Paintings, Writings* (London: Macdonald Orbis, 1988), p. 93, ill.; Rewald, *Cézanne and America* (1989), p. 263; Rewald, *Paintings of Cézanne* (1996), no. 607, vol. 1, pp. 403–4, vol. 2, ill. p. 203; Nina Maria Athanassoglou-Kallmyer, *Cézanne and Provence: The Painter in His Culture* (Chicago: University of Chicago Press, 2003), pp. 14, 47, fig. 1.35; W. Feilchenfeldt, *By Appointment Only* (2006), p. 239, ill. p. 238; Sidlauskas, *Cézanne's Other* (2009), pp. 7, 14–15, 21, 41, 57, 123, 127–29, 134, 135, pl. 3

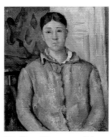

Pl. 18. *Madame Cézanne in Blue*, ca. 1888–90
Oil on canvas, 29¼ × 24 in. (74.2 × 61 cm)
Museum of Fine Arts, Houston, The Robert Lee Blaffer Memorial Collection, Gift of Sarah Campbell Blaffer (1947.29)

Provenance: [Ambroise Vollard, Paris]; Walther Halvorsen, Oslo; [Galerie Thannhauser, Lucerne, and Knoedler Galleries, New York]; Mrs. Robert Lee Blaffer, Houston; Museum of Fine Arts, Houston

Exhibitions: "Paintings and Drawings by Paul Cézanne, 1839–1906," Ernest Brown and Phillips, Leicester Galleries, London, June–July 1925, no. 14; "Erste Sonderausstellung in Berlin: Asselin, Bonnard, Bourdelle," Galerien Thannhauser at Künstlerhaus, Berlin, January 9–mid-February 1927, no. 25, ill.; "A Century of French Paintings," Knoedler Galleries, New York, November 12–December 8, 1928, no. 27; "Masterpieces by Nineteenth Century French Painters," Knoedler Galleries, New York, October–November 1930, no. 2, ill.; "A Century of French Paintings," Wilmington Society of the Fine Arts, Del., February 2–16, 1931, no. 3, ill.; "Pictures of People, 1870–1930," Knoedler Galleries, New York, April 6–18, 1931, no. 6, ill.; "Modern French Painting," Detroit Institute of Arts, May 22–June 30, 1931, no. 15; "A Century of Progress," Art Institute of Chicago, June 1–November 1, 1933, no. 312; "French Painting of the Nineteenth Century," National Gallery of Canada, Ottawa, January 1934, Art Gallery of Toronto, February 1934, and Art Association of Montreal, March 1934, no. 15; "Paul Cézanne: Exhibitions of Paintings, Water-Colors, Drawings, and Prints," San Francisco Museum of Art, September 1–October 4, 1937, no. 23, ill.; "Centenaire du peintre indépendant Paul Cézanne, 1839–1906," Grand Palais, Paris, March 17–April 10, 1939, no. 14; "French and British Contemporary Art," National Art Gallery, Adelaide, opened August 21, 1939, Town Hall, Melbourne, opened October 16, 1939, and

David Jones, Sydney, opened November 20, 1939, no. 23; "Centenaire de Paul Cézanne," Musée de Lyon, December 1939–February 1940, no. 31 (cat., pl. 12); "French Art of the Nineteenth Century: Paintings, Prints, Drawings," Fogg Museum of Art, Harvard University, Cambridge, Mass., July–August 1942, no. 7; "French Art of the Nineteenth and Twentieth Centuries: An Exhibition Held in Cooperation with the Rhode Island Chapter of France Forever to Honor the Cause of De Gaulle for Free France," Museum of Art, Rhode Island School of Design, Providence, November 1942, no. 47; "Old Masters of Modern Art," Memorial Art Gallery, University of Rochester, N.Y., April 10–May 7, 1944, unnumbered; "Celebrating Knoedler: One Hundred Years, 1846–1946," Knoedler Galleries, New York, April 1–27, 1946, no. 19; "Selected French Paintings, for American Aid for France," Knoedler Galleries, New York, December 26, 1946–January 11, 1947, unnumbered; "Paintings by Paul Cézanne," Cincinnati Art Museum, February 5–March 9, 1947, no. 7; "Cézanne: Paintings, Watercolors, and Drawings; A Loan Exhibition," Art Institute of Chicago, February 7–March 16, 1952, and The Metropolitan Museum of Art, New York, April 4–May 18, 1952, no. 67, ill.; "Inaugural Exhibition," Fort Worth Art Center, October 8–31, 1954, unnumbered; "Art in the Twentieth Century," San Francisco Museum of Art, 1955, unnumbered; "Great French Paintings, 1870–1910," Art Center in La Jolla, June 15–July 26, 1956, unnumbered; "Art from Ingres to Pollock: Painting and Sculpture since Neoclassicism," Alfred L. Kroeber Hall and Art Department of the University of California, Berkeley, March 6–April 3, 1960, unnumbered; "Important European Paintings from Texas Private Collections," Marlborough-Gerson Gallery, New York, November–December 1964, unnumbered; "La Peinture française: Collections américaines," [Galerie de Beaux-Arts], Bordeaux, May 13–September 15, 1966, unnumbered; "Cézanne," Musée Saint-Georges, Liège, March 12–May 9, 1982, and Musée Granet, Aix-en-Provence, June 12–August 31, 1982, no. 18, ill.; "Cézanne, Gemälde," Kunsthalle Tübingen, January 16–May 2, 1993, no. 38, ill.; "Cézanne," Galeries Nationales du Grand Palais, Paris, September 25, 1995–January 7, 1996, Tate Gallery, London, February 8–April 28, 1996, and Philadelphia Museum of Art, May 26–August 18, 1996, no. 125 (cat., Cachin and Rishel, Cézanne, p. 318, ill. p. 319); "Cézanne i blickpunkten," Nationalmuseum, Stockholm, October 17, 1997–January 11, 1998, no. 5 (cat. by Görel Cavalli-Björkman, p. 38, ill. p. 39); "'In the Company of Women': A Selection of Paintings from the Museum of Fine Arts, Houston," Seventh Regiment Armory, New York, International Fine Art Fair: Paintings, Drawings, Sculpture, Renaissance through Modern Masters, May 8–13, 1998, "Classic Cézanne," Art Gallery of New South Wales, Sydney, November 28, 1998–February 28, 1999, no. 69, ill.; "Hyusuton bijutsukan ten: Runesasu kara Yazannu Mateisu made / Masterpieces of European Painting from the Fourteenth to the Twentieth Centuries from the Museum of Fine Arts, Houston, and the Sarah Campbell Blaffer Foundation," Museum of Art, Ehime, Matsuyama, and other venues, April 13–October 3, 1999, no. 66 (cat. edited and translated by Peter C. Marzio, Edgar Peters Bowron, James Clifton, Heisaku Harada, Yuki Ikuta, and Keiko Sashimura, pp. 184–86, ill. p. 185); "Faces of Impressionism: Portraits from American Collections," Baltimore Museum of Art, October 10, 1999–January 30, 2000, Museum of Fine Arts, Houston, March 25–May 7, 2000, and Cleveland Museum of Art, May 28–July 30, 2000, no. 16 (cat. by Sona Johnston with Susan Bollendorf, p. 70, ill. p. 71); "Moscow / Houston: An Exchange of Masterpieces," Pushkin State Museum of Fine Arts, Moscow, February–August 2001; "Cézanne: Il padre dei moderni," Complesso del Vittoriano, Rome, March 7–July 7, 2002, unnumbered (cat. edited by Maria Teresa Benedetti, p. 168, ill. p. 169); "El espejo y la máscara: El retrato en el siglo de Picasso / The Mirror and the Mask: The Portrait in the Age of Picasso," Museo Thyssen-Bornemisza, Madrid, and Fundación Caja Madrid, February 6–May 20, 2007, and Kimbell Art Museum, Fort Worth, June 17–September 16, 2007, no. 42 (cat. by Paloma Alarcó and Malcolm Warner, p. 112, ills. pp. 24, 123, and on cover); "Sezannu shugi: Chichi to yobareru gaka e no raisan / Homage to Cézanne: His Influence on the Development of Twentieth-Century Painting," Yokohama Museum of Art, November 15, 2008–January 25, 2009, and Hokkaido Museum of Modern Art, Sapporo, February 7–April 12, 2009, no. 9 (cat. by Yasuhide Shimbata, Agnès Delannoy, and Takanori Nagai, pp. 40, 215, ills. front cover and p. 41); "Cézanne and the Past: Tradition and Creativity," Museum of Fine Arts, Budapest, October 25, 2012–February 17, 2013, no. 127 (cat. edited by Judit Geskó, p. 428, ill. p. 429)

References: Paul Jamot, "L'Art français en Norvège: Galerie nationale d'Oslo et collections particulières," *La Renaissance de l'art français et des industries de luxe* 12, no. 2 (February 1929), p. 89, ill.; ["Madame Cezanne in Blue," Cezanne], *Art News* 29, no. 6 (November 8, 1930), ill. on cover; "Nachrichten aus Amsterdam, Berlin, Frankfurt, London, München, New-York, Paris, Wien, Wiesbaden," *Pantheon* 6, no. 6 (December 1930), ill. p. 584, s.v. New York; Eugenio d'Ors, *Paul Cézanne*, translated by Francisco Amunategui (Paris: Editions des Chroniques du Jour, 1930), pl. 3; C[larence] J[oseph] Bulliet, *Art Masterpieces in a Century of Progress Fine Arts Exhibition*, exh. cat. (Chicago: Art Institute of Chicago; North-Mariano Press, 1933), vol. 1, pl. 44; Alfred M. Frankfurter, "Art in the Century of Progress," *Fine Arts* 20, no. 2 (June 1933), p. 36, ill.; C[larence] J[oseph] Bulliet, *The Significant Moderns and Their Pictures* (New York: Covici, Friede, 1936), pl. 7; Eugenio d'Ors, *Paul Cézanne*, translated by Francisco Amunategui (New York: Weyhe, 1936), pl. 4; G[ualtieri] di San Lazzaro, *Paul Cézanne* (Paris: Editions du Chroniques du Jour, 1936), fig. 4; Venturi, *Cézanne* (1936), no. 529, vol. 1, p. 178, vol. 2, pl. 165; Ambroise Vollard, *Souvenirs d'un marchand de tableaux* (Paris: A. Michel, 1937), pl. 24; W[illiam] Gaunt, "Paul Cézanne: An Essay in Valuation of the Ideals and Achievements of the Greatest Amateur of an Amateur Age in Painting," *Studio* 116, no. 546 (September 1938), p. 143, ill.; *Bulletin of the Museum of Fine Arts of Houston, Texas* 10, no. 2 (Spring 1948), inside front cover, s.v. The Robert Lee Blaffer Memorial Collection, p. 10, ill. on cover; C[harles] F[erdinand] Ramuz, *L'Exemple de Cézanne: Suivi de pages sur Cézanne*, Collection du Bouquet 48 (Lausanne: Mermod, 1951), p. 22; "The Frenchness of French Painting," *Forum* 8, no. 1 (Winter–Spring 1970), p. 42; Schapiro, *Paul Cézanne* (1973), pl. 14; *The Museum of Fine Arts, Houston: A Guide to the Collection*, introduction by William C. Agee (Houston: Museum of Fine Arts, 1981), no. 194, ill.; Richard Kendall, ed., *Cézanne by Himself: Drawings, Paintings, Writings* (London: Macdonald Orbis, 1988), p. 77, ill.; *A Permanent Legacy: 150 Works from the Collection of the Museum of Fine Arts, Houston*, introduction by Peter C. Marzio (New York: Hudson Hills Press; Houston: Museum of Fine Arts, 1989), p. 182; Götz Adriani, *Cézanne: Paintings*, essay by Walter Feilchenfeldt and

translated by Russell M. Stockman, exh. cat. (Cologne: DuMont Buchverlag; New York: Harry N. Abrams, 1993), p. 138; Linda Nochlin, "Cézanne: Studies in Contrast," *Art in America* 84, no. 6 (June 1996), p. 66, ill.; Rewald, *Paintings of Cézanne* (1996), no. 650, vol. 1, p. 421, vol. 2, ill. p. 219; Edgar Peters Bowron and Mary G. Morton, *Masterworks of European Painting in the Museum of Fine Arts, Houston* (Princeton, N.J.: Princeton University Press; Houston: Museum of Fine Arts, 2000), pp. 170–71, ill.; C. Feilchenfeldt, "Portraits" (2000), p. 170, fig. 1; Janet Landay, *The Museum of Fine Arts, Houston: Visitor Guide* (London: Scala in association with the Museum of Fine Arts, Houston, 2000), no. 1.55, ill.; Peter C. Marzio, *Masterpieces from the Museum of Fine Arts, Houston: Director's Choice* (Houston: Museum of Fine Arts, 2009), pp. 100–101; Rishel and Sachs, *Cézanne and Beyond* (2009), pp. 81–82, 314, ills. pp. 82, 126, pl. 111; Sidlauskas, *Cézanne's Other* (2009), pp. 8, 21, 41, 123, 125, 126–27, pl. 9

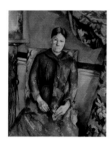

Pl. 22. *Madame Cézanne in a Red Dress,* ca. 1888–90
Oil on canvas, 45⅞ × 35¼ in. (116.5 × 89.5 cm)
The Metropolitan Museum of Art, New York, The Mr. and Mrs. Henry Ittleson Jr. Purchase Fund, 1962 (62.45)

Provenance: [Ambroise Vollard, Paris, and Galerie Bernheim-Jeune, Paris]; Auguste Pellerin, Paris; Jean-Victor Pellerin, Paris; The Metropolitan Museum of Art, New York

Exhibitions: "Rétrospective de Cézanne," at "Salon d'Automne," Grand Palais des Champs Elysées, Paris, October 1–22, 1907, no. 18; "Cézanne," Musée de l'Orangerie, Paris, May–October 1936, no. 76; "Cézanne, Gemälde," Kunsthalle Tübingen, January 16–May 2, 1993, no. 41, ill.; "Cézanne," Galeries Nationales du Grand Palais, Paris, September 25, 1995–January 7, 1996, Tate Gallery, London, February 8–April 28, 1996, and Philadelphia Museum of Art, May 26–August 18, 1996, no. 167 (cat., Cachin and Rishel, *Cézanne,* pp. 399–400, ill. p. 401); "Masterpieces of French Painting from The Metropolitan Museum of Art, 1800–1920," Museum of Fine Arts, Houston, February 4–May 6, 2007, no. 79 (cat. by Kathryn Calley Galitz, Sabine Rewald, Susan Alyson Stein, and Gary Tinterow, pp. 113, 186–87, ill. p. 113); "Französische Meisterwerke des 19. Jahrhunderts aus dem Metropolitan Museum of Art, New York," Neue Nationalgalerie, Berlin, May 31–October 7, 2007, unnumbered; "El Greco y la pintura moderna," Museo Nacional del Prado, Madrid, June 24–October 5, 2014, no. 17

References: Meier-Graefe, *Cézanne und sein Kreis,* 1st and 2nd eds. (1918 and 1920), p. 167, ill., 3rd ed. (1922), p. 201, ill.; Gustave Coquiot, *Paul Cézanne* (Paris: A. Michel, 1919), ill. opp., p. 249; *Cézanne, Maestri Moderni* 1 (Rome: La Voce, 1920), ill., n.p.; Tokuji Saisho, *Pooru sezannu* [Paul Cézanne] (Tokyo: Rakuyodo, Taisho 10, 1921), fig. 31; Maurice Denis, "Le Dessin de Cézanne," *L'Amour de l'art* 5, no. 2 (February 1924), p. 39, ill.; Roger Fry, "Le Développement de Cézanne," *L'Amour de l'art* 7, no. 12 (December 1926), ill. p. 408; Roger Fry, *Cézanne: A Study of His Development* (New York: Macmillan, 1927), fig. 34, pl. XXIII; Meier-Graefe, *Cézanne* (1927), pl. LXVIII; Roger Fry, "Cézannes Udvikling," *Samleren* 6 (1929), ill. p. 131; Georges Rivière, *Cézanne, le peintre solitaire,* Anciens et Modernes (Paris: Floury, 1933),

p. 111, ill.; Gerstle Mack, *Paul Cézanne* (London: Cape, 1935), fig. 17; Otto Benesch. "Cézanne," *Die Kunst* 75, no. 8 (December 1936), p. 70, ill.; René Huyghe, *Cézanne* (Paris: Aulard and Plon, 1936), pl. 28; Léo Larguier, *Paul Cézanne: Ou, Le Drame de la peinture* (Paris: Denoël et Steele, 1936), p. 17, ill.; Maurice Raynal, *Cézanne,* Initiation à l'Art Moderne (Paris: Editions de Cluny, 1936), pl. LXX; Venturi, *Cézanne* (1936), no. 570, vol. 1, p. 188, vol. 2, pl. 182; *Cézanne,* introduction by Fritz Novotny (Vienna: Phaidon; New York: Oxford University Press, 1937), pl. 63; Albert C[oombs] Barnes and Violette de Mazia, *The Art of Cézanne* (New York: Harcourt, Brace, 1939), no. 135, pp. 217, 251, 373–74, ill.; Raymond Cogniat, *Cézanne* (Paris: Tisné, 1939), pl. 87; Georges Rivière, *Cézanne, le peintre solitaire* (Paris: Floury, 1942), p. 91, ill.; Liliane Guerry, "Le Problème de l'équilibre spatial dans les portrait cézanniens de la période constructive," *Etudes d'Art* 2 (1946), fig. 1; Liliane Guerry, *Cézanne et l'expression de l'espace* (Paris: Flammarion, 1950), fig. 20; Benjamin Storey, "Retrospettiva Cézanne," *Emporium* 112, no. 689 (May 1952), p. 199, ill.; Jean de Beucken, *Cézanne, a Pictorial Biography* (New York: Viking Press, 1960), p. 93, ill.; G. W., "La Chronique des arts," *Gazette des beaux-arts* 61, no. 1129, suppl. (February 1963), no. 164, ill.; Liliane Brion-Guerry, *Cézanne et l'expression de l'espace* (Paris: A. Michel, 1966), pl. 44; Charles Sterling and Margaretta M. Salinger, *French Paintings: A Catalogue of the Collection of The Metropolitan Museum of Art,* vol. 3, *XIX–XX Centuries* (Cambridge, Mass.: Harvard University Press, 1967), p. 109, ill.; C[harles] F[erdinand] Ramuz, *Cézanne: Formes, Rythmes et Couleurs* 2, ser. 2 (Lausanne: International Art Book, 1968), pl. 19; Chuji Ikegami, *Sezannu* [Cézanne], Gendai Sekai Bijutsu Zenshu 3 (Tokyo: Shueisha, 1969), fig. 25; Schapiro, *Paul Cézanne* (1973), p. 41, ill.; Katharine Baetjer, *European Paintings in The Metropolitan Museum of Art: By Artists Born in or before 1865; A Summary Catalogue* (New York: The Metropolitan Museum of Art, 1980), vol. 1, p. 26, ill. p. 617; *Cézanne,* exh. cat., Musée Saint-Georges, Liège, and Musée Granet, Aix-en-Provence (Liège: Crédit Communal de Belgique; Aix-en-Provence: Musée Granet, 1982), p. 41, ill.; Charles S. Moffett, *Impressionist and Post-Impressionist Paintings in The Metropolitan Museum of Art* (New York: The Metropolitan Museum of Art and Harry N. Abrams, 1985), pp. 194–95, ill.; Ronald Pickvance and Hideo Takumi, *Sezannu ten / Cézanne,* exh. cat. (Tokyo: Tokyo Shimbun, 1986), p. 66, ill.; Richard Kendall, ed., *Cézanne by Himself: Drawings, Paintings, Writings* (London: Macdonald Orbis, 1988), p. 171, ill.; Rewald, *Paintings of Cézanne* (1996), no. 655, vol. 1, p. 423, vol. 2, ill. p. 221; John Golding, "Under Cézanne's Spell," *New York Review of Books* 43, no. 1 (January 11, 1996), pp. 46–47, ill.; Karen Wilkin, "Monsieur Pellerin's Collection: A Footnote to 'Cézanne,'" *New Criterion* 14 (April 1996), p. 22; Richard Shone, [Exhibition Review of "Cézanne," Tate Gallery, London, February 8–April 28, 1996], *Burlington Magazine* 138, no. 1118 (May 1996), p. 340, fig. 39; Michael Kimmelman, "At the Met with Wayne Thiebaud: A Little Weirdness Can Help an Artist Gain Cachet," *New York Times,* August 23, 1996, p. C25; Görel Cavalli-Björkman, *Cézanne i blickpunkten,* essay by Ulf Linde, exh. cat., Nationalmusei Utställningskatalog 602 (Stockholm: Nationalmuseum, 1997), p. 41, ill.; Richard Shiff, "La Touche de Cézanne: Entre vision impressionniste et vision symboliste," in *Cézanne aujourd'hui: Actes du colloque organisé par le musée d'Orsay, 29 et 30 novembre 1995,* edited by Françoise Cachin, Henri Loyrette, and Stéphane Guégan (Paris: Réunion des Musées Nationaux, 1997), p. 119, fig. 30; Katharina Schmidt, ed., *Cézanne, Picasso, Braque:*

Der Beginn des kubistischen Stillebens, exh. cat. (Basel: Kunstmuseum; Ostfildern-Ruit: Hatje, 1998), p. 33n36; *Sezannu ten / Cézanne and Japan*, exh. cat. (Tokyo: NHK Puromoshon and Tokyo Shinbun, 1999), pp. 203n15, 209–11, n17; C. Feilchenfeldt, "Portraits" (2000), p. 168, fig. 2; Mary Tompkins Lewis, "The Path to Les Lauves: A History of Cézanne's Studios," in *Atelier Cézanne, 1902–2002: Le Centenaire* (Aix-en-Provence: Société Paul Cézanne; Arles: Actes Sud, 2002), English ed., translated by A. J. F. Miller, p. 21, fig. 24; Young-Paik Chun, "Melancholia and Cézanne's Portraits: Faces Beyond the Mirror," in *Psychoanalysis and the Image: Transdisciplinary Perspectives on Subjectivity, Sexual Difference, and Aesthetics*, edited by Griselda Pollock, New Interventions in Art History (Malden: Blackwell, 2006), pp. 95–96, 101, 109, fig. 4.2; W. Feilchenfeldt, *By Appointment Only* (2006), p. 239, ill. p. 238; Tamar Garb, *The Painted Face: Portraits of Women in France, 1814–1914* (New Haven: Yale University Press, 2007), pp. 139–79; Butler, *Hidden in the Shadow of the Master* (2008), pp. 74, 76; Rishel and Sachs, *Cézanne and Beyond* (2009), pp. 59–60, 62, ill. p. 60, pl. 143; Sidlauskas, *Cézanne's Other* (2009), pp. 10, 40–41, 57, 138, 147–48, 174–75, 178–86, 192, 214, 219n7, 263n100, pl. 10; Barbara Schaefer, ed., *1912, Mission moderne: Die Jahrhundert des Sonderbundes*, exh. cat. (Cologne: Wienand, 2012), p. 556, ill.

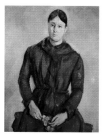

Pl. 21. *Madame Cézanne in a Red Dress*, ca. 1888–90
Oil on canvas, 35 × 27½ in. (89 × 70 cm)
Museu de Arte de São Paulo Assis Chateaubriand (88 P)

Provenance: [Ambroise Vollard, Paris]; Paul Cassirer, Berlin; Lucie Ceconi (Lucie Cassirer-Oberwart), Berlin; [Galerie Bernheim-Jeune, Paris]; Paul Cassirer, Berlin; Alfred Flechtheim, Düsseldorf; [Galerie E. Bignou, Paris]; Paul Guillaume, Paris; Mrs. William A. Clark, New York; [Knoedler Galleries, New York]; Museu de Arte de São Paulo, Brazil

Exhibitions: "Internationale Kunstausstellung des Sonderbundes westdeutscher Kunstfreunde und Künstler," Städtische Ausstellungshalle, Aachener Tor, Cologne, May 25–September 30, 1912, no. 145; "Beiträge zur Kunst des 19. Jahrhunderts und unserer Zeit," Galerie Alfred Flechtheim, Düsseldorf, 1913, unnumbered (cat., p. 58, ill. p. 57); "Cézanne-Ausstellung; Cézannes Werke in deutschem Privatbesitz: Gemälde, Aquarelle, Zeichnungen," Paul Cassirer, Berlin, November–December 1921, no. 22, ill.; "Herbstausstellung Impressionisten," Paul Cassirer, Berlin, September–October 1925, no. 10; "Paintings from El Greco and Rembrandt to Cézanne and Matisse, in Aid of the Greenwich House Music School," Reinhardt Galleries, New York, January 15–29, 1927, no. 22, ill.; "A Century of French Painting," McLellan Galleries, Glasgow, May 1927, no. 34; "Cent Ans de peinture française: Exposition organisée sous les auspices de l'Association française d'expansion et d'échanges artistiques," Van Wisselingh, Amsterdam, April 16–May 5, 1928, no. 2, ill.; "A Century of French Painting," Knoedler Galleries, New York, November 12–December 8, 1928, no. 27; "French Painting from the Fifteenth Century to the Present Day," California Palace of the Legion of Honor, San Francisco, June 8–July 8, 1934, no. 67; "Cézanne," Musée de l'Orangerie, Paris, May–October 1936, no. 84; "Cézanne: For the Benefit of the New York Infirmary," Wildenstein, New York, March 27–April 26, 1947, no. 50; "Chefs d'oeuvre du Musée d'Art de Sao-Paulo," Musée de l'Orangerie, Paris, October 1953–January 1954, no. 5, ill.; "Masterpieces from the São Paulo Museum of Art," Tate Gallery, London, June 19–August 15, 1954, no. 47 (cat., pl. xxxii); "Paintings from the São Paulo Museum," The Metropolitan Museum of Art, New York, March 21–May 5, 1957, unnumbered (cat. by Pietro Maria Bardi, ill. on cover); "Sezannu ten / Cézanne," Isetan Museum of Art, Tokyo, September 18–October 7, 1986, Hyogo Prefectural Museum of Modern Art, Kobe, October 10–November 9, 1986, and Aichi Prefectural Art Gallery, Nagoya, no. 31 (cat. by Ronald Pickvance and Hideo Takumi, p. 67, pl. 31); "Da Manet a Toulouse-Lautrec: Impressionisti e postimpressionisti dal Museu de Arte di San Paolo del Brasile," Palazzo Forti, Verona, July 4–September 27, 1987, Serrone della Villa Reale, Monza, October 7–December 6, 1987, and Villa Croce, Genoa, December 17, 1987–February 21, 1988, unnumbered (cat. edited by Ettore Camesasca, pp. 126–30, ill. p. 127); "Cézanne, Gemälde," Kunsthalle Tübingen, January 16–May 2, 1993, no. 43, ill.; "Cézanne: Finished—Unfinished," Kunstforum, Vienna, January 20–April 25, 2000, and Kunsthaus Zürich, May 5–July 30, 2000, no. 20, ill.

References: Albert Gleizes and Jean Metzinger, *Du "Cubisme"* (Paris: Figuière, 1912), pp. 8–10, pl. i; [Cézanne, Portrait de la femme de l'artiste, Coll. Etienne Bignou], *Cahiers d'art* 2 (1927), ill. p. 277; "Les Expositions à Paris et ses ailleurs," in "Feuilles volantes," special issue, *Cahiers d'art* 2, suppl. 4 (1927), p. 7, ill.; "Les Expositions à Paris et ailleurs," *Cahiers d'art* 3, no. 9 (1928), p. 407, ill.; [Frontispiece: Mme. Cézanne in Red, by Paul Cézanne], *Arts* 15, no. 1 (January 1929), ill. p. 2; Venturi, *Cézanne* (1936), no. 573, vol. 1, p. 189, vol. 2, pl. 183; Christian Zervos, *Histoire de l'art contemporain*, preface by Henri Laugier (Paris: Editions "Cahiers d'Art," 1938), p. 37, ill.; Robert J. Goldwater, "Cézanne in America: The Master's Painting in American Collections," in "1938 Annual," special issue, *Art News* 36, no. 26 (March 26, 1938), p. 139, ill.; Albert C[oombs] Barnes and Violette de Mazia, *The Art of Cézanne* (New York: Harcourt, Brace, 1939), no. 134, pp. 373, 381–82, ill. p. 251; Marco Valsecchi, "Capolavori del Museo di San Paolo," *L'Illustrazione Italiana* 80, no. 12 (December 1953), p. 64, ill.; P[ietro] M[aria] Bardi, "Paintings at São Paulo Museu de Arte," *Connoisseur* 133, no. 535 (March 1954), p. 16, ill.; P[ietro] M[aria] Bardi, *The Arts in Brazil: A New Museum at São Paulo*, translated by John Drummond, Ourselves and the Past 1 (Milan: Edizioni del Milione, 1956), no. 372, ill.; Andersen, *Cézanne's Portrait Drawings* (1970), fig. 34; Schapiro, *Paul Cézanne* (1973), p. 51, ill.; Marcel Brion, *Cézanne*, Impressionistes (Paris: Diffusion Princesse, 1974), p. 50; Frank Elgar, *Cézanne* (New York: Praeger Publishers, 1975), fig. 92; *Alex Reid and Lefevre, 1926–1976*, introduction by Douglas Cooper (London: Lefevre Gallery, 1976), p. 91, ill.; Gilles Plazy, *Cézanne* (Paris: Siloé, 1981), p. 29; Denis Thomas, *The Age of the Impressionists* (Twickenham, UK: Hamlyn for Marks and Spencer, 1987), p. 157, ill.; Rewald, *Paintings of Cézanne* (1996), no. 652, vol. 1, p. 422, vol. 2, ill. p. 220; W. Feilchenfeldt, *By Appointment Only* (2006), pp. 197–98, ill.; J. Teixeira Coelho Netto and Pablo Jiménez Burillo, *Mirar y Ser Visto: Colección del Museu de Arte de São Paulo Assis Chateaubriand*, exh. cat. (Madrid: Fundación MAPFRE, Instituto de Cultura, 2009), no. 88, p. 130; Sidlauskas, *Cézanne's Other*

(2009), p. 178, pl. 15; Barbara Schaefer, ed., *1912, Mission moderne: Die Jahrhundertschau des Sonderbundes*, exh. cat. (Cologne: Wienand, 2012), p. 556

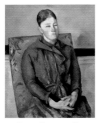

Pl. 20. *Madame Cézanne in a Yellow Chair*, ca. 1888–90
Oil on canvas, 31⁷⁄₈ × 25⁵⁄₈ in. (81 × 65 cm)
Art Institute of Chicago, Wilson L. Mead Fund (1948.54)

Provenance: [Ambroise Vollard, Paris]; [Galerie Bernheim-Jeune, Paris]; Théodore Duret, Paris; [Galerie Benheim-Jeune, Paris]; Deusser, Düsseldorf; [Galerie Thannhauser, Lucerne, and Paul Rosenberg, Paris]; Alphonse Kann, Saint-Germain-en-Laye; [Paul Rosenberg, Paris]; Art Institute of Chicago

Exhibitions: "Salon de la Toison d'Or," La Toison d'Or [Zolotoye Runo] Offices, Moscow, April 11–May 24, 1908, no. 15; "Great Masters of the French XIXth Century (Ingres to Picasso): The Property of M. Paul Rosenberg, of Paris," French Gallery, London, February 1926, no. 5; "Paintings by Paul Cézanne, 1839–1906," Wildenstein, New York, January 1928, no. 19; "Oeuvres importantes de grands maîtres du XIXe siècle," Galeries Paul Rosenberg, Paris, May 18–June 27, 1931, no. 7, ill.; "Cézanne," Musée de l'Orangerie, Paris, May–October 1936, no. 75; "Cézanne, 1839–1906," Paul Rosenberg, Paris, February 21–April 1, 1939, no. 26, ill.; "Cézanne (1839–1906), to Celebrate His Centenary: In Aid of the Rebuilding Fund of Saint George's Hospital," Rosenberg and Helft, London, April 19–May 29, 1939, no. 17, ill.; "The Art of Cézanne," Minneapolis Institute of Arts, January 7–February 5, 1950, unnumbered; "Cézanne: Paintings, Watercolors, and Drawings," Art Institute of Chicago, February 7–March 16, 1952, and The Metropolitan Museum of Art, New York, April 4–May 18, 1952, no. 70, ill.; "Masterpieces Recalled: A Loan Exhibition of 19th and 20th Century French Paintings for the Benefit of the League for Emotionally Disturbed Children," Paul Rosenberg, New York, February 6–March 2, 1957, no. 19, ill.; "Cézanne: An Exhibition in Honor of the Fiftieth Anniversary of the Phillips Collection," Phillips Collection, Washington, D.C., February 27–March 28, 1971, Art Institute of Chicago, April 17–May 16, 1971, and Museum of Fine Arts, Boston, June 1–July 3, 1971, no. 23; "Modern Masters: Manet to Matisse," Art Gallery of New South Wales, Sydney, April 10–May 11, 1975, National Gallery of Victoria, Melbourne, May 28–June 22, 1975, and Museum of Modern Art, New York, August 4–September 1, 1975, unnumbered, ill.; "European Portraits, 1600–1900, in the Art Institute of Chicago," Art Institute of Chicago, July 8–September 11, 1978, no. 22 (cat. edited by Susan Wise, pp. 92–94); "Shikago Bijutsukan Insho-ha ten" [The Impressionist tradition: Masterpieces from the Art Institute of Chicago], Seibu Museum of Art, Tokyo, October 18–December 17, 1985, Fukuoka Art Museum, January 5–February 2, 1986, and Kyoto Municipal Museum of Art, March 4–April 13, 1986, no. 48; "Post-Impressionists," Art Institute of Chicago, 1987, unnumbered (cat. by Richard R. Brettell, p. 65, ill. p. 64); "Cézanne, Gemälde," Kunsthalle Tübingen, January 16–May 2, 1993, no. 42, ill.; "Cézanne i blickpunkten," Nationalmuseum, Stockholm, October 17, 1997–January 11, 1998, no. 6 (cat. by Görel Cavalli-Björkman, p. 41, ill.

p. 40); "Pol Sezann i russkiĭ avangard nachala XX veka" [Paul Cézanne and the early twentieth-century Russian avant-garde], State Hermitage Museum, Saint Petersburg, August 8–September 24, 1998, and Pushkin State Museum of Fine Arts, Moscow, October 5–November 15, 1998, no. 26, ill.; "Cézanne to Picasso: Ambroise Vollard, Patron of the Avant-Garde," The Metropolitan Museum of Art, New York, September 13, 2006–January 7, 2007, Art Institute of Chicago, February 17–May 13, 2007, and Musée d'Orsay, Paris, June 18–September 16, 2007, no. 46, ill.; "Cézanne et Paris," Musée Luxembourg, Paris, October 12, 2011–February 26, 2012, no. 13 (cat. edited by Denis Coutagne, p. 30, ill.)

References: Ugo Nebbia, "Sul movimento pittorico contemporaneo," *Emporium* 38, no. 228 (December 1913), p. 422, ill.; Ambroise Vollard, *Paul Cézanne* (Paris: Galerie Vollard, 1914), pl. 46; Meier-Graefe, *Cézanne und sein Kreis*, 1st and 2nd eds. (1918 and 1920), p. 166, ill., 3rd ed. (1922), p. 200, ill.; André Salmon, *Cézanne*, Les Contemporains, Oeuvres et Portraits du XXe Siècle 25 (Paris: Stock: 1923), pl. 10; Meier-Graefe, *Cézanne* (1927), pl. LXVII; Kurt Pfister, *Cézanne: Gestalt, Werk, Mythos* (Potsdam: Gustav Kiepenheuer, 1927), fig. 74; Forbes Watson, "Recent Exhibitions," *Arts* 13, no. 1 (January 1928), p. 34, ill.; Eugenio d'Ors, *Paul Cézanne*, translated by Francisco Amunategui (Paris: Editions des Chroniques du Jour, 1930), p. 52, ill.; Nina Iavorskaia, *Paul Cézanne*, Arte Moderna Straniera 4 (Milan: Hoepli, 1935), pl. XVI; Nina Iavorskaia, *Sezann* [Cézanne] (Moscow: Ogiz-Izogiz, 1935), pl. 30; Eugenio d'Ors, *Paul Cézanne*, translated by Francisco Amunategui (New York: Weyhe, 1936), pl. 5; G[ualtieri] di San Lazzaro, *Paul Cézanne* (Paris: Editions des Chroniques du Jour, 1936), fig. 5; Venturi, *Cézanne* (1936), no. 572, vol. 1, p. 189, vol. 2, pl. 183; René Huyghe, "Cézanne et son oeuvre," *L'Amour de l'art* 17, no. 5 (May 1936), fig. 61; John Rewald, Maurice Denis, and H. Héraut, "Cézanne et son oeuvre," *L'Art sacré*, special number (May 1936), fig. 1; Jacques Combe, "L'Influence de Cézanne," *La Renaissance* 19, nos. 5–6 (May–June 1936), p. 27, ill.; Albert C[oombs] Barnes and Violette de Mazia, *The Art of Cézanne* (New York: Harcourt, Brace, 1939), no. 135, p. 262, ill. p. 373; Raymond Cogniat, *Cézanne* (Paris: Tisné, 1939), pl. 73, ill. on cover; Adrien-Pierre Bagarry, "Le Centenaire de Paul Cézanne," *La Renaissance* 22, no. 1 (March 1939), p. 7, ill.; Bernard Dorival, *Cézanne* (Paris: Tisné, 1948), pl. 113; John Rewald, "Cézanne's Theories about Art," *ARTnews* 47, no. 7 (November 1948), p. 35, ill.; Daniel Catton Rich, "Two Great French Portraits," *Bulletin of the Art Institute of Chicago* 42, no. 6 (November 15, 1948), pp. 77–81, ill.; Erle Loran, "Cézanne in 1952," *Art Institute of Chicago Quarterly* 46, no. 1 (February 1952), p. 12, ill.; Rudolf Arnheim, *Art and Visual Perception: A Psychology of the Creative Eye* (Berkeley: University of California Press, 1954), pp. 22–26, fig. 16; Fritz Novotny, *Cézanne* (London: Phaidon, 1961), pl. 33; *Paintings in the Art Institute of Chicago: A Catalogue of the Picture Collection* (Chicago: Art Institute of Chicago, 1961), p. 73, ill.; Richard W. Murphy, *The World of Cézanne, 1839–1906* (New York: Time-Life Books, 1968), p. 105; Anne d'Harnoncourt, "The Necessary Cézanne," *Art Gallery* 14, no. 2 (April 1971), p. 39, ill.; John Elderfield, "Drawing in Cézanne," *Artforum* 9, no. 10 (June 1971), p. 53, ill.; Nathaniel Sheppard Jr., "Three Stolen Cézanne Works Recovered; Suspect Arrested," *New York Times*, May 24, 1979, p. A16, ill.; Nello Ponente, ed., *Cézanne e le avanguardie*, La Coscienza e l'Altro, Contributi sull'Arte dell'Ottocento e del Novecento (Rome: Officina, 1981), pl. 27; *Cézanne au Musée d'Aix* (Aix-en-Provence: Musée

Granet, 1984), p. 195, ill.; Richard Kendall, ed., *Cézanne by Himself: Drawings, Paintings, Writings* (London: Macdonald Orbis, 1988), p. 170, ill.; Rewald, *Paintings of Cézanne* (1996), no. 653, vol. 1, pp. 422–23, vol. 2, ill. p. 220; C. Feilchenfeldt, "Portraits" (2000), p. 166, fig. 1; Butler, *Hidden in the Shadow of the Master* (2008), p. 74; Rishel and Sachs, *Cézanne and Beyond* (2009), p. 51, fig. 2.8; Sidlauskas, *Cézanne's Other* (2009), pp. 94, 130–31, 135, 178, pl. 14; Rudy Chiappini, "Quel silenzio, in attesa del tempo della rivelazione," in *Cézanne: Les Ateliers du midi*, edited by Rudy Chiappini, exh. cat. (Milan: Palazzo Reale; Skira, 2011), p. 35, fig. 18

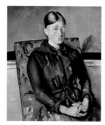

Pl. 19. *Madame Cézanne in a Yellow Chair*, ca. 1888–90
Oil on canvas, 31⁷⁄₈ × 25⁵⁄₈ in. (81 × 65 cm)
Fondation Beyeler, Basel

Provenance: [Ambroise Vollard, Paris]; Paul Cassirer, Berlin; Lucie Ceconi (Lucie Cassirer-Oberwart), Berlin; [Galerie Bernheim-Jeune, Paris]; [Moderne Galerie (Heinrich Thannhauser), Munich]; H. Pollak, Frankfurt; [Galerie Thannhauser, Lucerne, and Paul Rosenberg, Paris]; Adolph Lewisohn, New York; Samuel A. Lewisohn, New York; [Wildenstein Galleries, New York]; Mrs. H. Huttleston Rogers, New York; Peter A. Salm, New York; [Knoedler Galleries, New York]; Mr. and Mrs. John L. Loeb, New York (their sale, New York, Christie's, May 12, 1997, lot 115); Fondation Beyeler, Basel

Exhibitions: "Salon de Mai," Quai Rive-Neuve, Paris, May 1–15, 1912, no. 1, ill.; [Paul Cézanne Solo Exhibition], Moderne Galerie (Heinrich Thannhauser), Munich, December 1912, no. 4; "Summer Exhibition: Retrospective," Museum of Modern Art, New York, June–September 1930, no. 21; "Modern French Painting," Detroit Institute of Arts, May 22–June 30, 1931, no. 21; "Paintings by Cézanne, Gauguin, Redon," Durand-Ruel, New York, March 22–April 15, 1932, no. 3; [Traveling Exhibition under the Auspices of the Museum of Modern Art, New York], University Museum of Art, Princeton, N.J., 1934–35, unnumbered; "Summer Exhibition: The Museum Collection and a Private Collection on Loan," Museum of Modern Art, New York, June 4–September 24, 1935, unnumbered; "Summer Exhibition: Painting and Sculpture," Museum of Modern Art, New York, temporary quarters at the Time-Life Building, June 23–November 4, 1937, unnumbered; "Great Portraits, from Impressionism to Modernism," Wildenstein, New York, March 1–29, 1938, no. 5; "Golden Gate International Exposition," Palace of Fine Arts, San Francisco, [1939–]40, no. 239, ill.; "The Age of Impressionism," Detroit Institute of Arts, 1940, no. 5; exhibited, Museum of Modern Art, New York, 1945, unnumbered; "Cézanne: For the Benefit of the New York Infirmary," Wildenstein, New York, March 27–April 26, 1947, no. 49 (cat. by Vladimir Visson and Daniel Wildenstein, assisted by Ima N. Ebin, p. 56, ill. p. 52); "Six Masters of Post-Impressionism: Benefit of Girl Scout Council of Greater New York," Wildenstein, New York, April 8–May 8, 1948, no. 7; "Paintings by Cézanne," Royal Scottish Academy, Edinburgh, 1954, Tate Gallery, London, September 29–October 27, 1954, and National Gallery, Millbank, London, late October 1954, no. 47 (cat., pl. VII); "Paul Cézanne," Kunstnerforbundet, Oslo, November 13–December 1, 1954, no. 20,

ill.; "Paintings from Private Collections: Summer Loan Exhibition," The Metropolitan Museum of Art, New York, Summer 1958, no. 29; "Cézanne," Wildenstein, New York, November 5–December 5, 1959, no. 35, ill.; "Paintings from Private Collections: Summer Loan Exhibition," The Metropolitan Museum of Art, New York, Summer 1961, no. 14; "Paintings from Private Collections: Summer Loan Exhibition," The Metropolitan Museum of Art, New York, 1962, no. 10; "Paintings from Private Collections: Summer Loan Exhibition," The Metropolitan Museum of Art, New York, Summer 1963, no. 9; "Summer Loan Exhibition: Paintings, Drawings, and Sculpture from Private Collections," The Metropolitan Museum of Art, New York, Summer 1966, no. 26; "New York Collects: Paintings, Watercolors, and Sculpture from Private Collections," The Metropolitan Museum of Art, New York, July 3–September 2, 1968, no. 30; "Cézanne und die Moderne: Picasso, Braque, Léger, Mondrian, Klee, Matisse, Giacometti, Rothko, De Kooning, Kelly," Fondation Beyeler, Basel, October 10, 1999–January 9, 2000, no. 16, ill.; "Cézanne: Finished—Unfinished," Kunstforum, Vienna, January 20–April 25, 2000, and Kunsthaus Zürich, May 5–July 30, 2000, no. 19, ill.; "Cézanne: Aufbruch in die Moderne," Museum Folkwang, Essen, September 18, 2004–January 16, 2005, unnumbered (cat. edited by Felix A. Baumann, Walter Feilchenfeldt, and Hubertus Gassner, pp. 36, 232, ills. pp. 38, 210); "El espejo y la máscara: El retrato en el siglo de Picasso / The Mirror and the Mask: The Portrait in the Age of Picasso," Museo Thyssen-Bornemisza, Madrid, and Fundación Caja Madrid, February 6–May 20, 2007, and Kimbell Art Museum, Fort Worth, June 17–September 16, 2007, no. 41 (cat. by Paloma Alarcó and Malcolm Warner, p. 112, ill. p. 122); "Cézanne & Giacometti: Tvivlens veje / Cézanne and Giacometti: Paths of Doubt," Louisiana Museum of Modern Art, Humlebæk, February 20–June 29, 2008, no. 31, ill.

References: Georg Biermann, "Die Kunst aus dem internationalen Markt: I. Gemälde aus dem Besitz der Modernen Galerie Thannhauser, München," *Cicerone* 5, no. 9 (1913), p. 322, pl. 15; *Katalog der Modernen Galerie Heinrich Thannhauser*, introduction by Wilhelm Hausenstein (Munich: Moderne Galerie Thannhauser, 1916), p. 31, ill.; Forbes Watson, "American Collections: No. III—The Adolph Lewisohn Collection," *Arts* 10, no. 1 (July 1926), p. 34, ill.; Stephan Bourgeois, *The Adolph Lewisohn Collection of Modern French Paintings and Sculptures, with an Essay on French Painting during the Nineteenth Century and Notes on Each Artist's Life and Works* (New York: Weyhe, 1928), ill. opp. p. 180; Stephan Bourgeois and Waldemar George, "The French Paintings of the XIXth and XXth Centuries in the Adolph and Samuel Lewisohn Collection," *Formes*, nos. 28–29 (1932), ill. between pp. 302 and 303; Ralph Flint, "Gauguin, Cézanne and Redon Show at Durand-Ruel's," *Art News* 30, no. 16 (March 26, 1932), pp. 5, 7; Sheldon Cheney, *Expressionism in Art* (New York: Liveright, 1934), p. 251; Venturi, *Cézanne* (1936), no. 571, vol. 1, pp. 188–89, vol. 2, pl. 183; Sam A. Lewisohn, "Four Memoirs of the Growth of Art and Taste in America: The Collector; Personalities Past and Present," in "1939 Annual," special issue, *Art News* 37, no. 22 (February 25, 1939), p. 69, ill. (top); Alfred M. Frankfurter, "Master Paintings and Drawings of Six Centuries at the Golden Gate," *Art News* 38, no. 38 (July 13, 1940), p. 11, ill.; Amédée Ozenfant, "Cézanne," *Arts, Spectacles*, April 18, 1947, p. 1, ill.; James M. Carpenter, "Cézanne and Tradition," *Art Bulletin* 33, no. 3 (September 1951), pp. 179, 182, fig. 7; "The Museum of Modern

Art: Circulating Exhibitions, 1931–1954," special issue, *Bulletin of the Museum of Modern Art* 21, nos. 3–4 (Summer 1954), pp. 6, 21; *The Frances and John L. Loeb Collection*, introduction by Robert Rosenblum (London: White Brothers, 1982), no. 26, ill.; John Rewald, *Cézanne: A Biography* (New York: Harry N. Abrams, 1986), p. 196, ill.; James H. Rubin, *Manet's Silence and the Poetics of Bouquets* (Cambridge, Mass.: Harvard University Press, 1994), p. 216, fig. 94; Cachin and Rishel, *Cézanne* (1996), p. 400, fig. 1; Rewald, *Paintings of Cézanne* (1996), no. 651, vol. 1, p. 421, vol. 2, ill. p. 220; Butler, *Hidden in the Shadow of the Master* (2008), p. 74; Sidlauskas, *Cézanne's Other* (2009), pp. 6, 8, 40, 132–33, 178, pl. 2

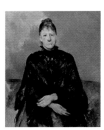

Pl. 25. *Portrait of Madame Cézanne,* ca. 1888–90
Oil on canvas, 36½ × 28¾ in. (92.7 × 73 cm)
Barnes Foundation, Philadelphia (BF710)

Provenance: [Ambroise Vollard, Paris, and Galerie Bernheim-Jeune, Paris]; August Pellerin, Paris; [Galerie Bernheim-Jeune, Paris]; [Ambroise Vollard, Paris]; [Moderne Galerie (Heinrich Thannhauser), Munich]; Sally Falk, Mannheim; Barnes Foundation, Philadelphia

Exhibitions: "Paul Cézanne," Paul Cassirer, Berlin, April–June 1904, unnumbered; "Die klassische Malerei Frankreichs im 19. Jahrhundert: Ein Überblick über die Entwicklung der modernen französischen Malerei in ausgewählten Werken der führenden Meister," Kunstverein, Frankfurt, July 18–October 20, 1912, no. 10; "From Cézanne to Matisse: Great French Paintings from the Barnes Foundation," National Gallery of Art, Washington, D.C., and other venues, May 2, 1993–October 22, 1995, unnumbered (cat. by Richard J. Wattenmaker, ill. p. 112)

References: Hans Rosenhagen, "Von Ausstellungen und Sammlungen: Berlin," *Die Kunst für Alle* 19, no. 17 (June 1904), p. 402; "Kunstausstellungen," *Kunst und Künstler* 10, no. 12 (December 1912), p. 619, ill.; *Moderne Galerie Heinrich Thannhauser: Nachtragswerk I zur grossen* (Munich: Moderne Galerie Thannhauser, 1916), p. 13, ill.; Henrik Häuser, "Ein Dänischer Sammler [Tetzned-Lund]," *Cicerone* 10, nos. 11–12 (June 1918), p. 164, ill. p. 161; Meier-Graefe, *Cézanne und sein Kreis*, 1st and 2nd eds. (1918 and 1920), p. 162, ill., 3rd ed. (1922), p. 199, ill.; Mary Mullen, *An Approach to Art* (Merion, Pa.: Barnes Foundation, 1923), p. 29, ill.; Albert C[oombs] Barnes, *The Art in Painting* (New York: Harcourt, Brace, 1925), p. 488, ill. p. 384; Emile Bernard, *Souvenirs sur Paul Cézanne: Une Conversation avec Cézanne, la méthode de Cézanne* (Paris: R. G. Michel, 1926), ill. opp. p. 44; Meier-Graefe, *Cézanne* (1927), pl. LXIV; Kurt Pfister, *Cézanne: Gestalt, Werk, Mythos* (Potsdam: Gustav Kiepenheuer, 1927), fig. 75; Lionello Venturi, "Cézanne," *L'Arte* 6 (July 1935), fig. 20; Venturi, *Cézanne* (1936), no. 522, vol. 1, p. 177, vol. 2, pl. 162; Albert C[oombs] Barnes and Violette de Mazia, *The Art of Cézanne* (New York: Harcourt, Brace, 1939), no. 118, pp. 360–63, ill. p. 231; Erle Loran, *Cézanne's Composition: Analysis of His Form, with Diagrams and Photographs of His Motifs* (Berkeley: University of California Press, 1943), pp. 84–85, pl. XVII; Erle Loran, "Pop Artists or Copy Cats?" *Art News* 62, no. 5 (September 1963), pp. 48–49; Van Buren, "Madame Cézanne's Fashions" (1966), fig. 11; James Johnson Sweeney, "The Albert C. Barnes Collection," *Barnes

Foundation Journal of the Art Department, Autumn 1972, p. 32, pl. 10; Hajo Düchting, *Paul Cézanne, 1839–1906: Natur wird kunst,* edited by Ingo F. Walther (Cologne: Benedikt, 1990), ill. p. 137; Roland Dorn, *Stiftung und Sammlung Sally Falk,* edited by Roland Dorn, Karoline Hille, and Jochen Kronjäger, Kunst + Dokumentation 11 (Mannheim: Städtische Kunsthalle Mannheim, 1994), no. 54, fig. 509; Rewald, *Paintings of Cézanne* (1996), no. 683, vol. 1, p. 435, vol. 2, ill. p. 234; Nina Maria Athanassoglou-Kallmyer, *Cézanne and Provence: The Painter in His Culture* (Chicago: University of Chicago Press, 2003), p. 48, fig. 1.36; W. Feilchenfeldt, *By Appointment Only* (2006), p. 140, ill.; Sidlauskas, *Cézanne's Other* (2009), pp. 14, 21, 97–99, 121, pl. 11

NOT IN EXHIBITION

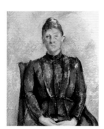

Pl. 24. *Portrait of Madame Cézanne,* ca. 1890
Oil on canvas, 31⅞ × 25⅝ in. (81 × 65 cm)
Musée de l'Orangerie, Paris, Collection Walter Guillaume (RF 1960-9)

Provenance: [Paul Cassirer, Berlin]; Paul Guillaume, Paris; Madame Jean Walter (Madame Paul Guillaume), Paris; Musée du Louvre, Paris; Musée de l'Orangerie, Paris

Exhibitions: "Trente Ans d'art indépendant, 1884–1914: Exposition rétrospective des oeuvres des membres inscrits au cours des trente premières," Grand Palais des Champs-Elysées, Paris, February 20–March 21, 1926, no. 2869; "Exposition Cézanne, 1839–1906," Galerie Pigalle, Paris, December (?) 1929, no. 12, ill.; "Vincent van Gogh en zijn tijdgenooten," Stedelijk Museum, Amsterdam, September 6–November 2, 1930, no. 129; "Cézanne, Corot, Manet, Renoir," Galerie Bernheim-Jeune, Paris, October 1931, unnumbered; "Cézanne," Musée de l'Orangerie, Paris, May–October 1936, no. 65; "Centenaire du peintre indépendant Paul Cézanne," Galerie Indépendants, Paris, 1939, no. 15; "Portraits français," Galerie Charpentier, Paris, 1945, no. 11; "Collection Jean Walter–Paul-Guillaume," Musée de l'Orangerie, Paris, 1966, no. 11, ill.; "Cézanne dans les musées nationaux," Musée de l'Orangerie, Paris, July 19–October 14, 1974 , no. 35 (cat., p. 92, ill. [detail] p. 16, ill. p. 93); "De Renoir à Matisse: 22 Chefs-d'oeuvre des musées soviétiques et français," Grand Palais, Paris, June 6–September 18, 1978, no. 4, ill.; "Impressionistes et post-impressionistes des musées français de Manet à Matisse," National Gallery, Athens, and other venues, 1980, no. 6 (cat. by Dimitrios Papastamos, pp. 63–65, ills. pp. 64, 74); "Od Courbeta K Cezannovi: Obrazy z let 1848–1886, ze sbírek francouzských muzeí" [From Courbet to Cézanne: Paintings from the years 1848–1886, from the collections of French museums], Valdštejnská jízdárna, Prague, September–October 1982, and other venues, no. 20, ill.; "Paul Cézanne," Museo Español de Arte Contemporáneo, Madrid, March–April 1984, no. 33; "Cézanne i blickpunkten," Nationalmuseum, Stockholm, October 17, 1997–January 11, 1998, no. 4 (cat. by Görel Cavalli-Björkman, p. 36, ill. p. 37); "Cézanne, Renoir: 30 capolavori dal Musée de l'Orangerie, I 'classici' dell'Impressionismo dalla collezione Paul Guillaume," Accademia Carrara, Bergamo, March 22–July 3, 2005, unnumbered

References: Waldemar George [pseud.], "Trente ans d'Art Independent: Rétrospective de la Société des Artistes Indépendants," *L'Amour de l'art* 7, no. 1 (January 1926), p. 90, ill.; Waldemar George

[pseud.], *La Grande Peinture contemporaine à la collection Paul Guillaume*, exh. cat. (Paris: Editions des "Arts à Paris," 1929), p. 19; [Georges] Charensol, "La Quinzaine artistique: Cezanne a la Galerie Pigalle," *L'Art vivant* 6, no. 124 (February 15, 1930), p. 181, ill.; Venturi, *Cézanne* (1936), no. 523, vol. 1, p. 177, vol. 2, pl. 162; Rainer Maria Rilke, *Lettres sur Cézanne*, translated by Maurice Betz (Paris: Corrêa, 1944), ill. on frontispiece; Van Buren, "Madame Cézanne's Fashions" (1966), fig. 15; Chuji Ikegami, *Sezannu* [Cézanne], Gendai Sekai Bijutsu Zenshu 3 (Tokyo: Shueisha, 1969), pl. 39; Andersen, *Cézanne's Portrait Drawings* (1970), fig. 32; Schapiro, *Paul Cézanne* (1973), p. 59, ill.; Michel Hoog with Hélène Guicharnaud and Colette Giraudon, *Musée de l'Orangerie: Catalogue de la collection Jean Walter et Paul Guillaume* (Paris: Ministère de la Culture, Editions de la Réunion des Musées Nationaux, 1984), no. 10, p. 32, ill. p. 33; Rewald, *Paintings of Cézanne* (1996), no. 684, vol. 1, p. 435, vol. 2, ill. p. 234; Sidlauskas, *Cézanne's Other* (2009), pp. 21, 102, 115, 117–21, 126, 127, pl. 13

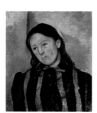

Pl. 9. *Portrait of Madame Cézanne*, 1890–92
Oil on canvas, 24 3/8 × 20 1/8 in. (61.9 × 51.1 cm)
Philadelphia Museum of Art, The Henry P. McIlhenny Collection in memory of Frances P. McIlhenny, 1986 (1986-26-1)

Provenance: [Ambroise Vollard, Paris]; ?Walther Halvorsen, Oslo; Gottlieb Friedrich Reber, Lausanne; [Paul Rosenberg, Paris]; Samuel Courtauld, London; [Paul Rosenberg, Paris]; Henry P. McIlhenny, Philadelphia; Philadelphia Museum of Art

Exhibitions: "Exposition Cézanne," Bernheim-Jeune, Paris, January 10–22, 1910, no. 11; "Great Masters of the French XIXth Century (Ingres to Picasso): The Property of M. Paul Rosenberg, of Paris," French Gallery, London, February 1926, no. 2; "Modern French Art," Rhode Island School of Design, Providence, March 11–31, 1930, no. 4; "Quelques Oeuvres importantes de Manet à Van Gogh," Durand-Ruel, Paris, February–March 1932, no. 5; "A Century of Progress," Art Institute of Chicago, June 1–November 1, 1934, no. 297; "Cézanne," Pennsylvania Museum of Art, Philadelphia, November 10–December 10, 1934, no. 13, and Fogg Art Museum, Harvard University, Cambridge, Mass., March 10–19, 1935, unnumbered; "Cézanne," Musée de l'Orangerie, Paris, May–October 1936, no. 58; "Significant Landmarks of Nineteenth Century French Painting," Bignou Gallery, New York, February 20–March 25, 1939, no. 3, ill.; "Masterpieces of Philadelphia Private Collections," Philadelphia Museum of Art, May 30–September 14, 1947, no. 21; "French Masterpieces of the Nineteenth Century from the Henry P. McIlhenny Collection," Allentown Art Museum, Pa., May 1–September 18, 1977, unnumbered (cat., p. 70, ill.); "Cézanne in Philadelphia Collections," Philadelphia Museum of Art, June 19–August 21, 1983, no. 15 (cat. by Joseph J. Rishel, p. 32, ill.); "Masterpieces from the Henry P. McIlhenny Collection," Museum of Fine Arts, Boston, June 27–August 31, 1986, unnumbered; "Cézanne, Gemälde," Kunsthalle Tübingen, January 16–May 2, 1993, no. 44, ill.; "Cézanne," Galeries Nationales du Grand Palais, Paris, September 25, 1995–January 7, 1996, Tate Gallery, London, February 8–April 28, 1996, and Philadelphia Museum of Art, May 26–August 18, 1996, no. 138 (cat., Cachin and Rishel, *Cézanne*,

p. 346, ill. p. 347); "Pol Sezann i russkiĭ avangard nachala XX veka" [Paul Cézanne and the early twentieth-century Russian avant-garde], State Hermitage Museum, Saint Petersburg, August 8–September 24, 1998, and Pushkin State Museum of Fine Arts, Moscow, October 5–November 15, 1998, no. 31, ill.; "Faces of Impressionism: Portraits from American Collections," Baltimore Museum of Art, October 10, 1999–January 30, 2000, Museum of Fine Arts, Houston, March 25–May 7, 2000, and Cleveland Museum of Art, May 28–July 30, 2000, no. 17 (cat. by Sona Johnston with Susan Bollendorf, p. 72, no. 17, ill. p. 73); "Cézanne and Beyond," Philadelphia Museum of Art, February 26–May 17, 2009, unnumbered (cat., Rishel and Sachs, *Cézanne and Beyond*, pp. 209, 533, fig. 8.4)

References: Julius Meier-Graefe, *Paul Cézanne*, 3rd ed. (Munich: Piper, 1910), pl. 49; Ambroise Vollard, *Paul Cézanne* (Paris: Galerie Vollard, 1914), pl. 46; Meier-Graefe, *Cézanne und sein Kreis*, 1st and 2nd eds. (1918 and 1920), ill. opp. p. 144, 3rd ed. (1922), p. 129, ill.; Elie Faure, "Toujours Cézanne," *L'Amour de l'art* 1, no. 8, suppl. (December 1920), p. 267, ill.; Tokuji Saisho, *Pooru sezannu* [Paul Cézanne] (Tokyo: Rakuyodo, Taisho 10, 1921), fig. 31; André Fontainas and Louis Vauxcelles, *Histoire générale de l'art français de la Révolution à nos jours* (Paris: Librairie de France, 1922), p. 230, ill.; Rivière, *Le Maître* (1923), p. 201; Meier-Graefe, *Cézanne* (1927), pl. XLIX; Kurt Pfister, *Cézanne: Gestalt, Werk, Mythos* (Potsdam: Gustav Kiepenheuer, 1927), fig. 72; Marie Dormoy, "La Collection Courtauld," *L'Amour de l'art* 10, no. 1 (January 1929), p. 17, ill.; J. B. Manson, "The Collection of Mr. and Mrs. Samuel Courtauld," *Creative Art* 4, no. 4 (April 1929), p. 262; Irene Weir, "A Cursive Review of Recent Museum Activities outside New York," *Parnassus* 2, no. 5 (May 1930), p. 25, ill.; C[larence] J[oseph] Bulliet, *The Significant Moderns and Their Pictures* (New York: Covici, Friede, 1936), pl. 2; Ingrid Rydbeck, "Apropå Cézanne," *Konstrevy* 12, no. 4 (1936), p. 137, ill.; Venturi, *Cézanne* (1936), no. 527, vol. 1, p. 178, vol. 2, pl. 163; *Cézanne*, introduction by Fritz Novotny (Vienna: Phaidon; New York: Oxford University Press, 1937), pl. 48; Robert J. Goldwater, "Cézanne in America: The Master's Painting in American Collections," in "1938 Annual," special issue, *Art News* 36, no. 26 (March 26, 1938), p. 138, ill.; Albert C[oombs] Barnes and Violette de Mazia, *The Art of Cézanne* (New York: Harcourt, Brace, 1939), no. 98, p. 343; Raymond Cogniat, *Cézanne* (Paris: Tisné, 1939), pl. 67; Bernard Dorival, *Cézanne* (Paris: Tisné, 1948), pl. 111; E[rnst] H. Gombrich, *The Story of Art* (New York: Phaidon, 1950), p. 412, fig. 342; Meyer Schapiro, *Paul Cézanne* (New York: Harry N. Abrams, 1952), pp. 58–59, ill.; Theodore Rousseau Jr., *Paul Cézanne, 1839–1906*, Fontana Pocket Library of Great Art A4 (New York: Harry N. Abrams in association with Pocket Books, 1953), pl. 14; Marteau de Langle de Cary, *Cézanne*, Collection "Visages et Souvenirs" 2 (Paris: Caritas, 1957), pp. 96–97; Rosamund Bernier, "Le Musée privé d'un conservateur," *L'Oeil*, no. 27 (March 1957), p. 28, ill.; Liliane Brion-Guerry, *Cézanne et l'expression de l'espace* (Paris: A. Michel, 1966), pl. 36; Schapiro, *Paul Cézanne* (1973), pl. 14; Richard Kendall, ed., *Cézanne by Himself: Drawings, Paintings, Writings* (London: Macdonald Orbis, 1988), p. 169, ill.; Hajo Düchting, *Paul Cézanne, 1839–1906: Natur wird Kunst*, edited by Ingo F. Walther (Cologne: Benedikt, 1990), ill. p. 131; Rewald, *Paintings of Cézanne* (1996), no. 685, vol. 1, p. 436, vol. 2, ill. p. 235; Sidlauskas, "Emotion, Color, Cézanne" (2004), n.p.; Butler, *Hidden in the Shadow of the Master* (2008), p. 70; Sidlauskas, *Cézanne's Other* (2009), pp. 7, 70–75, 77, 89, 116, pl. 4

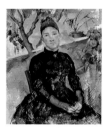

Pl. 28. *Madame Cézanne in the Conservatory*,
1891
Oil on canvas, 36¼ × 28¾ in. (92.1 × 73 cm)
The Metropolitan Museum of Art, New York,
Bequest of Stephen C. Clark, 1960 (61.101.2)

Provenance: Paul Cézanne *fils*, Paris;
[Ambroise Vollard, Paris]; Ivan Morozov,
Moscow; [Knoedler Galleries, New York];
Stephen C. Clark, New York; The Metropolitan
Museum of Art, New York

Exhibitions: "Exposition Paul Cézanne," Galerie Vollard, Paris,
November–December 1895, unnumbered; exhibited, Vienna
Secession, 1907, no. 19 (?); "Rétrospective de Cézanne," at "Salon
d'Automne," Grand Palais des Champs Elysées, Paris, October 1–22,
1907, no. 25; "[Paul Cézanne:] Ausstellung, XII. Jahrgang," Paul
Cassirer, Berlin, November 17–December 12, 1909, no. 17; "Manet and
the Post-Impressionists," Grafton Galleries, London, November 8,
1910–January 15, 1911, no. 11; "Französische Meister," Galerie
Miethke, Vienna, February 1911, unnumbered (?); "Paul Cézanne
(1839–1906), Vincent van Gogh (1853–1890)," Museum of Modern
Western Art, Moscow, 1926, no. 15; "A Century of Progress," Art
Institute of Chicago, June 1–November 1, 1934, no. 296 (cat., pl. L);
"Modern Works of Art: Fifth Anniversary Exhibition," Museum of
Modern Art, New York, November 20, 1934–January 20, 1935, no. 5,
ill.; "French Masterpieces of the Nineteenth Century," Century
Club, New York, January 11–February 10, 1936, no. 17, ill.; "Twentieth
Anniversary Exhibition," Cleveland Museum of Art, June 26–
October 4, 1936, no. 254 (cat., *Catalogue of the Twentieth Anniversary
Exhibition of the Cleveland Museum of Art: The Official Art Exhibit of
the Great Lakes Exposition*, pl. 65); "Paul Cézanne: Exhibitions of
Paintings, Water-Colors, Drawings, and Prints," San Francisco
Museum of Art, September 1–October 4, 1937, no. 27; "Masterpieces
by Cézanne," Durand-Ruel, New York, March 29–April 16, 1938,
no. 16; "Art in Our Time," Museum of Modern Art, New York,
May 10–September 30, 1939, no. 60; "Masterpieces of Art: European
and American Paintings, 1500–1900," World's Fair, New York,
May–October 1940, no. 341; "Paintings by Cézanne (1839–1906),"
Paul Rosenberg, New York, November 19–December 19, 1942, no. 15,
ill.; "Paintings from the Stephen C. Clark Collection," Century
Association, New York, June 6–September 28, 1946, unnumbered;
"Cézanne: For the Benefit of the New York Infirmary," Wildenstein,
New York, March 27–April 26, 1947, no. 48 (cat. by Vladimir Visson
and Daniel Wildenstein, assisted by Ima N. Ebin, p. 56, ill. on
frontispiece); "To Honor Henry McBride: An Exhibition of
Paintings, Drawings, and Water Colours," Knoedler Galleries, New
York, November 29–December 17, 1949, no. 2; "Cézanne: Paintings,
Watercolors, and Drawings," Art Institute of Chicago, February 7–
March 16, 1952, and The Metropolitan Museum of Art, New York,
April 4–May 18, 1952, no. 68 (cat., ill. on cover); "A Collector's Taste:
Selections from the Collection of Mr. and Mrs. Stephen Clark; For the
Benefit of the Fresh Air Association of Saint John," Knoedler
Galleries, New York, January 12–30, 1954, no. 12, ill.; "Paintings
from Private Collections: A Twenty-fifth Anniversary Exhibition,"
Museum of Modern Art, New York, May 31–September 5, 1955,
unnumbered; "Paintings from Private Collections: Summer Loan

Exhibition," The Metropolitan Museum of Art, New York, Summer
1958, no. 16; "Paintings from Private Collections: Summer Loan
Exhibition," The Metropolitan Museum of Art, New York, Summer
1959, no. 9; "Paintings, Drawings, and Sculpture Collected by Yale
Alumni," Yale University Art Gallery, New Haven, May 19–June 26,
1960, no. 76; "Paintings from Private Collections: Summer Loan
Exhibition," The Metropolitan Museum of Art, New York, July 6–
September 4, 1960, no. 9; "Capolavori impressionisti dei musei
americani," Pinacoteca di Brera, Milan, March 5–May 3, 1987, no. 7
(cat. edited by Gary Tinterow, Susan Alyson Stein, Anne M. P. Norton,
and Florence Coman, pp. 24–25, ill.); "Metoroporitan bijutsukan
meihinten: Furansu bijutsu gohyakunen" [Treasures from The
Metropolitan Museum of Art: French art from the Middle Ages to
the twentieth century], Yokohama Museum of Art, March 25–June 4,
1989, no. 92 (cat. by Gary Tinterow, pp. 146–47, ill.); "Morozov and
Shchukin, the Russian Collectors: Monet to Picasso / Morozov i
Shchukin, russkie kollektsionery: Ot Mone do Pikasso," Museum
Folkwang, Essen, June 25–October 31, 1993, Pushkin State Museum
of Fine Arts, Moscow, November 30, 1993–January 30, 1994, and
State Hermitage Museum, Saint Petersburg, February 16–April 16,
1994, no. 34 (cat. by Georg-W. Költzsch, pp. 103, 122, 129n166, 336,
387, 439, pl. 31); "Cézanne i blickpunkten," Nationalmuseum,
Stockholm, October 17, 1997–January 11, 1998, no. 7 (cat. by Görel
Cavalli-Björkman, p. 43, ill. p. 42); "Cézanne in Provence," National
Gallery of Art, Washington, D.C., January 29–May 7, 2006, and
Musée Granet, Aix-en-Provence, June 9–September 17, 2006, no. 37
(cat. by Philip Conisbee and Denis Coutagne, pp. 91–92, ill. p. 121,
French ed., pp. 111–12, ill. p. 141); "The Clark Brothers Collect:
Impressionist and Early Modern Paintings," Sterling and Francine
Clark Art Institute, Williamstown, Mass., June 4–September 4, 2006,
and The Metropolitan Museum of Art, New York, May 22–August 19,
2007, no. 55 (cat. by Michael Conforti, James A. Ganz, Neil Harris,
Sarah Lees, and Gilbert T. Vincent, pp. 156, 245–48, fig. 182, ill.
[detail] p. 244, pp. 250, 315, 321); "Masterpieces of French Painting
from The Metropolitan Museum of Art, 1800–1920," Museum of Fine
Arts, Houston, February 4–May 6, 2007, no. 78 (cat. by Kathryn Calley
Galitz, Sabine Rewald, Susan Alyson Stein, and Gary Tinterow, pp. 11,
112, 189–91, ill. p. 112)

References: Julius Meier-Graefe, *Impressionisten: Guys, Manet, Van
Gogh, Pissarro, Cézanne; Mit einer Einleitung über den Wert der
französischen Kunst und sechzig Abbildungen*, 2nd ed. (Munich: Piper,
1907), p. 201, ill.; Julius Meier-Graefe, *Paul Cézanne*, 3rd ed. (Munich:
Piper, 1910), p. 46, ill., 4th ed. (1913), p. 44, ill., 5th ed. (1923) p. 55, ill.;
S. Makowski, "Catalogue: French Artists in the J. Morosoff
Collection in Moscow," *Apollon* 3, nos. 3–4 (1912), pp. 28–29, ill.;
Jean Royère, "Paul Cézanne: Erinnerungen," *Kunst und Künstler* 10,
no. 10 (October 1912), p. 479, ill.; Fritz Burger, *Cézanne und Hodler:
Einführung in die Probleme der Malerei der Gegenwart* (Munich:
Delphin-Verlag, 1913), vol. 2, pl. 69, 4th ed. (1920), vol. 2, pl. 72, 5th ed.
(1923), vol. 2, pl. 71; Ambroise Vollard, *Paul Cézanne* (Paris: Galerie
Vollard, 1914), pl. 24; Roger Fry, "'Paul Cézanne' by Ambroise Vollard:
Paris, 1915; A Review," *Burlington Magazine* 31, no. 173 (August 1917),
pl. III; Meier-Graefe, *Cézanne und sein Kreis*, 1st and 2nd eds. (1918
and 1920), ill. opp. p. 192, 3rd ed. (1922), p. 235, ill.; Max Deri, *Die
Malerei im XIX. Jahrhundert: Entwicklungsgeschichtliche Darstellung auf
psychologischer Grundlage* (Berlin: Cassirer, 1920), pp. 201–3, pl. 46;

Emil Waldmann, *Das Bildnis im 19. Jarhundert* (Berlin: Propyläen, 1921), fig. 124; Curt Glaser, *Paul Cézanne* (Leipzig: Seeman, 1922), pl. 15; Hans von Wedderkop, *Paul Cézanne*, Bibliothek der Junge Kunst 4, Junge Kunst 30 (Leipzig: Klinkhardt & Biermann, 1922), ill. n.p. [12]; Rivière, *Le Maître* (1923), p. 218; [Boris Nikolaevich] Ternovietz, "Le Musée d'Art Moderne de Moscou (Ancienne Collections Stchoukine et Morosoff)," *L'Amour de l'art* 6, no. 12 (December 1925), pp. 470, 473, ill.; Ikuma Arishima, *Sezannu* [Cézanne] (Tokyo: Arusu, Taisho 14, 1926), pl. 14; Paul Ettinger, "Die modernen Franzosen in den Kunstammlungen Moskaus," *Cicerone* 18, no. 4 (1926), p. 114, ill.; Meier-Graefe, *Cézanne* (1927), pl. XCIII; Julius Meier-Graefe, *Entwicklungsgeschichte der modernen Kunst*, vol. 3, *Die Kunst unserer tage von Cézanne bis heute* (Munich: Piper, 1927), p. 497; Kurt Pfister, *Cézanne: Gestalt, Werk, Mythos* (Potsdam: Gustav Kiepenheuer, 1927), fig. 112; Karl Scheffler, *Geschichte der europäischen Malerei vom Impressionismus bis zur Gegenwart; Geschichte der europäischen Plastik im neunzehnten und zwanzigsten Jahrhundert*, vol. 2 of *Die europäische Kunst im neunzehnten Jahrhundert: Malerei und Plastik* (Berlin: Cassirer, 1927), p. 95; Christian Zervos, "Idéalisme et naturalisme dans la peinture moderne: II—Cézanne, Gauguin, Van Gogh," *Cahiers d'art* 2 (1927), p. 333, ill.; *Illustrated Catalogue: The Museum of Modern Western Art, Moscow* (Moscow: State Museum of Western Art, 1928), no. 560; Anthony Bertram, *Paul Cézanne, 1839–1906*, World's Masters 6 (London: The Studio, 1929), pl. 3; Louis Réau, *Catalogue de l'art français dans les musées russes*, Publication de la Société de l'Histoire de l'Art Français (Paris: Colin, 1929), no. 742; Joachim Gasquet, *Cézanne* (Berlin: Cassirer, 1930), ill. opp. p. 148; John Becker, "The Museum of Modern Western Painting in Moscow—Part 1," *Creative Art* 10, no. 3 (March 1932), ill. p. 195; ["A Woman Seated," by Cézanne], *Art News* 32, no. 32 (May 12, 1934), p. 3, ill.; Daniel Catton Rich, "The Century of Progress Art Exhibition for 1934," *Studio* (London), November 1934, p. 270, ill; Nina Iavorskaia, *Sezann* [Cézanne] (Moscow: Ogiz-Izogiz, 1935), pl. 31; Lionello Venturi, "Cézanne," *L'Arte* 6 (July 1935), fig. 19; Elie Faure, *Cézanne* (Paris: Braun, 1936), pl. 35; Venturi, *Cézanne* (1936), no. 569, vol. 1, p. 188, vol. 2, pl. 181; *Art News* 34, no. 18 (February 1, 1936), ill. on cover; Pierre Francastel, *L'Impressionisme: Les Origines de la peinture modern de Monet à Gauguin*, Publications de la Faculté des Lettres de Strasbourg 16, ser. 2 (Paris: Librairie "Les Belles Lettres," 1937), fig. 16; Christian Zervos, *Histoire de l'art contemporain*, preface by Henri Laugier (Paris: Editions "Cahiers d'Art," 1938), p. 35, ill.; Alfred M. Frankfurter, "Cézanne: Intimate Exhibition; Twenty-one Paintings Shown for the Benefit of Hope Farm," *Art News* 36, no. 26, section 2 (March 26, 1938), ills. on cover and p. 15; Alfred M. Frankfurter, "383 Masterpieces of Art: The World's Fair Exhibition of Paintings of Four Centuries Loaned from American Public and Private Collections," in "1940 Annual: Art at the Fair," special issue, *Art News* 38, no. 34, section 1 (May 25, 1940), ill. p. 39; Lionello Venturi, "Cézanne, Fighter for Freedom," *Art News* 41, no. 13 (November 15–30, 1942), p. 19, ill.; "Important Cézanne Survey Staged as Benefit for Fighting French," *Art Digest* 17, no. 5 (December 1, 1942), p. 5, ill.; Evelyn Marie Stuart, "Editor's Letters," *Art News* 41, no. 17 (January 15–31, 1943), p. 4; Edward Alden Jewell, *Paul Cézanne*, edited by Aimée Crane (New York: Hyperion, 1944), p. 26, ill.; Edward Alden Jewell with Aimée Crane, *French Impressionists and Their Contemporaries Represented in American Collections* (New York: Hyperion, 1944), p. 135,

ill.; Carlo Ludovico Ragghianti, *Impressionismo*, 1st ed. (Turin: Chiantore, 1944), pl. 45; John Rewald, *The History of Impressionism* (New York: Museum of Modern Art, 1946), p. 413, ill., rev. and enl. ed. (1961) and 4th ed. (1973), p. 561, ill.; Göran Schildt, *Cézanne* (Stockholm: Wahlström & Widstrand, 1946), fig. 24; Carlo Ludovico Ragghianti, *Impressionisme*, translated by A. Chanoux, 2nd ed. (Turin: Chiantore, 1947), pl. XLVIII; Bernard Dorival, *Cézanne* (Paris: Tisné, 1948), pl. 112; C. A., "L'Art modern français dans les collections des musées étrangers: I. Musée d'Art Moderne Occidental à Moscou," *Cahiers d'art* 25, no. 2 (1950), no. 16; Lionello Venturi, *Impressionists and Symbolists: Manet, Degas, Monet, Pissarro, Sisley, Renoir, Cézanne, Seurat, Gauguin, Van Gogh, Toulouse-Lautrec* (New York: Scribner, 1950), fig. 134; Meyer Schapiro, *Paul Cézanne* (New York: Harry N. Abrams, 1952), pp. 82–83, ill.; Winthrop Sargent, "Cézanne: The Great Paintings of a Frustrated Recluse Changed the Whole Course of Modern Art," *Life* 32, no. 8 (February 25, 1952), p. 76, ill.; Theodore Rousseau Jr., *Paul Cézanne, 1839–1906*, Fontana Pocket Library of Great Art A4 (New York: Harry N. Abrams in association with Pocket Books, 1953), pl. 21; Maurice Raynal, *Cézanne: Biographical and Critical Studies*, translated by James Emmons, Taste of Our Time 8 (Geneva: Skira, 1954), p. 87, ill.; Alfred J. Barr Jr., "Paintings from Private Collections," special issue, *Bulletin of the Museum of Modern Art* 22, no. 4 (Summer 1955), p. 11, ill.; Lionello Venturi, *Four Steps toward Modern Art: Giorgione, Caravaggio, Manet, Cézanne*, Bampton Lectures in America 8 (New York: Columbia University Press, 1956), fig. 29; Fritz Erpel, ed., *Paul Cézanne*, Welt der Kunst (Berlin: Henschel, 1958), p. 45, ill.; Peter H. Feist, *Paul Cézanne* (Leipzig: Seemann, 1963), pp. 17, 32, 54, pl. 47; Van Buren, "Madame Cézanne's Fashions" (1966), fig. 12; Charles Sterling and Margaretta M. Salinger, *French Paintings: A Catalogue of the Collection of The Metropolitan Museum of Art*, vol. 3, *XIX–XX Centuries* (Cambridge, Mass.: Harvard University Press, 1967), p. 101, ill.; Richard W. Murphy, *The World of Cézanne, 1839–1906* (New York: Time-Life Books, 1968), pp. 104–5, ill., and ill. on slipcase; Margaretta M. Salinger, "Windows Open to Nature," *The Metropolitan Museum of Art Bulletin* 27, no. 1 (Summer 1968), n.p. [40]; Jack Lindsay, *Cézanne: His Life and Art* (Greenwich, Conn.: New York Graphic Society, 1969), p. 351, fig. 76; Andersen, *Cézanne's Portrait Drawings* (1970), p. 98; Sandra Orienti, *L'opera completa di Cézanne*, Classici dell'Arte 39 (Milan: Rizzoli, 1970), no. 569, p. 112, ill.; Edith A. Standen and Thomas M. Folds, *Masterpieces of Painting in The Metropolitan Museum of Art*, introduction by Claus Virch, exh. cat. (New York: The Metropolitan Museum of Art, 1970), p. 82, ill; Marcel Brion, *Paul Cézanne*, translated by Maria Paola de Benedetti (Milan: Fabbri, 1972), p. 49, ill.; Chappuis, *Drawings of Paul Cézanne* (1973), vol. 1, p. 246, s.v. no. 1068; Schapiro, *Paul Cézanne* (1973), pl. 27; John Rewald, "The Impressionist Brush," *The Metropolitan Museum of Art Bulletin* 32, no. 3 (1973–74), no. 26, pp. 40–41, ill.; René Huyghe with Lydie Huyghe, *La Relève du reel: La Peinture française au XIXe siècle; Impressionisme, symbolisme* (Paris: Flammarion, 1974), p. 435; *The Impressionist Epoch*, text by Carl R. Baldwin (New York: The Metropolitan Museum of Art, 1974), p. 18, ill.; Frank Elgar, *Cézanne* (New York: Praeger Publishers, 1975), fig. 91; Bernard Dunstan, "Notes on Painting from the Model," *American Artist* 39, no. 398 (September 1975), pp. 36–37, ill.; Sidney Geist, "The Secret Life of Paul Cézanne," *Art International* 19, no. 9 (November 20, 1975), ill. p. 14; Alice Bellony-Rewald, *The Lost World of the Impressionists*

(London: Weidenfeld and Nicolson, 1976), p. 227; Vivian Endicott Barnett, *The Guggenheim Museum, Justin K. Thannhauser Collection* (New York: Solomon R. Guggenheim Museum, 1978), p. 33; Bram Dijkstra, ed., *A Recognizable Image: William Carlos Williams on Art and Artists* (New York: New Directions, 1978), ill. opp. p. 204; Lionello Venturi, *Cézanne*, preface by Giulio Carlo Argan (Geneva: Skira, 1978), p. 115, ill.; Joyce E. Brodsky, "Cézanne and the Image of Confrontation," *Gazette des beaux-arts* 92, no. 1316 (September 1978), p. 85; Katharine Baetjer, *European Paintings in The Metropolitan Museum of Art: By Artists Born in or before 1865; A Summary Catalogue* (New York: The Metropolitan Museum of Art, 1980), vol. 1, p. 26, ill. p. 615; Howard Hibbard, *The Metropolitan Museum of Art* (New York: Harper and Row, 1980), fig. 789; Nello Ponente, *Cézanne*, Collana d'Arte Paola Malipiero 9 (Bologna: Capitol, 1980), pl. 17; Robert C[hadwell] Williams, *Russian Art and American Money, 1900–1940* (Cambridge, Mass.: Harvard University Press, 1980), p. 34; Albert E. Elsen, *Purposes of Art: An Introduction to the History and Appreciation of Art*, 4th ed. (New York: Holt, Rinehart, and Winston, 1981), p. 326, fig. 457; Beverly Whitney Kean, *All the Empty Palaces: The Merchant Patrons of Modern Art in Pre-Revolutionary Russia* (London: Barrie and Jenkins, 1983), pp. 116, 124, 322n24; John Rewald, *Paul Cézanne, the Watercolors: A Catalogue Raisonné* (Boston: Little, Brown, 1983), p. 132, s.v. no. 194; *Cézanne au Musée d'Aix* (Aix-en-Provence: Musée Granet, 1984), p. 195, ill.; Charles S. Moffett, *Impressionist and Post-Impressionist Paintings in The Metropolitan Museum of Art* (New York: The Metropolitan Museum of Art; Harry N. Abrams, 1985), pp. 182–83, ill.; John Rewald, *Cézanne: A Biography* (New York: Harry N. Abrams, 1986), p. 277, ill. p. 191; *Modern Europe*, introduction by Gary Tinterow, The Metropolitan Museum of Art 8 (New York: The Metropolitan Museum of Art, 1987), p. 53, pl. 32; Ettore Camesasca, *The São Paulo Collection: From Manet to Matisse*, exh. cat. (Amsterdam: Rijksmuseum Vincent van Gogh; Waanders Publishing; Milan: Mazzotta, 1989), p. 112, ill.; Hajo Düchting, *Paul Cézanne, 1839–1906: Natur wird Kunst*, edited by Ingo F. Walther (Cologne: Benedikt, 1990), p. 155, ill. p. 157; Mary Louise Krumrine with Gottfried Boehm and Christian Geelhaar, *Paul Cézanne: The Bathers*, exh. cat. (Basel: Kunstmuseum Basel, 1990), pp. 290, 302n113; Götz Adriani, *Cézanne: Paintings*, essay by Walter Feilchenfeldt and translated by Russell M. Stockman, exh. cat. (Cologne: DuMont Bucheverlag; New York: Harry N. Abrams, 1993), p. 310n35; Maria Teresa Benedetti, *Cézanne* (Paris: Gründ, 1995), pp. 170, 186–87, ill.; Jean-Jacques Lévêque, *Paul Cézanne: Le Précurseur de la modernité, 1839–1906*, Poche Couleur 13 (Paris: ACR Edition, 1995), p. 115, ill.; Cachin and Rishel, *Cézanne* (1996), p. 272, fig. 2; Linda Nochlin, *Cézanne's Portraits*, Geske Lectures (Lincoln: College of Fine and Performing Arts, University of Nebraska, 1996), p. 19; Rewald, *Paintings of Cézanne* (1996), no. 703, vol. 1, pp. 441–42, vol. 2, ill. p. 241; Görel Cavalli-Björkman [Exhibition Review of "Cézanne i blickpunkten"], *Art Bulletin of Nationalmuseum Stockholm* 4 (1997), pp. 53–54, ill.; Albert Kostenevich, "Ivan: Morozov: The Textile Manufacturer with a Cautious but Sure Taste," in *Henri Matisse: Four Great Collectors*, edited by Kasper Monrad, exh. cat. (Copenhagen: Statens Museum for Kunst, 1999), p. 111; Felix Baumann, Evelyn Benesch, Walter Feilchenfeldt, and Klaus Albrecht Schröder, eds., *Cézanne: Finished—Unfinished*, exh. cat. (Vienna: Kunstforum; Zurich: Kunsthaus Zürich; Ostfildern: Hatje Cantz, 2000), pp. 52–54, 156,

fig. 18; Mary Tompkins Lewis, *Cézanne* (London: Phaidon, 2000), pp. 240–43, 252, fig. 149; Philippe Cros, *Paul Cézanne* (Paris: Terrail, 2002), p. 157, ill. p. 164; Ellen Schwinzer and Alla Chilova, with Petra Mecklenbrauck, eds., *Die russische Avantgarde und Paul Cézanne*, exh. cat. (Hamm: Gustav-Lübcke-Museum; Bönen: Kettler, 2002), pp. 16, 25; Nina Maria Athanassoglou-Kallmyer, *Cézanne and Provence: The Painter in His Culture* (Chicago: University of Chicago Press, 2003), pp. 48–50, fig. 1.37; Tobias G. Natter, *Die Galerie Miethke: Eine Kunsthandlung im Zentrum der Moderne*, exh. cat. (Vienna: Jüdisches Museum der Stadt Wien, 2003), pp. 123–24, 157, ill.; Denis Coutagne, "Les Paysages du Jas de Bouffan," in *Jas de Bouffan, Cézanne* (Aix-en-Provence: Société Paul Cézanne, 2004), p. 138, fig. 124; W. Feilchenfeldt, *By Appointment Only* (2006), pp. 180–81, ill.; Rebecca A. Rabinow, ed., with Douglas W. Druick, Ann Dumas, Gloria Groom, Anne Roquebert, and Gary Tinterow, *Cézanne to Picasso: Ambroise Vollard, Patron of the Avant-Garde*, with contributions by Maryline Assante di Panzillo, Isabelle Cahn, Anne Distel, et al., exh. cat. (New York: The Metropolitan Museum of Art; Chicago: Art Institute of Chicago; Paris: Musée d'Orsay; New Haven: Yale University Press, 2006), pp. 47n88, 253, 255–56, nn46, 54; Gary Tinterow in *Masterpieces of European Painting, 1800–1920, in The Metropolitan Museum of Art* (New York: The Metropolitan Museum of Art; New Haven: Yale University Press, 2007), no. 117, pp. xix, 128, 223–24, ill. p. 223; Butler, *Hidden in the Shadow of the Master* (2008), pp. 94–95, ill.; Rishel and Sachs, *Cézanne and Beyond* (2009), p. 394, fig. 14.14; Sidlauskas, *Cézanne's Other* (2009), pp. 6, 108–9, 135–36, 147, 148, 153, 158, 159, 162, 170, 174, 178, 186–93, 195–98, 265n114, pl. 1; Gail Stavitsky and Katherine Rothkopf, *Cézanne and American Modernism*, exh. cat. (Montclair, N.J.: Montclair Art Museum, 2009), p. 127; Nancy Ireson and Barnaby Wright, eds., *Cézanne's Card Players*, exh. cat. (New York: The Metropolitan Museum of Art; London: Courtauld Gallery in association with Paul Holberton Publishing, 2010), pp. 40, 43, figs. 14, 15; Pavel Machotka, "I ritratti di Cézanne: Il volto umano della grande pittura," in *Cézanne: Les Ateliers du midi*, edited by Rudy Chiappini, exh. cat. (Milan: Skira, 2011), p. 89, fig. 56

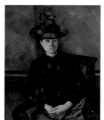

Pl. 26. *Madame Cézanne with Green Hat*, ca. 1891–92
Oil on canvas, 39 1/2 × 32 in. (100.3 × 81.3 cm)
Barnes Foundation, Philadelphia (BF141)

Provenance: [Ambroise Vollard, Paris]; Baron Denys Cochin, Paris; [Ambroise Vollard, Paris]; [Galerie Durand-Ruel, Paris]; Dr. Albert C. Barnes, Merion, Pa.; Barnes Foundation, Philadelphia

Exhibitions: "Exposition Paul Cézanne," Galerie Vollard, Paris, November–December 1895, unnumbered; "Salon d'Automne," Grand Palais des Champs-Elysées, Paris, October 15–November 15, 1904, no. 2; "Exposition d'art moderne," Manzi, Joyant, Paris, June–July 1912, no. 10; "From Cézanne to Matisse: Great French Paintings from the Barnes Foundation," National Gallery of Art, Washington, D.C., and other venues, May 2, 1993–October 22, 1995, unnumbered

References: Julius Meier-Graefe, *Paul Cézanne*, 3rd ed. (Munich: Piper, 1910), p. 47, ill., 4th ed. (1913), p. 45, ill., 5th ed. (1923), p. 53, ill.; Ambroise Vollard, *Paul Cézanne* (Paris: Galerie Vollard, 1914),

pls. 29, 45; Meier-Graefe, *Cézanne und sein Kreis*, 1st and 2nd eds. (1918 and 1920), p. 165, ill., 3rd ed. (1922), p. 198, ill.; Hans von Wedderkop, *Paul Cézanne*, Bibliothek der Junge Kunst 4, Junge Kunst 30 (Leipzig: Klinkhardt & Biermann, 1922), ill. n.p. [13]; Ambroise Vollard, *Paul Cézanne: His Life and Art*, translated by Harold L. Van Doren (New York: Little, Brown, 1923), ill. opp. p. 160; Georges Rivière, *Etudes: Baudelaire, Paul Claudel, André Gide, Rameau, Bach, Franck, Wagner, Moussorgsky, Debussy, Ingres, Cézanne, Gauguin* (Paris: Gallimard, 1925), p. 216; Ikuma Arishima, *Sezannu* [*Cézanne*] (Tokyo: Arusu, Taisho 14, 1926), pl. 13; Kurt Pfister, *Cézanne: Gestalt, Werk, Mythos* (Potsdam: Gustav Kiepenheuer, 1927), fig. 103; Venturi, *Cézanne* (1936), no. 704, vol. 1, pp. 216–17, vol. 2, pl. 230; Albert C[oombs] Barnes and Violette de Mazia, *The Art of Cézanne* (New York: Harcourt, Brace, 1939), no. 103, pp. 230, 548–83, ill.; Van Buren, "Madame Cézanne's Fashions" (1966), fig. 18; James Johnson Sweeney, "The Albert C. Barnes Collection," *Barnes Foundation Journal of the Art Department* (Autumn 1972), p. 33, pl. 9; Rewald, *Cézanne and America* (1989), pp. 268, 343, fig. 124; Rewald, *Paintings of Cézanne* (1996), no. 700, vol. 1, pp. 440–41, vol. 2, ill. p. 240; W. Feilchenfeldt, *By Appointment Only* (2006), p. 239, ill.; Sidlauskas, *Cézanne's Other* (2009), pp. 45–46, 57, 71, 108, pl. 16, fig. 31 (detail)

Pl. 12. *Portrait of a Woman (Madame Cézanne)*, ca. 1895–1900
Oil sketch on canvas, 25½ × 21⅞ in.
(64 × 53 cm)
Collection of Stephen Mazoh

Provenance: [Ambroise Vollard, Paris]; Estate of Ambroise Vollard; private collection; sale, Paris, Galerie Charpentier, June 3, 1954, lot 23, ill.; Justin K. Thannhauser, New York; Mr. and Mrs. Deane Johnson, Los Angeles; Norton Simon Foundation, Los Angeles; sale, New York, Parke-Bernet, May 3, 1973, lot 27, ill.; Michael F. Drinkhouse, New York; sale, New York, Christie's, May 16, 1977, lot 54, ill. (sold); sale, New York, Parke-Bernet, May 17, 1978, lot 18, ill. (sold); Paul Kantor, Los Angeles; sale, New York, Sotheby's, May 15, 1984, lot 41, ill.; Stephen Mazoh

Exhibitions: "Cézanne: Peintures, aquarelles, dessins," Musée des Beaux-Arts, Grenoble, September 15–18, 1953, unnumbered; exhibited, Phoenix Art Museum, 1969–70, unnumbered; exhibited, Los Angeles County Museum of Art, 1970–73, unnumbered; "Twentieth Century Works of Art," Stephen Mazoh, New York, November 1–December 31, 1983, no. 2 (cat., p. 6, ills. p. 7 and on cover); exhibited, Harvard University Art Museums, Cambridge, Mass., 1989–90; "Cézanne: Finished—Unfinished," Kunstforum, Vienna, January 20–April 25, 2000, and Kunsthaus Zürich, May 5–July 30, 2000, no. 33 (cat. edited by Felix Baumann, Evelyn Benesch, Walter Feilchenfeldt, and Klaus Albrecht Schröder, pp. 43–44, 192, ills. pp. 43 [fig. 2], 195)

References: Venturi, *Cézanne* (1936), no. 1611, vol. 1, p. 343, vol. 2, pl. 403; Sandra Orienti, *L'opera completa di Cézanne*, Classici dell'Arte 39 (Milan: Rizzoli, 1970), English ed., introduction by Ian Dunlop, Classics of the World's Great Art (New York: Harry N. Abrams, 1972), French ed., introduction by Gaëtan Picon and translated by Simone Darses (Paris: Flammarion, 1975), no. 597, p. 113, ill.; Nicholas Wadley,

Impressionist and Post-Impressionist Drawing (New York: Penguin, 1991), pp. 74–75, fig. 84; Rewald, *Paintings of Cézanne* (1996), no. 898, vol. 1, pp. 528–29, vol. 2, ill. p. 313; Sidlauskas, *Cézanne's Other* (2009), pp. 204–5, 215, fig. 60

DRAWINGS AND WATERCOLORS

The following sheets represent a selection of portrait studies of Hortense Fiquet.

Pl. 29. *Page of Studies* (recto), 1871–74
Graphite on laid paper, 8¾ × 11¼ in.
(22.2 × 28.5 cm)
Museum of Fine Arts, Budapest (1935-2678)

Provenance: Simon Meller, Budapest; Paul de Majovsky, Budapest; Museum of Fine Arts, Budapest

Exhibition: "Majovsky Collection," Museum of Fine Arts, Budapest, 1935, no. 67

References: Ambroise Vollard, *Paul Cézanne* (Paris: Galerie Vollard, 1914), p. 115; Venturi, *Cézanne* (1936), no. 1221, vol. 1, p. 297, vol. 2, pl. 341; *The Drawings of Cézanne*, introduction by Steven Longstreet, Master Draughtsman Series (Los Angeles: Borden Publishing, 1964), ill.; István Genthon, *Du Romantisme au post-impressionnisme: Tableaux français en Hongrie / Modern francia festmények a Szépmüvészeti múzeumban*, translated by János Győry (Budapest: Corvina Press, 1964), p. 9, ill.; Andersen, *Cézanne's Portrait Drawings* (1970), no. 32, pp. 18–20, 74; Chappuis, *Drawings of Paul Cézanne* (1973), no. 271, vol. 1, p. 107, vol. 2, pl. 271

Pl. 30. *Studies of a Child's Head, a Woman's Head, a Spoon, and a Longcase Clock* (verso), 1873–75
Graphite with touches of black crayon on fine-textured paper, 9⅜ × 12⅜ in.
(23.8 × 31.4 cm)
Ashmolean Museum of Art and Archaeology, Oxford, Bequeathed by Dr. Grete Ring, 1954 (WA1954.70.2)

Note: Fig. 44 is recto of this drawing.

Provenance: Egon Zerner, Berlin (his sale, Berlin, December 15–16, 1924, lot 212, pl. 70); [Galerie Alfred Flechtheim, Berlin]; Dr. Grete Ring, Zurich (?); Ashmolean Museum of Art and Archaeology, Oxford

Exhibitions: "Cézanne, Aquarelle und Zeichnungen; Bronzen von Edgar Degas," Galerie Alfred Flechtheim, Berlin, May 19–June 16, 1927, no. 45; "Seit Cézanne in Paris," Galerie Alfred Flechtheim, Berlin, November 23–December 14, 1929, no. 31; "Paul Cezanne: Water Colours," Paul Cassirer, London, July 1939, no. 1

References: Venturi, *Cézanne* (1936), no. 1222, vol. 1, p. 297, vol. 2, pl. 341; Van Buren, "Madame Cézanne's Fashions" (1966), p. 120; Andersen, *Cézanne's Portrait Drawings* (1970), no. 30, pp. 12, 14, 18, 20, 72; Chappuis, *Drawings of Paul Cézanne* (1973), no. 692, vol. 1, pp. 187–88, vol. 2, pl. 692

Pl. 34. *Page of Studies, Including One of Madame Cézanne*, 1873–76
Graphite on wove paper, 10³/₈ × 7⁷/₈ in. (26.5 × 20 cm)
Private collection, on loan to Staatliche Museen zu Berlin, Nationalgalerie, Museum Berggruen

Provenance: [Paul Cassirer, Berlin]; O. T. Falk, Oxford; [Matthiesen Gallery, London]; [Knoedler Galleries, New York]; Mrs. E. F. Hutton, New York, 1952 [through Fine Arts Associates, New York]; sale, London, Sotheby's, November 24–25, 1964, lot 129; private collection, on loan to Staatliche Museen zu Berlin, Nationalgalerie, Museum Berggruen

Exhibition: "Cézanne: Rarely Shown Works," Fine Arts Associates, New York, November 10–29, 1952, no. 6, ill.

References: Alfred Neumeyer, *Cézanne Drawings* (New York and London: Thomas Yoseloff, 1958), no. 35, ill.; Andersen, *Cézanne's Portrait Drawings* (1970), no. 68, p. 96; Chappuis, *Drawings of Paul Cézanne* (1973), no. 696, vol. 1, p. 188, vol. 2, pl. 696; Rewald, *Paintings of Cézanne* (1996), vol. 1, ill. p. 423

Pl. 36. *Page of Studies*, 1874–75
Graphite on laid paper, 9³/₈ × 12¹/₄ in. (23.8 × 31 cm)
Museum Boijmans Van Beuningen, Rotterdam (F II 118r [PK])

Provenance: [Paul Cassirer, Berlin]; F. Koenigs, Haarlem; Museum Boijmans Van Beuningen, Rotterdam

References: Venturi, *Cézanne* (1936), no. 1217, vol. 1, p. 296, vol. 2, pl. 340; Gertrude Berthold, *Cézanne und die alten Meister: Die Bedeutung der Zeichnungen Cézannes nach Werken anderer Künstler; Katalog der Zeichnungen* (Stuttgart: W. Kohlhammer, 1958), no. 258, ill.; Alfred Neumeyer, *Cézanne Drawings* (New York and London: Thomas Yoseloff, 1958), no. 14; *The Drawings of Cézanne*, introduction by Steven Longstreet, Master Draughtsman Series (Los Angeles: Borden Publishing, 1964), ill.; Hendrik Richard Hoetink, ed., *Franse tekeningen uit de 19e eeuw: Catalogus van de verzameling in het Museum Boymans-van Beuningen* (Rotterdam: Museum Boijmans Van Beuningen, 1968), no. 19, ill.; Andersen, *Cézanne's Portrait Drawings* (1970), no. 34, pp. 19, 76; Chappuis, *Drawings of Paul Cézanne* (1973), no. 354, vol. 1, pp. 122–23, vol. 2, pl. 354

Pl. 35. *Madame Cézanne, Milk Can*, 1877–80
Graphite on gray-brown laid paper, 9 × 5⁷/₈ in. (23 × 15 cm)
Prat Collection, Paris

Provenance: Kenneth Clark, London; Colin Clark, London; sale, New York, Christie's, May 9, 1991 (sale 7290), lot 106; Prat Collection, Paris

Exhibitions: "Dessins français de la collection Prat: XVIIe–XVIIIe–XIXe siècles," Musée du Louvre, Paris, April 26–July 24, 1995, National Gallery of Scotland, Edinburgh, August 17–October 1, 1995, and Ashmolean Museum, Oxford, October 15–December 15, 1995, no. 97 (cat. by Pierre Rosenberg, pp. 228–29, ill.); "David to Cézanne: Master Drawings from the Prat Collection," Art Gallery of New South Wales, Sydney, September 22–December 5, 2010, no. 96 (cat. edited by Peter Raissis, pp. 206–7, ill. p. 182)

References: Venturi, *Cézanne* (1936), no. 1481, vol. 1, p. 325, vol. 2, pl. 379; Fritz Novotny, *Paul Cézanne* (Vienna: Phaidon Press, 1937), fig. 121; Andersen, *Cézanne's Portrait Drawings* (1970), no. 46, p. 85; Chappuis, *Drawings of Paul Cézanne* (1973), no. 717, vol. 1, p. 191, vol. 2, pl. 717

Pl. 33. *Portrait of Madame Cézanne*, ca. 1877–80
Graphite on wove paper, 7¹/₈ × 7¹/₂ in. (18.2 × 19.2 cm)
Museum of Modern Art, New York, The William S. Paley Collection (SPC 8.90)

Provenance: Kenneth Clark, London; [Wildenstein Galleries, New York]; William S. Paley, New York; Museum of Modern Art, New York

Exhibitions: "The William S. Paley Collection," Museum of Modern Art, New York, February 2–May 7, 1992, no. 11 (cat. by William Rubin and Matthew Armstrong, pp. 20, 148–49, ills. pp. 21, 149); "The William S. Paley Collection," Portland Museum of Art, Maine, May 2, 2013–February 23, 2014, Musée National des Beaux Arts du Québec, Quebec City, October 10, 2013–January 5, 2014, and Crystal Bridges Museum of American Art, Bentonville, Ark., March 13–July 7, 2014, no. 11 (cat. by William Rubin and Matthew Armstrong, pp. 18, 20, ill. p. 21)

Pl. 39. *Page of Studies, Including Madame Cézanne Sewing* (recto), 1877–80
Graphite (conté crayon?) on wove paper, 7⁷/₈ × 9¹/₄ in. (20 × 23.5 cm)
Collection of Jasper Johns

Provenance: Kenneth Clark, London; [Wildenstein, New York, 1961]; Benjamin Sonnenberg, New York; sale, New York, Sotheby's, June 9, 1979, lot 1430; private collection; sale, London, Christie's, "Impressionist / Modern: Works on Paper," February 5, 2009 (sale 7703), lot 117; Jasper Johns, Connecticut

Exhibitions: "Paul Cézanne, 1839–1906," Österreichische Galerie im Oberen Belvedere, Vienna, April 14–June 18, 1961, no. 104 (cat., p. 37); "Artists and Writers: Nineteenth and Twentieth Century Portrait Drawings from the Collection of Benjamin Sonnenberg," Pierpont Morgan Library, New York, May 13–July 30, 1971, no. 17 (cat. by Felice Stampfle and Cara Dufour, p. 24, pl. 17)

References: Venturi, *Cézanne* (1936), no. 1240, vol. 1, p. 300, vol. 2, pl. 343; Van Buren, "Madame Cézanne's Fashions" (1966), pp. 115ff., n20; Mahonri Sharp Young, "Treasures in Gramercy Park," *Apollo* 85, no. 61 (March 1967), p. 181, fig. 31; Wayne Andersen, "Cézanne, Tanguy, Chocquet," *Art Bulletin* 39, no. 2 (June 1967), p. 137, fig. 7;

Andersen, *Cézanne's Portrait Drawings* (1970), no. 33, pp. 19, 20, 75; Chappuis, *Drawings of Paul Cézanne* (1973), no. 398, vol. 1, p. 131, vol. 2, pl. 398; Lionello Venturi, *Cézanne* (New York: Rizzoli, 1978), no. 4, p. 78

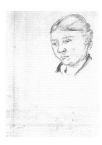

Pl. 38. *Head of Madame Cézanne*, ca. 1880
Graphite on laid paper, 6³/₄ × 4³/₄ in.
(17.2 × 12 cm)
Collection of Jasper Johns

Provenance: [Ambroise Vollard, Paris]; John Rewald, New York; sale, London, Sotheby's, July 7, 1960, lot 15; Heinz Berggruen, Paris; sale, New York, Sotheby's, May 13, 1992, lot 27; sale, New York, Christie's, May 13, 1999 (sale 9166), lot 305; Jasper Johns, Connecticut

Exhibitions: "Nineteenth Century Influences in French Drawing," Guild Hall, East Hampton, N.Y., August–September 1952, no. 27; "Cézanne: Rarely Shown Works," Fine Arts Associates, New York, November 10–29, 1952, no. 5, ill.; "Paul Cézanne, 1839–1906," Gemeentemuseum, The Hague, June–July 1956, no. 118, ill., Kunsthaus Zürich, August 22–October 7, 1956, no. 73, and Haus der Kunst, Munich, October–November 1956, no. 137; "Paul Cézanne," Pavillon Vendôme, Aix-en-Provence, July–August 1956, no. 89; "The Collection of Mr. and Mrs. John Rewald," Los Angeles Municipal Art Gallery, March 31–April 19, 1959, no. 137; "Cézanne," Wildenstein, New York, November 5–December 5, 1959, no. 65; "Wegbereiter der modernen Malerei: Cézanne, Gauguin, Van Gogh, Seurat," Kunstverein, Hamburg, May 4–July 14, 1963, no. 28 (cat., fig. 77); "Sezannu ten / Exposition Cézanne," National Museum of Western Art, Tokyo, March 30–May 19, 1974, Museum of the City of Kyoto, June 1–July 17, 1974, and Cultural Center of Fukuoka, July 24–August 18, 1974, no. 102, ill.; "Paul Cézanne: Zeichnungen," Kunsthalle Tübingen, October 21–December 31, 1978, no. 65

References: Venturi, *Cézanne* (1936), "Oeuvres Inédites," vol. 1, p. 350, s.v. Collection Ambroise Vollard, Paris; Theodore Reff, "A New Exhibition of Cézanne," *Burlington Magazine* 102, no. 684 (March 1960), p. 117; Peter H. Feist, *Paul Cézanne* (Leipzig: Seemann, 1963), no. 1, p. 13; Jiří Siblík, *Paul Cézanne: Kresby*, Mistři Světové Kresby 9 (Prague: Odeon, 1969), p. 20; Andersen, *Cézanne's Portrait Drawings* (1970), no. 89 fac., pp. 40, 110; Chappuis, *Drawings of Paul Cézanne* (1973), no. 736, vol. 1, p. 195, vol. 2, pl. 736; Lionello Venturi, *Cézanne* (New York: Rizzoli, 1978), no. 10, p. 81; Rewald, *Paintings of Cézanne* (1996), vol. 1, p. 362

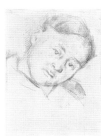

Pl. 47. *Head of Madame Cézanne* (recto), ca. 1880
Graphite on laid paper, 5³/₈ × 4 in. (13.5 × 10 cm)
Collection of Ralph Fassey

Provenance: W. Feuz, Bern; sale, London, Sotheby's, April 2, 1974, lot 10; Antonio Santamarina, Buenos Aires; [Lawrence O'Hana Gallery, London]; sale, New York, Sotheby's, May 21, 1975, lot 4; sale, London, Sotheby's, April 5, 1978, lot 107; private collection; [Katrin Bellinger, London]; Ralph Fassey, Milan

References: Venturi, *Cézanne* (1936), no. 1246, vol. 1, p. 301, vol. 2, pl. 344; Andersen, *Cézanne's Portrait Drawings* (1970), no. 57, p. 91; Chappuis, *Drawings of Paul Cézanne* (1973), no. 718, vol. 1, p. 191, vol. 2, pl. 718; Rewald, *Paintings of Cézanne* (1996), vol. 1, p. 171, s.v. no. 242

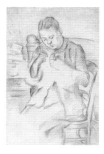

Pl. 44. *Madame Cézanne Sewing*, ca. 1880
Graphite on laid paper, 18⁵/₈ × 12¹/₈ in.
(47.2 × 30.9 cm)
Courtauld Institute of Art, London,
Bequest of Count Antoine Seilern, 1978
(D.1978.PG.239)

Provenance: [Ambroise Vollard, Paris]; Simon Meller, Munich; [Paul Cassirer, Berlin]; H. von Simolin, Berlin; [Paul Cassirer, Amsterdam]; Courtauld Gallery, London

Exhibitions: "Teekeningen van Ingres tot Seurat," Museum Boijmans, Rotterdam, December 20, 1933–January 21, 1934, no. 5 (cat., p. 34); "Fransche Meesters uit de XIXe eeuw: Teekeningen, aquarellen, pastels van Ingres, Géricault, Corot, Delacroix, Guys, Daumier, Rousseau, Millet, Manet, Pissarro, Degas, Cézanne, Renoir, Sisley, Toulouse-Lautrec," Paul Cassirer, Amsterdam, July–August 1938, no. 20, ill.; "Société des Artistes Independants: Centenaire du peintre indépendant Paul Cézanne, 1839–1906," Grand Palais, Paris, March 17–April 10, 1939, no. 44; "Paul Cezanne: Water Colours," Paul Cassirer, London, July 1939, no. 2; "Watercolour and Pencil Drawings by Cézanne," Laing Art Gallery, Newcastle upon Tyne, September 19–November 4, 1973, and Hayward Gallery, London, November 13–December 1973, no. 66; "The Princes Gate Collection," Courtauld Institute Galleries, London, opened July 14, 1981, no. 133; "Mantegna to Cézanne: Master Drawings from the Courtauld; A Fiftieth Anniversary Celebration," British Museum, London, 1983, no. 99, ill.; "Impressionist, Post-Impressionist and Related Drawings from the Courtauld Collections," Courtauld Institute Galleries, London, May 11–September 4, 1988, no. 5; "The Courtauld Cézannes," Courtauld Gallery, Somerset House, London, June 26–October 5, 2008, no. 11 (cat. edited by Stephanie Buck, John House, Ernst Vegelin van Claerbergen, and Barnaby Wright, pp. 110, 112–13, 171–72); "Master Drawings from the Courtauld Gallery," Courtauld Gallery, London, June 14–September 9, 2012, and Frick Collection, New York, October 2, 2012–January 27, 2013, no. 52 (cat. edited by Colin B. Bailey and Stephanie Buck, pp. 28, 233–34, ill. p. 235)

References: Ambroise Vollard, *Paul Cézanne* (Paris: Galerie Vollard, 1914), p. 177, ill. on frontispiece; Meier-Graefe, *Cézanne und sein Kreis*, 3rd ed. (1922), p. 37; Venturi, *Cézanne* (1936), no. 1466, vol. 1, p. 323, vol. 2, pl. 376; Count Antoine Seilern, *Paintings and Drawings of Continental Schools Other Than Flemish and Italian at 56 Princes Gate London, SW7* (London: Shenval Press, 1961), p. 105; Andersen, *Cézanne's Portrait Drawings* (1970), no. 67, p. 96; Chappuis, *Drawings of Paul Cézanne* (1973), no. 729, vol. 1, p. 193, vol. 2, pl. 729; Lionello Venturi, *Cézanne*, with a preface by Giulio Carlo Argan (Geneva: Skira, 1978), p. 76

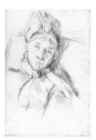

Pl. 37. *Portrait of Madame Cézanne*, ca. 1881–88
Graphite on laid paper, 19⅛ × 12⅝ in.
(48.5 × 32.2 cm)
Museum Boijmans Van Beuningen,
Rotterdam, Gift of D. G. van Beuningen, 1940
(F II 220 [PK])

Provenance: [Ambroise Vollard, Paris]; Simon
Meller, Budapest; [Paul Cassirer, Amsterdam];
F. Koenigs, Haarlem; Museum Boijmans
Van Beuningen, Rotterdam

Exhibitions: "Teekeningen van Ingres tot Seurat," Museum
Boijmans, Rotterdam, December 20, 1933–January 21, 1934, no. 6;
"Fransche Impressionisten," Frans Halsmuseum, Haarlem,
January 10–31, 1935, no. 33; "Meister-zeichnungen französischer
Künstler von Ingres bis Cézanne," Kunsthalle Basel, June 29–
August 18, 1935, no. 179; "Paul Cézanne," Kunsthalle Basel,
August 30–October 12, 1936, no. 136; "Fransche Meesters uit de
XIXe eeuw: Teekeningen, aquarellen, pastels van Ingres, Géricault,
Corot, Delacroix, Guys, Daumier, Rousseau, Millet, Manet, Pissarro,
Degas, Cézanne, Renoir, Sisley, Toulouse-Lautrec," Paul Cassirer,
Amsterdam, July–August 1938, no. 21; "Teekeningen van Fransche
meesters, 1800–1900," Stedelijk Museum, Amsterdam, February–
March 1946, no. 14; "Le Dessin français de Fouquet à Cézanne,"
Palais des Beaux-Arts, Brussels, November–December 1949, Museum
Boijmans, Rotterdam, December 25, 1949–February 6, 1950, Musée
d'Orangerie, Paris, February–March 1950, no. 206 (cat., pl. 91);
"Cézanne: Paintings, Watercolors, and Drawings," Art Institute of
Chicago, February 7–March 16, 1952, and The Metropolitan Museum
of Art, New York, April 4–May 18, 1952, no. 45, ill.; "Dessins du XVe
au XIXe siècle du Musée Boymans de Rotterdam," Bibliothèque
Nationale, Paris, February 20–April 20, 1952, no. 141 (cat. by Egbert
Haverkamp Begemann, p. 65); "French Drawings: Masterpieces from
Five Centuries," National Gallery of Art, Washington, D.C., and other
venues, November 2, 1952–April 19, 1953, no. 45; "French Drawings:
Masterpieces from Seven Centuries," Art Institute of Chicago, and
other venues, 1955–56, no. 156 (cat. by Roseline Bacou and Maurice
Sérullaz, edited by Jacqueline Bouchot-Saupique, p. 60, pl. 40); "Paul
Cézanne, 1839–1906," Österreichische Galerie im Oberen Belvedere,
Vienna, April 14–June 18, 1961, no. 97 (cat., p. 36, fig. 50); "Cézanne:
Tableaux, aquarelles, dessins," Pavillon Vendôme, Aix-en-Provence,
July 1–August 15, 1961, no. 97; "Le Dessin français de Claude à
Cézanne dans les collections hollandaises," Institut Néerlandais,
Paris, May 4–June 14, 1964, and Rijksmuseum, Prentenkabinet,
Amsterdam, June 25–August 16, 1964, no. 202; "Cézanne: An
Exhibition in Honor of the Fiftieth Anniversary of the Phillips
Collection," Phillips Collection, Washington, D.C., February 27–
March 28, 1971, Art Institute of Chicago, April 17–May 16, 1971, and
Museum of Fine Arts, Boston, June 1–July 3, 1971, no. 77; "Cézanne,"
Galeries Nationales du Grand Palais, Paris, September 25, 1995–
January 7, 1996, Tate Gallery, London, February 8–April 28, 1996, and
Philadelphia Museum of Art, May 26–August 18, 1996, no. 112 (cat.,
Cachin and Rishel, *Cézanne*, p. 293, ill.)

References: Venturi, *Cézanne* (1936), no. 1467, vol. 1, p. 323, vol. 2,
pl. 376; *Les Maîtres du dessin français: De Fouquet à Cézanne*, with a
preface by Jacqueline Bouchot-Saupique, Art et Style 14 (Paris: Art

et Style, 1950), ill. n.p. [pl. section, 56]; François Daulte, *Le Dessin
français de Manet à Cézanne*, Bibliothèque des Arts 3 (Lausanne: Spes,
1954), fig. 44; Alfred Neumeyer, *Cézanne Drawings* (New York and
London: Thomas Yoseloff, 1958), no. 37; Raymond Cogniat, *Le Siècle
des impressionistes* (Paris: Flammarion, 1959), p. 81; *The Drawings of
Cézanne*, introduction by Steven Longstreet, Master Draughtsman
Series (Los Angeles: Borden Publishing, 1964), ill.; *Cézanne*, Génies
et Réalités 26 (Paris: Hachette, 1966), p. 18, ill.; Van Buren, "Madame
Cézanne's Fashions" (1966), p. 118; Hendrik Richard Hoetink, ed.,
*Franse tekeningen uit de 19e eeuw: Catalogus van de verzameling in het
Museum Boymans-van Beuningen* (Rotterdam: Museum Boijmans
Van Beuningen, 1968), no. 34; Jean Leymarie, *Dessins de la période
impressionniste de Manet à Renoir* (Geneva: Skira, 1969), p. 87, ill.;
Andersen, *Cézanne's Portrait Drawings* (1970), no. 69, pp. 32, 40, 97;
Chappuis, *Drawings of Paul Cézanne* (1973), no. 1065, vol. 1, pp. 245–46,
vol. 2, pl. 1065; Hajo Düchting, *Paul Cézanne, 1839–1906: Natur wird
Kunst*, edited by Ingo F. Walther (Cologne: Benedikt, 1990), ill. p. 137;
Sidlauskas, *Cézanne's Other* (2009), p. 166, fig. 50

Pl. 43. *Bust of Madame Cézanne* (verso),
1884–85
Graphite on wove paper, 8⅝ × 4⅞ in.
(21.8 × 12.5 cm)
National Gallery of Art, Washington, D.C.,
Collection of Mr. and Mrs. Paul Mellon
(1985.64.83.b)

Provenance: Paul Cézanne *fils*, Paris; Paul
Guillaume, Paris; Adrien Chappuis, Tresserve;
private collection, Paris; Mr. and Mrs. Paul
Mellon, New York; National Gallery of Art,
Washington, D.C.

References: Venturi, *Cézanne* (1936), vol. 1, p. 307, s.v. no. 1290, as
"Deux têtes, l'une est celle de Paul Cézanne *fils*"; Adrien Chappuis,
Dessins de Paul Cézanne, XXe Siècle (Paris: Editions des Chroniques
du Jour, 1938), no. 24, as "Tête de femme. Orange," ill.; Chappuis,
Drawings of Paul Cézanne (1973), no. 840, vol. 1, pp. 208–9, vol. 2, pl. 840

Pl. 45. *Madame Cézanne*, 1884–87
Graphite on wove paper, 7⅝ × 4¾ in.
(19.4 × 11.8 cm)
Collection of Isabel Stainow Wilcox

Provenance: Paul Cézanne *fils*, Paris; Paul
Guillaume, Paris; Adrien Chappuis, Tresserve;
sale, London, Christie's, "Exceptional Works
on Paper by Paul Cézanne from the Chappuis-
Barut Collection," June 26, 2003 (sale 6737),
lot 317; Isabel Stainow Wilcox

Exhibitions: "Cézanne," Musée de l'Orangerie,
Paris, May–October 1936, no. 162; "Paul Cézanne: Exhibitions of
Paintings, Water-Colors, Drawings, and Prints," San Francisco
Museum of Art, September 1–October 4, 1937, no. 60; "Homage to
Paul Cézanne, 1839–1906," Wildenstein, London, July 1939, no. 84;
"Cézanne: Tableaux, aquarelles, dessins," Pavillon Vendôme,
Aix-en-Provence, July 1–August 15, 1961, no. 59; "Sezannu ten /

Exposition Cézanne," National Museum of Western Art, Tokyo, March 30–May 19, 1974, Museum of the City of Kyoto, June 1–July 17, 1974, and Cultural Center of Fukuoka, July 24–August 18, 1974, no. 106

References: Venturi, *Cézanne* (1936), no. 1280, vol. 1, p. 306, XLVII (verso), vol. 2, pl. 349; Gertrude Berthold, *Cézanne und die alten Meister: Die Bedeutung der Zeichnungen Cézannes nach Werken anderer Künstler; Katalog der Zeichnungen* (Stuttgart: W. Kohlhammer, 1958), no. 59, pl. 115; Andersen, *Cézanne's Portrait Drawings* (1970), no. 74, pp. 40, 99; Chappuis, *Drawings of Paul Cézanne* (1973), no. 665, vol. 2, pp. 180–81, vol. 2, pl. 665

Pl. 42. *Madame Cézanne with Hortensias*, 1885
Graphite and watercolor on paper, 12 × 18⅛ in. (30.5 × 46 cm)
Private collection

Provenance: Paul Cézanne *fils*, Paris; [Galerie Bernheim-Jeune, Paris]; Charles Viguier, Paris; Charles Gillet, Lyon; Heinz Berggruen, Paris; private collection

Exhibitions: "Twenty Watercolors by Cézanne," Little Galleries of the Photo-Secession (291), New York, 1911, no. 19; "Cézanne," Montross Gallery, New York, January 1–31, 1916, no. 17; "Ingres to Picasso," Graphisches Kabinett, Munich, March 1–25, 1929, no. 13, and I. B. Neumann Gallery, Summer 1929, no. 13; "Sezannu ten / Exposition Cézanne," National Museum of Western Art, Tokyo, March 30–May 19, 1974, Museum of the City of Kyoto, June 1–July 17, 1974, and Cultural Center of Fukuoka, July 24–August 18, 1974, no. 68, ill.; "Paul Cézanne: Zeichnungen," Kunsthalle Tübingen, October 21–December 31, 1978, no. 51 (cat. by Götz Adriani, pp. 146–47, ill.); "Paul Cézanne, Aquarelle," Kunsthalle Tübingen, January 16–March 21, 1982, and Kunsthaus Zürich, April 2–May 3, 1982, no. 85, ill.; "Cézanne," Galeries Nationales du Grand Palais, Paris, September 25, 1995–January 7, 1996, Tate Gallery, London, February 8–April 28, 1996, and Philadelphia Museum of Art, May 26–August 18, 1996, no. 101 (cat., Cachin and Rishel, *Cézanne*, pp. 274–75, ill.); "Cézanne: Finished—Unfinished," Kunstforum, Vienna, January 20–April 25, 2000, and Kunsthaus Zürich, May 5–July 30, 2000, no. 8 (cat. edited by Felix Baumann, Evelyn Benesch, Walter Feilchenfeldt, and Klaus Albrecht Schröder, p. 145, ill. p. 146; Sidlauskas, *Cézanne's Other* (2009), pp. 169–70, 193, 203–4, 266n133, pl. 17

References: Joseph Edgar Chamberlin, "Cézanne Embryos," *New York Evening Mail*, March 8, 1911, p. 9; Willard Huntington Wright, "Paul Cézanne," *International Studio* 57 (February 1916), p. cxxx; Jules Borély, "Cézanne à Aix," *L'Art vivant* 2, no. 37 (July 1926), p. 492, ill.; Venturi, *Cézanne* (1936), no. 1100, vol. 1, p. 277, vol. 2, pl. 317; Andersen, *Cézanne's Portrait Drawings* (1970), no. 66, p. 95; Chappuis, *Drawings of Paul Cézanne* (1973), vol. 1, p. 178, s.v. no. 648; Sidney Geist, "What Makes the Black Clock Run?" *Art International* 22, no. 2 (1978), p. 10, ill.; Götz Adriani, *Cézanne Watercolors*, translated by Russell M. Stockman (New York: Harry N. Abrams, 1983), no. 85, ill., pp. 279–80; John Rewald, *Paul Cézanne, the Watercolors: A Catalogue Raisonné* (Boston: Little, Brown, 1983), no. 209, ill., p. 135; Carol Armstrong, *Cézanne in the Studio: Still Life in Watercolors*, exh. cat. (Los Angeles:

J. Paul Getty Museum, 2004), p. 30, fig. 13; W. Feilchenfeldt, *By Appointment Only* (2006), pp. 227–28, ill.

NOT IN EXHIBITION

Pl. 48. *Portrait of Madame Cézanne*, ca. 1890
Graphite and watercolor on paper, 10¾ × 8¼ in. (27.3 × 21 cm)
Private collection, on loan to Staatliche Museen zu Berlin, Nationalgalerie, Museum Berggruen

Note: Originally part of sketchbook Chappuis IV, p. XXVII

Provenance: Paul Cézanne *fils*, Paris; Paul Guillaume, Paris; Adrien Chappuis, Tresserve; sale, London, Christie's, "Exceptional Works on Paper by Paul Cézanne from the Chappuis-Barut Collection," June 26, 2003 (sale 6737), lot 335; private collection, Paris; private collection, on loan to Berggruen Collection, Zurich

Exhibitions: "Cézanne," Musée de l'Orangerie, Paris, May–October 1936, no. 166*bis*; "Paul Cézanne: Exhibitions of Paintings, Water-Colors, Drawings, and Prints," San Francisco Museum of Art, September 1–October 4, 1937, no. 70; "Cézanne: Tableaux, aquarelles, dessins," Pavillon Vendôme, Aix-en-Provence, July 1–August 15, 1961, no. 51

References: Venturi, *Cézanne* (1936), no. 1316, vol. 1, p. 312, XXVII; Adrien Chappuis, *Dessins de Paul Cézanne, XXe Siècle* (Paris: Editions des Chroniques du Jour, 1938), no. 44; Alfred Neumeyer, *Cézanne Drawings* (New York and London: Thomas Yoseloff, 1958), no. 59; *Cézanne, Génies et Réalités* 26 (Paris: Hachette, 1966), p. 205, fig. 145; Andersen, *Cézanne's Portrait Drawings* (1970), no. 88, p. 109; John Rewald, *Paul Cézanne: The Watercolours: A Catalogue Raisonné* (London: Thames and Hudson, 1983), no. 384, ill., pp. 178–79

Pl. 41. *Madame Cézanne, Study of a Tree*, 1897–1900
Graphite and watercolor on wove paper, 12¼ × 18½ in. (31.2 × 47 cm)
Collection of Georges Pébereau

Provenance: Simon Meller, Budapest; Arthur Hahnloser, Winterthur; Hans R. Hahnloser, Bern; sale, New York, Christie's, November 7, 2002 (sale 1148), lot 113; Georges Pébereau

Exhibitions: "Die Hauptwerke der Sammlung Hahnloser, Winterthur," Kunstmuseum, Lucerne, 1940, no. 164; "Cézanne: Finished—Unfinished," Kunstforum, Vienna, January 20–April 25, 2000, and Kunsthaus Zürich, May 5–July 30, 2000, no. 9 (cat. edited by Felix Baumann, Evelyn Benesch, Walter Feilchenfeldt, and Klaus Albrecht Schröder, p. 145, ill. p. 147); "Cézanne: Il padre dei moderni," Complesso del Vittoriano, Rome, March 7–July 7, 2002, unnumbered (cat. edited by Maria T. Benedetti, pp. 206–7, ill.)

Reference: Chappuis, *Drawings of Paul Cézanne* (1973), no. 1188, vol. 1, p. 267, vol. 2, pl. 1188

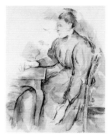

Pl. 49. *Seated Woman (Madame Cézanne)*, ca. 1902–4
Graphite and watercolor on wove paper, 19½ × 14⅝ in. (48 × 36 cm)
Judy and Michael Steinhardt Collection, New York

Provenance: [Ambroise Vollard, Paris]; Adams Brothers, London; private collection, London; [Paul Rosenberg, New York]; Robert von Hirsch, Basel; sale, London, Sotheby's, June 26–27, 1978, lot 838; private collection, Paris; Collection of Jan and Marie-Ann Krugier-Poniatowski; [Galerie Krugier, Geneva and New York]; sale, London, Sotheby's, "Impressionist, Modernist and Surrealist Art Evening Sale," February 5, 2014, lot 11; Judy and Michael Steinhardt Collection, New York

Exhibitions: "Paul Cézanne: An Exhibition of Watercolours," Tate Gallery, London, March–April 1946, Leicester Museum and Art Gallery, May 18–June 8, 1946, and Graves Art Gallery, Sheffield, June 15–July 6, 1946, no. 25; "Paul Cézanne, Aquarelle," Kunsthalle Tübingen, January 16–March 21, 1982, and Kunsthaus Zürich, April 2–May 3, 1982, no. 101 (cat. by Götz Adriani [1981], p. 17); "Galerie Jan Krugier: Dix ans d'activité," Galerie Jan Krugier, Geneva, 1983, no. 17, ill.; "L'Oeuvre ultime de Cézanne à Dubuffet," Fondation Maeght, Saint-Paul-de-Vence, July 4–October 4, 1989, no. 6 (cat. by Jean-Louis Prat, pp. 30–31); "Cézanne," Galeries Nationales du Grand Palais, Paris, September 25, 1995–January 7, 1996, Tate Gallery, London, February 8–April 28, 1996, and Philadelphia Museum of Art, May 26–August 18, 1996, no. 169 (cat., Cachin and Rishel, *Cézanne*, pp. 404–5); "The Timeless Eye: Master Drawings from the Jan and Marie-Anne Krugier-Poniatowski Collection / Miradas sin tiempo: Dibujos, pinturas y esculturas de la colección Jan y Marie-Anne Krugier-Poniatowski," Kupferstichkabinett, Staatliche Museen zu Berlin, Preussischer Kulturbesitz, Berlin, May 29–August 1, 1999, Peggy Guggenheim Collection, Venice, Solomon R. Guggenheim Foundation, September 4–December 12, 1999, Museo Thyssen-Bornemisza, Madrid, February–May 2000, and Musée de l'Art et d'Histoire, Geneva, Summer 2000, no. 141 (cat. edited by Chiara Barbieri, pp. 296–97, ill.); "La Passion du dessin: Collection Jan et Marie-Anne Krugier-Poniatowski," Musée Jacquemart-André, Institut de France, Paris, March 19–June 30, 2002, no. 124, ill.; "Cézanne in the Studio: Still Life in Watercolors," J. Paul Getty Museum, Los Angeles, October 12, 2004–January 2, 2005, no. 36 (cat. by Carol Armstrong, pp. 89–90, fig. 36); "Goya bis Picasso: Meisterwerke der Sammlung Jan Krugier und Marie-Anne Krugier-Poniatowski," Albertina, Vienna, April 8–August 28, 2005, no. 95, ill.; "Das ewige Auge, von Rembrandt bis Picasso: Meisterwerke aus der Sammlung Jan Krugier und Marie-Anne Krugier-Poniatowski," Kunsthalle der Hypo-Kulturstiftung, Munich, July 20–October 7, 2007, no. 125, ill.

References: Ambroise Vollard, *Paul Cézanne* (Paris: Galerie Vollard, 1914), p. 125, ill.; Venturi, *Cézanne* (1936), no. 1093, vol. 1, p. 276, vol. 2, pl. 316; Kurt Badt, *Die Kunst Cézannes* (Munich: Prestel-Verlag, 1956), p. 25; William Rubin, ed., *Cézanne: The Late Work*, with essays by Theodore Reff et al. (New York: Museum of Modern Art, 1977), p. 229,

pl. 21; John Rewald, *Paul Cézanne, the Watercolors: A Catalogue Raisonné* (Boston: Little, Brown, 1983), no. 543, p. 221, pl. 543; Felix Baumann, Evelyn Benesch, Walter Feilchenfeldt, and Klaus Albrecht Schröder, eds., *Cézanne: Finished—Unfinished*, exh. cat. (Vienna: Kunstforum Wien; Zurich: Kunsthaus Zürich; Ostfildern, Germany: Hatje Cantz, 2000), p. 192, ill.; Sidlauskas, *Cezanne's Other* (2009), pp. 201, 203–5, 208, 211, fig. 59

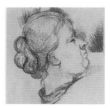

Pl. 46. Detail, *Portrait of Madame Cézanne* (verso)
Graphite on wove paper, overall 13 × 18½ in. (33 × 47 cm)
Private collection, New York

Provenance: Ambroise Vollard, Paris; Leo and Gertrude Stein, Paris; [Galerie Thannhauser, Lucerne]; Dr. and Mrs. F. H. Hirschland, New York; [Wildenstein Galleries, New York]; private collection, New York

References: Janet Bishop, Cécile Debray, and Rebecca Rabinow, eds., *The Steins Collect: Matisse, Picasso, and the Parisian Avant-Garde*, exh. cat. (San Francisco: San Francisco Museum of Modern Art; New Haven: Yale University Press, 2011), p. 397n1, s.v. no. 15

SKETCHBOOKS

Of the estimated eighteen sketchbooks in the hand of Paul Cézanne, seven are intact. Drawings of Hortense Fiquet from a selection of three sketchbooks are documented here.

Sketchbook No. 2 (L'Estaque), 1875–86
Graphite and pen and ink drawings on wove paper; cover and pencil holder: bound unbleached linen, linen tape
50 leaves, 100 pages total; book: 5 × 8¾ in. (12.4 × 21.7 cm)
Art Institute of Chicago, Arthur Heun Purchase Fund, 1951 (1951.1)

Notes: Roman numeral (I–L) on one side of each leaf (by former owner); "A.I.C." on p. L (verso)

Provenance: Paul Cézanne *fils*, Paris; Maurice Renou, Paris; Jean Poyet Collection, Lyons; Maurice Renou, Paris; Sam Salz, New York; Art Institute of Chicago

References: John Rewald, *Paul Cézanne: Carnets de dessins* (Paris: Quatre Chemins–Editart, 1951), vol. 1, pp. 30–37, vol. 2, pls. 1–4, 6, 10, 11, 16–20, 24–27, 29, 38, 42, 54–56, 58, 59, 62–67, 72, 73, 80, 84, 85, 87, 90, 91, 99–103, 142, 154, 156–60; Carl O. Schniewind, *Paul Cézanne Sketch Book: Owned by the Art Institute of Chicago* (New York: Curt Valentin, 1951); Wayne Andersen, "Cézanne's Sketchbook in the Art Institute of Chicago," *Burlington Magazine* 104, no. 710 (May 1962), p. 197, fig. 27; Van Buren, "Madame Cézanne's Fashions" (1966), p. 115; Richard W. Murphy, *The World of Cézanne, 1839–1906* (New York: Time-Life Books, 1968), p. 104, n20, ill.

Woman with Her Head Down (Madame Cézanne), 1880–81, p. VI (verso)
Chappuis, *Drawings of Paul Cézanne* (1973), no. 818, vol. 1, p. 205, vol. 2, pl. 818

Two Heads of Women (One Possibly Madame Cézanne), 1882–85, p. XXXVI (verso)

Chappuis, *Drawings of Paul Cézanne* (1973), no. 416, vol. 1, p. 134, vol. 2, pl. 416

The Artist's Father, Asleep, and Profile of a Woman, 1882–85, p. XXXVIII (verso)

Chappuis, *Drawings of Paul Cézanne* (1973), no. 415, vol. 1, p. 134, vol. 2, pl. 415

Head of the Artist and Head of a Woman, 1881–84, p. XXXIX

Chappuis, *Drawings of Paul Cézanne* (1973), no. 407, vol. 1, p. 133, vol. 2, pl. 407

Pl. 31. *Portrait of Madame Cézanne*, 1876–79, p. XLIX (verso)

Chappuis, *Drawings of Paul Cézanne* (1973), no. 716, vol. 1, p. 191, vol. 2, pl. 716

Fig. 50. *Madame Cézanne and Another Sketch*, 1877–80, p. L (verso)

Andersen, *Cézanne's Portrait Drawings* (1970), no. 39 fac., pp. 18–20, 81; Chappuis, *Drawings of Paul Cézanne* (1973), no. 719, vol. 1, pp. 191–92, vol. 2, pl. 719

Sketchbook, ca. 1877–1900
Graphite, pen and brown ink, watercolor on wove paper
71 drawings on 46 sheets; each page: 6 × 9⅜ in. (15.2 × 23.7 cm)
National Gallery of Art, Washington, D.C., Collection of Mr. and Mrs. Paul Mellon, in Honor of the 50th Anniversary of the National Gallery of Art (1992.51.9)

Notes: Several of the pages are blank; notes, lists, and arithmetical figures appear on the end papers (recto of the first page and half of the verso of final page); and a draft of a letter to the critic Octave-Henri-Marie Mirbeau (French, 1850–1917) is written on p. II (recto).

Provenance: Paul Cézanne *fils*, Paris; Paul Guillaume, Paris; Adrien Chappuis, Tresserve; Mr. and Mrs. Paul Mellon, Upperville, Va.; National Gallery of Art, Washington, D.C.

Exhibitions: "Art for the Nation: Gifts in Honor of the 50th Anniversary of the National Gallery of Art," National Gallery of Art, Washington, D.C., March 17–June 16, 1991, unnumbered (cat., p. 176); "An Enduring Legacy: Masterpieces from the Collection of Mr. and Mrs. Paul Mellon," National Gallery of Art, Washington, D.C., November 7, 1999–February 27, 2000

References: Venturi, *Cézanne* (1936), no. 1304, vol. 1, pp. 309–10; *Paul Cézanne Sketchbook, 1875–1885* (New York: Johnson Reprint Corporation, 1982)

Fig. 59. *Madame Cézanne*, 1897–1900, p. XIII (1992.51.9.r)

Andersen, *Cézanne's Portrait Drawings* (1970), no. 91 fac., pp. 40, 112; Chappuis, *Drawings of Paul Cézanne* (1973), no. 1189, vol. 1, p. 267, as "Head of Madame Cézanne," vol. 2, pl. 1189

Woman Leaning Forward, 1888–91, p. XXI (1992.51.9.ff)

Chappuis, *Drawings of Paul Cézanne* (1973), no. 1014, vol. 1, p. 234, vol. 2, pl. 1014

Pl. 40. *Madame Cézanne*, 1888–91, p. VII (1992.51.9.h)

Chappuis, *Drawings of Paul Cézanne* (1973), no. 1068, vol. 1, p. 246, vol. 2, pl. 1068

Madame Cézanne, 1886–89, p. XI (1992.51.9.l)

Chappuis, *Drawings of Paul Cézanne* (1973), no. 1064, vol. 1, p. 245, vol. 2, pl. 1064

Studies Including Madame Cézanne, 1884–87, p. LI (1992.51.9.nnn)

Chappuis, *Drawings of Paul Cézanne* (1973), no. 666, vol. 1, p. 181, vol. 2, pl. 666

Head of a Young Woman, ca. 1880, p. XI (verso) (1992.51.9.o)

Chappuis, *Drawings of Paul Cézanne* (1973), no. 609, vol. 1, p. 172, vol. 2, pl. 609

Fig. 55. *Madame Cézanne*, 1882–87, p. XII (1992.51.9.p)

Chappuis, *Drawings of Paul Cézanne* (1973), no. 827, vol. 1, pp. 206–7, as "Portrait of Madame Cézanne," vol. 2, pl. 827

Fig. 43. *Two Heads of Women*, 1890–94, p. XIIII [sic] (1992.51.9.t)

Chappuis, *Drawings of Paul Cézanne* (1973), no. 1016, vol. 1, p. 234, vol. 2, pl. 1016

Fig. 54. *Woman Leaning Forward*, 1890–94, p. XIIII [sic] (verso) (1992.51.9.u)

Chappuis, *Drawings of Paul Cézanne* (1973), no. 1015, vol. 1, p. 234, vol. 2, pl. 1015

Woman Leaning Forward, 1890–94, p. XV (1992.51.9.v)

Chappuis, *Drawings of Paul Cézanne* (1973), no. 1069, vol. 1, p. 246, vol. 2, pl. 1069

Madame Cézanne with Her Head Lowered, 1893–96, p. XVII (1992.51.9.z)

Chappuis, *Drawings of Paul Cézanne* (1973), no. 1073, vol. 1, p. 247, vol. 2, pl. 1073

Three Heads, One of Madame Cézanne, 1882–85, p. XXXI *bis* (1992.51.9.zz)

Chappuis, *Drawings of Paul Cézanne* (1973), no. 841, vol. 1, p. 209, vol. 2, pl. 841

Sketchbook, 1875–85
Graphite, with watercolor on one leaf only, on wove paper, four sheets of blue interleaved; rebound in linen-clad boards
73 drawings on 48 leaves; each leaf: approx. 5 × 8½ in. (12.6 × 21.6 cm); binding: 5¼ × 8¾ in. (13.4 × 22.1 cm)

Morgan Library & Museum, New York, Thaw Collection, Gift in Honor of the 75th Anniversary of the Morgan Library and the 50th Anniversary of the Association of Fellows (1999.9)

Note: Watermark "MONTGOLFIER S A."

Provenance: Paul Cézanne *fils*, Paris; Maurice Renou, Paris; Jean Poyet Collection, Lyons; Maurice Renou, Paris; Sam Salz, New York; Mr. and Mrs. Leigh Block, Chicago; Eugene V. and Clare Thaw, New York; Morgan Library & Museum, New York

References: John Rewald, *Paul Cézanne: Carnets de dessins* (Paris: Quatre Chemins–Editart, 1951), vol. 1, pp. 50–56, vol. 2, pls. 7–9, 12–15, 21, 22, 28, 32, 33, 37, 39–41, 44, 46–53, 68, 70, 71, 74, 76, 78, 79, 81, 88, 92–94, 104, 105, 134, 139, 141; Cara D. Denison et al., *Drawings from the Collection of Mr. and Mrs. Eugene Victor Thaw, Part II*, exh. cat. (New York: Pierpont Morgan Library, 1985), no. 47, ill. (pp. 11 [verso], 12, 13 [verso], 15); Cara D. Denison et al., *From Mantegna to Picasso: Drawings from the Thaw Collection at the Pierpont Morgan Library, New York*, exh. cat. (London: Royal Academy of Arts; New York: Pierpont Morgan Library, 1996), no. 77, ill. (pp. 11 [verso], 12, 13 [verso], 15)

Fig. 56. *Portrait of a Young Woman*, ca. 1881, p. 1 (verso)

Chappuis, *Drawings of Paul Cézanne* (1973), no. 826, vol. 1, p. 206, vol. 2, pl. 826

Peasant Woman Wearing a Coif, Head of a Woman, Round Pitcher, 1874–77, p. 3

Chappuis, *Drawings of Paul Cézanne* (1973), no. 331, vol. 1, p. 119, vol. 2, pl. 331

Madame Cézanne, Her Head Leaning on Her Hand, 1881–82, p. 4 (verso)

Chappuis, *Drawings of Paul Cézanne*, no. 828, vol. 1, p. 207, vol. 2, pl. 828

Fig. 51. *Figure Reading*, 1883–86, p. 26 (verso)

Chappuis, *Drawings of Paul Cézanne* (1973), no. 663, vol. 1, p. 180, vol. 2, pl. 663

Fig. 52. *Landscape with Bare Trees, Portrait of Madame Cézanne*, 1880–85, p. 36

Chappuis, *Drawings of Paul Cézanne* (1973), no. 774, vol. 1, p. 200, vol. 2, pl. 774

Pl. 32 *Head of Madame Cézanne, Two Chairs*, ca. 1876–80, p. 44 (recto)

Andersen, *Cézanne's Portrait Drawings* (1970), no. 54, p. 90; Chappuis, *Drawings of Paul Cézanne* (1973), no. 340, vol. 1, p. 120, vol. 2, pl. 340

INDEX

Page references in *italics* refer to illustrations.